DAVID BUSCH'S CANON® EOS® REBEL T5/1200D

GUIDE TO DIGITAL SLR PHOTOGRAPHY

David D. Busch

Cengage Learning PTR

CENGAGE
Learning®

Professional • Technical • Reference

Australia, Brazil, Japan, Korea, Mexico, Singapore, Spain, United Kingdom, United States

CENGAGE
Learning®

Professional • Technical • Reference

**David Busch's Canon® EOS®
Rebel T5/1200D Guide to Digital
SLR Photography**
David D. Busch

**Publisher and General Manager,
Cengage Learning PTR:**
Stacy L. Hiquet

Associate Director of Marketing:
Sarah Panella

Manager of Editorial Services:
Heather Talbot

Senior Marketing Manager:
Mark Hughes

Product Team Manager:
Kevin Harreld

Project Editor:
Jenny Davidson

Series Technical Editor:
Michael D. Sullivan

Interior Layout Tech:
Bill Hartman

Cover Designer:
Mike Tanamachi

Indexer:
Katherine Stimson

Proofreader:
Michael Beady

For product information and technology assistance, contact us at
Cengage Learning Customer & Sales Support, 1-800-354-9706

For permission to use material from this text or product,
submit all requests online at **cengage.com/permissions**
Further permissions questions can be emailed to
permissionrequest@cengage.com

Library of Congress Control Number: 2014943099

ISBN-13: 978-1-305-27199-9

ISBN-10: 1-305-27199-8

Cengage Learning PTR
20 Channel Center Street
Boston, MA 02210
USA

Cengage Learning is a leading provider of customized learning solutions with office locations around the globe, including Singapore, the United Kingdom, Australia, Mexico, Brazil, and Japan. Locate your local office at: **international.cengage.com/region**

Cengage Learning products are represented in Canada by Nelson Education, Ltd.

For your lifelong learning solutions, visit **cengageptr.com**

Visit our corporate website at **cengage.com**

Printed in Canada
1 2 3 4 5 6 7 16 15 14

For Cathy

Acknowledgments

Once again thanks to the folks at Cengage Learning PTR, who have pioneered publishing digital imaging books in full color at a price anyone can afford. Special thanks to product team manager Kevin Harreld, who always gives me the freedom to let my imagination run free with a topic, as well as my veteran production team including project editor, Jenny Davidson and series technical editor, Mike Sullivan. Also thanks to Bill Hartman, layout; Katherine Stimson, indexing; Mike Beady, proofreading; Mike Tanamachi, cover design; and my agent, Carole Jelen, who has the amazing ability to keep both publishers and authors happy. I'd also like to thank the Continent of Europe, without which this book would have a lot of blank spaces where illustrations are supposed to go.

About the Author

With more than a million books in print, **David D. Busch** is one of the bestselling authors of books on digital photography and imaging technology, and the originator of popular series like *David Busch's Pro Secrets* and *David Busch's Quick Snap Guides*. He has written dozens of hugely successful guidebooks for Canon digital camera models, including all-time #1 bestsellers for many of them, additional user guides for other camera models, as well as many popular books devoted to dSLRs, including *Mastering Digital SLR Photography, Fourth Edition* and *Digital SLR Pro Secrets*. As a roving photojournalist for more than 20 years, he illustrated his books, magazine articles, and newspaper reports with award-winning images. He's operated his own commercial studio, suffocated in formal dress while shooting weddings-for-hire, and shot sports for a daily newspaper and upstate New York college. His photos and articles have been published in *Popular Photography, Rangefinder, Professional Photographer*, and hundreds of other publications. He's also reviewed dozens of digital cameras for CNet (CBS Interactive) and *Computer Shopper*.

When About.com named its top five books on Beginning Digital Photography, debuting at the #1 and #2 slots were Busch's *Digital Photography All-In-One Desk Reference for Dummies* and *Mastering Digital Photography*. During the past year, he's had as many as five of his books listed in the Top 20 of Amazon.com's Digital Photography Bestseller list—simultaneously! Busch's 200-plus other books published since 1983 include bestsellers like *David Busch's Quick Snap Guide to Using Digital SLR Lenses*. His advice has been featured on National Public Radio's *All Tech Considered*.

Busch is a member of the Cleveland Photographic Society (www.clevelandphoto.org), which has operated continuously since 1887. Visit his website at http://www.dslrguides.com/blog.

Contents

PART I: GETTING STARTED WITH YOUR CANON EOS REBEL T5/1200D

Chapter 1
Canon EOS Rebel T5/1200D: Thinking Outside of the Box 5

Chapter 2
Canon EOS Rebel T5/1200D Quick Start 19

Chapter 3
Canon EOS Rebel T5/1200D Roadmap 35

PART II: BEYOND THE BASICS

Chapter 4
Understanding Exposure 57

Chapter 5
Mastering the Mysteries of Autofocus 93

Chapter 6
Live View and Movies 107

Chapter 7
Advanced Shooting 135

PART III: ADVANCED TOOLS

Chapter 8
Customizing with the Shooting and Playback Menus 157

Chapter 9
Customizing with the Set-up Menu and My Menu 209

Chapter 10
Working with Lenses 233

Chapter 11
Working with Light
267

Chapter 12
Canon EOS T5 /1200D:
Troubleshooting and Prevention 319

Preface

You don't want good pictures from your new Canon EOS T5/1200D—you demand *outstanding* photos. After all, the T5/1200D is one of the most affordable entry-level cameras that Canon has ever introduced. It has a useful 18 megapixels of resolution, fast automatic focus, and cool features like the real-time preview system called live view and high-definition movie shooting. But your gateway to pixel proficiency is dragged down by the slim little book included in the box as a manual. You know everything you need to know is in there, somewhere, but you don't know where to start. In addition, the camera manual doesn't offer much information on photography or digital photography. Nor are you interested in spending hours or days studying a comprehensive book on digital SLR photography that doesn't necessarily apply directly to your T5.

What you need is a guide that explains the purpose and function of the T5's basic controls, how you should use them, and *why*. Ideally, there should be information about file formats, resolution, exposure, and other special autofocus modes available, but you'd prefer to read about those topics only after you've had the chance to go out and take a few hundred great pictures with your new camera. Why isn't there a book that summarizes the most important information in its first two or three chapters, with lots of illustrations showing what your results will look like when you use this setting or that?

Now there is such a book. If you want a quick introduction to the T5's focus controls, flash synchronization options, how to choose lenses, or which exposure modes are best, this book is for you. If you can't decide on what basic settings to use with your camera because you can't figure out how changing ISO or white balance or focus defaults will affect your pictures, you need this guide.

Introduction

Canon took a daring step in providing relatively advanced features in this basic entry-level model, the Canon EOS T5/1200D. The company has packaged up many of the most alluring capabilities of its more advanced digital SLRs and stuffed them into a compact, highly affordable body. Your new 18-megapixel camera is loaded with capabilities that few would have expected to find in a dSLR in the sub-$1,000 price range only a few years ago. Indeed, the T5 retains the ease of use that smoothes the transition for those new to digital photography. For those just dipping their toes into the digital pond, the experience is warm and inviting.

But once you've confirmed that you made a wise purchase decision, the question comes up, *how do I use this thing?* All those cool features can be mind-numbing to learn, if all you have as a guide is the manual furnished with the camera. Help is on the way. I sincerely believe that this book is your best bet for learning how to use your new camera, and for learning how to use it well.

If you're a Canon EOS Rebel T5 owner who's looking to learn more about how to use this great camera, you've probably already explored your options. There are DVDs and online tutorials—but who can learn how to use a camera by sitting in front of a television or computer screen? Do you want to watch a movie or click on HTML links, or do you want to go out and take photos with your camera? Videos are fun, but not the best answer.

There's always the manual furnished with the T5. It's compact and filled with information, but there's really very little about *why* you should use particular settings or features, and its organization may make it difficult to find what you need. Multiple cross-references may send you flipping back and forth between two or three sections of the book to find what you want to know. The basic manual is also hobbled by black-and-white line drawings and tiny monochrome pictures that aren't very good examples of what you can do.

Also available are third-party guides to the T5, like this one. I haven't been happy with some of these guidebooks, which is why I wrote this one. The existing books range from skimpy and illustrated by black-and-white photos to lushly illustrated in full color but too generic to do much good. Photography instruction is useful, but it needs to be related directly to the Canon EOS T5 as much as possible.

I've tried to make *David Busch's Canon EOS T5/1200D Guide to Digital SLR Photography* different from your other T5 learn-up options. The roadmap sections use larger, color pictures to show you where all the buttons and dials are, and the explanations of what they do are longer and more comprehensive. I've tried to avoid overly general advice, including the two-page checklists on how to take a "sports picture" or a "portrait picture" or a "travel picture." Instead, you'll find tips and techniques for using all the features of your Canon EOS T5 to take *any kind of picture* you want. If you want to know where you should stand to take a picture of a quarterback dropping back to unleash a pass, there are plenty of books that will tell you that. This one concentrates on teaching you how to select the best autofocus mode, shutter speed, f/stop, or flash capability to take, say, a great sports picture under any conditions.

David Busch's Canon EOS T5/1200D Guide to Digital SLR Photography is aimed at both Canon and dSLR veterans as well as newcomers to digital photography and digital SLRs. Both groups can be overwhelmed by the options the T5 offers, while underwhelmed by the explanations they receive in their user's manual. The manuals are great if you already know what you don't know, and you can find an answer somewhere in a booklet arranged by menu listings and written by a camera vendor employee who last threw together instructions on how to operate a camcorder.

Of course, once you've read this book and are ready to learn more, you might want to pick up one of my other guides to digital SLR photography. I'm listing them here not to hawk my other books, but because a large percentage of the e-mails I get are from readers who want to know if I've got a book on this topic or that. In the chapters that follow, I also may mention another one of my books that covers a particular subject in more depth than is possible in a camera-specific guide. Again, that's only for the benefit of those who want to delve more deeply into a topic. *Most* of what you need to know to use and enjoy your T5 is contained right here in this book. My other guides offered by Cengage Learning PTR include:

Quick Snap Guide to Digital SLR Photography

Consider this a prequel to the book you're holding in your hands. It might make a good gift for a spouse or friend who may be using your T5, but who lacks even basic knowledge about digital photography, digital SLR photography, and Canon EOS photography. It serves as an introduction that summarizes the basic features of digital SLR cameras in general (not just the T5), and what settings to use and when, such as continuous autofocus/single autofocus, exposure, EV settings, and so forth. The guide also includes recipes for shooting the most common kinds of pictures, with step-by-step instructions for capturing effective sports photos, portraits, landscapes, and other types of images.

David Busch's Quick Snap Guide to Using Digital SLR Lenses

A bit overwhelmed by the features and controls of digital SLR lenses, and not quite sure when to use each type? This book explains lenses, their use, and lens technology in easy-to-access two- and four-page spreads, each devoted to a different topic, such as depth-of-field, lens aberrations, or using zoom lenses.

David Busch's Quick Snap Guide to Lighting

This book tells you everything you need to know about using light to create the kind of images you'll be proud of. It's not Canon-specific, and doesn't include any details on using any of the Canon-dedicated flash units, but the information you'll find applies to any digital SLR photography.

Mastering Digital SLR Photography, Fourth Edition

This book is an introduction to digital SLR photography, with nuts-and-bolts explanations of the technology, more in-depth coverage of settings, and whole chapters on the most common types of photography. While not specific to the T5, this book can show you how to get more from its capabilities. I've added six brand new chapters and the latest technology secrets in this new version.

Why the Canon EOS T5/1200D Needs Special Coverage

There are many general digital photography books on the market. Why do I concentrate on books about specific digital SLRs like the T5? One reason is that I feel dSLRs are the wave of the future for serious photographers, and those who join the ranks of digital photographers with single lens reflex cameras deserve books tailored to their equipment.

When I started writing digital photography books in 1995, digital SLRs cost $30,000 and few people other than certain professionals could justify them. Most of my readers a dozen years ago were stuck using the point-and-shoot, low-resolution digital cameras of the time—even if they were advanced photographers. I myself took countless digital pictures with an Epson digital camera with 1,024 × 768 (less than 1 megapixel!) resolution, and which cost $500.

Less than a decade ago (before the original Digital Rebel was introduced), the lowest-cost dSLRs were priced at $3,000 or more. Today, anyone with around $600 can afford one of those basic cameras, and roughly $550 buys you a sophisticated model like the Canon EOS T5 (with lens). The digital SLR is no longer the exclusive bailiwick of the professional, the wealthy, or the serious photography addict willing to scrimp and save to acquire a dream camera. Digital SLRs have become the favored camera for anyone who wants to go beyond point-and-shoot capabilities. And Canon cameras have enjoyed a dominating position among digital SLRs because of Canon's innovation in introducing affordable cameras with interesting features and outstanding performance (particularly in the area of high ISO image quality). It doesn't hurt that Canon also provides both full-frame and smaller format digital cameras and a clear migration path between them (if you stick to the Canon EF lenses that are compatible with both).

Who Am I?

After spending years as the world's most successful unknown author, I've become slightly less obscure in the past few years, thanks to a horde of camera guidebooks and other photographically oriented tomes. You may have seen my photography articles in *Popular Photography* magazine. I've also written about 2,000 articles for magazines like *Petersen's PhotoGraphic* (which is now defunct through no fault of my own), plus *Rangefinder, Professional Photographer*, and dozens of other photographic publications. But, first, and foremost, I'm a photojournalist and made my living in the field until I began devoting most of my time to writing books.

Although I love writing, I'm happiest when I'm out taking pictures, which is why I invariably spend several days each week photographing landscapes, people, close-up subjects, and other things. I spend a month or two each year traveling to events, such as Native American "powwows," Civil War re-enactments, county fairs, ballet, and sports (baseball, basketball, football, and soccer are favorites). Later this year I'm scheduled to spend a full two weeks in Spain, strictly to shoot photographs of the people, landscapes, and monuments that I've grown to love. I can offer you my personal advice on how to take photos under a variety of conditions because I've had to meet those challenges myself on an ongoing basis.

Like all my digital photography books, this one was written by someone with an incurable photography bug. My first Canon SLR was a now-obscure model called the Pellix back in the 1960s, and I've used a variety of newer models since then. I've worked as a sports photographer for an Ohio newspaper and for an upstate New York college. I've operated my own commercial studio and photo lab, cranking out product shots on demand and then printing a few hundred glossy 8 × 10s on a tight deadline for a press kit. I've served as a photo-posing instructor for a modeling agency. People have actually paid me to shoot their weddings and immortalize them with portraits. I even prepared press kits and articles on photography as a PR consultant for a formerly large Rochester, N.Y., company, which shall remain nameless. My trials and travails with imaging and computer technology have made their way into print in book form an alarming number of times, including a few dozen on scanners and photography.

Like you, I love photography for its own merits, and I view technology as just another tool to help me get the images I see in my mind's eye. But, also like you, I had to master this technology before I could apply it to my work. This book is the result of what I've learned, and I hope it will help you master your T5 digital SLR, too.

As I write this, I'm currently in the throes of upgrading my website, which you can find at www.dslrguides.com/blog, adding tutorials and information about my other books. There's a lot of information about several Canon models right now, but I'll be adding more tips and recommendations (including a list of equipment and accessories that I can't live without) in the next few months. I've also set up a wish list of Canon cameras, lenses, and accessories on Amazon.com for those who want to begin shopping now. If you happen to spot a typo or two in this book, I'd love to fix them for the next printing, and add the goofs that you spot to my errata page at my blog. If you like, you can register there and contact me directly with your comments and questions.

Part I

Getting Started with Your Canon EOS Rebel T5/1200D

The first part of this book, consisting of just three short chapters, is designed to familiarize you with the basics of your Canon EOS Rebel T5/1200D as quickly as possible, even though I have no doubt that you've already been out shooting a few hundred (or thousand) photographs with your pride and joy.

After all, inserting a memory card, mounting a lens, stuffing a charged battery into the base, and removing the lens cap to fire off a shot or two isn't rocket science. Even the rawest neophyte can rotate the Mode Dial (located at top right on the camera body) to the P (Programmed auto) or Full Auto (marked with a green icon) position and point the T5 at something interesting and press the shutter release. Presto! A pretty good picture will pop up on the color LCD on the back of the camera. It's easy!

However, in digital photography, there is such a thing as *too* easy. If you bought a T5, you certainly did not intend to use the camera as a point-and-shoot snapshooter. After all, the T5 is a tool suitable for the most advanced photographic pursuits, with an extensive array of customization possibilities. As such, you don't want the camera's operation to be brainless; you want *access* to the advanced features to be easy.

You get that easy access with the Canon T5. However, you'll still need to take the time to learn how to use these features, and I'm going to provide everything you need to know in these first three chapters to begin shooting:

- **Chapter 1:** This is a "Meet Your T5" introduction, where you'll find information about what came in the box with your camera and, more importantly, what *didn't* come with the camera that you seriously should consider adding to your arsenal. I'll also cover some things you might not have known about charging the T5's battery, choosing a memory card, setting the time and date, and a few other pre-flight tasks. This is basic stuff, and if you're a Canon veteran, you can skim over it quickly. A lot of this first chapter is intended for EOS newbies, and even if you personally don't find it essential, you'll probably agree that there was some point during your photographic development (so to speak) that you would have wished this information was spelled out for you. There's no extra charge!

- **Chapter 2:** Here, you'll find a Quick Start aimed at those who may not be old hands with Canon cameras having this level of sophistication. The T5 has some interesting new features, including one of the most advanced autofocus systems ever seen in a mid-level camera body (and which deserves an entire chapter of its own later in this book). But even with all the goodies to play with and learning curve still to climb, you'll find that Chapter 2 will get you shooting quickly with a minimum of fuss.

■ **Chapter 3:** This is a Streetsmart Roadmap to the Canon EOS Rebel T5/1200D. Confused by the tiny little diagrams and multiple cross-references for each and every control that send you scurrying around looking for information you know is buried somewhere in the small and inadequate manual stuffed in the box? This chapter uses multiple large full-color pictures that show every dial, knob, and button, and explain the basics of using each in clear, easy-to-understand language. I'll give you the basics up front, and, even if I have to send you deeper into the book for a full discussion of a complex topic, you'll have what you need to use a control right away.

Once you've finished (or skimmed through) these three chapters, you'll be ready for Part II, which explains how to use the most important basic features, such as the T5's exposure controls, nifty new autofocus system, and the related tools that put live view and movie-making tools at your fingertips. Then, you can visit Part III, the advanced tools section, which explains all the dozens of setup options that can be used to modify the capabilities you've learned to use so far, how to choose and use lenses, and introduces the EOS Rebel T5/1200D's built-in flash and external flash capabilities. I'll wind up this book with Part IV, which covers image software, printing, and transfer options and includes some troubleshooting that may help you when good cameras (or film cards) go bad.

1

Canon EOS Rebel T5/1200D: Thinking Outside of the Box

Whether you subscribe to the "my camera is just a tool" theory, or belong to the "an exquisite camera adds new capabilities to my shooting arsenal" camp, picking up a new Canon EOS Rebel T5/1200D is a special experience. Those who simply wield tools will find this camera as comforting as an old friend, a solid piece of fine machinery ready and able to do their bidding as part of the creative process.

Other photographers see the low-light capabilities (up to ISO 12,800), the 3 frames-per-second continuous shooting, commendable ruggedness, and 18-megapixel resolution of the T5, and gain a sense of empowerment. *Here* is a camera with fewer limitations and more capabilities for exercising renewed creative vision. In either case, using less mawkish terms, the T5 is one of the coolest "beginner" cameras Canon has ever offered. Whether you're upgrading from another brand, from another Canon model, or the T5 is your first digital camera and/or SLR, welcome to the club.

But, now that you've unwrapped and recharged the beast, mounted a lens, and fueled it with a memory card, what do you *do* with it? That's where this chapter—and the chapters that follow—should come in handy. Like many of you, I am a Canon user of long standing. And, like other members of our club, I had to learn at least some aspects of my newest EOS camera for the very first time at some point. Experienced pro, or Canon newbie, you bought this book because you wanted to get the most from a very powerful tool, and I'm here to help.

Whether you've already taken a dozen or twelve hundred photos with your new camera, now that you've got that initial creative burst out of your system, you'll want to take a more considered approach to operating the camera. This chapter and the next are designed to get your camera fired up and ready for shooting as quickly as possible. After all, the T5 is not a point-and-shoot camera, even though it does boast easy-to-use "Basic Zone" and "Image Zone" options with icons on a handy dial representing various fully automatic modes, plus "Scene" modes with icons for a person (for portraits), flower (close-ups), mountain scene (landscapes), or runner (sports activity).

So I'm going to provide a basic pre-flight checklist that you need to complete before you really spread your wings and take off. You won't find a lot of detail in these first two chapters. Indeed, I'm going to tell you just what you absolutely *must* understand, accompanied by some interesting tidbits that will help you become acclimated to your T5. I'll go into more depth and even repeat some of what I explain here in later chapters, so you don't have to memorize everything you see. Just relax, follow a few easy steps, and then go out and begin taking your best shots—ever.

Even if you're a long-time Canon shooter, I hope you won't be tempted to skip this chapter or the next one. I realize that you probably didn't purchase this book the same day you bought your camera and that, even if you did, the urge to go out and take a few hundred—or thousand—photos with your new camera is enticing. As valuable as a book like this one is, nobody can suppress their excitement long enough to read the instructions before initiating play with a new toy.

No matter how extensive your experience level is, you don't need to fret about wading through a manual to find out what you must know to take those first few tentative snaps. I'm going to help you hit the ground running with this chapter, which will help you set up your camera and begin shooting in minutes. You won't find a lot of detail in this chapter. Indeed, I'm going to give you the basics, accompanied by some interesting tidbits that will help you become acclimated. I'll go into more depth and even repeat some of what I explain here in later chapters, so you don't have to memorize everything you see. Because I realize that some of you may already have experience with Canon cameras similar to the T5, each of the major sections in this chapter will begin with a brief description of what is covered in that section, so you can easily jump ahead to the next if you are in a hurry to get started.

First Things First

This section helps get you oriented with all the things that come in the box with your Canon EOS Rebel T5/1200D, including what they do. I'll also describe some optional equipment you might want to have. If you want to get started immediately, skim through this section and jump ahead to "Initial Setup" later in the chapter.

The Canon EOS Rebel T5/1200D comes in an impressive box filled with stuff, including a connecting cable, CDs, and lots of paperwork. The most important components are the camera and lens (if you purchased your T5 with a lens, which is probable, as it was initially available only in kit

form), battery, battery charger, and, if you're the nervous type, the neck strap. You'll also need a memory card, as one is not included. If you purchased your EOS Rebel T5/1200D from a camera shop, as I did, the store personnel probably attached the neck strap for you, ran through some basic operational advice that you've already forgotten, tried to sell you a memory card, and then, after they'd given you all the help you could absorb, sent you on your way with a handshake.

Perhaps you purchased your T5 from one of those mass merchandisers that also sell washing machines and vacuum cleaners. In that case, you might have been sent on your way with only the handshake, or, maybe, not even that if you resisted the efforts to sell you an extended warranty. You save a few bucks, but don't get the personal service a professional photo retailer provides. It's your choice. There's a third alternative, of course. You might have purchased your camera from a mail order or Internet source, and your T5 arrived in a big brown (or purple/red) truck. Your only inter-action when you took possession of your camera was to scrawl your signature on an electronic clipboard.

In all three cases, the first thing to do is carefully unpack the camera and double-check the contents with the checklist on one end of the box, helpfully designated with a CONTENTS heading. At a minimum, the box should include a Digital Camera EOS Rebel T5/1200D, Wide Strap EW-200D, Battery Charger LC-E10, Battery Pack LP-E10, Interface Cable, and a set of software/instructional CD-ROMs, all described in more detail below. It's likely that the camera was accompanied by a lens, as well, and that the contents I've listed above will vary slightly depending on when and where you bought the camera.

While this level of setup detail may seem as superfluous as the instructions on a bottle of shampoo, checking the contents *first* is always a good idea. No matter who sells a camera, it's common to open boxes, use a particular camera for a demonstration, and then repack the box without replacing all the pieces and parts afterward. Someone might actually have helpfully checked out your camera on your behalf—and then mispacked the box. It's better to know *now* that something is missing so you can seek redress immediately, rather than discover two months from now that the USB cable you thought you'd never use (but now *must* have) was never in the box.

At a minimum, the box should have the following:

■ **Canon EOS Rebel T5/1200D digital camera.** This is hard to miss. The camera is the main reason you laid out the big bucks, and it is tucked away inside a nifty bubble-wrap envelope you should save for protection in case the T5 needs to be sent in for repair.

■ **Rubber eyecup Ef.** This slide-on soft-rubber eyecup should be attached to the viewfinder when you receive the camera. It helps you squeeze your eye tightly against the window, excluding extraneous light, and also protects your eyeglasses (if you wear them) from scratching.

■ **Lens.** The Rebel T5 probably came in a kit with the Canon Zoom Lens EF-S 18-55mm f/3.5-56 IS II lens. Or, you may purchase it with another lens. The lens will come with a lens cap on the front, and a rear lens cap aft.

- **Battery pack LP-E10 (with cover).** The power source for your Rebel T5 is packaged separately. You'll need to charge this 7.4V, 860mAh (milliampere hour) battery before using it. It should be charged as soon as possible (as described next) and inserted in the camera. Save the protective cover. If you transport a battery outside the camera, it's a good idea to re-attach the cover to prevent the electrical contacts from shorting out.

- **Battery charger LC-E10 or LC-E10e.** One of these two battery chargers will be included.

- **Wide strap EW-200D.** Canon provides you with a suitable neck strap, emblazoned with Canon advertising. While I am justifiably proud of owning a fine Canon camera, I prefer a low-key, more versatile strap from UPstrap (www.upstrap.com). If you carry your camera over one shoulder, as many do, I particularly recommend the UPstrap shown in Figure 1.1. That patented non-slip pad offers reassuring traction and eliminates the contortions we sometimes go through to keep the camera from slipping off. I know several photographers who refuse to use anything else. If you do purchase an UPstrap, be sure you mention to photographer-inventor Al Stegmeyer that I sent you hence. You won't get a discount, but Al will get yet another confirmation of how much I like his neck straps.

- **Interface cable.** You can use this USB cable to transfer photos from the camera to your computer, although I don't recommend that mode, because direct transfer uses a lot of battery power. You can also use the cable to upload and download settings between the camera and your computer (highly recommended), and to operate your camera remotely using the software included on the CD-ROM. This cable is a standard one that works with the majority of digital cameras—Canon and otherwise—so if you already own one, now you have a spare.

- **EOS Digital Solution Disc CD.** The disc contains useful software that will be discussed in more detail in Chapter 12.

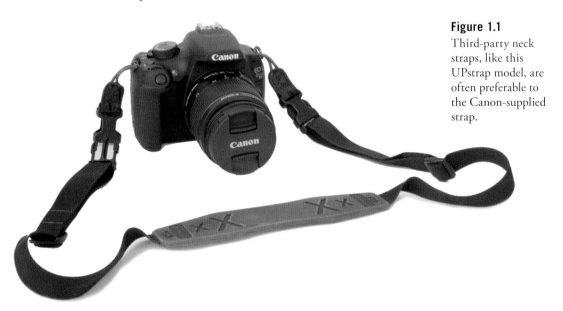

Figure 1.1
Third-party neck straps, like this UPstrap model, are often preferable to the Canon-supplied strap.

- **Software instruction manual CD.** While the software itself is easy to use, if you need more help, you'll find it in the PDF manuals included on this CD.

- **Full instructional manual CD.** The full manual for this camera is not supplied in printed form. You must access it from a PDF file stored on this CD.

- **Warranty and registration card.** Don't lose these! You can register your Canon T5 by mail, although you don't really need to in order to keep your warranty in force, but you may need the information in this paperwork (plus the purchase receipt/invoice from your retailer) should you require Canon service support.

Don't bother rooting around in the box for anything beyond what I've listed previously. There are a few things Canon classifies as optional accessories, even though you (and I) might consider some of them essential. Here's a list of what you *don't* get in the box, but might want to think about as an impending purchase. I'll list them roughly in the order of importance:

- **Memory card.** First-time digital camera buyers are sometimes shocked that their new tool doesn't come with a memory card. Why should it? The manufacturer doesn't have the slightest idea of how much storage you require, or whether you want a slow/inexpensive card or one that's faster/more expensive, so why should they pack one in the box and charge you for it? For an 18-megapixel camera, you really need a Class 10 SDHC/SDXC memory card that's a minimum of 8GB in size. I'll explain more about card specs later in this book.

- **Extra LP-E10 battery.** Even though you might get 500 to more than 1,000 shots from a single battery, it's easy to exceed that figure in a few hours of shooting sports at 3 fps. Batteries can unexpectedly fail, too, or simply lose their charge from sitting around unused for a week or two. Buy an extra (I own four, in total), keep it charged, and free your mind from worry.

- **Add-on Speedlite.** One of the best ways to enhance your lighting effects is with an external Speedlite such as the 320EX and 270EX II strobes, which were designed especially for cameras in this class. Your built-in flash can function as the main illumination for your photo, or soft-ened and used to fill in shadows. If you do much flash photography at all, consider an add-on Speedlite as an important accessory.

- **AC Adapter Kit ACK-E10.** This includes the Compact Power Adapter CA-PS700 and DC Coupler DR-E10, which are used together to power the T5 independently of the batteries. There are several typical situations where this capability can come in handy: when you're clean-ing the sensor manually and want to totally eliminate the possibility that a lack of juice will cause the fragile shutter and mirror to spring to life during the process; when indoors shooting tabletop photos, portraits, class pictures, and so forth for hours on end; when using your T5 for remote shooting as well as time-lapse photography; for extensive review of images on your television; or for file transfer to your computer. These all use prodigious amounts of power, which can be provided by this AC adapter. (Beware of power outages and blackouts when cleaning your sensor, however!)

- **Angle Finder C right angle viewer.** This handy accessory fastens in place of the standard rubber eyecup and provides a 90-degree view for framing and composing your image at right angles to the original viewfinder, useful for low-level (or high-level) shooting. (Or, maybe, shooting around corners!)
- **HDMI cable HTC-100.** You'll need this optional cable if you want to connect your camera directly to an HDTV for viewing your images. Not everyone owns a high-def television, and Canon saved the holdouts a few bucks by not including one (or charging for it).

Initial Setup

This section helps you become familiar with the controls most used to make adjustments: the cross keys and the Main Dial. You'll also find information on charging the battery, setting the clock, mounting a lens, and making diopter vision adjustments.

The initial setup of your Canon EOS Rebel T5/1200D is fast and easy. Basically, you just need to charge the battery, attach a lens, and insert a memory card. I'll address each of these steps separately, but if you already feel you can manage these set-up tasks without further instructions, feel free to skip this section entirely. You should at least skim its contents, however, because I'm going to list a few options that you might not be aware of.

Battery Included

Your Canon EOS Rebel T5/1200D is a sophisticated hunk of machinery and electronics, but it needs a charged battery to function, so rejuvenating the LP-E10 lithium-ion battery pack furnished with the camera should be your first step. A fully charged power source should be good for approximately 500 shots, based on standard tests defined by the Camera & Imaging Products Association (CIPA) document DC-002.

A BATTERY AND A SPARE

My experience is that the CIPA figures are often a little optimistic, so it's probably a good idea to have a spare battery on hand. I always recommend purchasing Canon-brand batteries (for less than $65) over less-expensive third-party packs. My reasoning is that it doesn't make sense to save $20 on a component for an advanced camera, especially since batteries (from Canon as well as other sources) have been known to fail in potentially harmful ways. Canon, at least, will stand behind its products, issue a recall if necessary, and supply a replacement if a Canon-brand battery is truly defective. A third-party battery supplier that sells under a half-dozen or more different product labels and brands may not even have an easy way to get the word out that a recall has been issued.

If your pictures are important to you, always have at least one spare battery available, and make sure it is an authentic Canon product.

All rechargeable batteries undergo some degree of self-discharge just sitting idle in the camera or in the original packaging. Li-ion cells lose their power through a chemical reaction that continues when the camera is switched off. It's very likely that the battery purchased with your camera is at least partially pooped out, so you'll want to revive it before going out for some serious shooting.

There are many situations in which you'll be glad you have that spare battery:

- **Remote locales.** If you like to backpack and will often be far from a source of electricity, rechargeable cells won't be convenient. They tend to lose some charge over time, even if not used, and will quickly become depleted as you use them. You'll have no way to recharge the cells, lacking a solar-powered charger that might not be a top priority for your backpacking kit.

- **Unexpected needs.** Perhaps you planned to shoot landscapes one weekend, and then are given free front-row tickets to a Major League Soccer game. Instead of a few dozen pictures of trees and lakes, you find yourself shooting hundreds of images of Landon Donovan and company, which may be beyond the capacity of the single battery you own. If you have a spare battery, you're in good shape.

- **Unexpected failures.** I've charged up batteries and then discovered that they didn't work when called upon, usually because the rechargeable cells had past their useful life, the charger didn't work, or because of human error. (I *thought*, I'd charged them!) That's one reason why I always carry three times as many batteries as I think I will need.

- **Long shooting session.** Perhaps your niece is getting married, and you want to photograph the ceremony, receiving line, and reception. Several extra batteries will see you through the longest shooting session.

Power Options

Several battery chargers and power sources are available for the Canon EOS Rebel T5. The compact LC-E10 plugs directly into a wall socket and is commonly furnished with the camera. Canon also provides the LC-E10E, shown in Figure 1.2, which is similar, but has a cord. Purchasing one of the optional charging devices offers more than some additional features: You gain a spare that can keep your camera running until you can replace your primary power rejuvenator. Here's a list of your power options:

- **LC-E10E.** This charges a single battery, but requires a cord. That can be advantageous in certain situations. For example, if your power outlet is behind a desk or in some other semi-inaccessible location, the cord can be plugged in and routed so the charger sits on your desk or another more convenient spot. The cord itself is a standard one that works with many different chargers and devices (including the power supply for my laptop), so I purchased several of them and leave them plugged into the wall in various locations. I can connect my T5's charger, my laptop computer's charger, and several other electronic components to one of these cords without needing to crawl around behind the furniture. The cord draws no power when it's not plugged in to a charger.

- **LC-E10.** This charger may be the most convenient for some, because of its compact size and built-in wall plug prongs that connect directly into your power strip or wall socket and require no cord. This charger, as well as the LC-E8E, has a switching power module that is fully compatible with 100V to 240V 50/60Hz AC power, so you can use it outside the U.S. with no problems. When I travel to Europe, for example, I take my charger and an adapter to convert the plug shape for the European sockets. No voltage converter is needed.
- **AC Adapter Kit ACK-E5.** This device consists of Compact Power Adapter CA-PS700 and DC Coupler DR-E10, and allows you to operate your Rebel T5 directly from AC power, with no battery required. You also might want to use the AC adapter when viewing images on a TV connected to your T5, or when shooting remote or time-lapse photos.

Charging the Battery

When the battery is inserted into the LC-E10 charger properly (it's impossible to insert it incorrectly), a Charge light begins glowing orange-red. When the battery completes the charge, the Full Charge lamp glows green, approximately two hours later. When the battery is charged, remove it from the charger, flip the lever on the bottom of the camera, and slide the battery in. (See Figure 1.3.) To remove the battery, you must press a lever, which prevents the pack from slipping out when the door is opened.

Figure 1.2 A flashing status light (not shown) indicates that the battery is being charged.

Figure 1.3 Insert the battery in the camera; it only fits one way. Press the button to release the battery when you want to remove it.

Final Steps

Your Canon EOS Rebel T5 is almost ready to fire up and shoot. You'll need to select and mount a lens, adjust the viewfinder for your vision, and insert a memory card. Each of these steps is easy, and if you've used any Canon EOS camera in the past, you already know exactly what to do. I'm going to provide a little extra detail for those of you who are new to the Canon or digital SLR worlds.

Mounting the Lens

As you'll see, my recommended lens mounting procedure emphasizes protecting your equipment from accidental damage, and minimizing the intrusion of dust. If your T5 has no lens attached, select the lens you want to use and loosen (but do not remove) the rear lens cap. I generally place the lens I am planning to mount vertically in a slot in my camera bag, where it's protected from mishaps, but ready to pick up quickly. By loosening the rear lens cap, you'll be able to lift it off the back of the lens at the last instant, so the rear element of the lens is covered until then.

After that, remove the body cap by rotating the cap toward the shutter release button. You should always mount the body cap when there is no lens on the camera, because it helps keep dust out of the interior of the camera, where it can settle on the mirror, focusing screen, or interior mirror box, and potentially find its way past the shutter onto the sensor. (While the T5's sensor cleaning mechanism works fine, the less dust it has to contend with, the better.) The body cap also protects the vulnerable mirror from damage caused by intruding objects (including your fingers, if you're not cautious).

Once the body cap has been removed, remove the rear lens cap from the lens, set it aside, and then mount the lens on the camera by matching the alignment indicator on the lens barrel (red for EF lenses and white for EF-S lenses) with the red or white dot on the camera's lens mount (see Figure 1.4).

Figure 1.4
Match the white dot on EF-S lenses with the white dot on the camera mount to properly align the lens with the bayonet mount. For EF lenses, use the red dots.

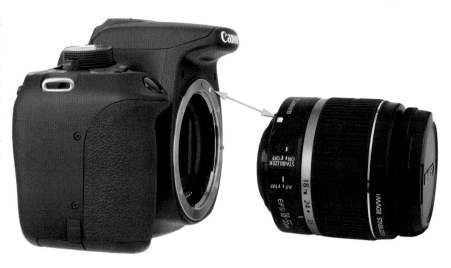

Rotate the lens away from the shutter release until it seats securely. (You can find out more about the difference between EF and EF-S lenses in Chapter 10.) Set the focus mode switch on the lens to AF (autofocus). If the lens hood is bayoneted on the lens in the reversed position (which makes the lens/hood combination more compact for transport), twist it off and remount with the edge facing outward (see Figure 1.5). A lens hood protects the front of the lens from accidental bumps and stray fingerprints, and reduces flare caused by extraneous light arriving at the front element of the lens from outside the picture area.

Adjusting Diopter Correction

Those of us with less than perfect eyesight can often benefit from a little optical correction in the viewfinder. Your contact lenses or glasses may provide all the correction you need, but if you are a glasses wearer and want to use the EOS Rebel T5/1200D without your glasses, you can take advantage of the camera's built-in diopter adjustment, which can be varied from –2.5 to +0.5 correction. Press the shutter release halfway to illuminate the indicators in the viewfinder, then rotate the diopter adjustment knob next to the viewfinder (see Figure 1.6) while looking through the viewfinder until the indicators appear sharp.

If the available correction is insufficient, Canon offers 10 different Dioptric Adjustment Lens Series E correction lenses for the viewfinder window. If more than one person uses your T5, and each requires a different diopter setting, you can save a little time by noting the number of clicks and direction (clockwise to increase the diopter power; counterclockwise to decrease the diopter value) required to change from one user to the other. There are 18 detents in all.

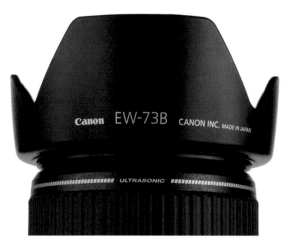

Figure 1.5 A lens hood protects the lens from extraneous light and accidental bumps.

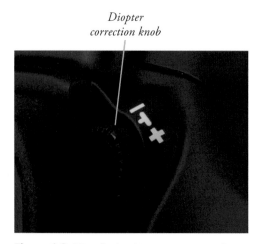

Diopter correction knob

Figure 1.6 Viewfinder diopter correction from –2.5 to +0.5 can be dialed in.

Inserting a Memory Card

You can't take photos without a memory card inserted in your EOS Rebel T5/1200D (although there is a Release Shutter without Card entry in the Shooting 1 menu that enables/disables shutter release functions when a memory card is absent—learn about that in Chapter 8). So, your final step will be to insert a memory card. First, open the battery compartment door. You should only remove the memory card when the camera is switched off, but the T5 will remind you if the door is opened while the camera is still writing photos to the memory card.

Then, insert the memory card with the label facing the back of the camera, as shown in Figure 1.7, oriented so the edge with the connectors goes into the slot first. Close the door, and your pre-flight checklist is done! (I'm going to assume you remember to remove the lens cap when you're ready to take a picture!) When you want to remove the memory card later, push it inward to make the memory card pop out.

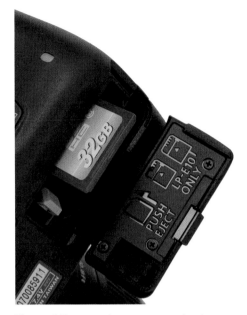

Figure 1.7 Insert the memory in the slot with the label facing the back of the camera.

Formatting a Memory Card

There are three ways to create a blank memory card for your T5, and two of them are at least partially wrong. Here are your options, both correct and incorrect:

- **Transfer (move) files to your computer.** When you transfer (rather than copy) all the image files to your computer from the memory card (either using a direct cable transfer or with a card reader, as described later in this chapter), the old image files are erased from the card, leaving the card blank. Theoretically. This method does *not* remove files that you've labeled as Protected (choosing the Protect Images function in the Playback menu) nor does it identify and lock out parts of your memory card that have become corrupted or unusable since the last time you formatted the card. Therefore, I recommend always formatting the card, rather than simply moving the image files, each time you want to make a blank card. The only exception is when you *want* to leave the protected/unerased images on the card for awhile longer, say, to share with friends, family, and colleagues.

- **(Don't) Format in your computer.** With the memory card inserted in a card reader or card slot in your computer, you can use Windows or Mac OS to reformat the memory card. Don't! The operating system won't necessarily arrange the structure of the card the way the T5 likes to see it (in computer terms, an incorrect *file system* may be installed). The only way to ensure that the card has been properly formatted for your camera is to perform the format in the camera itself. The only exception to this rule is when you have a seriously corrupted memory card that your camera refuses to format. Sometimes it is possible to revive such a corrupted card by allowing the operating system to reformat it first, then trying again in the camera.

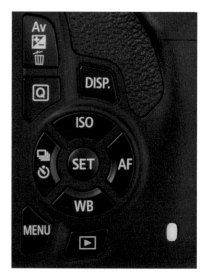

- **Setup menu format.** To use the recommended method to format a memory card, turn on the camera, press the MENU button, rotate the Main Dial (located on top of the camera, just behind the shutter release button) or use the left-right cross keys to choose the Set-up 1 menu (which is represented by a wrench icon with a single dot next to it), use the up/down cross keys to navigate to the Format entry, and press the SET button in the center of the cross key pad to access the Format screen. Press the left/right cross keys again to select OK and press the SET button one final time to begin the format process.

Figure 1.8 The cross keys and SET button in their center are your basic navigational controls for menus.

LOW LEVEL FORMAT

You can also press the Trash button, located in the lower-right corner of the back of the camera, to mark the Low level format box on the Format screen. This tells the T5 to perform an additional, more thorough, formatting of the card after the initial format is finished. The Low level format serves to remove data from all writable portions of your memory card while locking out "bad" sectors, and can be used to restore a memory card that is slowing down as it "trips" over those bad sectors. This extra step takes a bit longer than a standard reformat, and need not be used every time you format your card.

Powering Up/Setting Date and Time

Rotate the On/Off switch on top of the camera (see Figure 1.9) to the On position. Automatic sensor cleaning takes place (unless you specifically disable this action) as the T5 powers up. The camera will remain on or in a standby mode until you manually turn it off. After 30 seconds of idling, the T5 goes into standby mode to save battery power. Just tap the shutter release button to bring it back to life. The automatic sensor cleaning operation does not occur when exiting standby mode.

The first time you use the Rebel T5, it may ask you to enter the time and date. (This information may have been set by someone checking out your camera on your behalf prior to sale.) Just follow these steps:

1. Press the MENU button, located in the lower-right corner of the back of the T5.
2. Rotate the Main Dial (near the shutter release button on top of the camera) until the Set-up 1 menu is highlighted. It's marked by a wrench with one dot next to it.
3. Use the up/down cross keys to move the highlighting down to the Date/Time entry.
4. Press the SET button in the center of the keypad to access the Date/Time setting screen, shown in Figure 1.10.
5. Use the left/right cross keys to select the value you want to change. When the gold box highlights the month, day, year, hour, minute, or second format you want to adjust, press the SET button to activate that value. A pair of up/down pointing triangles appears above the value.

Figure 1.9
The On/Off switch is located on top of the camera, next to the large Mode Dial on the right side.

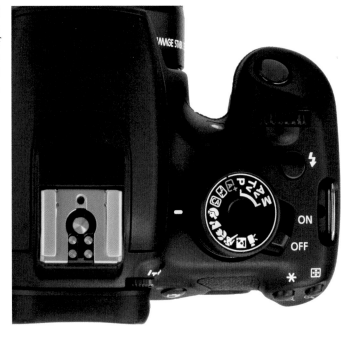

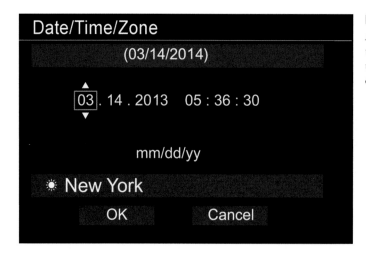

Figure 1.10
Adjust the date, time, and format used to display the date.

6. Press the up/down cross keys to adjust the value up or down. Press the SET button to confirm the value you've entered.

7. Repeat steps 5 and 6 for each of the other values you want to change. The date format can be switched from the default mm/dd/yy to yy/mm/dd or dd/mm/yy.

8. When finished, navigate with the right cross key to select either OK (if you're satisfied with your changes) or Cancel (if you'd like to return to the Set-up 2 menu screen without making any changes). Press SET to confirm your choice.

9. When finished setting the date and time, press the MENU button to exit.

Your Canon EOS Rebel T5/1200D is ready to go. If you need a quick start for its basic operation, jump ahead to Chapter 2.

2

Canon EOS Rebel T5/1200D Quick Start

Now it's time to fire up your EOS T5 and take some photos. The easy part is turning on the power—that Off-On switch on the right side, just to the right of the Mode Dial. Turn on the camera, and, if you mounted a lens and inserted a fresh battery and memory card—as I prompted you in the last chapter—you're ready to begin. You'll need to select a shooting mode, metering mode, focus mode, and, if need be, elevate the T5's built-in flash.

Selecting a Shooting Mode

The following sections show you how to choose scene, semi-automatic, or automatic shooting (exposure) modes; select a metering mode (which tells the camera what portions of the frame to evaluate for exposure); and set the basic autofocus functions. If you understand how to do these things, you can skip ahead to "Other Settings."

You can choose a shooting method from the Mode Dial located on the top right of the Canon EOS Rebel T5. (See Figure 2.1.) There are eight Basic Zone/Image Zone shooting modes, in which the camera makes virtually all the decisions for you (except when to press the shutter), plus Movie mode. Canon has started sub-dividing the Basic Zone modes, referring to the true scene settings (Portrait, Landscape, Close-up, Sports, and Night Portrait) as "Image Zone" modes, while the other three automatic modes (Scene Intelligent Auto, Flash Off, and Creative Auto) are just plain vanilla Basic Zone modes. Because these automatic modes share so many characteristics, I'm going to stick

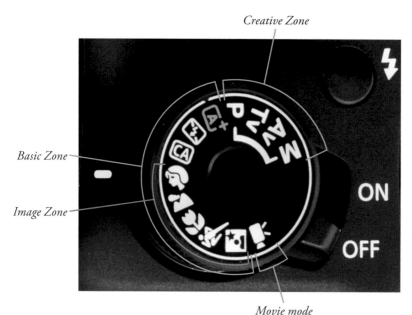

Creative Zone

Basic Zone

Image Zone

Movie mode

Figure 2.1
The Creative Zone modes (upper-right side of dial as shown) let the photographer control how exposures are made, to increase creative options. The Basic Zone settings (left side of the dial) make all the exposure decisions for you. The Movie mode is used for capturing video clips.

with the original Basic Zone nomenclature for all of them after I've explained the functions of each in this chapter. You'll find a complete discussion of both Basic/Image Zone and Creative Zone modes in Chapter 4.

Turn your camera on by flipping the power switch (located to the right of the Mode Dial) to On. Next, you need to select which shooting mode to use. If you're very new to digital photography, you might want to set the camera to Scene Intelligent Auto (the A in a green frame on the Mode Dial) or P (Program mode) and start snapping away. Either mode will make all the appropriate settings for you for many shooting situations. If you have a specific type of picture you want to shoot, you can try out one of the Image Zone (scene) modes within the Basic Zone. They are indicated on the Mode Dial with appropriate icons, as shown in the figure.

- **Scene Intelligent Auto.** In this mode, marked with a green icon, the EOS T5 makes all the exposure decisions for you, and will pop up the flash if necessary under low-light conditions.

- **Flash Off.** This mode is like Full Auto with the flash disabled. You'll want to use it in museums and other locations where flash is forbidden or inappropriate. It otherwise operates exactly like the Auto setting but disables the pop-up internal flash unit.

- **CA.** This Creative Auto mode is basically the same as the Full Auto option, but, unlike the other Basic Zone modes, allows you to change the brightness and other parameters of the image. The T5 still makes most of the decisions for you, but you can make some simple adjustments using the Creative Auto setting screen that appears when you press the Q button (located immediately to the right of the LCD). You can find instructions for using this mode and the other shooting modes in Chapter 4, and a brief summary below.

- **Portrait.** Use this mode when you're taking a portrait of a subject standing relatively close to the camera and want to de-emphasize the background, maximize sharpness, and produce flattering skin tones.

- **Landscape.** Select this mode when you want extra sharpness and rich colors of distant scenes.

- **Close-up.** This mode's settings are fine-tuned for close-up pictures of a subject from about one foot away or less.

- **Sports.** Use this mode to freeze fast-moving subjects.

- **Night Portrait.** Choose this mode when you want to illuminate a subject in the foreground with flash, but still allow the background to be exposed properly by the available light. Be prepared to use a tripod or an image-stabilized (IS) lens to reduce the effects of camera shake. (You'll find more about IS and camera shake in Chapter 10.)

- **Movie.** Use this mode to shoot videos in live view.

If you have more photographic experience, you might want to opt for one of the Creative Zone modes. These, too, are described in more detail in Chapter 4. These modes let you apply a little more creativity to your camera's settings. These modes are indicated on the Mode Dial by letters M, Av, Tv, and P.

- **M (Manual).** Select when you want full control over the shutter speed and lens opening, either for creative effects or because you are using a studio flash or other flash unit not compatible with the T5's automatic flash metering.

- **Av (Aperture-priority).** Choose when you want to use a particular lens opening, especially to control sharpness or how much of your image is in focus. The T5 will select the appropriate shutter speed for you. Av stands for *aperture value.*

- **Tv (Shutter-priority).** This mode (Tv stands for *time value*) is useful when you want to use a particular shutter speed to stop action or produce creative blur effects. The T5 will select the appropriate f/stop for you.

- **P (Program).** This mode allows the T5 to select the basic exposure settings, but you can still override the camera's choices to fine-tune your image.

You can change some settings when the shooting settings display is shown on the screen (press the DISP button if you want to make the display visible). Press the Q button and then use the cross keys to navigate to the setting you'd like to adjust. When the setting is highlighted, rotate the front dial, located just aft of the shutter release button, to adjust. The available adjustments change, depending on what Basic Zone or Creative Zone exposure mode you're using. (See Figure 2.2 for a typical Creative Zone shooting settings display, with the camera set to Manual exposure.)

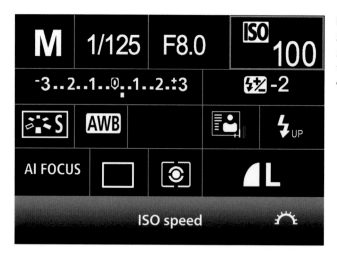

Figure 2.2
Some settings can be made quickly when the shooting settings display is visible.

TWEAKING SETTINGS WITH CREATIVE AUTO

"Ambience" is a new, Picture-Style-like feature, available to let you tweak settings when using Basic Zone modes, including Creative Auto. I'll explain all the options in Chapter 4, but you can begin using ambience now.

If you've set the Mode Dial to CA, when you press the Q button, a screen like the one shown in Figure 2.3 appears. One of nine "ambience" options can be selected by pressing the left/right/up/down cross keys. Your choices are Vivid, Soft, Warm, Intense, Cool, Brighter, Darker, or Monochrome, plus Standard Setting. Once your ambience is selected, the up/down cross keys let you highlight an intensity for that kind of ambience (for example, more vivid or less vivid), plus background/foreground blur, and drive/flash settings. Choose the parameter you want to modify, and press the left/right buttons to make the change.

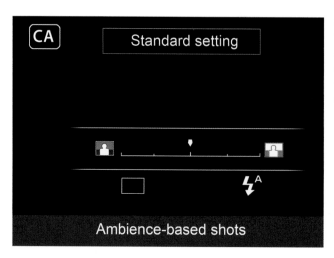

Figure 2.3
You can tweak the settings of the Creative Auto mode using this screen of options.

Choosing a Metering Mode

You might want to select a particular metering mode for your first shots, although the default Evaluative metering (which is set automatically when you choose a Basic Zone mode) is probably the best choice as you get to know your camera. There are two ways to change the metering system when using a Creative Zone mode:

1. Press the MENU button and rotate the Main Dial until the Shooting 2 menu is highlighted. (It's represented by a camera icon with two dots next to it.)

2. Press the down cross key to highlight Metering mode and press SET. A screen pops up (see Figure 2.4) on the LCD offering three choices.

3. Use the left/right cross keys to highlight the choice you want. Then press the SET button to confirm your selection.

Or

1. Tap the shutter release button or press the DISP. button, and then press the Q button to produce the Quick Control screen shown earlier in Figure 2.2.

2. Use the cross keys to navigate to the Metering Mode choice, located in the bottom row of the screen, second from the right.

3. When the Metering Mode icon is highlighted, you can *either* rotate the Main Dial to change to one of the other modes, then press the Q button to confirm *or* press SET to view a selection screen similar to the one in Figure 2.4 (but with a different color scheme), choose with the cross keys, and then press Q to confirm.

Figure 2.4
Metering modes
(left to right)
Evaluative, Partial,
Center-weighted.

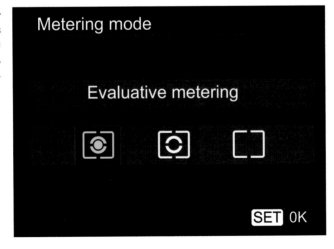

Your three choices in either case are as follows:

- **Evaluative metering.** The standard metering mode; the T5 attempts to intelligently classify your image and choose the best exposure based on readings from 63 different zones in the frame, with emphasis on the autofocus points.
- **Partial metering.** Exposure is based on a central spot, roughly ten percent of the image area. (The T5, unlike most other EOS Rebels, does not have a true Spot metering mode.)
- **Center-weighted averaging metering.** The T5 meters the entire scene, but gives the most emphasis to the central area of the frame.

You'll find a detailed description of each of these modes in Chapter 4.

Choosing a Focus Mode

You can easily switch between automatic and manual focus by moving the AF/MF switch on the lens mounted on your camera. However, if you're using a Creative Zone shooting mode, you'll still need to choose an appropriate focus mode. (You can read more on selecting focus parameters in Chapter 5.) If you're using a Basic Zone mode, the focus method is set for you automatically.

To set the focus mode, you must first have set the lens to the AF position (instead of the manual focus MF position). Then press the AF button (it's the right cross key) on the back of the camera repeatedly until the focus mode you want is selected (see Figure 2.5). Finally, press SET to confirm your focus mode. The three choices available in Creative Zone modes are as follows:

- **One-Shot.** This mode, sometimes called *single autofocus*, locks in a focus point when the shutter button is pressed down halfway, and the focus confirmation light glows at the bottom right of the viewfinder. The focus will remain locked until you release the button or take the picture. If the camera is unable to achieve sharp focus, the focus confirmation light will blink. This mode is best when your subject is relatively motionless. Portrait, Night Portrait, and Landscape Basic Zone modes use this focus method exclusively.
- **AI Servo.** This mode, sometimes called *continuous autofocus*, sets focus when you partially depress the shutter button, but continues to monitor the frame and refocuses if the camera or subject is moved. This is a useful mode for photographing sports and moving subjects. The Sports Basic Zone mode uses this focus method exclusively.
- **AI Focus.** In this mode, the T5 switches between One-Shot and AI Servo as appropriate. That is, it locks in a focus point when you partially depress the shutter button (One-Shot mode), but switches automatically to AI Servo if the subject begins to move. This mode is handy when photographing a subject, such as a child at quiet play, which might move unexpectedly. The Flash Off Basic Zone mode uses this focus method.

Figure 2.5
Set AF mode.

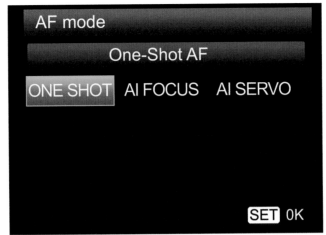

Selecting a Focus Point

The Canon EOS Rebel T5 uses nine different focus points to calculate correct focus. In any of the Basic Zone shooting modes, the focus point is selected automatically by the camera. In the other Creative Zone modes, you can allow the camera to select the focus point automatically, or you can specify which focus point should be used.

There are several methods to set the focus point manually. You can press the AF point selection button on the back of the camera (it's in the upper-right corner, marked with a grid-like icon), and choose a zone from the AF point selection screen that pops up. Press the SET button to toggle between automatic focus point selection (the camera does it for you) or manual focus point selection (you need to specify the point yourself). In manual selection mode, the cross keys are used to highlight the point you want to use, or you can rotate the Main Dial to cycle highlighting among the available points. (See Figure 2.6.) Press the AF point selection button again (or just tap the shutter release button) to confirm your choice and exit. If you choose the central focus point, it will illuminate in red when you press the shutter release halfway.

Or, you can look through the viewfinder, press the AF point selection button, and rotate the Main Dial to move the focus point to the zone you want to use. The focus point will cycle among the edge points counterclockwise (if you turn the Main Dial to the left) or clockwise (if you spin the Main Dial to the right), ending/starting with the center focus point/all nine focus points. (See Figure 2.7.)

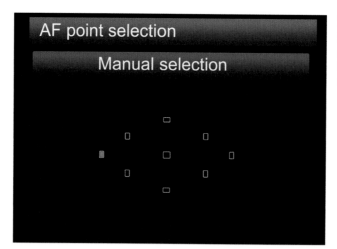

Figure 2.6
Select a focus point and selection mode from the AF point selection screen.

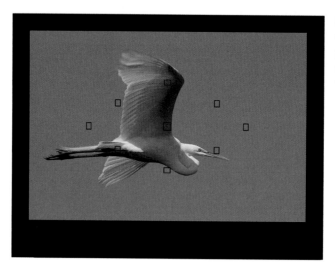

Figure 2.7
Or choose the focus point while looking through the viewfinder.

Other Settings

There are a few other options, such as ISO, using the self-timer, or working with flash. You can use these right away if you're feeling ambitious, but don't feel ashamed if you postpone using these features until you've racked up a little more experience with your EOS T5.

Adjusting White Balance and ISO

If you like, you can custom-tailor your white balance (color balance) and ISO sensitivity settings. To start out, it's best to set white balance (WB) to Auto, and ISO to ISO 100 or ISO 200 for daylight photos, and ISO 400 for pictures in dimmer light.

MAKING SETTINGS

When making settings, if a screen I'm describing does not appear when you press a button, the display may be turned off, either because you've pressed the DISP. button, or the T5 has gone to sleep. In either case, just press the DISP. button again or tap the shutter release button. The camera will then be ready to obey your commands. Keep this in mind as a general rule; I may not remind you at the start of each and every list of steps to wake up the camera.

You can adjust either one now by pressing the WB button (the down cross key) (for white balance) or the ISO button (the up cross key) and then using the cross keys to navigate until the setting you want appears on the LCD.

If you've been playing with your camera's settings, or your T5 has been used by someone else, you can restore the factory defaults by selecting Clear Settings from the Set-up 3 menu. Just press the MENU button (located just to the bottom right of the LCD), press the right cross key until the yellow wrench icon with a vertical row of three dots is highlighted, then press the down cross key to select Clear Settings. Press the SET button to reach the selection screen. You can choose from Clear All Camera Settings, or Clear all Custom Func. (C.Fn). Choose the one you'd like to reset, and press the SET button.

Using the Self-Timer

If you want to set a short delay before your picture is taken, you can use the self-timer. Press the drive/left cross key and then press the right cross key or Main Dial to select from Self-timer: 10 sec (which also can be used with the optional RS-60E3 wired remote), Self-timer: 2 sec, or Self-timer: Continuous, which allows you to press the up/down cross keys to specify a number of shots to be taken (from 2 to 10) once the timer runs its course (see Figure 2.8). Press the SET button to confirm your choice, and a self-timer icon will appear on the shooting settings display on the back of the Rebel T5. Press the shutter release to lock focus and start the timer. The self-timer lamp will blink and the beeper will sound (unless you've silenced it in the menus) until the final two seconds, when the lamp remains on and the beeper beeps more rapidly.

Canon recommends slipping off the eyepiece cup and replacing it with the viewfinder cap, in order to keep extraneous light from reaching the exposure meter through the viewfinder "back door." I usually just shade the viewfinder window with my hand (if I'm using the self-timer to reduce camera shake for a long exposure) or drape a jacket or sweater over the back of the camera (if I'm scurrying to get into the picture myself).

Using the Built-in Flash

Working with the EOS T5's built-in flash (as well as external flash units like the Canon 270EX II) deserves more space, and I am providing it in Chapter 11. But the built-in flash is easy enough to work with that you can begin using it right away, either to provide the main lighting of a scene, or

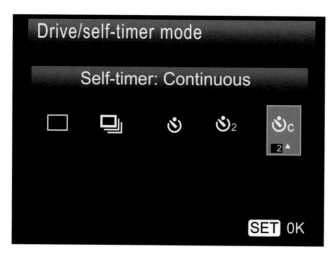

Figure 2.8
The drive modes include (left to right): Single shooting, Continuous shooting, Self-timer: 10 sec, Self-timer: 2 sec, Self-timer: Continuous (which takes multiple shots when the self-timer's delay has elapsed).

as supplementary illumination to fill in the shadows. The T5 will automatically balance the amount of light emitted from the flash so that it illuminates the shadows nicely, without overwhelming the highlights and producing a glaring "flash" look. (Think *Baywatch* when they're using too many reflectors on the lifeguards!)

The T5's flash has a power rating of 9.2/30 (meters/feet) at ISO 100, using the GN (guide number) system that dates back to the film era and before electronic flash units had any sort of automatic features. I'll explain guide numbers (which can be a little confusing) in more detail in Chapter 11, but in plain terms the flash's rating means that the unit is powerful enough to allow proper illumination of a subject that's 10 feet away at f/4 at the *lowest* ISO (sensitivity) setting of your camera. Boost the ISO (or use a wider f/stop) and you can shoot subjects that are located at a great distance. For example, at ISO 800, the T5's flash is good enough for a subject at 20 feet using f/5.6 or, alternatively, you can expose that scene at the original 10 feet distance at f/11. Ordinarily, the T5 takes care of all these calculations for you. If you need a bigger blast of light, you can add one of the Canon external flash units, described in Chapter 11.

The flash will pop up automatically when using any of the Basic Zone modes except for Landscape, Sports, or No Flash modes. In Creative Zone modes, just press the flash button (marked with a lighting bolt as shown in Figure 2.9). When using these modes, the flash functions in the following way:

- **P (Program mode).** The T5 selects a shutter speed from 1/60th to 1/200th second and appropriate aperture automatically.
- **Tv (Shutter-priority mode).** You choose a shutter speed from 30 seconds to 1/200th second, and the T5 chooses the lens opening for you, while adjusting the flash output to provide the correct exposure.

■ **Av (Aperture-priority mode).** You select the aperture you want to use, and the camera will select a shutter speed from 30 seconds to 1/200th second, and adjust the flash output to provide the correct exposure. In low light levels, the T5 may select a very slow shutter speed to allow the flash and background illumination to balance out, so you should use a tripod. (You can disable this behavior using Custom Function I-03: Flash Sync. Speed in Av mode, as described in Chapter 9.)

Figure 2.9 The electronic flash will pop up when you press the flash button next to the mode dial on top of the camera.

■ **M (Manual mode).** You choose both shutter speed (from 30 seconds to 1/200th second) and aperture, and the camera will adjust the flash output to produce a good exposure based on the aperture you've selected.

You can read about flash exposure compensation, red-eye reduction options, and other built-in flash features in Chapter 11.

Taking a Picture

This final section of the chapter guides you through taking your first pictures, reviewing them on the LCD, and transferring your shots to your computer.

Just press the shutter release button halfway to lock in focus at the selected autofocus point. (Remember that you can select a focus point manually when using Creative Zone modes.) When the shutter button is in the half-depressed position, the exposure, calculated using the shooting mode you've selected, is also locked.

Press the button the rest of the way down to take a picture. At that instant, the mirror flips up out of the light path to the optical viewfinder (assuming you're not using live view mode, discussed in Chapter 6), the shutter opens, the electronic flash (if enabled) fires, and your T5's sensor absorbs a burst of light to capture an exposure. In moments, the shutter closes, the mirror flips back down restoring your view, and the image you've taken is escorted off the CMOS sensor chip very quickly into an in-camera store of memory called a buffer, and the EOS T5 is ready to take another photo. The buffer continues dumping your image onto the Secure Digital card as you keep snapping pictures without pause (at least until the buffer fills and you must wait for it to get ahead of your continuous shooting, or your memory card fills completely).

Reviewing the Images You've Taken

The Canon EOS Rebel T5 has a broad range of playback and image review options, including the ability to jump ahead 10 or 100 images at a time. I'll cover them in more detail in Chapter 3. For now, you'll want to learn just the basics. Here is all you really need to know at this time, as shown in Figure 2.10:

- **Display image.** Press the Playback button (marked with a blue right-pointing triangle just southeast of the color LCD) to display the most recent image on the LCD in full-screen Single Image mode. If you last viewed your images using the thumbnail mode (described later in this list), the Index display appears instead.

- **View additional images.** Use the left and right cross keys to view the next or previous image.

- **Jump forward or back.** Specify a "jump" mode of either one image, 10 images, 100 images, Jump by Stills, Date, or Movies in the Playback 2 menu. (I'll explain all the jump options in Chapter 8.) Once a jump increment has been selected, you can leap forward or back that number of pictures by rotating the Main Dial. Turn it counterclockwise to review images from most recent to oldest, or clockwise to start with the first image on the memory card and cycle forward to the newest, using the jump size you've selected.

- **View image information.** Press the DISP. button repeatedly to cycle among overlays of basic image information, detailed shooting information, or no information at all.

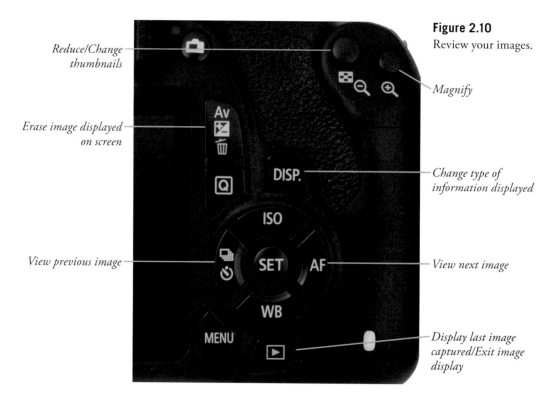

Reduce/Change thumbnails

Erase image displayed on screen

View previous image

Figure 2.10
Review your images.

Magnify

Change type of information displayed

View next image

Display last image captured/Exit image display

- **Zoom in on an image.** When an image is displayed full-screen on your LCD, press the Magnify/Enlarge button repeatedly to zoom in. The Magnify button is located in the upper-right corner of the back of the camera, marked with a blue magnifying glass with a plus sign in it. The Reduce button, located to the right of the Magnify button, zooms back out. Press the Playback button to exit magnified display.

- **Scroll around in a magnified image.** Use the left/right/up/down cross keys to scroll around within a magnified image.

- **View thumbnail images.** You can also rapidly move among a large number of images using the Index mode described in the section that follows this list. The Reduce button in full-frame view switches from single image to display of four or nine reduced-size thumbnails. To change from a larger number of thumbnails to a smaller number (from nine to four to single image, for example), press the Magnify button until the display you want appears.

Cruising Through Index Views

You can navigate quickly among thumbnails representing a series of images using the T5's index mode. Here are your options:

- **Display thumbnails.** Press the Playback button to display an image on the color LCD. If you last viewed your images using index mode, an index array of four or nine reduced-size images appears automatically (see Figure 2.11). If an image pops up full-screen in single image mode, press the Reduce button once to view four thumbnails, or twice to view nine thumbnails. You can switch between four, nine, and single images by pressing the Reduce button to see more/smaller versions of your images, and the Magnify button to see fewer/larger versions of your images.

Figure 2.11
Review thumbnails of four or nine images using index review.

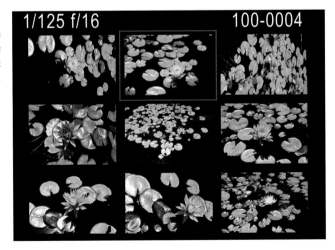

■ **Navigate within a screen of index images.** In index mode, use the up/down/left/right cross keys to move the blue highlight box around within the current index display screen.

■ **View more index pages.** To view additional index pages, rotate the Main Dial. The display will leap ahead or back by the jump increment you've set in the Playback 2 menu (as described in Chapter 8), 10 or 100 images, by index page, by date, or by folder, movies, stills, or quality rating.

■ **Check image.** When an image you want to examine more closely is highlighted, press the Magnify button until the single image version appears full-screen on your LCD.

Transferring Photos to Your Computer

The final step in your picture-taking session will be to transfer the photos you've taken to your computer for printing, further review, or image editing. Your T5 allows you to print directly to PictBridge-compatible printers and to create print orders right in the camera, plus you can select which images to transfer to your computer.

For now, you'll probably want to transfer your images either by using a cable transfer from the camera to the computer or by removing the memory card from the T5 and transferring the images with a card reader. The latter option is usually the best, because it's usually much faster and doesn't deplete the battery of your camera. However, you can use a cable transfer when you have the cable and a computer, but no card reader (perhaps you're using the computer of a friend or colleague, or at an Internet café).

USB port

To transfer images from the camera to a Mac or PC computer using the USB cable:

1. Turn off the camera.

2. Pry back the rubber cover that protects the Rebel T5's USB port, and plug the USB cable furnished with the camera into the USB port. (See Figure 2.12.)

3. Connect the other end of the USB cable to a USB port on your computer.

4. Turn the camera on. Your installed software usually detects the camera and offers to transfer the pictures, or the camera appears on your desktop as a mass storage device, enabling you to drag and drop the files to your computer.

Figure 2.12 Images can be transferred to your computer using a USB cable.

To transfer images from a memory card to the computer using a card reader, as shown in Figure 2.13:

1. Turn off the camera.
2. Slide open the memory card door, and press on the card, which causes it to pop up so it can be removed from the slot.
3. Insert the memory card into your memory card reader. Your installed software detects the files on the card and offers to transfer them. The card can also appear as a mass storage device on your desktop, which you can open, and then drag and drop the files to your computer.

Figure 2.13
A card reader is the fastest way to transfer photos.

3

Canon EOS Rebel T5/1200D Roadmap

One thing that surprises new owners of the Canon EOS Rebel T5 is that the camera has a total of 496 buttons, dials, switches, levers, latches, and knobs bristling from its surface. Okay, I lied. Actually, the real number is closer to two dozen controls and adjustments, but that's still a lot of components to master, especially when you consider that many of these controls serve double-duty to give you access to multiple functions.

Traditionally, there have been two ways of providing a roadmap to guide you through this maze of features. One approach uses two or three tiny 2 × 3–inch black-and-white line drawings or photos impaled with dozens of callouts labeled with cross-references to the actual pages in the book that tell you what these components do. You'll find this tactic used in the pocket-sized manual Canon provides with the Rebel T5, and most of the other third-party guidebooks as well. Deciphering one of these miniature camera layouts is a lot like being presented with a world globe when what you really want to know is how to find the capital of Belgium.

I originated a more useful approach in my guides, providing you, instead of a satellite view, a street-level map that includes close-up full-color photos of the camera from several angles (see Figure 3.1), with a smaller number of labels clearly pointing to each individual feature. And, I don't force you to flip back and forth among dozens of pages to find out what a particular component does. Each photo is accompanied by a brief description that summarizes the control, so you can begin using it right away. Only when a particular feature deserves a lengthy explanation do I direct you to a more detailed write-up later in the book.

So, if you're wondering what the depth-of-field preview does (or how you can turn the SET button into a depth-of-field button, because the T5 lacks a traditional DOF control), I'll tell you up front, rather than have you flip to Page 264. This book is not a scavenger hunt. But after I explain how to use the ISO button to change the sensitivity of the T5, I *will* provide a cross-reference to a longer explanation later in the book that clarifies noise reduction, ISO, and its effects on exposure. I think this kind of organization works best for a camera as sophisticated as the Rebel T5.

By the time you finish this chapter, you'll have a basic understanding of every control and what it does. I'm not going to delve into menu functions here—you'll find a discussion of your Set-up, Shooting, and Playback menu options in Chapters 8 and 9. Everything here is devoted to the button pusher and dial twirler in you.

Front View

When we picture a given camera, we always imagine the front view. That's the view that your subjects see as you snap away, and the aspect that's shown in product publicity and on the box. The frontal angle is, for all intents and purposes, the "face" of a camera like the Rebel T5. But, not surprisingly, most of the "business" of operating the camera happens *behind* it, where the photographer resides. The front of the T5 actually has relatively few controls and features to worry about, as shown in Figures 3.1 and 3.2:

- **DC power port.** You'll find an opening to connect the cable from the DC power pack under this small rubber door in the side of the camera.
- **Hand grip.** This provides a comfortable hand-hold, and also contains the T5's battery.

Figure 3.1

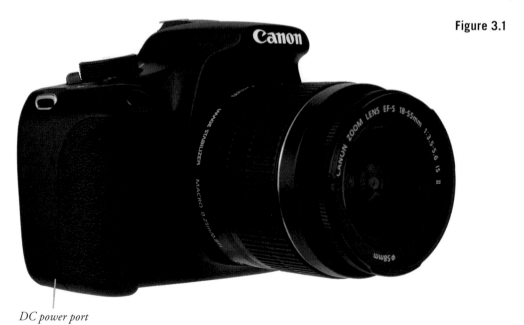

DC power port

■ **Shutter release.** Angled on top of the hand grip is the shutter release button. Press this button down halfway to lock exposure and focus (in One-Shot mode and AI Focus with nonmoving subjects). The T5 assumes that when you tap or depress the shutter release, you are ready to take a picture, so the release can be tapped to activate the exposure meter or to exit from most menus.

■ **Main Dial.** This dial is used to change shooting settings. When settings are available in pairs (such as shutter speed/aperture), this dial will be used to make one type of setting, such as shutter speed. The other setting, say, the aperture, is made using an alternate control, such as spinning the Main Dial while holding down an additional button like the exposure compensation button (which resides conveniently under the thumb on the back of the camera).

■ **Red-eye reduction/Self-timer lamp.** This LED provides a blip of light shortly before a flash exposure to cause the subjects' pupils to close down, reducing the effect of red-eye reflections off their retinas. When using the self-timer, this lamp also flashes to mark the countdown until the photo is taken.

■ **Microphone.** This is a monaural (non-stereo) microphone for recording the audio track of your HDTV movies.

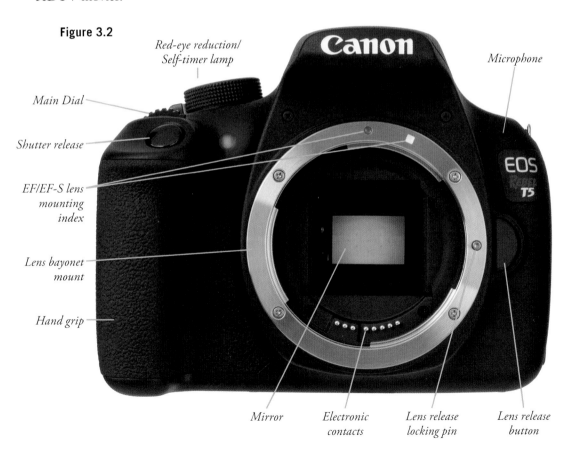

Figure 3.2

■ **Lens bayonet mount.** This metal accepts the rear bayonet on the lens and allows mounting the lens firmly on the camera body.

■ **Mirror.** When using the optical viewfinder, the mirror reflects most of the light upward to the focusing screen and exposure meter system, and directs a small amount of light downward to the autofocus sensors. The mirror flips up out of the way to expose the shutter curtain/sensor when taking a picture, and the sensor when using live view mode or capturing video.

■ **EF/EF-S lens mounting index.** Line up the red index mark to align EF lenses for mounting, and use the white square to align EF-S optics.

■ **Electronic contacts.** These contacts mate with matching contacts on the rear of the lens to allow the camera and lens to exchange information about focus, aperture setting, and other functions.

■ **Lens release button.** Press and hold down this button to allow rotating the lens to remove it from the camera.

■ **Lens release locking pin.** This pin retracts when the lens release button is held down, allowing the lens to rotate.

You'll find more controls on the other side of the T5, shown in Figures 3.3 and 3.4:

■ **Lens autofocus/manual switch.** Canon autofocus lenses have a switch to allow changing between automatic focus and manual focus.

■ **Lens image stabilization switch.** With IS lenses, this switch is used to turn image stabilization on and off.

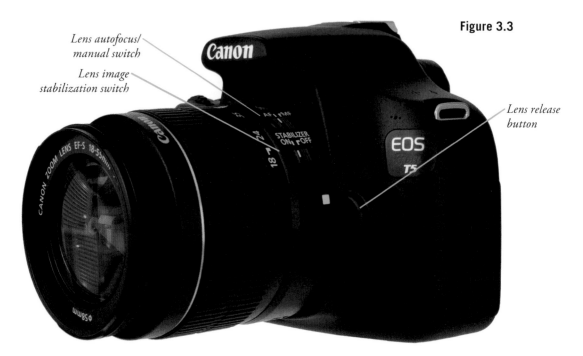

Figure 3.3

Lens autofocus/ manual switch

Lens image stabilization switch

Lens release button

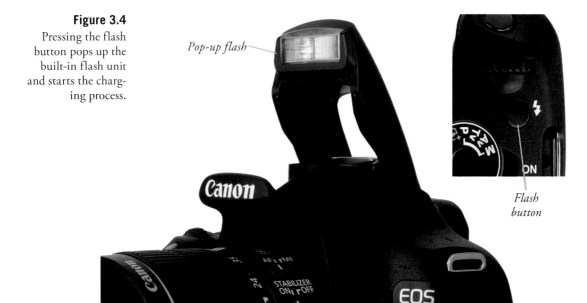

Figure 3.4
Pressing the flash button pops up the built-in flash unit and starts the charging process.

Pop-up flash

Flash button

- **Lens release button.** Another view of the button used to unlock the lens so you can rotate the lens to remove it from the camera.

- **Pop-up flash.** The internal flash unit pops up automatically when needed when using Basic Zone Full Auto, Portrait, Close-up, and Night Portrait modes (and is disabled when using Auto-No Flash, Landscape, and Sports modes). The flash can be popped up manually when using Creative Auto, and any of the Creative Zone modes (P, Tv, Av, or M). (See Figure 3.4.)

- **Flash button.** This button, located *on top* of the camera, but mentioned here, releases the built-in flash in Creative Zone and Creative Auto modes so it can flip up and start the charging process (see Figure 3.4, upper right). If you decide you do not want to use the flash, you can turn it off by pressing the flash head back down. This button can be re-programmed to produce the ISO screen using Custom Function IV-10, as described in Chapter 9. If you redefine this button, you can still raise the built-in flash using the Quick Control screen, described later in this chapter.

The main feature on the side of the Rebel T5 is a flexible cover (see Figure 3.5) that protects the three connector ports underneath from dust and moisture, plus one of two neck strap mounts (the other is on the other side of the camera).

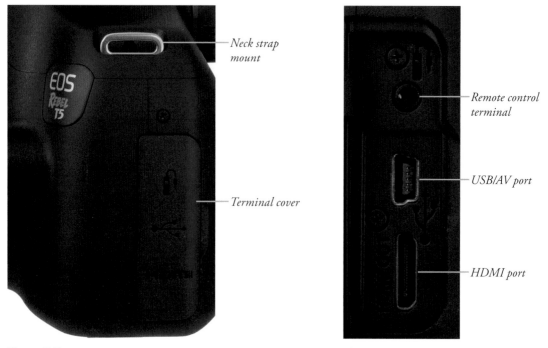

Figure 3.5 **Figure 3.6**

The three connectors, shown in Figure 3.6, are as follows:

- **Remote control terminal.** You can plug various Canon remote release switches, timers, and wireless controllers into this connector.

- **USB/AV port.** Plug in the USB cable furnished with your Rebel T5 and connect the other end to a USB port in your computer to transfer photos. Or, connect the AV cable and connect your camera to a television to view your photos on a large screen. Note that some previous Rebel models used two separate ports with different connectors for this pair of functions. They were combined to make room for the HDMI port.

- **HDMI port.** Use an HTC-100 Type C HDMI cable (not included in the box with your camera) to direct the video and audio output of the T5 to a high-definition television (HDTV) or HD monitor.

The Canon EOS Rebel T5's Business End

The back panel of the Rebel T5 (see Figure 3.7) bristles with more than a dozen different controls, buttons, and knobs. That might seem like a lot of controls to learn, but you'll find, as I noted earlier, that it's a lot easier to press a dedicated button and spin a dial than to jump to a menu every time you want to change a setting.

Figure 3.7

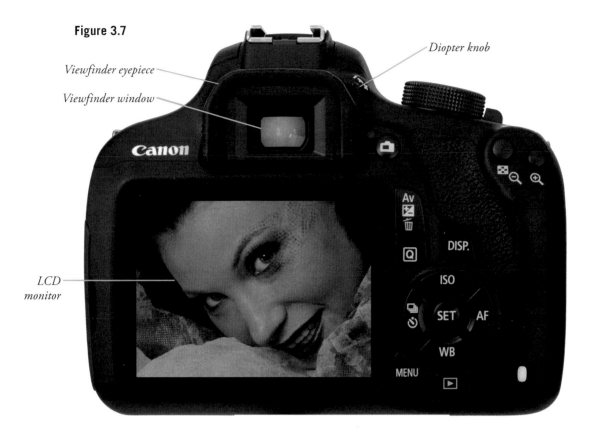

Diopter knob

Viewfinder eyepiece

Viewfinder window

LCD monitor

You can see the controls clustered on the right two-thirds of the T5 in Figure 3.7. The key buttons and components and their functions are as follows:

- **Viewfinder eyepiece.** You can frame your composition by peering into the viewfinder. It's surrounded by a soft rubber frame that seals out extraneous light when pressing your eye tightly up to the viewfinder, and it also protects your eyeglass lenses (if worn) from scratching.

- **Viewfinder window.** Peer through this to view and frame your subject. If you're shooting a picture under bright lighting conditions with the camera mounted on a tripod, or you are otherwise not looking through the viewfinder during the exposure, it's a good idea to cover up this window (I use my hand).

- **Diopter knob.** Use this to provide optical correction in the viewfinder. While your contact lenses or glasses may provide sufficient correction, some glasses wearers want to shoot without them, so the built-in diopter adjustment, which can be varied from –2.5 to +0.5 correction is useful. Press the shutter release halfway to illuminate the indicators in the viewfinder, then rotate the diopter adjustment wheel next to the viewfinder while looking through the viewfinder until the indicators appear sharp. Canon also offers 10 different Dioptric Adjustment Lens Series E correction lenses for additional correction. I recommend using these "permanent" add-ons only if you are the only person using your T5.

- **LCD monitor.** This is the 3-inch display that shows your live view preview, displays a shot for image review after the picture is taken, shows the shooting settings display before the photo is snapped, and all the menus used by the Rebel T5.

The most-used controls reside on the right side of the Rebel T5 (see Figure 3.8). There are more than a dozen buttons in all, many of which do double-duty to perform several functions. I've divided them into two groups; here's the first:

- **MENU button.** Summons/exits the menu displayed on the rear LCD of the T5. When you're working with submenus, this button also serves to exit a submenu and return to the main menu.

- **DISP. button.** When pressed repeatedly, changes the amount of picture information displayed. In playback mode, pressing the DISP. button cycles among basic display of the image; a detailed display with a thumbnail of the image, shooting parameters, and a brightness histogram; and a display with less detail but with separate histograms for brightness, red, green, and blue channels. (I'll show you what these look like later in the chapter.) When setting Picture Styles, the DISP. button is used to select a highlighted Picture Style for modification. In live view mode, the DISP. button adjusts the amount of information overlaid on the live image that appears on the LCD screen. When the camera is connected to a printer, you can trim an image; in direct printing mode, the DISP. button selects the orientation.

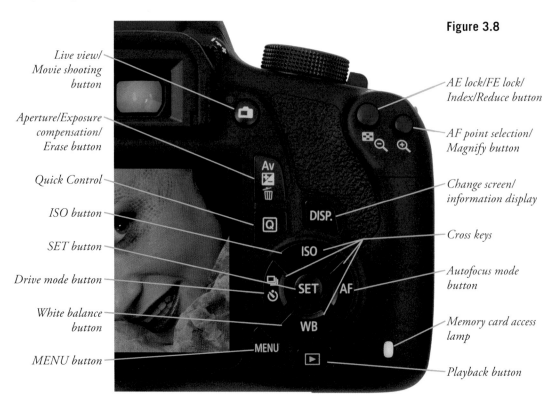

Figure 3.8

Live view/Movie shooting button

Aperture/Exposure compensation/Erase button

Quick Control

ISO button

SET button

Drive mode button

White balance button

MENU button

AE lock/FE lock/Index/Reduce button

AF point selection/Magnify button

Change screen/information display

Cross keys

Autofocus mode button

Memory card access lamp

Playback button

■ **Live view/Movie shooting button.** Press this button, marked with a red dot to its left, to activate/deactivate live view. To shoot movies, turn the Mode Dial to the Movie position, and then press this button to start/stop video/audio recording.

■ **Cross keys.** This array of four-directional keys provides left/right/up/down movement to navigate menus, and is used to cycle among various options (usually with the left/right buttons) and to choose amounts (with the up/down buttons). The four cross keys also have secondary functions to adjust ISO, white balance, autofocus mode, and drive mode (I'll describe these separately).

■ **SET button.** Located in the center of the cross key cluster, this button is used to confirm a selection or activate a feature. Because the T5 does not have a dedicated depth-of-field preview button, you might want to redefine the SET button to perform this function, using Custom Function IV-9: Assign SET button, as described in Chapter 9. The DOF preview stops down the lens to the aperture that will be used to take the picture, so you can see in the viewfinder how much of the image is in focus. The view grows dimmer as the aperture is reduced.

■ **Quick Control button.** This button activates the Quick Control screen (described later in this chapter), which allows you to set image recording quality and switch between single shot and self-timer/remote settings, including Ambience options, when using Basic Zone exposure modes, and to set a full range of controls when using Creative Zone exposure modes.

■ **Aperture value (AV)/Exposure compensation/Erase button.** When using manual exposure mode, hold down this button and rotate the Main Dial to specify a lens aperture; rotate the Main Dial alone to choose the shutter speed. In other Creative Zone exposure modes— Aperture-priority (Av), Shutter-priority (Tv), or Program (P)—hold down this button and rotate the Main Dial to the right to add exposure compensation (EV) to an image (making it brighter), or rotate to the left to subtract EV and make the image darker. When you're reviewing an image you've already taken, this control functions as an Erase button. Press to erase the image shown on the LCD. A menu will pop up displaying Cancel and Erase choices. Use the left/right cross keys to select one of these actions, then press the SET button to activate your choice.

■ **Playback button.** Displays the last picture taken. Thereafter, you can move back and forth among the available images by pressing the left/right cross keys to advance or reverse one image at a time, or the Main Dial, to jump forward or back using the jump method you've selected. (See the section below for more on jumping.) To quit playback, press this button again. The T5 also exits playback mode automatically when you press the shutter button (so you'll never be prevented from taking a picture on the spur of the moment because you happened to be viewing an image).

The next group of buttons allows you to change settings:

■ **AE/FE (Autoexposure/Flash exposure) lock/Index/Reduce button.** This button, which has a * label above it, has several functions, which differ depending on the AF point and metering mode.

In shooting mode, it locks the exposure or flash exposure that the camera sets when you partially depress the shutter button. In Evaluative exposure mode, exposure is locked at the AF point that achieved focus. In Partial, Spot, or Center-weighted modes, exposure is locked at the AF center point. The exposure lock indication (*) appears in the viewfinder and on the shooting settings display. If you want to recalculate exposure with the shutter button still partially depressed, press the * button again. The exposure will be unlocked when you release the shutter button or take the picture. To retain the exposure lock for subsequent photos, keep the * button pressed while shooting.

When using flash, pressing the * button fires an extra pre-flash that allows the unit to calculate and lock exposure prior to taking the picture. The characters FEL will appear momentarily in the viewfinder, and the exposure lock indication and a flash indicator appear. (See the description of the viewfinder display later in this chapter.)

In playback mode, press this button to switch from single-image display to nine-image thumbnail index. (See Figure 3.9.) Move highlighting among the thumbnails with the cross keys or Main Dial. To view a highlighted image, press the Magnify button.

In playback mode, when an image is zoomed in, press this button to zoom out.

■ **AF point selection/Magnify button.** In shooting mode, this button activates autofocus point selection. (See Chapter 5 for information on setting autofocus/exposure point selection when using Creative Zone exposure modes.) In playback mode, if you're viewing a single image, this button zooms in on the image that's displayed. If thumbnail indexes are shown, pressing this button switches from nine thumbnails to four thumbnails, or from four thumbnails to a full-screen view of a highlighted image.

Figure 3.9
The Reduce button changes the playback display from single image to four or nine thumbnails.

- **ISO button.** The up cross key also serves to set the ISO sensitivity. Press this ISO button when using one of the Creative Zone modes (M, Av, Tv, or P) to produce the ISO screen. Then, use the left/right cross keys to select an ISO setting, and press SET to confirm.

- **White balance button.** The down cross key also serves to access the white balance function. Press this WB button when using one of the Creative Zone modes (A-DEP, M, Av, Tv, or P) to produce the White Balance screen. Then, use the left/right cross keys to select a white balance, and press SET to confirm.

- **AF mode button.** Press the right cross key when using a Creative Zone mode to produce a screen that allows choosing autofocus mode from among One-Shot, AI Focus, and AI Servo. Press repeatedly until the focus mode you want is selected. Then press SET to confirm your focus mode.

- **Drive mode button.** Press the left cross key to produce a screen that allows choosing a drive mode, in both Creative Zone and Basic Zone modes. Then press the right cross key to select the 10-second self-timer, 2-second self-timer, or Self-timer: Continuous, which allows you to specify a number of shots to be taken (from 2 to 10) with the up/down keys. Press SET to confirm your choice.

- **Memory card access lamp.** When lit or blinking, this lamp indicates that the memory card is being accessed.

Jumping Around

When a photo you've taken is displayed on the color LCD, you can change the method used to jump with the Main Dial. To jump, when viewing a single full-screen image during playback, rotate the Main Dial. An overlay appears showing you the amount of the jump. (See Figure 3.10.)

You can choose a Jump method using the Playback 2 menu (using the procedure described with all the other menus in Chapter 8). The advantage of using the menu is that you can set both the number of images to jump and the type of jump. The Jump feature allows you to leap forward and

Figure 3.10
Jump by rotating the Main Dial when viewing a full-screen image.

backward among the images on your memory card using the increment/method you have chosen by rotating the Main Dial. The Jump method is shown briefly on the screen as you leap ahead to the next image displayed. Your options are as follows:

- **1 image.** Rotating the Main Dial one click jumps forward or back one image.
- **10 images.** Rotating the Main Dial one click jumps forward or back ten images.
- **100 images.** Rotating the Main Dial one click jumps forward or back one hundred images.
- **Date.** Rotating the Main Dial one click jumps forward or back to the first image taken on the next or previous calendar date.
- **Folder.** Rotating the Main Dial one click jumps to the next folder on your memory card.
- **Display Movies only.** Tells the T5 to jump only among movie images when using a card that contains both video clips and still images. This option is useful when you prefer to view only one kind of file.
- **Display Stills only.** Specifies jumping only between still images when using a card that has both video clips and still images.
- **Display by image rating.** As explained in Chapter 8, you can rate a particular movie or still photo by applying from one to five stars, using the Rating menu entry in the Playback 2 menu. This Jump choice allows you to select a rating rank, and then jump among photos with that rating applied.

Going Topside

The top surface of the Canon EOS Rebel T5 has a few frequently accessed controls of its own. The key controls, shown in Figure 3.11, are as follows:

- **Mode Dial.** Rotate this dial to switch among Basic Zone, Creative Zone, and Movie modes. You'll find these modes and options described in more detail in Chapters 4 and 6.
- **Sensor focal plane.** Precision macro and scientific photography sometimes requires knowing exactly where the focal plane of the sensor is. The symbol on the top side of the camera, to the left of the viewfinder, marks that plane.
- **Flash accessory/hot shoe.** Slide an electronic flash into this mount when you need a more powerful Speedlite. A dedicated flash unit, like those from Canon, can use the multiple contact points shown to communicate exposure, zoom setting, white balance information, and other data between the flash and the camera. There's more on using electronic flash in Chapter 11.
- **Main Dial.** This dial is used to make many shooting settings. When settings come in pairs (such as shutter speed/aperture in manual shooting mode), the Main Dial is used for one (for example, shutter speed), while some other control, such as the AV button+Main Dial (when shooting in manual exposure mode) is used for the other (aperture).

Figure 3.11

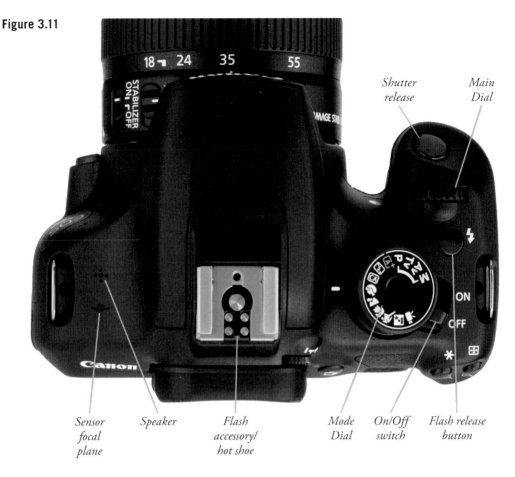

Shutter release *Main Dial*

Sensor focal plane *Speaker* *Flash accessory/ hot shoe* *Mode Dial* *On/Off switch* *Flash release button*

- **Shutter release button.** Partially depress this button to lock in exposure and focus. Press all the way to take the picture. Tapping the shutter release when the camera has turned off the autoexposure and autofocus mechanisms reactivates both. When a review image is displayed on the back-panel color LCD, tapping this button removes the image from the display and reactivates the autoexposure and autofocus mechanisms.

- **On/Off switch.** Flip forward to turn the Rebel T5 on, and back to turn it off again.

- **Flash release button.** I described this button earlier in the chapter, along with the pop-up flash. As I noted, pressing this button releases the built-in flash in Creative Zone and Creative Auto modes. If you decide you do not want to use the flash, you can turn it off by pressing the flash head back down. This button can be re-programmed to produce the ISO screen using Custom Function IV-10, as described in Chapter 9. If you redefine this button, you can still raise the built-in flash using the Quick Control screen, described later in this chapter.

- **Speaker.** Sounds emanating from your T5 are heard through this small solid-state speaker.

Underneath Your Rebel T5

There's not a lot going on with the bottom panel of your Rebel T5. You'll find a tripod socket, which secures the camera to a tripod, and the access door that opens to allow inserting/removing both the battery and a memory card. Note that certain tripod heads may keep you from opening this door, so it's a good idea to plan ahead and insert a fresh memory card and/or battery that might be needed. Figure 3.12 shows the underside view of the camera.

Figure 3.12

Battery/ Memory card access door

Tripod socket

Lens Components

The typical lens, like the ones shown in Figure 3.13, has seven or eight common features. Not every component appears on every lens. The lens on the left, for example, lacks the distance scale and distance indicator that the lens on the right has. Lenses that lack image stabilization will not have a stabilization switch.

- **Filter thread.** Lenses have a thread on the front for attaching filters and other add-ons. Some also use this thread for attaching a lens hood (you screw on the filter first, and then attach the hood to the screw thread on the front of the filter).
- **Lens hood.** Shields the front element of the lens from extraneous light arriving from outside the image area, and serves as protection.
- **Lens hood bayonet.** This is used to mount the lens hood for lenses that don't use screw-mount hoods (the majority).
- **Zoom ring.** Turn this ring to change the zoom setting.
- **Zoom scale.** These markings on the lens show the current focal length selected.

- **Focus ring.** This is the ring you turn when you manually focus the lens.
- **Focus distance scale.** This is a readout that rotates in unison with the lens's focus mechanism to show the distance at which the lens has been focused. It's a useful indicator for double-checking autofocus, roughly evaluating depth-of-field, and for setting manual focus guesstimates.
- **Infrared focus adjustment.** IR illumination doesn't focus at the exact same plane as visible light, so if you're shooting infrared photos, move the focus ring to line up to the appropriate focal length opposite the distance determined by normal focusing.
- **Autofocus/manual focus switch.** Allows you to change from automatic focus to manual focus.

Figure 3.13

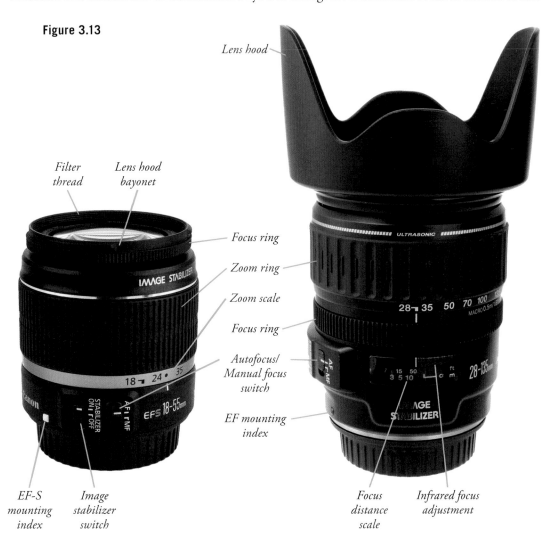

Lens hood

Filter thread

Lens hood bayonet

Focus ring

Zoom ring

Zoom scale

Focus ring

Autofocus/ Manual focus switch

EF mounting index

EF-S mounting index

Image stabilizer switch

Focus distance scale

Infrared focus adjustment

- **Image stabilizer switch.** Lenses with IS always include a separate switch for adjusting the stabilization feature.
- **EF-S/EF mounting index.** EF-S lenses have a raised white square, while EF lenses have a raised red bump; line up these indexes with the matching white and red indicators on the camera lens mount to attach the lens.
- **Electrical contacts.** On the back of the lens (see Figure 3.14) are electrical contacts that the camera uses to communicate focus, aperture setting, and other information.
- **Lens mount bayonet.** This mount is used to attach the lens to a matching bayonet on the camera body. (See Figure 3.14.)

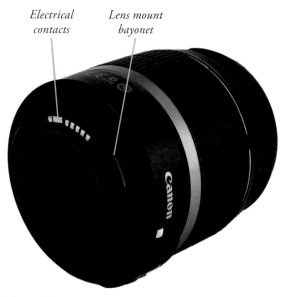

Electrical contacts *Lens mount bayonet*

Figure 3.14

LCD Panel Readouts

The Rebel T5 does not have a monochrome status LCD like the one found on the top panel of the mid- and upper-level EOS cameras, such as the 70D and 5D Mark III. Nor does it have such a monochrome panel underneath the color LCD on the back, as the original Digital Rebel and Rebel XT did. Lacking this auxiliary information display, the T5 uses the generously expansive 3-inch color LCD to show you everything you need to see, from images to a collection of informational data displays. Here's an overview of these displays, and how to access them:

- **Image playback displays.** When the T5 shows you a picture for review, you can select from among four different information overlays. To switch among them, press the DISP. button while the image is on the screen. The LCD will cycle among the single-image display (Figure 3.15); single-image display with recording quality (Figure 3.16); histogram display, which shows basic shooting information as well as a brightness histogram at bottom right, with individual histograms for the red, green, and blue channels above (Figure 3.17); and a complete shooting information display (Figure 3.18), which includes most of the relevant shooting settings, plus a brightness histogram. I'll explain how to work with histograms in Chapter 4.
- **Shooting settings display.** While you are taking pictures in a Creative Zone mode, this screen will be shown, with information like that in Figure 3.19. Not all of the data pictured will be seen at one time; only the settings that are appropriate for the current shooting mode will be displayed. I'll explain how to make and use each of these settings later in this book. You

can turn this display off by pressing the DISP. button, and restore it again by pressing the DISP. button a second time. When the shooting settings display is active, you can return to it when there is a menu screen or image review on the LCD by tapping the shutter release button. If you want to make adjustments, press the Quick Control button to activate the Quick Control screen, and use the cross keys to navigate to the setting you want to change. With Creative Zone modes, you can change any of the settings visible in the Quick Control screen, including the Flash Up function, which raises the built-in flash. (You may need to use this option if you've redefined the Flash button to function as an ISO settings button instead.)

■ **Camera function settings.** When any menu is displayed, you can switch to the Camera Functions settings screen by pressing the DISP. button. A screen like the one shown in Figure 3.20 will appear, with key camera function settings arrayed.

Figure 3.15

Figure 3.16

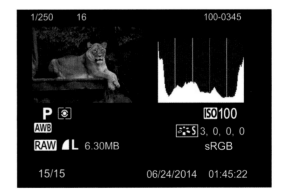

Figure 3.17 Figure 3.18

Image playback displays include single image, single image with recording quality, histogram, and shooting information.

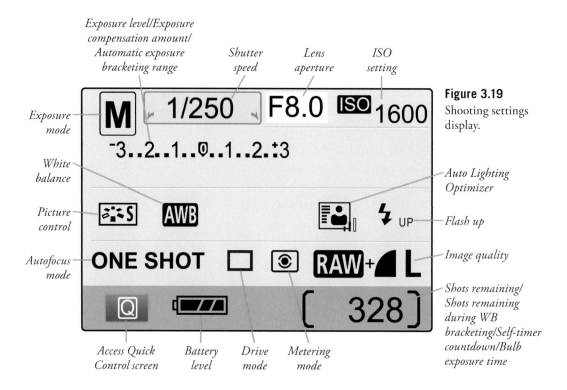

Exposure level/Exposure compensation amount/ Automatic exposure bracketing range

Shutter speed

Lens aperture

ISO setting

Exposure mode

White balance

Picture control

Autofocus mode

Access Quick Control screen

Battery level

Drive mode

Metering mode

Auto Lighting Optimizer

Flash up

Image quality

Shots remaining/ Shots remaining during WB bracketing/Self-timer countdown/Bulb exposure time

Figure 3.19
Shooting settings display.

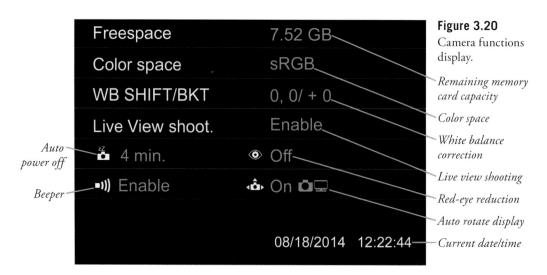

Auto power off

Beeper

Remaining memory card capacity

Color space

White balance correction

Live view shooting

Red-eye reduction

Auto rotate display

Current date/time

Figure 3.20
Camera functions display.

Looking Inside the Viewfinder

Much of the important shooting status information is shown inside the viewfinder of the Rebel T5. As with the displays shown on the color LCD, not all of this information will be shown at any one time. Figure 3.21 shows what you can expect to see. I'll explain all of these readouts later in this book, with those pertaining to exposure in Chapter 4, and those relating to flash in Chapter 11. These readouts include:

■ **Autofocus zones.** Shows the nine areas used by the T5 to focus. The camera can select the appropriate focus zone for you, or you can manually select one or all of the zones, as described in Chapters 2 and 5.

■ **AE lock/Automatic exposure bracketing in progress.** Shows that exposure has been locked. This icon also appears when an automatic exposure bracketing sequence is in process.

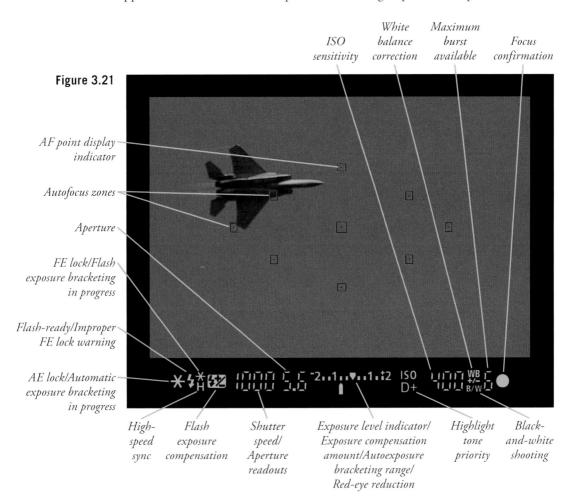

Figure 3.21

- **Flash-ready/Improper FE lock warning.** This icon appears when the flash is fully charged. It also shows when the flash exposure lock has been applied for an inappropriate exposure value.

- **Flash status indicator.** Appears along with the flash-ready indicator: The H is shown when high-speed (focal plane) flash sync is being used. The * appears when flash exposure lock or a flash exposure bracketing sequence is underway.

- **Flash exposure compensation.** Appears when flash EV changes have been made.

- **Shutter speed/aperture readouts.** Most of the time, these readouts show the current shutter speed and aperture. This pair can also warn you of memory card conditions (full, error, or missing), ISO speed, flash exposure lock, and a buSY indicator when the camera is busy doing other things (including flash recycling).

- **Exposure level indicator/Exposure compensation amount/Autoexposure bracketing range/Red-eye reduction.** This scale shows the current exposure level, with the bottom indicator centered when the exposure is correct as metered. The indicator may also move to the left or right to indicate under- or overexposure (respectively). The scale is also used to show the amount of EV and flash EV adjustments, the number of stops covered by the current automatic exposure bracketing range, and is used as a red-eye reduction lamp indicator.

- **ISO sensitivity.** This useful indicator shows the current ISO setting value. Those who have accidentally taken dozens of shots under bright sunlight at ISO 1600 because they forgot to change the setting back after some indoor shooting will treasure this addition.

- **B/W indicator.** Illuminates when the Monochrome Picture Style is being used. There's no way to restore color when you're shooting JPEGs without RAW, so this indicator is another valuable warning.

- **White balance correction.** Shows that white balance has been tweaked.

- **Maximum burst available.** Changes to a number to indicate the number of frames that can be taken in continuous mode using the current settings.

- **Focus confirmation.** This green dot appears when the subject covered by the active autofocus zone is in sharp focus.

- **Highlight Tone Priority.** Displayed when this highlight detail-boosting feature is turned on.

Part II

Beyond the Basics

When you bought your Canon Rebel T5, you probably thought your days of worrying about getting the correct exposure, achieving focus, and struggling with using more advanced features, like live view and movie making were over. To paraphrase an old Kodak tagline dating back to the 19th century—the goal is, "you press the button, and the camera does the rest."

For the most part, that's a realistic objective. The T5 is one of the smartest cameras available when it comes to calculating the right exposure for most situations, locking in focus, and shooting video clips. For exposure, you can generally choose one of the automatic modes—either Full Auto or Creative Auto—or spin the Mode Dial to Program (P), Aperture-priority (Av), or Shutter-priority (Tv), and shoot away. Autofocus, too, is quick and easy. You can use One-Shot AF for stationary subjects, AI Servo AF for subjects that are in motion, or AI Focus to allow the T5 to decide which of the other two modes to use, depending on circumstances. Most of the other advanced features are also straightforward to use.

So, why do you need the four chapters in Part II: Beyond the Basics? I think you'll find that even if you've mastered the fundamentals and controls of the Rebel T5, there is lots of room to learn more and use the features of the camera to their fullest. Even if you're getting great exposures a high percentage of the time, you can fine-tune tonal values and use your shutter speed, aperture, and ISO controls creatively. Your camera's high performance autofocus system may zero in on your subject in most situations—but you still need to be able to tell the T5 *what* to focus on, and *when*. Other tools at your disposal let you freeze an instant of time, record a continuous series of instants as a movie, and improve your images in other imaginative ways. The chapters in this Part will help you move your photography to the next level by understanding exposure, mastering the mysteries of autofocus, and using the Canon Rebel T5's advanced features.

4

Understanding Exposure

As you learn to use your T5 creatively, you're going to find that the right settings—as determined by the camera's exposure meter and intelligence—need to be *adjusted* to account for your creative decisions or special situations.

For example, when you shoot with the main light source behind the subject, you end up with *backlighting*, which results in an overexposed background and/or an underexposed subject. The Rebel T5 recognizes backlit situations nicely, and can properly base exposure on the main subject, producing a decent photo. Features like Highlight Tone Priority and the Auto Lighting Optimizer can fine-tune exposure to preserve detail in the highlights and shadows.

But what if you *want* to underexpose the subject, to produce a silhouette effect? Or, perhaps, you might want to flip up the T5's built-in flash unit to fill in the shadows on your subject. The more you know about how to use your T5, the more you'll run into situations where you want to creatively tweak the exposure to provide a different look than you'd get with a straight shot.

This chapter shows you the fundamentals of exposure, so you'll be better equipped to override the Rebel T5's default settings when you want to, or need to. After all, correct exposure is one of the foundations of good photography, along with accurate focus and sharpness, appropriate color balance, freedom from unwanted noise and excessive contrast, as well as pleasing composition.

The Rebel T5 gives you a great deal of control over all of these, although composition is entirely up to you. You must still frame the photograph to create an interesting arrangement of subject matter, but all the other parameters are basic functions of the camera. You can let your T5 set them for you automatically, you can fine-tune how the camera applies its automatic settings, or you can make them yourself, manually. The amount of control you have over exposure, sensitivity (ISO settings), color balance, focus, and image parameters like sharpness and contrast make the T5 a versatile tool for creating images.

In the next few pages, I'm going to give you a grounding in one of those foundations, and explain the basics of exposure, either as an introduction or as a refresher course, depending on your current level of expertise. When you finish this chapter, you'll understand most of what you need to know to take well-exposed photographs creatively in a broad range of situations.

Getting a Handle on Exposure

Exposure determines the look, feel, and tone of an image, in more ways than one. Incorrect exposure can impair even the best-composed image by cloaking important tones in darkness, or by washing them out so they become featureless to the eye. On the other hand, correct exposure brings out the detail in the areas you want to picture, and provides the range of tones and colors you need to create the desired image. However, getting the perfect exposure can be tricky, because digital sensors can't capture all the tones we are able to see. If the range of tones in an image is extensive, embracing both inky black shadows and bright highlights, the sensor may not be able to capture them all. Sometimes, we must settle for an exposure that renders most of those tones—but not all—in a way that best suits the photo we want to produce. You'll often need to make choices about which details are important, and which are not, so that you can grab the tones that truly matter in your image. That's part of the creativity you bring to bear in realizing your photographic vision.

For example, look at two bracketed exposures presented in Figure 4.1. For the image at the left, the highlights (chiefly the clouds at upper left and the top-left edge of the skyscraper) are well-exposed, but everything else in the shot is seriously underexposed. The version at the right, taken an instant later with the tripod-mounted camera, shows detail in the shadow areas of the buildings, but the highlights are completely washed out. The camera's sensor simply can't capture detail in both dark areas and bright areas in a single shot.

With digital camera sensors, it's tricky to capture detail in both highlights and shadows in a single image, because the number of tones, the *dynamic range* of the sensor, is limited. The solution, in this particular case, was to resort to a technique called High Dynamic Range (HDR) photography,

Figure 4.1 At left, the image is exposed for the highlights, losing shadow detail. At right, the exposure captures detail in the shadows, but the background highlights are washed out.

in which the two exposures from Figure 4.1 were combined in an image editor such as Photoshop, or a specialized HDR tool like Photomatix (about $100 from www.hdrsoft.com). The resulting shot is shown in Figure 4.2. I'll explain more about HDR photography later in this chapter. For now, though, I'm going to concentrate on showing you how to get the best exposures possible without resorting to such tools, using only the features of your Canon Rebel T5.

To understand exposure, you need to understand the six aspects of light that combine to produce an image. Start with a light source—the sun, an interior lamp, or the glow from a campfire—and trace its path to your camera, through the lens, and finally to the sensor that captures the illumination. Here's a brief review of the things within our control that affect exposure:

■ **Light at its source.** Our eyes and our cameras—film or digital—are most sensitive to that portion of the electromagnetic spectrum we call *visible light*. That light has several important aspects that are relevant to photography, such as color and harshness (which is determined primarily by the apparent size of the light source as it illuminates a subject). But, in terms of exposure, the important attribute of a light source is its *intensity*. We may have direct control over intensity, which might be the case with an interior light that can be brightened or dimmed. Or, we might have only indirect control over intensity, as with sunlight, which can be made to appear dimmer by introducing translucent light-absorbing or reflective materials in its path.

Figure 4.2 Combining the two exposures produces the best compromise image.

- **Light's duration.** We tend to think of most light sources as continuous. But, as you'll learn in Chapter 11, the duration of light can change quickly enough to modify the exposure, as when the main illumination in a photograph comes from an intermittent source, such as an electronic flash.

- **Light reflected, transmitted, or emitted.** Once light is produced by its source, either continuously or in a brief burst, we are able to see and photograph objects by the light that is reflected from our subjects toward the camera lens; transmitted (say, from translucent objects that are lit from behind); or emitted (by a candle or television screen). When more or less light reaches the lens from the subject, we need to adjust the exposure. This part of the equation is under our control to the extent we can increase the amount of light falling on or passing through the subject (by adding extra light sources or using reflectors), or by pumping up the light that's emitted (by increasing the brightness of the glowing object).

- **Light passed by the lens.** Not all the illumination that reaches the front of the lens makes it all the way through. Filters can remove some of the light before it enters the lens. Inside the lens barrel is a variable-sized diaphragm that dilates and contracts to vary the size of the aperture and control the amount of light that enters the lens. You, or the T5's autoexposure system, can control exposure by varying the size of the aperture. The relative size of the aperture is called the *f/stop* (see Figure 4.3).

- **Light passing through the shutter.** Once light passes through the lens, the amount of time the sensor receives it is determined by the T5's shutter, which can remain open for as long as 30 seconds (or even longer if you use the Bulb setting) or as briefly as 1/4,000th second.

- **Light captured by the sensor.** Not all the light falling onto the sensor is captured. If the number of photons reaching a particular photosite doesn't pass a set threshold, no information is recorded. Similarly, if too much light illuminates a pixel in the sensor, then the excess isn't recorded or, worse, spills over to contaminate adjacent pixels. We can modify the minimum and maximum number of pixels that contribute to image detail by adjusting the ISO setting. At higher ISOs, the incoming light is amplified to boost the effective sensitivity of the sensor.

These factors—the quantity of light produced by the light source, the amount reflected or transmitted toward the camera, the light passed by the lens, the amount of time the shutter is open, and the sensitivity of the sensor—all work proportionately and reciprocally to produce an exposure. That is, if you double the amount of light that's available, increase the aperture by one stop, make the shutter speed twice as long, or boost the ISO setting 2X, you'll get twice as much exposure. Similarly, you can increase any of these factors while decreasing one of the others by a similar amount to keep the same exposure.

Most commonly, exposure settings are made using the aperture and shutter speed, followed by adjusting the ISO sensitivity if it's not possible to get the preferred exposure; that is, the one that uses the "best" f/stop or shutter speed for the depth-of-field (range of sharp focus) or action stopping we want (produced by short shutter speeds, as I'll explain later). Table 4.1 shows equivalent exposure settings using various shutter speeds and f/stops.

Figure 4.3
Top row
(left to right):
f/2, f/2.8, f/4, f/5.6;
bottom row:
f/8, f/11, f/16, f/22.

Table 4.1 Equivalent Exposures

Shutter Speed	f/stop	Shutter Speed	f/stop
1/30th second	f/22	1/500th second	f/5.6
1/60th second	f/16	1/1,000th second	f/4
1/125th second	f/11	1/2,000th second	f/2.8
1/250th second	f/8	1/4,000th second	f/2

F/STOPS AND SHUTTER SPEEDS

If you're *really* new to more advanced cameras (and I realize that many soon-to-be-ambitious photographers do purchase the T5 as their first digital SLR), you might need to know that the lens aperture, or f/stop, is a ratio, much like a fraction, which is why f/2 is larger than f/4, just as 1/2 is larger than 1/4. However, f/2 is actually *four times* as large as f/4. (If you remember your high school geometry, you'll know that to double the area of a circle, you multiply its diameter by the square root of two: 1.4.)

Lenses are usually marked with intermediate f/stops that represent a size that's twice as much/half as much as the previous aperture. So, a lens might be marked f/2, f/2.8, f/4, f/5.6, f/8, f/11, f/16, f/22, with each larger number representing an aperture that admits half as much light as the one before, as shown in Figure 4.3.

Shutter speeds are actual fractions (of a second), but the numerator is omitted, so that 60, 125, 250, 500, 1,000, and so forth represent 1/60th, 1/125th, 1/250th, 1/500th, and 1/1,000th second. To avoid confusion, EOS uses quotation marks to signify longer exposures: 2", 2"5, 4", and so forth representing 2.0-, 2.5-, and 4.0-second exposures, respectively.

When the T5 is set for P (Program) mode, the metering system selects the correct exposure for you automatically, but you can change quickly to an equivalent exposure by holding down the shutter release button halfway ("locking" the current exposure), and then spinning the Main Dial until the desired *equivalent* exposure combination is displayed. You can use this standard Program Shift feature more easily if you remember that you need to rotate the dial toward the *left* when you want to increase the amount of depth-of-field or use a slower shutter speed; rotate to the *right* when you want to reduce the depth-of-field or use a faster shutter speed. The need for more/less DOF and slower/faster shutter speed are the primary reasons you'd want to use Program Shift. I'll explain Program mode exposure shifting options in more detail later in this chapter.

In Aperture-priority (Av) and Shutter-priority (Tv) modes, you can change to an equivalent exposure using a different combination of shutter speed and aperture, but only by either adjusting the aperture in Aperture-priority mode (the camera then chooses the shutter speed) or shutter speed in Shutter-priority mode (the camera then selects the aperture). I'll cover all these exposure modes and their differences later in the chapter.

How the Rebel T5 Calculates Exposure

Your Canon T5 calculates exposure by measuring the light that passes through the lens and is bounced up by the mirror to sensors located near the focusing surface, using a pattern you can select (more on that later) and based on the assumption that each area being measured reflects about the same amount of light as a neutral gray card that reflects a "middle" gray of about 12 to 18 percent reflectance. (The photographic "gray cards" you buy at a camera store have an 18 percent gray tone; your camera is calibrated to interpret a somewhat darker 12 percent gray; I'll explain more about this later.) That "average" 12 to 18 percent gray assumption is necessary, because different subjects reflect different amounts of light. In a photo containing, say, a white cat and a dark gray cat, the white cat might reflect five times as much light as the gray cat. An exposure based on the white cat will cause the gray cat to appear to be black, while an exposure based only on the gray cat will make the white cat washed out.

This is more easily understood if you look at some photos of subjects that are dark (they reflect little light), those that have predominantly middle tones, and subjects that are highly reflective. The next few figures show some images of actual cats (actually, the *same* cat rendered in black, gray, and white varieties through the magic of Photoshop), with each of the three strips exposed using a different cat for reference.

Correctly Exposed

The three pictures shown in Figure 4.4 represent how the black, gray, and white cats would appear if the exposure were calculated by measuring the light reflecting from the middle, gray cat, which, for the sake of illustration, we'll assume reflects approximately 12 to 18 percent of the light that strikes it. The exposure meter sees an object that it thinks is a middle gray, calculates an exposure based on that, and the feline in the center of the strip is rendered at its proper tonal value. Best of all, because the resulting exposure is correct, the black cat at left and white cat at right are rendered properly as well.

When you're shooting pictures with your T5, and the meter happens to base its exposure on a subject that averages that "ideal" middle gray, then you'll end up with similar (accurate) results. The camera's exposure algorithms are concocted to ensure this kind of result as often as possible, barring any unusual subjects (that is, those that are backlit, or have uneven illumination). The T5 has three different metering modes (described next), each of which is equipped to handle certain types of unusual subjects, as I'll outline.

Figure 4.4
When exposure is calculated based on the middle-gray cat in the center, the black and white cats are rendered accurately, too.

Overexposed

The strip of three images in Figure 4.5 shows what would happen if the exposure were calculated based on metering the leftmost, black cat. The light meter sees less light reflecting from the black cat than it would see from a gray middle-tone subject, and so figures, "Aha! I need to add exposure to brighten this subject up to a middle gray!" That lightens the black cat, so it now appears to be gray.

Figure 4.5
When exposure is calculated based on the black cat at the left, the black cat looks gray, the gray cat appears to be a light gray, and the white cat is seriously overexposed.

But now, the cat in the middle that was *originally* middle gray is overexposed and becomes light gray. And the white cat at right is now seriously overexposed, and loses detail in the highlights, which have become a featureless white.

Underexposed

The third possibility in this simplified scenario is that the light meter might measure the illumination bouncing off the white cat, and try to render that feline as a middle gray. A lot of light is reflected by the white kitty, so the exposure is *reduced*, bringing that cat closer to a middle gray tone. The cats that were originally gray and black are now rendered too dark. Clearly, measuring the gray cat—or a substitute that reflects about the same amount of light—is the only way to ensure that the exposure is precisely correct. (See Figure 4.6.)

As you can see, the ideal way to measure exposure is to meter from a subject that reflects 12–18 percent of the light that reaches it. If you want the most precise exposure calculations, if you don't have a gray cat handy, the solution is to use a stand-in, such as the evenly illuminated gray card I mentioned earlier. But, because the standard Kodak gray card reflects 18 percent of the light that reaches it and, as I said, your camera is calibrated for a somewhat darker 12 percent tone, you would need to add about one-half stop *more* exposure than the value metered from the card.

Another substitute for a gray card is the palm of a human hand (the backside of the hand is too variable). But a human palm, regardless of ethnic group, is even brighter than a standard gray card, so instead of one-half stop more exposure, you need to add one additional stop. That is, if your meter reading is 1/500th of a second at f/11, use 1/500th second at f/8 or 1/250th second at f/11 instead. (Both exposures are equivalent.) You can use exposure compensation (described later in this chapter) to add the half or full stop of exposure in either case.

If you actually wanted to use a gray card, place it in your frame near your main subject, facing the camera, and with the exact same even illumination falling on it that is falling on your subject. Then, use the Partial metering function (described in the next section) to calculate exposure. Of course, in most situations, it's not necessary to make the (technically correct) adjustment from the gray card/human hand reading. Your camera's light meter will do a good job of calculating the right exposure that's close enough for practical purposes, especially if you use the exposure tips in the next section. But, I felt that explaining exactly what is going on during exposure calculation would help you understand how your T5's metering system works.

Figure 4.6
When exposure is calculated based on the white cat on the right, the other two cats are underexposed.

WHY THE GRAY CARD CONFUSION?

Why are so many photographers under the impression that cameras and meters are calibrated to the 18 percent "standard," rather than the true value, which may be 12 to 14 percent, depending on the vendor? The most common explanation is that during a revision of Kodak's instructions for its gray cards in the 1970s, the advice to open up an extra half stop was omitted, and a whole generation of shooters grew up thinking that a measurement off a gray card could be used as-is. The proviso returned to the instructions by 1987, it's said, but by then it was too late. Next to me is a (c)2006 version of the instructions for KODAK Gray Cards, Publication R-27Q, and the current directions read (with a bit of paraphrasing from me in italics):

- For subjects of normal reflectance increase the indicated exposure by 1/2 stop.
- For light subjects use the indicated exposure; for very light subjects, decrease the exposure by 1/2 stop. (*That is, you're measuring a cat that's lighter than middle gray.*)
- If the subject is dark to very dark, increase the indicated exposure by 1 to 1-1/2 stops. (*You're shooting a black cat.*)

Choosing a Metering Method

To calculate exposure automatically, you need to tell the T5 *where* in the frame to measure the light (this is called the *metering method*) and *what controls* should be used to set the exposure. That's called *exposure mode,* and includes Program (P), Shutter-priority (Tv), Aperture-priority (Av), or Manual (M) options, plus Auto and Creative Auto. I'll explain all these next.

But first, I'm going to introduce you to the three metering methods. You can select any of the three if you're working with P, Tv, Av, or M exposure modes; if you're using Auto or Creative Auto, Evaluative metering is selected automatically and cannot be changed:

1. There are two ways to specify a metering method.
 - Press the MENU button and navigate to the Shooting 2 menu (a camera icon with two dots next to it). The third entry is Metering mode. Highlight it, press SET, and choose one of the two modes described below.
 - Use the Quick Control key (Q button) to access the Quick Control screen and navigate to the metering mode section at the bottom of the screen. Then rotate the Main Dial to change the metering mode directly (see Figure 4.7).

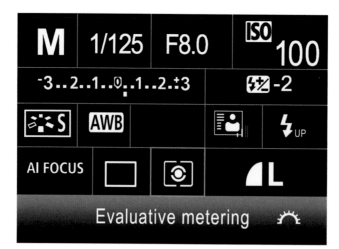

Figure 4.7
The Quick Control screen is the fastest way to change metering mode (and many other common settings).

2. With any of these two methods, you'll be choosing one of these options: Evaluative, Partial, or Center-weighted.

- **Evaluative.** The T5 slices up the frame into 63 different zones, shown as blue rectangles in Figure 4.8. The zones used are linked to the autofocus system (the 9 autofocus zones are also shown in the figure). The camera evaluates the measurements, giving extra emphasis to the metering zones that indicate sharp focus to make an educated guess about what kind of picture you're taking, based on examination of thousands of different real-world photos. For example, if the top sections of a picture are much lighter than the bottom portions, the algorithm can assume that the scene is a landscape photo with lots of sky. This mode is the best all-purpose metering method for most pictures. I'll explain how to choose an autofocus/exposure zone in the section on autofocus operation later in this chapter. See Figure 4.9 for an example of a scene that can be easily interpreted by the Evaluative metering mode.

Figure 4.8 Evaluative metering uses 63 zones marked by blue rectangles, linked to the autofocus points shown as red brackets.

Figure 4.9 An evenly lit scene like this one can be metered effectively using the Evaluative metering setting.

■ **Partial.** This is a *faux* spot mode, using roughly 10 percent of the image area to calculate exposure, which, as you can see in Figure 4.10, is a rather large spot, represented by the larger blue circle. The status LCD icon is shown in the upper-left corner. Use this mode if the background is much brighter or darker than the subject, as in Figure 4.11. Unlike some other models in the Canon line-up, the T5 does not have a true spot metering mode.

■ **Center-weighted.** In this mode, the exposure meter emphasizes a zone in the center of the frame to calculate exposure, as shown in Figure 4.12, on the theory that, for most pictures, the main subject will be located in the center. Center-weighting works best for portraits, architectural photos, and other pictures in which the most important subject is located in the middle of the frame, as in Figure 4.13. As the name suggests, the light reading is *weighted* toward the central portion, but information is also used from the rest of the frame. If your main subject is surrounded by very bright or very dark areas, the exposure might not be exactly right. However, this scheme works well in many situations if you don't want to use one of the other modes.

3. Press the SET button to confirm your choice.

Figure 4.10 Partial metering uses a center spot that's roughly 10 percent of the frame area.

Figure 4.11 Partial metering allowed measuring exposure from the central area of the image, while giving less emphasis to the darker areas at top and bottom.

Figure 4.12 Center-weighted metering calculates exposure based on the full frame, but emphasizes the center area.

Figure 4.13 Center-weighted metering calculated the exposure for this shot from the large area in the center of the frame, with less emphasis on the bright, window-lit area behind the subject.

Choosing an Exposure Method

You'll find four Creative Zone methods for choosing the appropriate shutter speed and aperture: Program (P), Shutter-priority (Tv), Aperture-priority (Av), and Manual (M). To select one of these modes, just spin the Mode Dial (located at the top-right side of the camera) to choose the method you want to use. You can also select from the Basic Zone exposure methods, which provide much less control.

Your choice of which exposure method is best for a given shooting situation will depend on things like your need for lots of (or less) depth-of-field, a desire to freeze action or allow motion blur. Each of the Rebel T5's exposure methods emphasizes one of those aspects of image capture or another. This section introduces you to all of them.

Basic Zone Exposure Methods

When using Basic Zone modes, you have little control over exposure. In any of these modes, the T5 sets Evaluative metering for you, and chooses the shutter speed and aperture automatically. Indeed, when using scene modes, you can't change any of the other shooting settings (other than image quality).

In Scene Intelligent Auto mode, the T5 selects an appropriate ISO sensitivity setting, color (white) balance, Picture Style, color space, noise reduction features, and use of the Auto Lighting Optimizer. Use the Full Auto exposure mode when you hand your camera to a friend to take a picture (say, of you standing in front of the Eiffel Tower), and want to be sure they won't accidentally change any settings.

In Creative Auto mode, the T5 makes most of the exposure decisions for you (just as in Full Auto mode), but allows you to make some adjustments, in a round-about way. In terms of exposure adjustments, what you can do is adjust the f/stop used by telling the T5 whether you want the background more blurred or less blurred. Because the Basic Zone modes don't provide extensive exposure control, I'll continue the description of the adjustments you *can* make at the end of this chapter.

Aperture-Priority

In Av mode, you specify the lens opening used, and the T5 selects the shutter speed. Aperture-priority is especially good when you want to use a particular lens opening to achieve a desired effect. Perhaps you'd like to use the smallest f/stop possible to maximize depth-of-field in a close-up picture, as in Figure 4.14. Or, you might want to use a large f/stop to throw everything except your main subject out of focus, as in Figure 4.15. Maybe you'd just like to "lock in" a particular f/stop because it's the sharpest available aperture with that lens. Or, you might prefer to use, say, f/2.8 on a lens with a maximum aperture of f/1.4, because you want the best compromise between speed and sharpness.

Figure 4.14
Aperture-priority allowed specifying a small aperture and maximum depth-of-field for this long exposure with the camera mounted on a tripod.

Figure 4.15 Use Aperture-priority to "lock in" a large f/stop when you want to blur the background.

Aperture-priority can even be used to specify a *range* of shutter speeds you want to use under varying lighting conditions, which seems almost contradictory. But think about it. You're shooting a soccer game outdoors with a telephoto lens and want a relatively high shutter speed, but you don't care if the speed changes a little should the sun duck behind a cloud. Set your T5 to Av, and adjust the aperture until a shutter speed of, say, 1/1,000th second is selected at your current ISO setting. (In bright sunlight at ISO 400, that aperture is likely to be around f/11.) Then, go ahead and shoot, knowing that your T5 will maintain that f/11 aperture (for sufficient DOF as the soccer players move about the field), but will drop down to 1/750th or 1/500th second if necessary should the lighting change a little.

A blinking 30 or 4000 shutter speed in the viewfinder indicates that the T5 is unable to select an appropriate shutter speed at the selected aperture and that over- and underexposure will occur at the current ISO setting. That's the major pitfall of using Av: you might select an f/stop that is too small or too large to allow an optimal exposure with the available shutter speeds. For example, if you choose f/2.8 as your aperture and the illumination is quite bright (say, at the beach or in snow), even your camera's fastest shutter speed might not be able to cut down the amount of light reaching the sensor to provide the right exposure. Or, if you select f/8 in a dimly lit room, you might find yourself shooting with a very slow shutter speed that can cause blurring from subject movement or camera shake. Aperture-priority is best used by those with a bit of experience in choosing settings. Many seasoned photographers leave their T5 set on Av all the time.

Shutter-Priority

Shutter-priority (Tv) is the inverse of Aperture-priority: you choose the shutter speed you'd like to use, and the camera's metering system selects the appropriate f/stop. Perhaps you're shooting action photos and you want to use the absolute fastest shutter speed available with your camera; in other cases, you might want to use a slow shutter speed to add some blur to a ballet photo that would be mundane if the action were completely frozen (see Figure 4.18, later in this section). Shutter-priority mode gives you some control over how much action-freezing capability your digital camera brings to bear in a particular situation, as you can see in Figure 4.16.

You'll also encounter the same problem as with Aperture-priority when you select a shutter speed that's too long or too short for correct exposure under some conditions. I've shot outdoor soccer games on sunny fall evenings and used Shutter-priority mode to lock in a 1/1,000th second shutter speed, which triggered the blinking warning, even with the lens wide open.

Like Av mode, it's possible to choose an inappropriate shutter speed. If that's the case, the maximum aperture of your lens (to indicate underexposure) or the minimum aperture (to indicate overexposure) will blink.

Figure 4.16
Lock the shutter at a slow speed to introduce a little blur into an action shot, seen here in the stick at right, and the puck.

Program Mode

Program mode (P) uses the T5's built-in smarts to select the correct f/stop and shutter speed using a database of picture information that tells it which combination of shutter speed and aperture will work best for a particular photo. If the correct exposure cannot be achieved at the current ISO setting, the shutter speed indicator in the viewfinder will blink 30 or 4000, indicating under- or overexposure (respectively). You can then boost or reduce the ISO to increase or decrease sensitivity.

The T5's recommended exposure can be overridden if you want. Use the EV setting feature (described later, because it also applies to Tv and Av modes) to add or subtract exposure from the metered value. And, as I mentioned earlier in this chapter, you can change from the recommended setting to an equivalent setting (as shown in Table 4.1) that produces the same exposure, but using a different combination of f/stop and shutter speed. To accomplish this:

1. **Lock in base exposure.** Press the shutter release halfway to lock in the current base exposure, or press the AE lock button (*) on the back of the camera, in which case the * indicator will illuminate in the viewfinder to show that the exposure has been locked. (There is no such indicator on the LCD.)

2. **Select a different combination of shutter speed/aperture.** Spin the Main Dial to change the shutter speed (the T5 will adjust the f/stop to match). The Program Shift will be canceled after taking the current picture. The feature is not available when using flash.

Your adjustment remains in force for a single exposure; if you want to change from the recommended settings for the next exposure, you'll need to repeat those steps.

Making EV Changes

Sometimes you'll want more or less exposure than indicated by the T5's metering system. Perhaps you want to underexpose to create a silhouette effect, or overexpose to produce a high key look. It's easy to use the T5's exposure compensation system to override the exposure recommendations, available in any Creative Zone mode except Manual. There are two ways to make exposure value (EV) changes with the Rebel T5. One method is fast and a bit clumsy to use, especially if your fingers aren't well coordinated. The other method takes a few seconds longer, but can be done smoothly by the most fumble-fingered among us.

Fast EV Changes

Activate the exposure meters by tapping the shutter release button. Then, just hold down the AV button (located on the back next to the upper-right corner of the LCD) and rotate the Main Dial to the right to make the image brighter (add exposure), and to the left to make the image darker (subtract exposure). The exposure scale in the viewfinder and on the LCD indicates the EV change you've made. The EV change you've made remains for the exposures that follow, until you manually zero out the EV setting with the AV button + Main Dial. EV changes are ignored when using M or any of the Basic Zone modes.

Slower EV Changes

If you find yourself not turning the Main Dial quickly enough after you tap the shutter release button, try the second method for making EV changes with the T5. It can be a little slower, but gives you more time to dial in your EV adjustment. You also have the option of setting exposure bracketing at the same time:

1. Press the MENU button and navigate to the Expo. Comp./AEB entry on the Shooting 2 menu.

2. When the screen appears, press the left/right cross keys to add or subtract EV adjustment. The screen has helpful labels (Darker on the left and Brighter on the right) to make sure you're adding/subtracting when you really want to. Note that you can also set automatic exposure bracketing, as discussed in Chapter 8, by rotating the Main Dial while viewing this screen. (See Figure 4.17.)

3. Press SET to confirm your choice.

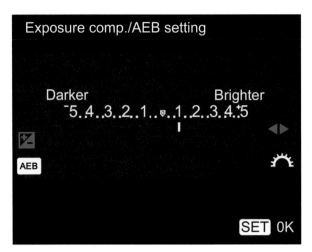

Figure 4.17
EV changes are displayed on the scale in the LCD when using the Shooting 2 menu.

Manual Exposure

Part of being an experienced photographer comes from knowing when to rely on your Rebel T5's automation (including Full Auto, Creative Auto, or P mode), when to go semi-automatic (with Tv or Av), and when to set exposure manually (using M). Some photographers actually prefer to set their exposure manually, as the T5 will be happy to provide an indication of when its metering system judges your settings provide the proper exposure, using the analog exposure scale at the bottom of the viewfinder.

Manual exposure can come in handy in some situations. You might be taking a silhouette photo and find that none of the exposure modes or EV correction features give you exactly the effect you want. For example, when I shot the ballet dancer in Figure 4.18 in front of a mostly dark background highlighted by an illuminated curtain off to the right, there was no way any of my camera's exposure modes would be able to interpret the scene the way I wanted to shoot it, even with Partial metering, which didn't have a narrow enough field-of-view from my position. So, I took a couple test exposures, and set the exposure manually to use the exact shutter speed and f/stop I needed. You might be working in a studio environment using multiple flash units. The additional flash are triggered by slave devices (gadgets that set off the flash when they sense the light from another flash, or, perhaps from a radio or infrared remote control). Your camera's exposure meter doesn't compensate for the extra illumination, and can't interpret the flash exposure at all, so you need to set the aperture manually.

Because, depending on your proclivities, you might not need to set exposure manually very often, you should still make sure you understand how it works. Fortunately, the Rebel T5 makes setting exposure manually very easy. Just set the Mode Dial to M, turn the Main Dial to set the shutter speed, and hold down the Av button while rotating the Main Dial to adjust the aperture. Press the shutter release halfway or press the AE lock button, and the exposure scale in the viewfinder shows you how far your chosen setting diverges from the metered exposure.

Figure 4.18 Manual exposure allows selecting both f/stop and shutter speed, especially useful when you're experimenting, as with this shot of ballet dancers.

Adjusting Exposure with ISO Settings

Another way of adjusting exposures is by changing the ISO sensitivity setting. Sometimes photographers forget about this option, because the common practice is to set the ISO once for a particular shooting session (say, at ISO 100 or 200 for bright sunlight outdoors, or ISO 800 when shooting indoors) and then forget about ISO. The reason for that is that ISOs higher than ISO 100 or 200 are seen as "bad" or "necessary evils." However, changing the ISO is a valid way of adjusting exposure settings, particularly with the Canon EOS Rebel T5, which produces good results at ISO settings that create grainy, unusable pictures with some other camera models.

Indeed, I find myself using ISO adjustment as a convenient alternate way of adding or subtracting EV when shooting in Manual mode, and as a quick way of choosing equivalent exposures when in Auto or semi-automatic modes. For example, I've selected a Manual exposure with both f/stop and shutter speed suitable for my image using, say, ISO 200. I can change the exposure in full-stop increments by pressing the ISO button (the up cross key), and spinning the Main Dial one click at a time. The difference in image quality/noise at the base setting of ISO 200 is negligible if I dial in ISO 100 to reduce exposure a little, or change to ISO 400 to increase exposure. I keep my preferred f/stop and shutter speed, but still adjust the exposure.

Or, perhaps, I am using Tv mode and the metered exposure at ISO 200 is 1/500th second at f/11. If I decide on the spur of the moment I'd rather use 1/500th second at f/8, I can press the ISO button and spin the Main Dial to switch to ISO 100. Of course, it's a good idea to monitor your ISO changes, so you don't end up at ISO 1600 accidentally. ISO settings can, of course, also be used to boost or reduce sensitivity in particular shooting situations. The Rebel T5 can use ISO settings from ISO 100 up to 12,800.

The camera can adjust the ISO automatically as appropriate for various lighting conditions. In Basic Zone modes, ISO is normally set between ISO 100 and ISO 3200. When you choose the Auto ISO setting, the T5 adjusts the sensitivity dynamically to suit the subject matter. In Basic Zone Full Auto, Landscape, Close-Up, Sports, Night Portrait, and Flash Off modes, the T5 adjusts ISO between ISO 100 and ISO 3200 as required. In Portrait mode, ISO is fixed at ISO 100, because the T5 attempts to use larger f/stops to blur the background, and the lower ISO setting lends itself to those larger stops.

When using flash, Auto ISO produces a setting of ISO 800 automatically, except when overexposure would occur (as when shooting subjects very close to the camera), in which case a lower setting (down to ISO 100) will be used. If you have an external dedicated flash attached, the T5 can set ISO in the range of ISO 800 to ISO 1600 automatically. That capability can be useful when shooting outdoor field sports at night and other "long distance" flash pictures, particularly with a telephoto lens, because you want to extend the "reach" of your external flash as far as possible (to dozens of feet or more), and boosting the ISO does that. Remember that if the Auto ISO ranges aren't suitable for you, individual ISO values can also be selected in any of the Creative Zone modes.

Tip

Find yourself locked out of ISO settings lower than 200 or higher than 12,800? Check C.Fn (Custom Function) II-05: Highlight Tone Priority. When set to 1: Enable, only ISO 200 to ISO 12,800 can be selected.

Bracketing

Bracketing is a method for shooting several consecutive exposures using different settings, as a way of improving the odds that one will be exactly right. Before digital cameras took over the universe, it was common to bracket exposures, shooting, say, a series of three photos at 1/125th second, but varying the f/stop from f/8 to f/11 to f/16. In practice, smaller than whole-stop increments were used for greater precision. Plus, it was just as common to keep the same aperture and vary the shutter speed, although in the days before electronic shutters, film cameras often had only whole increment shutter speeds available.

Today, cameras like the T5 can bracket exposures much more precisely, and bracket white balance as well. While WB bracketing is sometimes used when getting color absolutely correct in the camera is important, autoexposure bracketing (AEB) is used much more often. When this feature is activated, the T5 takes three consecutive photos: one at the metered "correct" exposure, one with less exposure, and one with more exposure, using an increment of your choice up to plus 2/minus 2 stops, in 1/3 stop increments. In Av mode, the shutter speed will change; in Tv mode, the aperture speed will change.

Using AEB is trickier than it needs to be, but has been made more flexible than with some earlier Rebel models. With the T5 you can now choose to bracket only overexposures or underexposures—a very useful improvement! Just follow these steps:

1. **Activate the EV/AEB screen.** Press the MENU button and navigate to the Shooting 2 menu, where you'll find the Expo. Comp/AEB option. Press SET to select this choice.

2. **Set the bracket range.** Rotate the Main Dial to spread out or contract the three dots to include the desired range you want to cover. For example, with the dots clustered tightly together, the three bracketed exposures will be spread out over a single stop. Separating the cluster produces a wider range and larger exposure change between the three shots in the bracket set, as shown in Figure 4.19.

3. **Adjust zero point.** By default, the bracketing is zeroed around the center of the scale, which represents the correct exposure. But you might want to have your three bracketed shots all biased toward overexposure or underexposure. Perhaps you feel that the metered exposure will be too dark or too light, and you want the bracketed shots to lean in the other direction. Use the left/right cross keys to move the bracket spread toward one end of the scale or the other, as shown in Figure 4.19.

Figure 4.19
Use the left/right cross keys to bias the bracketing toward more or less exposure.

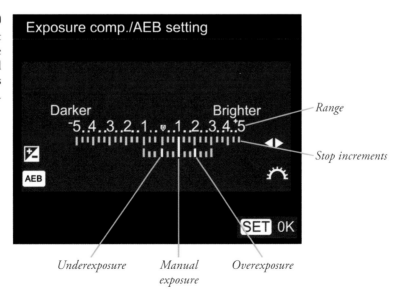

NON-BRACKETING IS EXPOSURE COMPENSATION

When the three bracket indicators aren't separated, using the left/right cross keys simply, in effect, adds or subtracts exposure compensation. You'll be shooting a "bracketed" set of one picture, with the zero point placed at the portion of the scale you indicated. Until you rotate the Main Dial to separate the three bracket indicators by at least one indicator, this screen just supplies EV adjustment. Also keep in mind that the increments shown will be either 1/3 stop or 1/2 stop, depending on how you've set C.Fn I-01.

4. **Confirm your choice.** Press the SET button to enter the settings.

5. **Take your three photos.** You can use Single shooting mode to take the trio of pictures yourself, use the self-timer (which will expose all three pictures after the delay), or switch to Continuous shooting mode to take the three pictures in a burst.

6. **Monitor your shots.** As the images are captured, three indicators will appear on the exposure scale in the viewfinder, with one of them flashing for each bracketed photo, showing when the base exposure, underexposure, and overexposure are taken.

7. **Turn bracketing off when done.** Bracketing remains in effect when the set is taken so you can continue shooting bracketed exposures until you use the electronic flash, turn off the camera, or return to the menu to cancel bracketing.

Bracketing and Merge to HDR

HDR (High Dynamic Range) photography is, at the moment, an incredibly popular fad. There are even entire books that do nothing but tell you how to shoot HDR images. If you aren't familiar with the technique, HDR involves shooting two or three or more images at different bracketed exposures, giving you an "underexposed" version with lots of detail in highlights that would otherwise be washed out; an "overexposed" rendition that preserves detail in the shadows; and several intermediate shots. These are combined to produce a single image that has an amazing amount of detail throughout the scene's entire tonal range.

I call this technique a fad because the reason it exists in the first place is due to a (temporary, I hope) defect in current digital camera sensors. It's presently impossible to capture the full range of brightness that we perceive; digital cameras, including the EOS T5, can't even grab the full range of brightness that *film* can see, as I showed you in Figures 4.1 and 4.2 at the beginning of this chapter.

But as the megapixel race slows down, sensor designers have already begun designing capture electronics that have larger density (dynamic) ranges, and I fully expect to see cameras within a few years that can produce images similar to what we're getting now with HDR manipulation in image editors.

HDR works like this: Suppose you wanted to photograph a dimly lit room that had a bright window showing an outdoors scene. Proper exposure for the room might be on the order of 1/60th second at f/2.8 at ISO 200, while the outdoors scene probably would require f/11 at 1/400th second. That's almost a 7 EV step difference (approximately 7 f/stops) and well beyond the dynamic range of any digital camera, including the EOS T5.

When you're using Merge to HDR Pro, a feature found in Adobe Photoshop (similar functions are available in other programs, including the Mac/PC utility Photomatix [www.hdrsoft.com; free to try, $99 to buy]), you'd take several pictures. As I mentioned earlier, one would be exposed for the shadows, one for the highlights, and perhaps one for the midtones. Then, you'd use the Merge to HDR command (or the equivalent in other software) to combine all of the images into one HDR image that integrates the well-exposed sections of each version. You can use the EOS T5's bracketing feature to produce those images.

The images should be as identical as possible, except for exposure. So, it's a good idea to mount the T5 on a tripod, use a remote release, and take all the exposures in one burst. Just follow these steps:

1. Mount the T5 on a tripod and either connect an optional remote release cable or plan on using the self-timer to avoid camera shake.

2. Set the camera to shoot RAW images, as described in Chapter 8.

3. Set bracketing to a 2-stop increment, as described above.

4. Use Aperture-priority (Av) and select an aperture, so that the camera will adjust only shutter speed while bracketing (thus retaining the same depth-of-field and focus, which would produce ghosts in the final HDR image).

5. Manually focus or autofocus the T5.

6. Trigger the camera to expose your set of three images.

7. Copy your images to your computer and continue in Photoshop with the Merge to HDR Pro steps listed next.

The next steps show you how to combine the separate exposures into one merged high dynamic range image. The sample images shown in Figure 4.20 show the results you can get from a three-shot bracketed sequence, exposed for the highlights, midtones, and shadow areas of the scene.

1. If you use an application to transfer the files to your computer, make sure it does not make any adjustments to brightness, contrast, or exposure. You want the real raw information for Merge to HDR to work with.

2. Load the images into Photoshop using your preferred RAW converter.

3. Save as .PSD files.

4. Activate Merge to HDR Pro by choosing File > Automate > Merge to HDR Pro.

5. Select the photos to be merged. You'll note a checkbox that can be used to automatically align the images if they were not taken with the T5 mounted on a rock-steady support.

6. Once HDR merge has done its thing, you must save in .PSD, to retain the file's full color information, in case you want to work with the HDR image later. Otherwise, you can convert to a normal 24-bit file and save in any compatible format.

If you do everything correctly, you'll end up with a photo like the one shown in Figure 4.21, which has the properly exposed foreground of the first shot, the well-exposed ocean of the second image, and the detail-filled sky of the third version. Note that, ideally, nothing should move between shots. In the example pictures, the ocean is moving, but the exposures were made so close together that (all within about one-half second), after the merger, you can't really tell.

What if you don't have the opportunity, inclination, or skills to create several images at different exposures, as described? If you shoot in RAW format, you can still use Merge to HDR, working with a *single* original image file. What you do is import the image into Photoshop several times, using Adobe Camera Raw to create multiple copies of the file at different exposure levels.

For example, you'd create one copy that's too dark, so the shadows lose detail, but the highlights are preserved. Create another copy with the shadows intact and allow the highlights to wash out. Then, you can use Merge to HDR to combine the two and end up with a finished image that has the extended dynamic range you're looking for.

Figure 4.20 Make one exposure for the shadow areas (left), a second for the midtones (middle), and a third for the highlights, such as the sky.

Figure 4.21 You'll end up with an extended dynamic range photo like this one.

Dealing with Noise

Visual image noise is that random grainy effect that some like to use as a special effect, but which, most of the time, is objectionable because it robs your image of detail even as it adds that "interesting" texture. Noise is caused by two different phenomena: high ISO settings and long exposures.

High ISO noise commonly first appears when you raise your camera's sensitivity setting above ISO 800. With Canon cameras, which are renowned for their good ISO noise characteristics, noise may become visible at ISO 1600, and is usually fairly noticeable at ISO 3200. At the H setting (ISO 12,800 equivalent) noise is usually quite bothersome. This kind of noise appears as a result of the amplification needed to increase the sensitivity of the sensor. While higher ISOs do pull details out of dark areas, they also amplify non-signal information randomly, creating noise.

A similar noisy phenomenon occurs during long time exposures, which allow more photons to reach the sensor, increasing your ability to capture a picture under low-light conditions. However, the longer exposures also increase the likelihood that some pixels will register random phantom photons, often because the longer an imager is "hot," the warmer it gets, and that heat can be mistaken for photons. There's also a special kind of noise that CMOS sensors like the one used in the T5 are potentially susceptible to. With a CCD, the entire signal is conveyed off the chip and funneled through a single amplifier and analog-to-digital conversion circuit. Any noise introduced there is, at least, consistent. CMOS imagers, on the other hand, contain millions of individual amplifiers and A/D converters, all working in unison. Because all these circuits don't necessarily process in precisely the same way all the time, they can introduce something called fixed-pattern noise into the image data.

Fortunately, Canon's electronics geniuses have done an exceptional job minimizing noise from all causes in the T5. This type of noise reduction involves the T5 taking a second, blank exposure, and comparing the random pixels in that image with the photograph you just took. Pixels that coincide in the two represent noise and can safely be suppressed. This noise reduction system, called *dark frame subtraction,* effectively doubles the amount of time required to take a picture, and is used only for exposures longer than one second. Noise reduction can reduce the amount of detail in your picture, as some image information may be removed along with the noise. So, you might want to use this feature with moderation. Some types of images don't require noise reduction, because the grainy pattern tends to blend into the overall scene. Figure 4.22 shows some jellyfish photographed at ISO 3200; there is some noise in the background, but the noise becomes lost in the creatures' watery environment.

To activate your T5's long exposure noise reduction features, go to the Custom Functions in the Set-up menu, choose C.Fn II: Image, and select either C.Fn II-04: (Long Exposure Noise Reduction) or C.Fn II-05: (High ISO Speed Noise Reduction) as explained further in Chapter 9.

You can also apply noise reduction to a lesser extent using Photoshop, and when converting RAW files to some other format, using your favorite RAW converter, or an industrial-strength product like Noise Ninja (www.picturecode.com) to wipe out noise after you've already taken the picture.

Figure 4.22 A slight amount of noise is not objectionable for some types of images, such as this photograph of jellyfish.

Fixing Exposures with Histograms

While you can often recover poorly exposed photos in your image editor, your best bet is to arrive at the correct exposure in the camera, minimizing the tweaks that you have to make in post-processing. However, you can't always judge exposure just by viewing the image on your T5's LCD after the shot is made. Nor can you get a 100 percent accurately exposed picture by using the T5's live view "exposure simulation" feature described in Chapter 6. Ambient light may make the LCD difficult to see, and the brightness level you've set can affect the appearance of the playback image.

Instead, you can use a histogram, which is a chart displayed on the Rebel T5's LCD that shows the number of tones being captured at each brightness level. You can use the information to provide

correction for the next shot you take. The T5 offers two histogram variations: one that shows overall brightness levels for an image and an alternate version that separates the red, green, and blue channels of your image into separate histograms.

Both types are charts that include a representation of up to 256 vertical lines on a horizontal axis that show the number of pixels in the image at each brightness level, from 0 (black) on the left side to 255 (white) on the right. (The 2.7-inch LCD doesn't have enough pixels to show each and every one of the 256 lines, but, instead provides a representation of the shape of the curve formed.) The more pixels at a given level, the taller the bar at that position. If no bar appears at a particular position on the scale from left to right, there are no pixels at that particular brightness level.

A typical histogram produces a mountain-like shape, with most of the pixels bunched in the middle tones, with fewer pixels at the dark and light ends of the scale. Ideally, though, there will be at least some pixels at either extreme, so that your image has both a true black and a true white representing some details. Learn to spot histograms that represent over- and underexposure, and add or subtract exposure using an EV modification to compensate.

DISPLAYING HISTOGRAMS

To view histograms on your screen, press the DISP. button (to the right of the Q button) while an image is shown on the LCD. Keep pressing the button until the histogram(s) are shown. The display will cycle between several levels of information, including flashing highlights and two screens that show histograms. (An explanation of all the information screens can be found in Chapter 3.) One histogram (Figure 4.23) shows overall brightness levels; the second one (Figure 4.24) shows tonal values for the red, green, and blue channels as well as a brightness histogram. During histogram display, you'll also see a thumbnail of your image at the top-left side of the screen. To change your default histogram type from Brightness to RGB, use the Histogram setting in the Playback 2 menu.

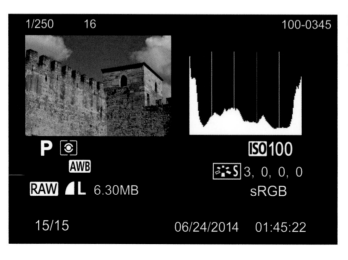

Figure 4.23
A histogram shows the relationship of tones in an image.

For example, Figure 4.25 shows the histogram for an image that is badly underexposed. You can guess from the shape of the histogram that many of the dark tones to the left of the graph have been clipped off. There's plenty of room on the right side for additional pixels to reside without having them become overexposed. Or, a histogram might look like Figure 4.26, which is overexposed. In either case, you can increase or decrease the exposure (either by changing the f/stop or shutter speed in manual mode or by adding or subtracting an EV value in autoexposure mode) to produce the corrected histogram shown in Figure 4.27, in which the tones "hug" the right side of the histogram to produce as many highlight details as possible. See "Making EV Changes" above for information on dialing in exposure compensation.

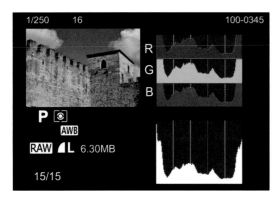

Figure 4.24 Color and brightness histograms.

Figure 4.25 This histogram shows an underexposed image.

Figure 4.26 This histogram reveals that the image is overexposed.

Figure 4.27 A histogram for a properly exposed image should look like this.

The histogram can also be used to aid in fixing the contrast of an image, although gauging incorrect contrast is more difficult. For example, if the histogram shows all the tones bunched up in one place in the image, the photo will be low in contrast. If the tones are spread out more or less evenly, the image is probably high in contrast. In either case, your best bet may be to switch to RAW (if you're not already using that format) so you can adjust contrast in post-processing. However, you can also change to a user-defined Picture Style (User Def. 1, User Def. 2, or User Def. 3 in the Picture Style menu) with contrast set lower (–1 to –4) or higher (+1 to +4) as required. (See Chapter 8 for more information on Picture Styles.)

Basic Zone Modes

The final factor in the exposure equation is one that your T5 offers little control over: Basic Zone modes. Your Canon Rebel T5 includes eight Basic Zone shooting modes that can automatically make all the basic settings needed for certain types of shooting situations, such as Portraits, Landscapes, Close-ups, Sports, Night Portraits, and "No-Flash zone" pictures. They are especially useful when you suddenly encounter a picture-taking opportunity and don't have time to decide exactly which Creative Zone mode you want to use. Instead, you can spin the Mode Dial to the appropriate Basic Zone mode and fire away, knowing that, at least, you have a fighting chance of getting a good or usable photo.

Basic Zone modes are also helpful when you're just learning to use your T5. Once you've learned how to operate your camera, you'll probably prefer one of the Creative Zone modes that provide more control over shooting options. The Basic Zone scene modes may give you few options or none at all. The AF mode, drive mode, and metering mode are all set for you. Here are the modes available:

- **Scene Intelligent Auto.** All the photographer has to do in this mode is press the shutter release button. Every other decision is made by the camera's electronics.
- **Flash Off.** Absolutely prevents the flash from flipping up and firing, which you might want in some situations, such as religious ceremonies, museums, classical music concerts, and your double-naught spy activities.
- **Creative Auto.** Similar to Full Auto, Creative Auto, like the scene modes described next, allows you to change some parameters.
- **Portrait.** This mode tends to use wider f/stops and faster shutter speeds, providing blurred backgrounds and images with no camera shake. If you hold down the shutter release, the T5 will take a continuous sequence of photos, which can be useful in capturing fleeting expressions in portrait situations.
- **Landscape.** The T5 tries to use smaller f/stops for more depth-of-field, and boosts saturation slightly for richer colors.

■ **Close-up.** This mode is similar to the Portrait setting, with wider f/stops to isolate your close-up subjects, and high shutter speeds to eliminate the camera shake that's accentuated at close focusing distances. However, if you have your camera mounted on a tripod or are using an image-stabilized (IS) lens, you might want to use the Creative Zone Aperture-priority (Av) mode instead, so you can specify a smaller f/stop with additional depth-of-field.

■ **Sports.** In this mode, the T5 tries to use high shutter speeds to freeze action, switches to continuous shooting to allow taking a quick sequence of pictures with one press of the shutter release, and uses AI Servo AF to continually refocus as your subject moves around in the frame. You can find more information on autofocus options in Chapter 5.

■ **Night Portrait.** Combines flash with ambient light to produce an image that is mainly illuminated by the flash, but the background is exposed by the available light. This mode uses longer exposures, so a tripod, monopod, or IS lens is a must.

That Quick Control Screen Again

I've previously described how to use the Quick Control screen when working with Creative Zone modes, to change many settings, such as ISO, shutter speed, aperture, and other parameters. When using Basic Zone modes, your options are different. In each case, you can activate the Quick Control screen by pressing the Quick Control button. Then, one of several different screens will appear on your LCD.

Full Auto/Auto (No Flash)

In either of these modes, a screen like the one shown in Figure 4.28 will pop up. Your only choices are Single shooting and Self-timer/10 Second Remote Control. Press the DISP. button to exit.

Figure 4.28
Quick Control
screen in Scene
Intelligent Auto/
Auto (No Flash)
modes.

Creative Auto Mode

When the Mode Dial is set to Creative Auto, a screen like the one shown in Figure 4.29 appears. You can then do one of three things:

- **Change shooting parameters by ambience.** Press the Quick Control button and then the up cross key to select the ambience box. When the top box on the screen is highlighted, it will display the most recent "ambience" setting you've selected (Standard, unless you've made a change). Ambience is a type of picture style that adjusts parameters like sharpness or color richness to produce a particular look.

 - Press the left/right cross keys or rotate the Main Dial and select from among Vivid, Soft, Warm, Intense, Cool, Brighter, Darker, or Monochrome.

 - You can then rotate the Main Dial to change the Effect to Low, Standard, or Strong. Press the Quick Control button to exit.

- **Press the down cross key to highlight Background: Blurred→Sharp.** Then, rotate the Main Dial to adjust the amount of background blurring. The T5 will try to use a larger f/stop to reduce depth-of-field and blur the background, or a smaller f/stop and increased depth-of-field to sharpen the background.

- **Press the down cross key to highlight Drive mode/Flash firing.** Then press the SET button to pop up the Drive mode/Flash firing screen. In this screen, you can rotate the Main Dial to change among the various drive modes, or use the left/right cross keys to switch among flash modes.

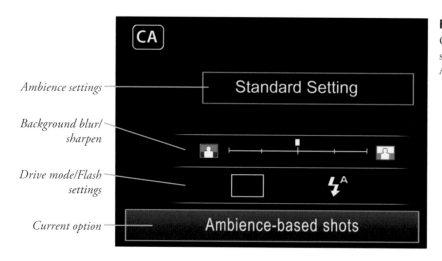

Figure 4.29
Quick Control screen in Creative Auto mode.

Ambience settings

Background blur/ sharpen

Drive mode/Flash settings

Current option

Other Basic Zone Modes

When you select one of the other Basic Zone modes, you'll see a screen similar to Figure 4.30, which pictures the Landscape version. Your options are similar to those in Creative Auto mode:

- **Change shooting parameters by ambience.** When the top box on the screen is highlighted, it will display the most recent "ambience" setting you've selected.
 - Press the left/right cross keys or rotate the Main Dial and select from among: Vivid, Soft, Warm, Intense, Cool, Brighter, Darker, or Monochrome, the same choices available in Creative Auto mode.
 - You can then rotate the Main Dial to change the Effect to Low, Standard, or Strong. Press the Quick Control button to exit.
- **Press the down cross key to highlight Default Settings.** This option is available only if you're using Portrait, Landscape, Close-up, and Sports modes. The prompt in the blue box at the bottom of the screen will change to Shoot by Lighting or Scene Type. You can then rotate the Main Dial to cycle through Default setting, Daylight, Shade, Cloudy, Tungsten Light, Fluorescent Light, or Sunset. You can also press the SET button and see a menu listing each of these options simultaneously.
- **Press the down cross key to highlight Drive mode/Self-timer.** In this screen, you can press the left/right cross keys or rotate the Main Dial to switch between the available drive mode (either Single shot or Continuous shooting, depending on the Basic Zone mode selected) and 10-Second Self-timer/Remote.

PREVIEW AMBIENCE

If you set ambience in live view mode, the T5 will provide a preview image that simulates the effect your ambience setting will have on the finished image. Examples of each ambience setting can be seen in Figure 4.31.

Figure 4.30
Quick Control screen in other Basic Zone modes.

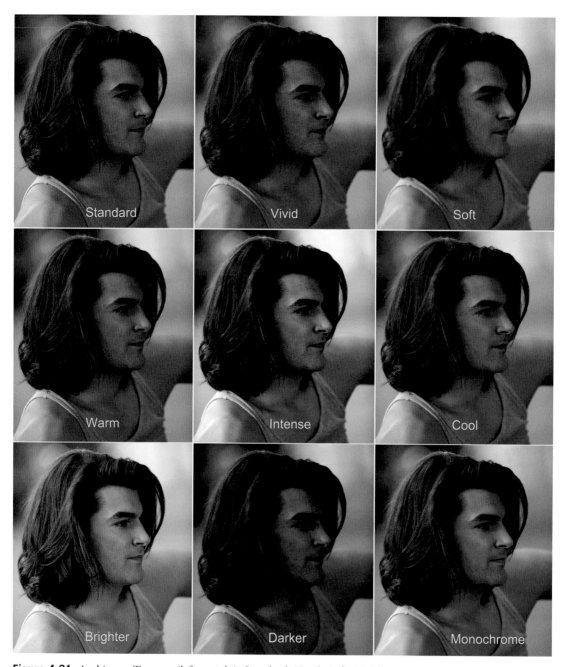

Figure 4.31 Ambience: Top row (left to right): Standard, Vivid, Soft; Middle: Warm, Intense, Cool; Bottom: Brighter, Darker, Monochrome.

Find your desired ambience in Table 4.2.

Table 4.2 Selecting Ambience

Ambience Setting	Effect
Standard	This is the customized set of parameters for each Basic Zone mode, each tailored specifically for Portrait, Landscape, Close-Up, Sports, or other mode.
Vivid	Produces a look that is slightly sharper and with richer colors for the relevant Basic Zone mode.
Soft	Reduced sharpness for adult portraits, flowers, children, and pets.
Warm	Warmer, soft tones. An alternative setting for portraits and other subjects that you want to appear both soft and warm.
Intense	Darker tones with increased contrast to emphasize your subject. This setting is great for portraits of men.
Cool	Darker, cooler tones. Use with care on human subjects, which aren't always flattered by the icier look this setting can produce.
Brighter	Overall lighter image with less contrast.
Darker	Produces a darker image.
Monochrome	Choose from black-and-white, sepia, or blue (cyanotype) toning.

Mastering the Mysteries of Autofocus

Getting the right exposure is one of the foundations of a great photograph, but a lot more goes into a compelling shot than good tonal values. A sharp image, proper white balance, good color, and other factors all can help elevate your image from good to exceptional. One of the most important and, sometimes, the most frustrating aspects of shooting with a highly automated—yet fully adjustable—camera like the T5 is achieving sharp focus. Your camera has lots of AF controls and options and new users and veterans alike can quickly become confused. In this chapter, I'm going to clear up the mysteries of autofocus and show you exactly how to use your T5's AF features to their fullest. I'll even tell you when to abandon the autofocus system and turn to the ancient art of manual focus, too.

How Focus Works

Although Canon added autofocus capabilities in the 1980s, back in the day of film cameras, prior to that focusing was always done manually. Honest. Even though SLR viewfinders were bigger and brighter than they are today, special focusing screens, magnifiers, and other gadgets were often used to help the photographer achieve correct focus. Imagine what it must have been like to focus manually under demanding, fast-moving conditions such as sports photography.

I don't have to imagine it. I did it for many years. I started my career as a sports photographer, and then traveled the country as a roving photojournalist for more years than I like to admit. (Okay, eighteen years. You forced it out of me.) Indeed, I was a hold-out for manual focus right through the film era, even as AF lenses became the norm and autofocus systems in cameras were (gradually)

perfected. I purchased my first autofocus lens back in 2004, at the same time I switched from non-SLR digital cameras and my film cameras to digital SLR models.

Manual focusing was problematic because our eyes and brains have poor memory for correct focus, which is why your eye doctor must shift back and forth between sets of lenses and ask "Does that look sharper—or was it sharper before?" in determining your correct prescription. Similarly, manual focusing involves jogging the focus ring back and forth as you go from almost in focus, to sharp focus, to almost focused again. The little clockwise and counterclockwise arcs decrease in size until you've zeroed in on the point of correct focus. What you're looking for is the image with the most contrast between the edges of elements in the image.

The camera also looks for these contrast differences among pixels to determine relative sharpness. There are two ways that sharp focus is determined: phase detection and contrast detection.

Phase Detection

Like all digital SLRs that use an optical viewfinder and mirror system to preview an image (that is, when not in live view mode), the Canon EOS T5 calculates focus using what is called a *passive phase detection* system. It's passive in the sense that the ambient illumination in a scene (or that illumination augmented with a focus-assist beam) is used to determine correct focus. (An *active* phase detection system might use a laser, sonar, or other special signal.)

Parts of the image from two opposite sides of the lens are directed down to the floor of the camera's mirror box, where an autofocus sensor array resides; the rest of the illumination from the lens bounces upward toward the optical viewfinder system and the autoexposure sensors. Figure 5.1 is a wildly over-simplified illustration that may help you visualize what is happening.

As light emerges from the rear element of the lens, most of it is reflected upward toward the focusing screen, where the relative sharp focus (or lack of it) is displayed (and which can be used to evaluate manual focus). It then bounces off two more reflective surfaces in the pentamirror (a lighter-weight, less expensive version of the solid-glass *pentaprism* system used in Canon EOS models from the 70D on up) emerging at the optical viewfinder correctly oriented left/right and up/down. (The image emerges from the lens reversed.) Some of the illumination is directed to the autoexposure sensor at the top of the pentamirror housing.

A small portion of the illumination passes through the partially silvered center of the main mirror, and is directed downward to the autofocus sensor array, which includes nine separate autofocus "detectors." In the interests of arrow-clutter reduction (ACR), the diagram doesn't show that parts of the image from opposite sides of the lens surface are directed through separate microlenses, producing two half-images. These images are compared with each other, much like (actually, *exactly* like) a two-window rangefinder used in surveying, weaponry—and non-SLR cameras like the venerable Leica M film models.

Figure 5.1

Part of the light is bounced downward to the autofocus sensor array, and split into two images, which are compared and aligned to create a sharply focused image.

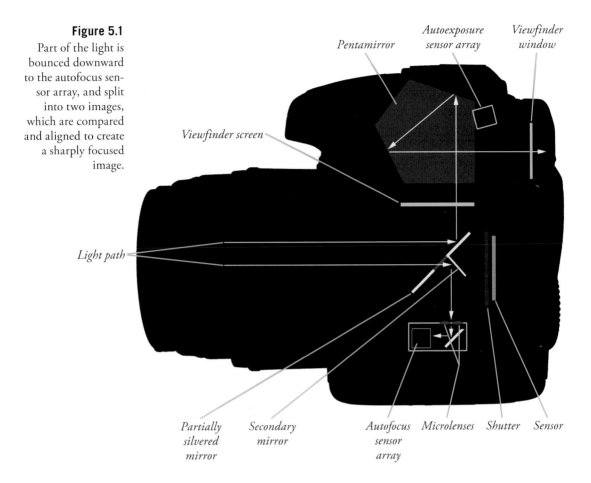

SIMPLIFICATION MADE OVERLY SIMPLE

To reduce the complexity of the diagram, it doesn't show the actual path of the light passing through the lens, as it converges to the point of focus—on the viewfinder screen when the mirror is down, and on the sensor plane when the mirror is flipped up and the shutter has opened. Nor does it show the path of the light directed to the autoexposure sensor. Only two of the nine pairs of autofocus microlenses are shown, and greatly enlarged so you can see their approximate position. All we're concerned about here is how light reaches the autofocus sensor.

When the image is out of focus—or out of phase—as in Figure 5.2, the two halves, each representing a slightly different view from opposite sides of the lens, don't line up. Sharp focus is achieved when the images are "in phase," and aligned, as in Figure 5.3. The two figures don't show exactly what happens, because eight of the nine of the AF sensors in the T5 are of the simpler line sensor variety, while the center sensor is of the cross-type. I'll explain cross-type sensors shortly, but, first, you needed to understand the basic phase detection process.

As with any rangefinder-like function, accuracy is better when the "base length" between the two images is larger. (Think back to your high school trigonometry; you could calculate a distance more accurately when the separation between the two points where the angles were measured was greater.) For that reason, phase detection autofocus is more accurate with larger (wider) lens openings than with smaller lens openings, and may not work at all when the f/stop is smaller than f/5.6. Obviously, the "opposite" edges of the lens opening are farther apart with a lens having an f/2.8 maximum aperture than with one that has a smaller, f/5.6 maximum f/stop, and the base line is much longer. The T5 is able to perform these comparisons and then move the lens elements directly to the point of correct focus very quickly, in milliseconds.

Unfortunately, while the T5's focus system finds it easy to measure degrees of apparent focus at each of the focus points in the viewfinder, it doesn't really know with any certainty *which* object should be in sharpest focus. Is it the closest object? The subject in the center? Something lurking *behind* the closest subject? A person standing over at the side of the picture? Many of the techniques for using autofocus effectively involve telling the EOS T5 exactly what it should be focusing on, by choosing a focus zone or by allowing the camera to choose a focus zone for you. I'll address that topic shortly.

Figure 5.2 In phase detection, parts of an image are split in two and compared.

Figure 5.3 When the image is in focus, the two halves of the image align, as with a rangefinder.

Cross-Type Focus Points

So far, we've only looked at focus sensors that calculate focus in a single direction. (Canon calls them *AF points*, but I use the term *sensors* to avoid confusion, because they aren't really "points" at all.) Figures 5.2 and 5.3 illustrate a horizontally oriented focus sensor evaluating a subject that is made up, predominantly, of vertical lines. But what does such a sensor do when it encounters a subject that isn't conveniently aligned at right angles to the sensor array? You can see the problem in Figure 5.4, which pictures the same weathered wood siding rotated 90 degrees. The horizontal grain of the wood isn't divided as neatly by the split image, so focusing using phase detection is more difficult.

In the past, the "solution" was to include a sprinkling of vertically oriented AF sensors in with horizontally oriented sensors. The vertical sensors could detect differences in horizontal lines, while the horizontal sensors took care of the vertical lines. Both types were equally adept at handling *diagonal* lines, which crossed each type at a 45-degree angle. Today, however, Canon's entry-level digital SLRs use at least one "multi-function" sensor (in the center of the array) that has a cross-type arrangement. In the T5, this sensor operates with any lens having a maximum aperture of f/5.6 or larger, and is especially sensitive when used with lenses having a maximum aperture of at least f/2.8.

The value of cross-type focus sensors in phase detection is that such sensors can line up edges and interpret image contrast in both horizontal and vertical directions, as shown in Figure 5.5. The horizontal lines are still more difficult to interpret with the horizontal arm of the cross, but they stand out in sharp contrast in the vertical arms, and allow the camera to align the edges and snap the image into focus easily, as you can see at lower right. In lower light levels, with subjects that were moving, or with subjects that have no pattern and less contrast to begin with, the cross-type

Figure 5.4 Horizontal focus sensors do a poor job of interpreting the alignment of horizontal lines; they work better with vertical lines or diagonals.

Figure 5.5 Cross-type sensors can achieve sharp focus with both horizontal and vertical lines.

Figure 5.6
The AF sensors in
the T5 are arranged
like this.

sensor not only works faster but can focus subjects that a horizontal- or vertical-only sensor can't handle at all. (Note that the actual horizontal, vertical, and cross-type sensors don't look like the illustrations—we're still in over-simplification mode.) The location of the sensors in the viewfinder is shown in Figure 5.6.

Contrast Detection

Contrast detection is a slower mode and used by the Canon T5 with live view and live face detection modes, because, to allow live viewing of the sensor image, the camera's mirror has to be flipped up out of the way so that the illumination from the lens can continue through the open shutter to the sensor. Your view through the viewfinder is obstructed, of course, and there is no partially silvered mirror to reflect some light down to the autofocus sensors. So, an alternate means of autofocus must be used, and that method is *contrast detection*. The T5 does have a Quick mode feature that temporarily flips the mirror back down to allow phase detection autofocus, but unless you use that mode—which I'll discuss later, focus must be achieved either manually (with the color LCD live view as a focusing screen), or by contrast detection.

Contrast detection is a bit easier to understand and is illustrated by Figure 5.7. At top in the extreme enlargement of the wood siding, the transitions between pixels are soft and blurred. When the image is brought into focus (bottom), the transitions are sharp and clear. Although this example is a bit exaggerated so you can see the results on the printed page, it's easy to understand that when maximum contrast in a subject is achieved, it can be deemed to be in sharp focus.

Contrast detection is used in live view mode, and may be the only focus mode possible with point-and-shoot cameras that don't offer a through-the-lens optical viewfinder as found in a digital SLR like the T5. Contrast detection works best with static subjects, because it is inherently slower and not well-suited for tracking moving objects. Contrast detection works less well than phase detection in dim light, because its accuracy is determined not by the length of the baseline of a rangefinder

Figure 5.7
Focus in contrast detection mode evaluates the increase in contrast in the edges of subjects, starting with a blurry image (top) and producing a sharp, contrasty image (bottom).

focus system, but by its ability to detect variations in brightness and contrast. You'll find that contrast detection works better with faster lenses, too, not as with phase detection (which gains accuracy because the diameter of the lens is simply wider) but because larger lens openings admit more light that can be used by the sensor to measure contrast.

Focus Modes

Focus modes tell the camera *when* to evaluate and lock in focus. They don't determine *where* focus should be checked; that's the function of other autofocus features. Focus modes tell the camera whether to lock in focus once, say, when you press the shutter release halfway (or use some other control, such as the AF-ON button), or whether, once activated, the camera should continue tracking your subject and, if it's moving, adjust focus to follow it.

The T5 has three AF modes: One-Shot AF (also known as single autofocus), AI Servo (continuous autofocus), and AI Focus AF (which switches between the two as appropriate). I'll explain all of these in more detail later in this section. But first, some confusion…

MANUAL FOCUS

With manual focus activated by sliding the AF/MF switch on the lens, your T5 lets you set the focus yourself. There are some advantages and disadvantages to this approach. While your batteries will last longer in manual focus mode, it will take you longer to focus the camera for each photo, a process that can be difficult. Modern digital cameras, even dSLRs, depend so much on autofocus that the viewfinders of models that have less than full-frame-sized sensors are no longer designed for optimum manual focus. Pick up any film camera and you'll see a bigger, brighter viewfinder with a focusing screen that's a joy to focus on manually.

Adding Circles of Confusion

You know that increased depth-of-field brings more of your subject into focus. But more depth-of-field also makes autofocusing (or manual focusing) more difficult because the contrast is lower between objects at different distances. This is an added factor *beyond* the rangefinder aspects of lens opening size in phase detection. An image that's dimmer is more difficult to focus with any type of focus system, phase detection, contrast detection, or manual focus.

So, focus with a 200mm lens (or zoom setting) may be easier in some respects than at a 28mm focal length (or zoom setting) because the longer lens has less apparent depth-of-field. By the same token, a lens with a maximum aperture of f/1.8 will be easier to autofocus (or manually focus) than one of the same focal length with an f/4 maximum aperture, because the f/4 lens has more depth-of-field *and* a dimmer view. That's yet another reason why lenses with a maximum aperture smaller than f/5.6 can give your T5's autofocus system fits—increased depth-of-field joins forces with a dimmer image that's more difficult to focus using phase detection.

To make things even more complicated, many subjects aren't polite enough to remain still. They move around in the frame, so that even if the T5 is sharply focused on your main subject, it may change position and require refocusing. An intervening subject may pop into the frame and pass between you and the subject you meant to photograph. You (or the T5) have to decide whether to lock focus on this new subject, or remain focused on the original subject. Finally, there are some kinds of subjects that are difficult to bring into sharp focus because they lack enough contrast to allow the T5's AF system (or our eyes) to lock in. Blank walls, a clear blue sky, or other subject matter may make focusing difficult.

If you find all these focus factors confusing, you're on the right track. Focus is, in fact, measured using something called a *circle of confusion*. An ideal image consists of zillions of tiny little points, which, like all points, theoretically have no height or width. There is perfect contrast between the point and its surroundings. You can think of each point as a pinpoint of light in a darkened room. When a given point is out of focus, its edges decrease in contrast and it changes from a perfect point to a tiny disc with blurry edges (remember, blur is the lack of contrast between boundaries in an image). (See Figure 5.8.)

Figure 5.8

When a pinpoint of light (left) goes out of focus, its blurry edges form a circle of confusion (center and right).

If this blurry disc—the circle of confusion—is small enough, our eye still perceives it as a point. It's only when the disc grows large enough that we can see it as a blur rather than a sharp point that a given point is viewed as out of focus. You can see, then, that enlarging an image, either by displaying it larger on your computer monitor or by making a large print, also enlarges the size of each circle of confusion. Moving closer to the image does the same thing. So, parts of an image that may look perfectly sharp in a 5 × 7–inch print viewed at arm's length, might appear blurry when blown up to 11 × 14 and examined at the same distance. Take a few steps back, however, and it may look sharp again.

To a lesser extent, the viewer also affects the apparent size of these circles of confusion. Some people see details better at a given distance and may perceive smaller circles of confusion than someone standing next to them. For the most part, however, such differences are small. Truly blurry images will look blurry to just about everyone under the same conditions.

Technically, there is just one plane within your picture area, parallel to the back of the camera (or sensor, in the case of a digital camera), that is in sharp focus. That's the plane in which the points of the image are rendered as precise points. At every other plane in front of or behind the focus plane, the points show up as discs that range from slightly blurry to extremely blurry until, as you can see in Figure 5.9, the out-of-focus areas become one large blur that de-emphasizes the background.

Figure 5.9
The background is almost totally blurred, thanks to a wide f/stop.

In practice, the discs in many of these planes will still be so small that we see them as points, and that's where we get depth-of-field. Depth-of-field is just the range of planes that include discs that we perceive as points rather than blurred splotches. The size of this range increases as the aperture is reduced in size and is allocated roughly one-third in front of the plane of sharpest focus, and two-thirds behind it. The range of sharp focus is always greater behind your subject than in front of it.

Making Sense of Sensors

The number and type of autofocus sensors can affect how well the system operates. As I mentioned, the Canon EOS T5 has nine AF points or zones. Other EOS cameras may have from 7 to 45 AF points. These focus sensors can consist of vertical or horizontal lines of pixels, cross-shapes, and often a mixture of these types within a single camera, although, as I mentioned, the EOS T5 includes a cross-type sensor only at the center position. The more AF points available, the more easily the camera can differentiate among areas of the frame, and the more precisely you can specify the area you want to be in focus if you're manually choosing a focus spot.

As the camera collects focus information from the sensors, it then evaluates it to determine whether the desired sharp focus has been achieved. The calculations may include whether the subject is moving, and whether the camera needs to "predict" where the subject will be when the shutter release button is fully depressed and the picture is taken. The speed with which the camera is able to evaluate focus and then move the lens elements into the proper position to achieve the sharpest focus determines how fast the autofocus mechanism is. Although your T5 will almost always focus more quickly than a human, there are types of shooting situations where that's not fast enough. For example, if you're having problems shooting sports because the T5's autofocus system manically follows each moving subject, a better choice might be to switch autofocus modes or shift into manual and prefocus on a spot where you anticipate the action will be, such as a goal line or soccer net. At night football games, for example, when I am shooting with a telephoto lens almost wide open, I often focus manually on one of the referees who happens to be standing where I expect the action to be taking place (say, a halfback run or a pass reception). When I am less sure about what is going to happen, I may switch to AI Servo autofocus and let the camera decide.

Your Autofocus Mode Options

Choosing the right autofocus mode and the way in which focus points are selected is your key to success. Using the wrong mode for a particular type of photography can lead to a series of pictures that are all sharply focused—on the wrong subject. When I first started shooting sports with an autofocus SLR (back in the film camera days), I covered one game alternating between shots of base runners and outfielders with pictures of a promising young pitcher, all from a position next to the third-base dugout. The base runner and outfielder photos were great, because their backgrounds didn't distract the autofocus mechanism. But all my photos of the pitcher had the focus tightly zeroed in on the fans in the stands behind him. Because I was shooting film instead of a digital

camera, I didn't know about my gaffe until the film was developed. A simple change, such as locking in focus or focus zone manually, or even manually focusing, would have done the trick.

To save battery power, your T5 doesn't start to focus the lens until you partially depress the shutter release. But, autofocus isn't some mindless beast out there snapping your pictures in and out of focus with no feedback from you after you press that button. There are several settings you can modify that return at least a modicum of control to you. Your first decision should be whether you set the T5 to One-Shot, AI Servo AF, or AI Focus AF. With the camera set for one of the Creative Zone modes, press the AF button (the right cross key) and use the Main Dial or left/right cross keys to select the focus mode you want (see Figure 5.10). Press SET to confirm your choice. (The AF/M switch on the lens must be set to AF before you can change autofocus mode.)

Figure 5.10
Press the left/right cross keys or rotate the Main Dial until the AF choice you want is selected.

One-Shot AF

In this mode, also called *single autofocus*, focus is set once and remains at that setting until the button is fully depressed, taking the picture, or until you release the shutter button without taking a shot. For non-action photography, this setting is usually your best choice, as it minimizes out-of-focus pictures (at the expense of spontaneity). The drawback here is that you might not be able to take a picture at all while the camera is seeking focus; you're locked out until the autofocus mechanism is happy with the current setting. One-Shot AF/single autofocus is sometimes referred to as *focus priority* for that reason. Because of the small delay while the camera zeroes in on correct focus, you might experience slightly more shutter lag. This mode uses less battery power.

When sharp focus is achieved, the selected focus point will flash red in the viewfinder, and the focus confirmation light at the lower right will flash green. If you're using Evaluative metering, the exposure will be locked at the same time. By keeping the shutter button depressed halfway, you'll find you can reframe the image while retaining the focus (and exposure) that's been set. With other metering methods, you can use the AE lock/FE lock button to retain the exposure calculated from the center AF point while reframing.

AI Servo AF

This mode, also known as *continuous autofocus*, is the mode to use for sports and other fast-moving subjects. In this mode, once the shutter release is partially depressed, the camera sets the focus but continues to monitor the subject, so that if it moves or you move, the lens will be refocused to suit. Focus and exposure aren't really locked until you press the shutter release down all the way to take the picture. You'll often see continuous autofocus referred to as *release priority.* If you press the shutter release down all the way while the system is refining focus, the camera will go ahead and take a picture, even if the image is slightly out of focus. You'll find that AI Servo AF produces the least amount of shutter lag of any autofocus mode: press the button and the camera fires. It also uses the most battery power, because the autofocus system operates as long as the shutter release button is partially depressed.

AI Servo AF uses a technology called *predictive AF*, which allows the T5 to calculate the correct focus if the subject is moving toward or away from the camera at a constant rate. It uses either the automatically selected AF point or the point you select manually to set focus.

AI Focus AF

This setting is actually a combination of the first two. When selected, the camera focuses using One-Shot AF and locks in the focus setting. But, if the subject begins moving, it will switch automatically to AI Servo AF and change the focus to keep the subject sharp. AI Focus AF is a good choice when you're shooting a mixture of action pictures and less dynamic shots and want to use One-Shot AF when possible. The camera will default to that mode, yet switch automatically to AI Servo AF when it would be useful for subjects that might begin moving unexpectedly.

Setting AF Point

You can change which of the nine focus points the Canon EOS Rebel T5 uses to calculate correct focus, or allow the camera to select the point for you. In any of the Basic Zone shooting modes, the focus point is always selected automatically by the camera. In the other Creative Zone modes, you can allow the camera to select the focus point automatically, or you can specify which focus point should be used.

To review, there are several methods to set the focus point manually. You can press the AF point selection button on the back of the camera (at the upper-right edge of the back), look through the viewfinder, and use the cross keys to move the focus point to the zone you want to use. It is not necessary to *hold* the AF point selection button down. Just press it once, and the cross keys become active for about four seconds, or until you stop moving the focus point around. For example, press the cross keys straight up or down, and the top or bottom focus points are selected. To the left or right, and the side points are selected. Press the SET button, and the center focus point becomes active. Press the SET button twice, and automatic focus is selected with all focus points active.

You can also choose a focus point by pressing the AF point selection button and then rotating the Main Dial. The focus point will cycle among the edge points counterclockwise (if you turn the Main Dial to the left) or clockwise (if you spin the Main Dial to the right). At each end of the cycle, the center focus point and then all nine focus points will be active. When all nine are "live," auto point selection will be switched back on.

When you press the Q button and the Quick Control screen is visible, press the AF point selection button, and the screen shown in Figure 5.11 appears on the LCD. You can then rotate the Main Dial or use the cross keys to select the focus point. This method may be easier under dark conditions, when the viewfinder focus points are not as easily seen, or when you're photographing a subject that has many red hues (it happens!) and the viewfinder image, awash in red, doesn't show the red-highlighted focus points readily.

Figure 5.11
When selecting focus points manually, rotate the Main Dial to select specific points. Continue rotating until all nine points are visible, and the T5 switches back to automatic AF point selection mode.

6

Live View and Movies

Cameras like the Canon EOS T5 are loaded with killer features. And, by killer, I mean that new capabilities found in digital SLRs have virtually killed off whole categories of cameras, such as high-end, point-and-shoot cameras that lack interchangeable lenses or superzoom optics, and, in the future, camcorders. Who needs a camcorder when your digital SLR can shoot full HD 1080p video *and* stills?

Live view has been around long enough that it's becoming old hat for some, but, we have learned, it was really just a precursor to one of the T5's deadliest killer features—full HD video shooting. Indeed, the opening montages of *Saturday Night Live* were all shot using Canon cameras, so you can see that movie shooting with your camera has a lot of potential. You can now buy fancy harnesses, rigs, and Steadycam setups for Canon digital cameras, turning the more ambitious among us into one-person motion picture studios, ready and able to shoot everything from family vacation movies suitable for broadcasting on PBS during pledge week to full-length feature films. It's mind-boggling to see how far movie-shooting dSLRs have progressed in the past several years.

Of course, live view is, in fact, tightly integrated with movie shooting; we'll start with that.

Working with Live View

Live view is one of those features that, despite increasing evidence to the contrary, experienced SLR users (especially those dating from the film era) sometimes think they don't need—until they try it. But live view is a permanent fixture, even for latecomers to the party. Indeed, many point-and-shoot models don't even *have* optical viewfinders, engendering a whole generation of amateur photographers who think the only way to frame and compose an image is to hold the camera out at arm's length so the back-panel LCD can be viewed more easily.

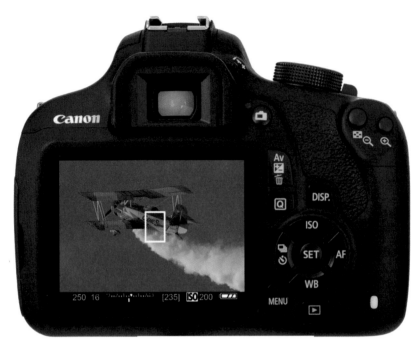

Figure 6.1
Live view really shines on the Canon EOS T5's 3-inch LCD.

While dSLR veterans didn't really miss what we've come to know as live view, it was at least, in part, because they didn't have it and couldn't miss what they never had. After all, why would you eschew a big, bright, magnified through-the-lens optical view that showed depth-of-field fairly well, and which was easily visible under virtually all ambient light conditions? LCD displays, after all, were small, tended to wash out in bright light, and didn't really provide you with an accurate view of what your picture was going to look like.

There were technical problems, as well. Real-time previews theoretically disabled a dSLR's autofocus system, as focus was achieved by measuring contrast through the optical viewfinder, which is blocked when the mirror is flipped up for a live view. Extensive previewing had the same effect on the sensor as long exposures: the sensor heated up, producing excess noise. Pointing the camera at a bright light source when using a real-time view could damage the sensor. The list of potential problems goes on and on.

That was then. This is now.

The Canon EOS T5 has a 3-inch LCD that can be viewed under a variety of lighting conditions and from wide-ranging angles, so you don't have to be exactly behind the display to see it clearly. (See Figure 6.1.) It offers a 100 percent view of the sensor's capture area (the optical viewfinder shows just 95 percent of the sensor's field of view). It's large enough to allow manual focusing—but if you want to use automatic focus, there's an option that allows briefly flipping the mirror back down for autofocusing, interrupting live view, and then restoring the sensor preview image after focus is achieved. You still have to avoid pointing your T5 at bright light sources (especially the sun) when using live view, but the real-time preview can be used for fairly long periods without frying

the sensor. (Image quality can degrade, but the camera issues a warning when the sensor starts to overheat.)

Live View Essentials

You may not have considered just what you can do with live view, because the capability is so novel. But once you've played with it, you'll discover dozens of applications for this capability. Here's a list of things to think about:

- **Preview your images on a TV.** Connect your EOS T5 to a standard-definition television using the video cable (or to an HDTV with the optional HDMI cable), and you can preview your image on a large screen.

- **Preview remotely.** Extend the cable between the camera and TV screen, and you can preview your images some distance away from the camera.

- **Shoot from your computer.** Canon gives you the software you need to control your camera from your computer, so you can preview images and take pictures or movies without physically touching the EOS T5.

- **Shoot from a tripod or hand-held.** Of course, holding the camera out at arm's length to preview an image is poor technique, and will introduce a lot of camera shake. If you want to use live view for hand-held images, use an image-stabilized lens and/or a high shutter speed. A tripod is a better choice if you can use one.

- **Watch your power.** Live view uses a lot of juice and will deplete your battery rapidly. Canon estimates that you can get several hundred shots per battery when using live view, depending on the temperature. Expect slightly fewer exposures when using flash. The optional AC adapter is a useful accessory.

Enabling Live View

You need to take some steps before using live view. This workflow prevents you from accidentally using live view when you don't mean to, thus potentially losing a shot, and it also helps ensure that you've made all the settings necessary to successfully use the feature efficiently. Here are the steps to follow:

1. **Choose a shooting mode.** Live view works with any exposure mode, including Full Auto and Creative Auto. You can even switch from one Basic Zone mode to another or from one Creative Zone mode to another while live view is activated. (If you change from Basic to Creative, or vice versa while live view is on, it will be deactivated and must be restarted.)

2. **Enable live view.** You'll need to activate live view by choosing the Live View Shoot. setting from the Shooting 4 menu (when the Mode Dial is set to a Creative Zone mode; if you're using a Basic Zone mode, an abbreviated list of live view options is found in the Shooting 2 menu). Press SET and use the up/down cross keys to select Enable and press the SET button again to exit.

TIP

Note that even if you've disabled live view, you can still set the Mode Dial to Movie and shoot video.

3. **Choose other live view functions.** Select from the other live view functions in the Shooting 4 menu (described next; or from the Shooting 2 menu if using a Basic Zone mode), then press the MENU button to exit from the Live View Function Settings menu. Make sure you're using a Creative Zone mode if you want to view the full array of live view function options.

4. **Specify movie or live view shooting.** Rotate the Mode Dial to the Movie position if you want to shoot video instead of stills.

5. **Activate live view.** Press the Start/Stop button on the right side of the viewfinder to begin or end live view, or to begin/end video capture. The button is labeled with a red dot, so it's easy to find.

There are five choices in the Live View menu (Shooting 4 menu when using a Creative Zone mode). (See Figure 6.2.) When you're using a Basic Zone mode, only the first three choices listed below are available, and they are found in the Shooting 2 menu instead. The entries include:

■ **Live View Shoot.** Enable/disable live view shooting here. As I mentioned, disabling live view does not affect movie shooting, which is activated by rotating the Mode Dial to the Movie position.

■ **Autofocus Mode (Quick mode, Live mode, Live "face detection" mode).** This option, explained next, lets you choose between phase detection, contrast detection, and contrast detection with "face" recognition.

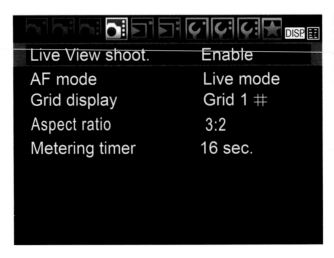

Figure 6.2
Live view function settings can be found in the Shooting 4 menu.

- **Grid Display (Off, Grid 1, Grid 2).** Overlays Grid 1, a "rule of thirds" grid, on the screen to help you compose your image and align vertical and horizontal lines; or Grid 2, which consists of four rows of six boxes, which allow finer control over placement of images in your frame.

- **Aspect Ratio.** Choose from the default 3:2, or select 4:3, 16:9, or 1:1 proportions.

- **Metering Timer (4 sec. to 30 min.).** This option allows you to specify how long the EOS T5's metering system will remain active before switching off. Tap the shutter release to start the timer again after it switches off. This choice is not available when using a Basic Zone mode.

Activating Live View

Once you've enabled live view, you can continue taking pictures normally through the T5's viewfinder. When you're ready to activate live view, press the Movie/Stop/Start button on the back of the camera, to the immediate right of the viewfinder window (and marked with a red dot). The mirror will flip up, and the sensor image will appear on the LCD. (See Figure 6.3.)

Figure 6.3
Press the DISP. button to increase or decrease the amount of information shown on the LCD in live view mode.

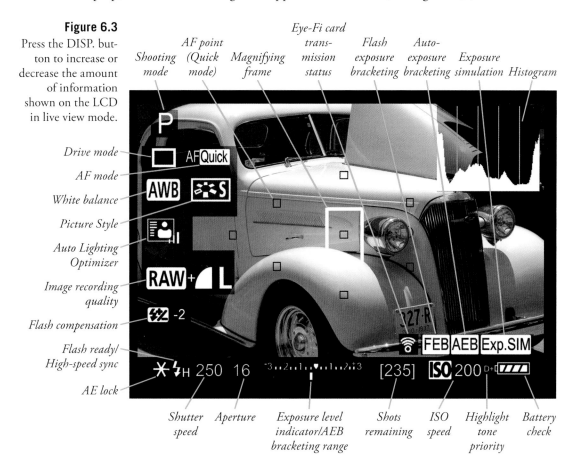

Focusing in Live View

Press the shutter button halfway to activate autofocus using the currently set live view autofocus mode. Those modes are Live mode, Live "face detection" mode, and Quick mode. You can also use manual focus. I'll describe each of these separately.

Select the focus mode for live view from the entries in the Shooting 4 menu, described earlier. You can also change focus mode while using live view by pressing the Q button and highlighting the focus options with the cross keys (see the top left of the column, as you saw in Figure 6.3). Then press the SET button and use the left/right cross keys to choose one of the following three focus modes. Press SET again to confirm your choice.

Live Mode

This mode uses contrast detection, described in Chapter 5, using the relative sharpness of the image as it appears on the sensor to determine focus. This method is less precise, and usually takes longer than Quick mode. To autofocus using Live mode, follow these steps:

1. **Set lens to autofocus.** Make sure the focus switch on the lens is set to AF.

2. **Activate live view.** Press the Start/Stop button.

3. **Choose AF point.** Use the cross keys to move the AF point anywhere you like on the screen, except for the edges. Press the SET button to return the AF point to the center of the screen.

4. **Select subject.** Compose the image on the LCD so the selected focus point is on the subject.

5. **Press and hold the shutter button halfway.** When focus is achieved, the AF point turns green, and you'll hear a beep if the sound has been turned on in the Shooting 1 menu. If the T5 is unable to focus, the AF point turns orange instead.

6. **Take picture.** Press the shutter release all the way down to take the picture.

Live (Face Detection) Mode

This mode also uses contrast detection, using the relative sharpness of the image as it appears on the sensor to determine focus. The T5 will search the frame for a human face and attempt to focus on the face. Like Live mode, this method is less precise, and usually takes longer than Quick mode. To autofocus using Live (face detection) mode, follow these steps:

1. **Set lens to autofocus.** Make sure the focus switch on the lens is set to AF.

2. **Activate live view.** Press the Start/Stop button.

3. **Face detection.** If you've selected face detection using the AF button or Quick Control screen, a frame will appear around a face found in the image. (See Figure 6.4.) If more than one face is found, a frame with notches that look like "ears" appears. In that case, use the cross keys to move the frame to the face you want to use for focus. If no face is detected, the AF point will be displayed and focus will be locked into the center.

Figure 6.4
The T5 can detect
faces during
autofocus.

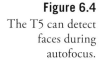

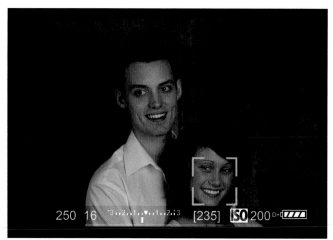

Figure 6.4 The T5 can detect faces during autofocus.

4. **Troubleshoot (if necessary).** If you experience problems in Live (face detection) mode, press down on the AF button or use the Quick Control screen to toggle between modes. Face detection is far from perfect. The AF system may fail to find a face if the person's visage is too large/ small or light/dark in the frame, tilted, or located near an edge of the picture. It may classify a non-face as a face. If you switch to Live mode, you can always select another AF point and press the cross keys button again to toggle back to Live (face detection) mode.

5. **Press and hold the shutter release halfway.** When focus is achieved, the AF point turns green, and you'll hear a beep. If the T5 is unable to focus, the AF point turns orange instead.

6. **Take picture.** Press the shutter release all the way down to take the picture.

Quick Mode

This mode uses phase detection, as described in Chapter 5. It temporarily interrupts live view to allow the EOS T5 to focus the same AF sensor used when you focus through the viewfinder. Because the step takes a second or so, you may get better results using this autofocus mode when the camera is mounted on a tripod. If you hand-hold the T5, you may displace the point of focus achieved by the autofocus system. It also simplifies the operation if you use One-Shot focus and center the focus point. You can use AI Servo and AF or Manual focus point selection, but if the focus point doesn't coincide with the subject you want to focus on, you'll end up with an out-of-focus image. Just follow these steps:

1. **Set lens to autofocus.** Make sure the focus switch on the lens is set to AF.

2. **Activate live view.** Press the Start/Stop button.

3. **Choose AF point.** Press the Q button, and then use the cross keys to move the active AF focus point around on the screen.

4. **Select subject.** Compose the image on the LCD so the selected focus point is on the subject.

5. **Press and hold the shutter release halfway.** The LCD will blank as the mirror flips down, reflecting the view of the subject to the phase detection AF sensor.

6. **Wait for focus.** When the T5 is able to lock in focus using phase detection, a beep (if activated) will sound. If you are hand-holding the T5, you may hear several beeps as the AF system focuses and refocuses with each camera movement. Then, the mirror will flip back up, and the live view image reappears. The AF focus point will be highlighted in green on the LCD.

7. **Take picture.** Press the shutter release *all* the way down to take the picture. (You can't take a photo while Quick mode AF is in process, until the mirror flips back up.)

Manual Mode

Focusing manually on an LCD screen isn't as difficult as you might think, but Canon has made the process even easier by providing a magnified view. Just follow these steps to focus manually:

1. **Set lens to manual focus and activate live view.** Make sure the focus switch on the lens is set to MF.

2. **Move magnifying frame.** Use the cross keys to move the focus frame that's superimposed on the screen to the location where you want to focus. You can press the cross keys to center the focus frame in the middle of the screen.

3. **Press the Magnify button.** The area of the image inside the focus frame will be magnified 5X. (See Figure 6.5.) Press the Magnify button a second time to increase the magnification to 10X. A third press will return you to the full-frame view. The enlarged area is artificially sharpened to make it easier for you to see the contrast changes, and simplify focusing. When zoomed in, press the shutter release halfway and the current shutter speed and aperture are shown in orange. If no information at all appears, press the DISP. button.

4. **Focus manually.** Use the focus ring on the lens to focus the image. When you're satisfied, you can zoom back out by pressing the Reduce button.

Figure 6.5
You can manually focus the center area, which can be zoomed in 5X or 10X.

Using Final Image (Exposure) Simulation

When Exp. Sim. is displayed in non-flashing form on the live view screen, it indicates that the LCD screen image brightness is an approximation of the brightness of the captured image. If the Exp. Sim. display is blinking, it shows that the screen image does *not* represent the appearance of the final image. When using flash or bulb exposure, the Exp. Sim. indicator is dimmed out to show you that the LCD image is not being adjusted to account for the actual exposure. Exposure simulation is not a feature that can be turned on or off with this camera; however, you can show or hide the indicator by pressing the DISP. button to change to a different information view.

The T5 applies any active Picture Style settings to the LCD image, so you can have a rough representation of the image as it will appear when modified. Sharpness, contrast, color saturation, and color tone will all be applied. In addition, the camera applies the following parameters to the live view image shown:

- White balance/white balance correction
- Shoot by ambience/lighting/scene choices
- Auto lighting optimization
- Peripheral illumination correction
- Highlight tone priority
- Aspect ratio
- Depth-of-field when DOF button is pressed

Quick Control

Press the Q button while using a Creative Zone in live view, and you can adjust any of the values shown in the left-hand column in Figure 6.3. These include AF mode, Drive mode, white balance, Picture Style, Auto Lighting Optimizer settings, and image quality settings, plus ISO sensitivity (which appears in the left-hand column only when you press the Q button). If you're using a Basic Zone mode, you can change AF mode, self-timer, and several other settings, depending on the Basic Zone mode you are using:

- **Shoot by ambience.** Can be changed when using Creative Auto, Portrait, Landscape, Close-up, Sports, and Night Portrait modes.
- **Shoot by lighting or scene type.** Can be changed in Portrait, Landscape, Close-up, and Sports modes.
- **Blurring/Sharpening the background.** Can be changed in Creative Auto mode.
- **Automatic Flash Firing.** Can be changed in Creative Auto mode; is set automatically in Full Auto, Auto (Flash Off), Portrait, Close-Up, and Night Portrait modes.
- **Flash on at all times (Fill flash).** Can be set in Creative Auto mode.

- **Flash Off.** Can be set in Creative Auto mode; is set automatically in Auto (Flash Off), Landscape, and Sports modes.
- **Drive mode, continuous shooting.** Can be set in Creative Auto, Portrait, and Sports modes.

Shooting Movies

The Canon EOS T5 can shoot standard HDTV movies with monaural sound at 1280 × 1080 resolution. In some ways, the camera's Movie mode is closely related to the T5's live view still mode. In fact, the T5 uses live view type imaging to show you the video clip on the LCD as it is captured. Many of the functions and setting options are the same, so the information in the previous sections will serve you well as you branch out into shooting movies with your camera.

To shoot in movie mode, just rotate the Mode Dial to the Movie position. Press the Movie/Start/Stop button to begin/end capture. That's quite simple, but there are some additional things you need to keep in mind before you start:

- **Choose movie recording size resolution.** The T5 can capture movies in 1,920 × 1,080, 30 fps; 1,920 × 1,080, 24 fps (both Full High Definition); 1,280 × 720, 60 fps (Standard Definition); and 640 × 480, 30 fps (VGA resolution). I'll explain movie resolution and frame rates next.
- **Use the right card.** You'll want to use a fast memory card, at least a Class 6 SDHC card; a Class 10 card is even better. Slower cards may not work properly. Choose a memory card with at least 4GB capacity (8GB or 16GB are preferable). If the card you are working with is too slow, a five-level thermometer-like "buffer" indicator may appear at the right side of the LCD, showing the status of your camera's internal memory. If the indicator reaches the top level because the buffer is full, movie shooting will stop automatically.
- **Use a fully charged battery.** Canon says that a fresh battery will allow about up to one hour, fifty minutes of filming at normal (non-winter) temperatures.
- **Image stabilizer uses extra power.** If your lens has an image stabilizer, it will operate at all times (not just when the shutter button is pressed halfway, which is the case with still photography) and use a considerable amount of power, reducing battery life. You can switch the IS feature off to conserve power. Mount your camera on a tripod, and you don't need IS anyway.
- **Silent running.** You can connect your T5 to a television or video monitor while shooting movies, and see the video portion on the bigger screen as you shoot. However, the sound will not play—that's a good idea, because, otherwise, you could likely get a feedback loop of sound going. The sound will be recorded properly and will magically appear during playback once shooting has concluded.

Resolution

The T5 offers several different resolution and frame rate options. Resolution settings include:

- **1,920 × 1,080.** This resolution is so-called "full HD" and is the maximum resolution displayed when using the HDTV format. Many monitors and most HD televisions can display this resolution, and you'll have the best image quality when you use it. Use this resolution for your "professional" productions, especially those you'll be editing and converting to nifty-looking DVDs. However, the top-of-the-line resolution requires the most storage space, approximately 330 megabytes per minute, yielding about 44 minutes of "shooting time" on a 16GB memory card. (The maximum length of a single continuous clip is nearly 30 minutes.)

- **1,280 × 720.** "Standard HD" provides less resolution, and can be displayed on any monitor or television that claims HDTV compatibility. If your production will appear only on computer monitors with 1,280 × 720 resolution, or on HDTVs that max out at 720p, this resolution will be fine.

- **640 × 480.** This is so-called VGA resolution, suitable for display on computer monitors and, possibly, old standard-definition televisions. (Remember the ones with CRT tubes instead of LCD, LED, or plasma displays?) This lower-resolution format is less demanding of your storage, too, requiring about 82 megabytes per minute capture, and providing more than three hours of video clips on a single 16GB card. You'll use this resolution for productions destined for display on the Internet, and other similar uses.

Frame Rates

Frame rates are a trickier proposition. Fortunately, one seemingly confusing set of alternatives can be dispensed with quickly: The 50 fps/25 fps and 60 fps/30 fps options can be considered as pairs of *video*-oriented frame rates. The 60 fps/30 fps rates are used only where the NTSC television standard is in place, such as North America, Japan, Korea, and a few other places. The 50 fps/25 fps frame rates are used where the PAL standard reigns, such as Europe, Russia, China, Africa, Australia, and other places. For simplicity, I'll refer just to the 60 fps/30 fps frame rates in this section; if you're reading this in India, just convert to 50 fps/25 fps.

The third possibility is 24 fps, which is a standard frame rate used for motion pictures. Keep in mind that the rates are *nominal*. A 24 fps setting actually yields 23.976 frames per second; 30 fps gives you 29.97 actual "frames" per second.

The difference lies in the two "worlds" of motion images: film and video. The standard frame rate for motion picture film is 24 fps, while the video rate, at least in the United States, Japan, and those other places using the NTSC standard is 30 fps (actually 60 interlaced *fields* per second, which is why we can choose either 30 frames/fields per second or 60 frames/fields per second). Computer-editing software can handle either type, and convert between them. The choice between 24 fps and 30 fps is determined by what you plan to do with your video.

The short explanation is that, for technical reasons I won't go into here, shooting at 24 fps gives your movie a "film" look, excellent for showing fine detail. However, if your clip has moving subjects, or you pan the camera, 24 fps can produce a jerky effect called "judder." A 30 fps or 60 fps rate produces a home-video look that some feel is less desirable, but which is smoother and less jittery when displayed on an electronic monitor. I suggest you try both and use the frame rate that best suits your tastes and video-editing software.

Movie Settings

The Movie Settings menus can be summoned by the MENU button only when the T5 has been set to movie mode (rotate the Mode Dial to the Movie position). The five settings on the Movie 1 menu (see Figure 6.6) include:

- **Movie Exposure.** Choose Auto to allow the camera to select the exposure for you. In Manual mode, the settings are much like Manual still photo exposure mode.

 First, rotate the Main Dial to change the shutter speed. Note that the frame rate will not change, and will remain at 60, 30, or 24 frames per second, but the amount of time each *frame* is exposed during that interval will be adjusted. For technical reasons, you'll get the best results using a shutter speed that is *no briefer* than about twice the frame rate—for example, 1/125th second with 60 fps and 1/60th second at 30 fps or 24 fps. You can use a higher shutter speed to adjust the exposure, however, if, say, you want to use a larger f/stop.

 Hold down the Av button and rotate the Main Dial to adjust the aperture. You can use manual control over the shutter speed and aperture to depart from automatic exposures to provide a specific mood, or because you need a particular shutter speed for aperture. For most shooting, however, you'll probably want to set Movie Exposure on Auto.

Figure 6.6
The Movie 1 menu has five entries.

- **AF method (Quick mode, Live mode, Live "face detection" mode).** This option, explained earlier in the live view section, lets you choose between phase detection, contrast detection, and contrast detection with "face" recognition. In movie modes, none of these autofocus modes will track a moving subject.

- **AF w/shutter button during movie recording.** You can choose Enable, to allow refocusing during movie shooting, or Disable, to prevent it. Refocusing after you've begun capturing a movie clip can be a good thing or a bad thing, so you want to be able to control when it happens. If you select Enable, then you can refocus during capture by pressing the shutter button. Refocusing will take place *only* when you press the shutter button; the T5 is not able to refocus continually as you shoot.

 Changing the focus during capture can be dangerous—your image is likely to go out of focus for a fraction of a second while the camera refocuses. That might not be bad if you plan on editing your movie and can remove the out-of-focus part of the clip. But refocusing during a shot can be disconcerting. Note that even if you've set the T5 to Quick mode focus, it will use phase detection only at the beginning of the clip; subsequent refocusing will be performed using the Live mode. Most of the time, I set this parameter to Disable to avoid accidentally refocusing during a shot.

- **Shutter/AE lock button.** Use this choice to specify what happens when you press the shutter release halfway, or use the AE lock button. Your options are shown in Table 6.1.

- **Movie recording Highlight Tone Priority.** Choose Enable to improve the detail in highlights in your movie clips, say, when shooting under high contrast lighting conditions. Use Disable if you'd like to keep the standard tonal range, which is optimized for middle gray tones. If you enable this feature, then the Auto Lighting Optimizer (discussed in Chapter 8) is disabled, and your ISO speed range is limited to ISO 200 to ISO 12,800.

Table 6.1 Shutter/AE Lock Button Functions

Option	Shutter release half-press	AE lock button function	Purpose
AF/AE lock	Activates autofocus	Locks exposure	Autofocus and lock exposure separately; normal operation.
AE lock/AF	Locks exposure	Activates autofocus	Lock exposure, then AF after reframing.
AF/AF lock, No AE lock	Activates autofocus	Hold while taking a still photo to shoot at current AF setting	Avoid refocusing when taking a still while shooting a movie.
AE/AF, No AE lock	Meters but does not lock exposure	Activates autofocus	Exposure metering continues after shutter is half-pressed; initiate autofocus when desired.

The Movie 2 menu has six entries (see Figure 6.7):

- **Movie rec. size.** Choose 1,920 × 1,080 at 30 fps or 24 fps; 1,280 × 1,080 at 60 fps; or 640 × 480 at 30 fps, as described earlier.

- **Sound recording.** Choose Auto, Manual, or Disable. At the Auto setting, the camera will adjust the sound levels; select Manual and you can use the left/right cross keys to adjust the recording level, with a volume unit meter at the bottom of the screen. Disable turns sound recording off. You might not want to record sound if you want to shoot silently, and add voice over, narration, music, or other sound later in your movie editing software.

- **Metering timer (4 sec. to 30 min.).** This option allows you to specify how long the EOS T5's metering system will remain active before switching off.

- **Grid display.** You can select Off, Grid #1, or Grid #2.

- **Video snapshot.** You can enable or disable this feature, described later in the chapter.

- **Video system.** Choose NTSC or PAL. The NTSC television standard is used in North America, Japan, Korea, and a few other places. The PAL standard reigns in Europe, Russia, China, Africa, Australia, and other places.

The Movie 3 menu (not pictured) has four entries that have the same functions as their counterparts in the still photography Shooting menus, and explained in Chapter 8. Those entries are Exposure Compensation, Auto Lighting Optimizer, Custom White Balance, and Picture Style. I won't duplicate those descriptions here. Refer to Chapter 8 for information on how to use those options.

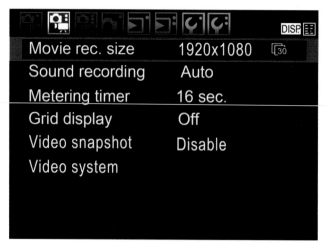

Figure 6.7
The Movie 2 menu has six entries.

Capturing Video/Sound

To shoot movies with your camera, just follow these steps:

1. **Change to movie mode.** Rotate the Mode Dial to the Movie setting.

2. **Focus.** Use the autofocus or manual focus techniques described in the preceding sections to achieve focus on your subject.

3. **Begin filming.** Press the Start/Stop button to begin shooting. A red dot appears in the upper-right corner of the screen to show that video/sound are being captured. The access lamp also flashes during shooting.

4. **Changing shooting functions.** As with live view, you can change settings or review images normally when shooting video.

5. **Lock exposure.** You can lock in exposure by pressing the Reduce button on top of the T5, located just aft of the Main Dial. Unlock exposure again by pressing the Magnify button.

6. **Stop filming.** Press the Start/Stop button again to stop filming.

7. **View your clip.** Press the Playback button (located to the bottom right of the LCD). You will see a still frame with the clip timing and a symbol telling you to press the SET button to see the clip. A series of video controls appear at the bottom of the frame. Press SET again and the clip begins. A blue thermometer bar progresses in the upper-left corner as the timing counts down. Press SET to stop at any time.

GETTING INFO

The information display shown on the LCD screen when shooting movies is almost identical to the one displayed during live view shooting. The settings icons in the left column show the same options, which can be changed in movie mode, too, except that the Drive mode choice is replaced by an indicator that shows the current movie resolution and time remaining on your memory card.

Playback and Editing

You can play back your video snapshots from the confirmation screen. Or, you can exit movie mode and review your stills and images and play any of them back by pressing the playback button located to the lower right of the LCD. A movie will be marked with an icon in the upper-left corner. Press the SET button to play back a movie when you see this icon.

As a movie is being played back, a screen of options appears at the bottom of the screen, as shown in Figure 6.8. When the icons are shown, use the left/right cross keys to highlight one, and then press the SET button to activate that function:

- **Exit.** Exits playback mode.
- **Playback.** Begins playback of the movie. To pause playback, press the SET button again. That restores the row of icons so you can choose a function.
- **Slow motion.** Displays the video in slow motion.
- **First frame.** Jumps to the first frame of the video, or the first scene of an album's first video snapshot.
- **Previous frame.** Press SET to view the previous frame; hold down SET to rewind the movie.
- **Next frame.** Press SET to view the next frame; hold down SET to fast forward the movie.
- **Last frame.** Jumps to the last frame of the video, or the last scene of the album's last video snapshot.
- **Edit.** Summons an editing screen (see Figure 6.9).
- **Background music/volume.** Select to turn background music on/off. Rotate the Main Dial to adjust the volume of the background music.

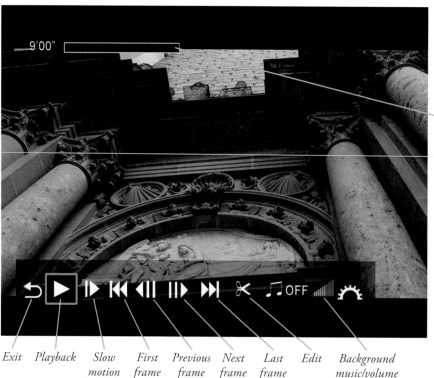

Figure 6.8
Options appear as a movie is being played back.

Playback time

Exit Playback Slow motion First frame Previous frame Next frame Last frame Edit Background music/volume

Figure 6.9
The editing screen allows you to snip off the beginning or end of a video clip.

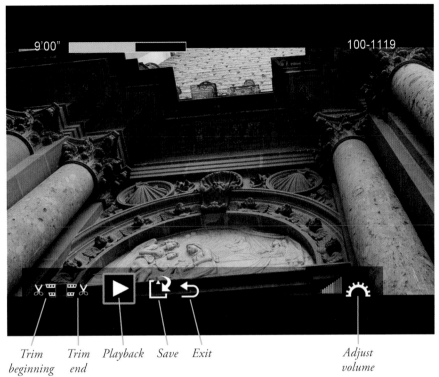

Trim Trim Playback Save Exit Adjust
beginning end volume

While reviewing your video, you can trim from the beginning or end of your video clip by selecting the scissors symbol. The icons that appear have the following functions:

- **Trim beginning.** Trims off all video prior to the current point.
- **Trim end.** Removes video after the current point.
- **Playback.** Play back your video to reach the point where you want to trim the beginning or end.
- **Save.** Saves your video to the memory card. A screen appears offering to save the clip as a New File, or to Overwrite the existing movie with your edited clip.
- **Exit.** Exits editing mode.
- **Adjust volume.** Modifies the volume of the background music.

Video Snapshots

Video snapshots are movie clips, all the same length, assembled into video albums as a single movie. You can choose a fixed length of 2, 4, or 8 seconds for all clips in a particular album. I use the 2-second length to compile mini-movies of fast-moving events, such as parades, giving me a lively album of clips that show all the things going on without lingering too long on a single scene.

The 8-second length is ideal for landscapes and many travel clips, because the longer scenes give you time to absorb all the interesting things to see in such environments. The 4-second clips are an excellent way to show details of a single subject, such as a cathedral or monument when traveling, or an overview of the action at a sports event.

Activate the video snapshot feature in the Movie 2 menu, as described above. Then, follow these steps:

1. **Begin an album.** In movie mode, press the Start/Stop button. The T5 will begin shooting a clip, and a set of blue bars will appear at the bottom of the frame showing you how much time remains before shooting stops automatically.

2. **Save your clip as a video snapshot album.** A confirmation appears at the bottom of the LCD. Press the left/right cross keys to choose the left-most icon, Save as Album.

3. **Press SET.** Your first clip will be saved as the start of a new album.

4. **Shoot additional clips.** Press the Movie button to shoot more clips of the length you have chosen, and indicated by the blue bars at the bottom of the frame. At the end of the specified time, the confirmation screen will appear again. (See Figure 6.10.)

5. **Add to album or create new album.** Select the left-most icon again if you want to add the most recent clip to the album you just started. Alternatively, you can choose the second icon from the left, Save as a New Album. That will complete your previous album, and start a new one with the most recent clip.

 Or, if you'd like to review the most recent clip first to make sure it's worth adding to an album, select the Playback Video Snapshot icon (second from the right) and review the clip you just shot. You can then Add to Album, Create New Album, or Delete the Clip.

6. **Delete most recent clip.** If you decide the most recent clip is not one you'd like to add to your current album, you can select Do Not Save to Album/Delete without Saving to Album (the right-most icon).

7. **Switch from video snapshots to conventional movie clips.** If you want to stop shooting video snapshots and resume shooting regular movie clips (of a variable length), navigate to the Movie 2 menu again, and disable Video Snapshot.

You can play back your snapshots that have been combined into an album using the same Playback screen used to review stills and movies. In single image display, an icon in the upper left of the review image indicates that the snapshot can be played back by pressing the SET button.

The clips in a video album can be edited, either by deleting a particular snapshot from the collection or moving it to a new location within the album. Video album editing is much like editing conventional video clips, as described previously.

Figure 6.10
Save your clip as a
video snapshot
album.

Save as Save as Playback Do not save
album new album video to album
snapshot

Tips for Shooting Better Movies

Producing high-quality movies can be a real challenge for amateur photographers. After all, by comparison we're used to watching the best productions that television, video, and motion pictures can offer. Whether it's fair or not, our efforts are compared to what we're used to seeing produced by experts. While this chapter can't make you into a pro videographer, it can help you improve your efforts.

There are a number of different things to consider when planning a video shoot, and when possible, a shooting script and storyboard can help you produce a higher quality video.

Make a Shooting Script

A shooting script is nothing more than a coordinated plan that covers both audio and video and provides order and structure for your video. A detailed script will cover what types of shots you're going after, what dialogue you're going to use, audio effects, transitions, and graphics. When you first begin shooting movies, your shooting scripts will be very simple. As you gain experience, you'll learn how to tell stories with video, and will map out your script in more detail before you even begin to capture the first sequence.

A shooting script will also help you if you need to shoot out of sequence. For example, you may have several scenes that take place on different days at the same location. It probably will make sense to shoot all those scenes at one time, rather than in the movie's chronological order. You can check the shooting script to see what types of video and audio you need for the separate scenes, as well as what dialogue your "actors" need to deliver (even, if, as is the case for most informal videos, the "lines" are ad-libbed as you shoot).

Use Storyboards

A storyboard is a series of panels providing visuals of what each scene should look like. While the ones produced by Hollywood are generally of very high quality, there's nothing that says drawing skills are important for this step. Stick figures work just fine if that's the best you can do. The storyboard just helps you visualize locations, placement of actors/actresses, props and furniture, and also helps everyone involved get an idea of what you're trying to show. It also helps show how you want to frame or compose a shot. You can even shoot a series of still photos and transform them into a "storyboard" if you want, as I did in Figure 6.11. In this case, I took pictures of a parade, and then used them to assemble a storyboard to follow when I shot video at a similar parade on a later date.

Storytelling in Video

Today's audience is accustomed to fast-paced, short scene storytelling. In order to produce interesting video for such viewers, it's important to view video storytelling as a kind of shorthand code for the more leisurely efforts print media offers. Audio and video should always be advancing the story. While it's okay to let the camera linger from time to time, it should only be for a compelling reason and only briefly.

Figure 6.11 A storyboard is a series of simple sketches or photos to help visualize a segment of video.

Composition is one of the most important tools available to you for telling a story in video. However, while you can crop a still frame any old way you like, in movie shooting, several factors restrict your composition, and impose requirements you just don't always have in still photography (although other rules of good composition do apply). Here are some of the key differences to keep in mind when composing movie frames:

■ **Horizontal compositions only.** Some subjects, such as basketball players and tall buildings, just lend themselves to vertical compositions. But movies are shown in horizontal format only. So if you're interviewing a local basketball star, you can end up with a worst-case situation like the one shown in Figure 6.12. Using the T5's 1,280 × 1,080 format, you are limited to relatively wide frames. If you want to show how tall your subject is, it's often impractical to move back far enough to show him full-length. You really can't capture a vertical composition. Tricks like getting down on the floor and shooting up at your subject can exaggerate the perspective, but aren't a perfect solution.

Figure 6.12
Movie shooting requires you to fit all your subjects into a horizontally oriented frame.

■ **Wasted space at the sides.** Moving in to frame the basketball player as outlined by the yellow box in Figure 6.12, means that you're still forced to leave a lot of empty space on either side. (Of course, you can fill that space with other people and/or interesting stuff, but that defeats your intent of concentrating on your main subject.) So when faced with some types of subjects in a horizontal frame, you can be creative, or move in *really* tight. For example, if I was willing to give up the "height" aspect of my composition, I could have framed the shot as shown by the green box in the figure, and wasted less of the image area at either side of the subject.

■ **Seamless (or seamed) transitions.** Unless you're telling a picture story with a photo essay, still pictures often stand alone. But with movies, each of your compositions must relate to the shot that preceded it, and the one that follows. It can be jarring to jump from a long shot to a tight close-up unless the director—you—is very creative. Another common error is the "jump cut" in which successive shots vary only slightly in camera angle, making it appear that the main subject has "jumped" from one place to another. (Although everyone from French New Wave director Jean-Luc Goddard to Guy Ritchie—Madonna's ex—have used jump cuts effectively in their films.) The rule of thumb is to vary the camera angle by at least 30 degrees between shots to make it appear to be seamless. Unless you prefer that your images flaunt convention and appear to be "seamy."

■ **The time dimension.** Unlike still photography, with motion pictures there's a lot more emphasis on using a series of images to build on each other to tell a story. Static shots where the camera is mounted on a tripod and everything is shot from the same distance are a recipe for dull videos. Watch a television program sometime and notice how often camera shots change distances and directions. Viewers are used to this variety and have come to expect it. Professional video productions are often done with multiple cameras shooting from different angles and positions. But many professional productions are shot with just one camera and careful planning, and you can do just fine with your camera.

Within those compositional restraints, you still have a great deal of flexibility. It only takes a second or two for an establishing shot to impart the necessary information. For example, many of the scenes for a video documenting a model being photographed in a Rock and Roll music setting might be close-ups and talking heads, but an establishing shot showing the studio where the video was captured helps set the scene.

Provide variety too. Change camera angles and perspectives often and never leave a static scene on the screen for a long period of time. (You can record a static scene for a reasonably long period and then edit in other shots that cut away and back to the longer scene with close-ups that show each person talking.)

When editing, keep transitions basic! I can't stress this one enough. Watch a television program or movie. The action "jumps" from one scene or person to the next. Fancy transitions that involve exotic "wipes," dissolves, or cross fades take too long for the average viewer and make your video ponderous.

Here's a look at the different types of commonly used compositional tools:

- **Establishing shot.** Much like it sounds, this type of composition establishes the scene and tells the viewer where the action is taking place. Let's say you're shooting a video of your offspring's move to college; the establishing shot could be a wide shot of the campus with a sign welcoming you to the school in the foreground. Another example would be for a child's birthday party; the establishing shot could be the front of the house decorated with birthday signs and streamers or a shot of the dining room table decked out with party favors and a candle-covered birthday cake. Or, in Figure 6.13, left, I wanted to show the studio where the video was shot.

- **Medium shot.** This shot is composed from about waist to head room (some space above the subject's head). It's useful for providing variety from a series of close-ups and also makes for a useful first look at a speaker. (See Figure 6.13, right.)

- **Close-up.** The close-up, usually described as "from shirt pocket to head room," provides a good composition for someone talking directly to the camera. Although it's common to have your talking head centered in the shot, that's not a requirement. In Figure 6.14, left, the subject was offset to the right. This would allow other images, especially graphics or titles, to be superimposed in the frame in a "real" (professional) production. But the compositional technique can be used with your videos, too, even if special effects are not going to be added.

- **Extreme close-up.** When I went through broadcast training back in the '70s, this shot was described as the "big talking face" shot and we were actively discouraged from employing it. Styles and tastes change over the years and now the big talking face is much more commonly used (maybe people are better looking these days?) and so this view may be appropriate. Just remember, your camera is capable of shooting in high-definition video and you may be playing the video on a high-def TV; be careful that you use this composition on a face that can stand up to high definition. (See Figure 6.14, right.)

- **"Two" shot.** A two shot shows a pair of subjects in one frame. (See Figure 6.15, left.) They can be side by side or one in the foreground and one in the background. This does not have to be a head-to-ground composition. Subjects can be standing or seated. A "three shot" is the same principle except that three people are in the frame.

- **Over-the-shoulder shot.** Long a composition of interview programs, the "over-the-shoulder shot" uses the rear of one person's head and shoulder to serve as a frame for the other person. This puts the viewer's perspective as that of the person facing away from the camera. (See Figure 6.15, right.)

Figure 6.13 An establishing shot from a distance sets the stage for closer views (left); a medium shot is used to bring the viewer into a scene without shocking them (right).

Figure 6.14 A close-up generally shows the full face with a little head room at the top and down to the shoulders at the bottom of the frame (left); an extreme close-up is a very tight shot that cuts off everything above the top of the head and below the chin (right).

Figure 6.15 A "two-shot" features two people in the frame. This version can be framed at various distances such as medium or close-up (left); an "over-the-shoulder" shot is a popular shot for interview programs (right).

Lighting for Video

Much like in still photography, how you handle light pretty much can make or break your videography. Lighting for video though can be more complicated than lighting for still photography, since both subject and camera movement is often part of the process.

Lighting for video presents several concerns. First off, you want enough illumination to create a useable video. Beyond that, you want to use light to help tell your story or increase drama. Let's take a better look at both.

Illumination

You can significantly improve the quality of your video by increasing the light falling in the scene. This is true indoors or out, by the way. While it may seem like sunlight is more than enough, it depends on how much contrast you're dealing with. If your subject is in shadow (which can help them from squinting) or wearing a ball cap, a video light can help make them look a lot better.

Lighting choices for amateur videographers are a lot better these days than they were a decade or two ago. An inexpensive shoe mount video light, which will easily fit in a camera bag, can be found for $15 or $20. You can even get a good-quality LED video light for less than $100. Work lights sold at many home improvement stores can also serve as video lights since you can set the camera's white balance to correct for any colorcasts.

Much of the challenge depends upon whether you're just trying to add some fill light on your subject versus trying to boost the light on an entire scene. A small video light in the camera's hot shoe mount or on a flash bracket will do just fine for the former. It won't handle the latter.

Creative Lighting

While ramping up the light intensity will produce better technical quality in your video, it won't necessarily improve the artistic quality of it. Whether we're outdoors or indoors, we're used to seeing light come from above. Videographers need to consider how they position their lights to provide even illumination while up high enough to angle shadows down low and out of sight of the camera.

When considering lighting for video, there are several factors. One is the quality of the light. It can either be hard (direct) or soft (diffused). Hard light is good for showing detail, but can also be very harsh and unforgiving. "Softening" the light, but diffusing it somehow, can reduce the intensity of the light but make for a kinder, gentler light as well.

While mixing light sources isn't always a good idea, one approach is to combine window light with supplemental lighting. Position your subject with the window to one side and bring in either a supplemental light or a reflector to the other side for reasonably even lighting.

Lighting Styles

Some lighting styles are more heavily used than others. Some forms are used for special effects, while others are designed to be invisible. At its most basic, lighting just illuminates the scene, but when used properly it can also create drama. Let's look at some types of lighting styles:

- **Three-point lighting.** This is a basic lighting setup for one person. A main light illuminates the strong side of a person's face, while a fill light lights up the other side. A third light is then positioned above and behind the subject to light the back of the head and shoulders.

- **Flat lighting.** Use this type of lighting to provide illumination and nothing more. It calls for a variety of lights and diffusers set to raise the light level in a space enough for good video reproduction, but not to create a particular mood or emphasize a particular scene or individual. With flat lighting, you're trying to create even lighting levels throughout the video space and minimizing any shadows. Generally the lights are placed up high and angled downward (or possibly pointed straight up to bounce off of a white ceiling).

- **"Ghoul lighting."** This is the style of lighting used for old horror movies. The idea is to position the light down low, pointed upward. It's such an unnatural style of lighting that it makes its targets seem weird and abnormal.

- **Outdoor lighting.** While shooting outdoors may seem easier because the sun provides more light, it also presents its own problems. As a general rule of thumb, keep the sun behind you when you're shooting video outdoors, except when shooting faces (anything from a medium shot and closer) since the viewer won't want to see a squinting subject. When shooting another human this way, put the sun behind them and use a video light to balance light levels between the foreground and background. If the sun is simply too bright, position the subject in the shade and use the video light for your main illumination. Using reflectors (white board panels or aluminum foil covered cardboard panels are cheap options) can also help balance light effectively.

- **On-camera lighting.** While not "technically" a lighting style, this method is commonly used. A hot shoe mounted light provides direct lighting in the same direction the lens is pointing. It's commonly used at weddings, events, and in photojournalism since it's easy and portable. LED video lights are all the rage these days and a wide variety of these lights are available at various price points. At the low end, these lights tend to be small and produce minimal light (but useful for fill work). More expensive versions offer greater light output and come with built-in barn doors (panels that help you control and shape the light) and diffusers and filters.

Tips for Better Audio

Since recording high-quality audio is such a challenge, it's a good idea to do everything possible to maximize recording quality. Here are some ideas for improving the quality of the audio your T5 records:

- **Get the camera and its built-in microphone close to the speaker.** The farther the microphone is from the audio source, the less effective it will be in picking up that sound. This means you'll have to boost volume in post-production, which will also amplify any background noises. While having to position the camera closer to the subject affects your lens choices and lens perspective options, it will make the most of your audio source.

- **Turn off any sound makers you can.** Little things like fans and air handling units aren't obvious to the human ear, but will be picked up by the microphone. Try to turn off any machinery or devices that you can plus make sure cell phones are set to silent mode. Also, do what you can to minimize sounds such as wind, radio, television, or people talking in the background. Don't forget to close windows if you're inside to shut out noises from the outside.

- **Make sure to record some "natural" sound.** If you're shooting video at an event of some kind, make sure you get some background sound that you can add to your audio as desired in post-production.

- **Consider recording audio separately.** Lip-syncing is probably beyond most of the people you're going to be shooting, but there's nothing that says you can't record narration separately and add it later. Any time the speaker is off camera, you can work with separately recorded narration, using a program like Adobe Premiere, rather than recording the speaker on camera. This can produce much cleaner sound.

7

Advanced Shooting

You can happily spend your entire shooting career using the techniques and features already explained in this book. Great exposures, sharp pictures, and creative compositions are all you really need to produce great shot after great shot. But, those with enough interest in getting the most out of their Canon EOS T5 who buy this book probably will be interested in going beyond those basics to explore some of the more advanced techniques and capabilities of the camera. Capturing the briefest instant of time, transforming common scenes into the unusual with lengthy time exposures, and working with new tools like Wi-Fi are all tempting avenues for exploration. So, in this chapter, I'm going to offer longer discussions of some of the more advanced techniques and capabilities that I like to put to work.

Continuous Shooting

The Canon EOS T5's Continuous shooting mode reminds me how far digital photography has brought us. The first accessory I purchased when I worked as a sports photographer some years ago was a motor drive for my film SLR. It enabled me to snap off a series of shots in rapid succession, which came in very handy when a fullback broke through the line and headed for the end zone. Even a seasoned action photographer can miss the decisive instant when a crucial block is made, or a baseball superstar's bat shatters and pieces of cork fly out. Continuous shooting simplifies taking a series of pictures, either to ensure that one has more or less the exact moment you want to capture or to capture a sequence that is interesting as a collection of successive images.

The T5's "motor drive" capabilities are, in many ways, much superior to what you get with a film camera. For one thing, a motor-driven film camera can eat up film at an incredible pace, which is why many of them are used with cassettes that hold hundreds of feet of film stock. At three frames per second (typical of film cameras), a short burst of a few seconds can burn up as much as half of

an ordinary 36 exposure roll of film. Digital cameras, in contrast, have reusable "film," so if you waste a few dozen shots on non-decisive moments, you can erase them and shoot more. Save only the best shots, like the series shown in Figure 7.1.

To use the T5's continuous shooting mode, when using one of the Creative Zone modes, press the drive button (the left cross key) and use the cross keys to select the continuous shooting icon. When you partially depress the shutter button, the viewfinder will display a number representing the maximum number of shots you can take at the current quality settings. (If your battery is low, this figure will be lower.)

Continuous shooting can be affected by the speed with which your T5 is able to focus. So, in AI Servo AF mode, the frames-per-second rate may be lower. Lenses which inherently focus more slowly (see Chapter 10 for information on the various types of autofocus motors built into Canon lenses), and scenes that are poorly lit can also affect the frame rate. The buffer in the T5 will generally allow you to take as many as 69 Large/Fine JPEG shots in a single burst (your battery may not hold out that long!), or 6 RAW photos at the 18MP resolution setting. To increase this number in RAW mode, reduce the image-quality setting by switching to JPEG only (from JPEG+RAW) or by reducing the T5's resolution from L to M or S.

Figure 7.1 Continuous shooting allows you to capture an entire sequence of exciting moments as they unfold.

The reason the size of your bursts is limited by the buffer in RAW mode is that continuous images are first shuttled into the T5's internal memory, then doled out to the memory card as quickly as they can be written to the card. Technically, the T5 takes the RAW data received from the digital image processor and converts it to the output format you've selected—either JPG or CR2 (raw) or both—and deposits it in the buffer ready to store on the card.

This internal "smart" buffer can suck up photos much more quickly than the memory card and, indeed, some memory cards are significantly faster or slower than others. Setting C.Fn II-5: High ISO Speed Noise Reduction to "Strong" also limits the length of your continuous burst, because of the extra processing time needed for aggressive noise reduction. When the buffer fills, you can't take any more continuous shots (a buSY indicator appears in the viewfinder and LCD status panel) until the T5 has written some of them to the card, making more room in the buffer. (You should keep in mind that faster memory cards write images more quickly, freeing up buffer space faster.)

More Exposure Options

In Chapter 4, you learned techniques for getting the *right* exposure, but I haven't explained all your exposure options just yet. You'll want to know about the *kind* of exposure settings that are available to you with the Canon EOS T5. There are options that let you control when the exposure is made, or even how to make an exposure that's out of the ordinary in terms of length (time or bulb exposures). The sections that follow explain your camera's special exposure features, and even discuss a few it does not have (and why it doesn't).

A Tiny Slice of Time

Exposures that seem impossibly brief can reveal a world we didn't know existed. In the 1930s, Dr. Harold Edgerton, a professor of electrical engineering at MIT, pioneered high-speed photography using a repeating electronic flash unit he patented called the *stroboscope*. As the inventor of the electronic flash, he popularized its use to freeze objects in motion, and you've probably seen his photographs of bullets piercing balloons and drops of milk forming a coronet-shaped splash.

Electronic flash freezes action by virtue of its extremely short duration—as brief as 1/50,000th second or less. Although the EOS T5's built-in flash unit can give you these ultra-quick glimpses of moving subjects, an external flash, such as one of the Canon Speedlites, offers even more versatility. You can read more about using electronic flash to stop action in Chapter 11.

Of course, the T5 is fully capable of immobilizing all but the fastest movement using only its shutter speeds, which range all the way up to 1/4,000th second. Indeed, you'll rarely have need for such a brief shutter speed in ordinary shooting. If you wanted to use an aperture of f/2.8 at ISO 100 outdoors in bright sunlight, for some reason, a shutter speed of 1/4,000th second would more than do

the job. You'd need a faster shutter speed only if you moved the ISO setting to a higher sensitivity (but why would you do that?). Under less than full sunlight, 1/4,000th second is more than fast enough for any conditions you're likely to encounter.

Most sports action can be frozen at 1/2,000th second or slower, and for many sports a slower shutter speed is actually preferable—for example, to allow the wheels of a racing automobile or motorcycle, or the propeller on a classic aircraft to blur realistically.

But if you want to do some exotic action-freezing photography without resorting to electronic flash, the T5's top shutter speed is at your disposal. Here are some things to think about when exploring this type of high-speed photography:

- **You'll need a lot of light.** High shutter speeds cut very fine slices of time and sharply reduce the amount of illumination that reaches your sensor. To use 1/4,000th second at an aperture of f/6.3, you'd need an ISO setting of 800—even in full daylight. To use an f/stop smaller than f/6.3 or an ISO setting lower than 800, you'd need *more* light than full daylight provides. (That's why electronic flash units work so well for high-speed photography when used as the sole illumination; they provide both the effect of a brief shutter speed and the high levels of illumination needed.)

- **Forget about reciprocity failure.** If you're an old-time film shooter, you might recall that very brief shutter speeds (as well as very high light levels and very *long* exposures) produced an effect called *reciprocity failure,* in which given exposures ended up providing less than the calculated value because of the way film responded to very short, very intense, or very long exposures of light. Solid-state sensors don't suffer from this defect, so you don't need to make an adjustment when using high shutter speeds (or brief flash bursts).

- **Don't combine high shutter speeds with electronic flash.** You might be tempted to use an electronic flash with a high shutter speed. Perhaps you want to stop some action in daylight with a brief shutter speed and use electronic flash only as supplemental illumination to fill in the shadows. Unfortunately, under most conditions you can't use flash in subdued illumination with your T5 at any shutter speed faster than 1/200th second. That's the fastest speed at which the camera's focal plane shutter is fully open: at shorter speeds, the "slit" described above comes into play, so that the flash will expose only the small portion of the sensor exposed by the slit during its duration. (Check out "Avoiding Sync Speed Problems" in Chapter 11 if you want to see how you *can* use shutter speeds shorter than 1/200th second with certain Canon Speedlites, albeit at much-reduced effective power levels.)

Working with Short Exposures

You can have a lot of fun exploring the kinds of pictures you can take using very brief exposure times, whether you decide to take advantage of the action-stopping capabilities of your built-in or external electronic flash or work with the Canon EOS T5's faster shutter speeds.

Here are a few ideas to get you started:

■ **Take revealing images.** Fast shutter speeds can help you reveal the real subject behind the façade, by freezing constant motion to capture an enlightening moment in time. Legendary fashion/portrait photographer Philippe Halsman used leaping photos of famous people, such as the Duke and Duchess of Windsor, Richard Nixon, and Salvador Dali to illuminate their real selves. Halsman said, *"When you ask a person to jump, his attention is mostly directed toward the act of jumping and the mask falls so that the real person appears."* Try some high-speed portraits of people you know in motion to see how they appear when concentrating on something other than the portrait.

■ **Create unreal images.** High-speed photography can also produce photographs that show your subjects in ways that are quite unreal. A helicopter in mid-air with its rotors frozen makes for an unusual picture. Figure 7.2 shows a pair of pictures. At top, a shutter speed of 1/1,000th second virtually stopped the rotation of the chopper's rotors, while the bottom image, shot at 1/200th second, provides a more realistic view of the blurry blades as they appeared to the eye.

■ **Capture unseen perspectives.** Some things are *never* seen in real life, except when viewed in a stop-action photograph. Edgerton's balloon bursts were only a starting point. Freeze a hummingbird in flight for a view of wings that never seem to stop. Or, capture the splashes as liquid falls into a bowl, as shown in Figure 7.3. No electronic flash was required for this image (and wouldn't have illuminated the water in the bowl as evenly). Instead, a clutch of high-intensity lamps and an ISO setting of 1600 allowed the EOS T5 to capture this image at 1/2,000th second.

Figure 7.2
Top: the chopper's blades are frozen at 1/1,000th second; bottom: a more realistic blurry rendition at 1/200th second shutter speed.

■ **Vanquish camera shake and gain new angles.** Here's an idea that's so obvious it isn't always explored to its fullest extent. A high enough shutter speed can free you from the tyranny of a tripod, making it easier to capture new angles, or to shoot quickly while moving around, especially with longer lenses. I tend to use a monopod or tripod for almost everything when I'm not using an image-stabilized lens, and I end up missing some shots because of a reluctance to adjust my camera support to get a higher, lower, or different angle. If you have enough light and can use an f/stop wide enough to permit a high shutter speed, you'll find a new freedom to choose your shots. I have a favored 170mm-500mm lens that I use for sports and wildlife photography, almost invariably with a tripod, as I don't find the "reciprocal of the focal length" rule particularly helpful in most cases. (I would *not* hand-hold this hefty lens at its 500mm setting with a 1/500th second shutter speed under most circumstances.) However, at 1/2,000th second or faster, and with a sufficiently high ISO setting (I recommend ISO 800 to ISO 1600) to allow such a speed, it's entirely possible for a steady hand to use this lens without a tripod or monopod's extra support, and I've found that my whole approach to shooting animals and other elusive subjects changes in high-speed mode. Selective focus allows dramatically isolating my prey wide open at f/6.3, too.

Figure 7.3
A large amount of artificial illumination and an ISO 1600 sensitivity setting allowed capturing this shot at 1/2,000th second without use of an electronic flash.

Long Exposures

Longer exposures are a doorway into another world, showing us how even familiar scenes can look much different when photographed over periods measured in seconds. At night, long exposures produce streaks of light from moving, illuminated subjects like automobiles or amusement park rides. Extra-long exposures of seemingly pitch-dark subjects can reveal interesting views using light levels barely bright enough to see by. At any time of day, including daytime (in which case you'll often need the help of neutral-density filters, which reduce the amount of light passing through the lens, to make the long exposure practical), long exposures can cause moving objects to vanish entirely, because they don't remain stationary long enough to register in a photograph.

Three Ways to Take Long Exposures

There are actually three common types of lengthy exposures: *timed exposures*, *bulb exposures*, and *time exposures*. The EOS T5 offers only the first two, but once you understand all three, you'll see why Canon made the choices it did. Because of the length of the exposure, all of the following techniques should be used with a tripod to hold the camera steady:

■ **Timed exposures.** These are long exposures from 1 second to 30 seconds, measured by the camera itself. To take a picture in this range, simply use Manual or Tv modes and use the Main Dial to set the shutter speed to the length of time you want, choosing from preset speeds of 1.0, 1.5, 2.0, 3.0, 4.0, 6.0, 8.0, 10.0, 15.0, 20.0, or 30.0 seconds (if you've specified 1/2 stop increments for exposure adjustments), or 1.0, 1.3, 1.6, 2.0, 2.5, 3.2, 4.0, 5.0, 6.0, 8.0, 10.0, 13.0, 15.0, 20.0, 25.0, and 30.0 seconds (if you're using 1/3 stop increments). The advantage of timed exposures is that the camera does all the calculating for you. There's no need for a stopwatch. If you review your image on the LCD and decide to try again with the exposure doubled or halved, you can dial in the correct exposure with precision. The disadvantage of timed exposures is that you can't take a photo for longer than 30 seconds.

■ **Bulb exposures.** This type of exposure is so-called because in the olden days the photographer squeezed and held an air bulb attached to a tube that provided the force necessary to keep the shutter open. Traditionally, a bulb exposure is one that lasts as long as the shutter release button is pressed; when you release the button, the exposure ends. To make a bulb exposure with the T5, set the camera on M using the Mode Dial, then rotate the Main Dial all the way past the longest available shutter speeds to the Bulb position. Then, press the shutter button to start the exposure, and release it again to close the shutter.

■ **Time exposures.** This is a setting found on some cameras to produce longer exposures. With cameras that implement this option, the shutter opens when you press the shutter release button, and remains open until you press the button again. Usually, you'll be able to close the shutter using a mechanical cable release or, more commonly, an electronic release cable. The advantage of this approach is that you can take an exposure of virtually any duration without the need for special equipment (the tethered release is optional). You can press the shutter release button, go off for a few minutes, and come back to close the shutter (assuming your camera is still there). The disadvantages of this mode are exposures must be timed manually, and with shorter exposures, it's possible for the vibration of manually opening and closing the shutter to register in the photo. For longer exposures, the period of vibration is relatively brief and not usually a problem—and there is always the release cable option to eliminate photographer-caused camera shake entirely. While the T5 does not have a built-in time exposure capability, you can simulate it with the bulb exposure technique, described previously.

WATCH OUT FOR AMP NOISE

When exposures extend past 30 seconds into the realm of several minutes—or more—all digital cameras are theoretically susceptible to a phenomenon called *amp noise*, which manifests itself as a purplish glow, often around the edges of an image, creating an aurora borealis–style ghost effect. Amp noise happens when the sensor heats up during a long exposure, and some cameras fall victim more readily than others. The EOS T5 resists this phenomenon better than most dSLRs, but you should be aware it exists, even if you'd need to use an uncommon exposure (on the order of 30 minutes or so) to create the effect with your camera.

Working with Long Exposures

Because the EOS T5 produces such good images at longer exposures, and there are so many creative things you can do with long-exposure techniques, you'll want to do some experimenting. Get yourself a tripod or another firm support and take some test shots with long exposure noise reduction both enabled and disabled using the Custom Function II-4, as explained in Chapter 9 (to see whether you prefer low noise or high detail) and get started. Here are some things to try:

■ **Make people invisible.** One very cool thing about long exposures is that objects that move rapidly enough won't register at all in a photograph, while the subjects that remain stationary are portrayed in the normal way. That makes it easy to produce people-free landscape photos and architectural photos at night or, even, in full daylight if you use a neutral-density filter (or two or three) to allow an exposure of at least a few seconds. At ISO 100, f/22, and a pair of 8X (three-stop) neutral-density filters, you can use exposures of nearly two seconds; overcast days and/or more neutral-density filtration would work even better if daylight people-vanishing is your goal. They'll have to be walking *very* briskly and across the field of view (rather than directly toward the camera) for this to work. At night, it's much easier to achieve this effect with the 20- to 30-second exposures that are possible, as you can see in Figures 7.4 and 7.5.

Figure 7.4
This alleyway is thronged with people, as you can see in this two-second exposure using only the available illumination.

Figure 7.5
With the camera still on a tripod, a 30-second exposure rendered the passersby almost invisible.

- **Create streaks.** If you aren't shooting for total invisibility, long exposures with the camera on a tripod or monopod can produce some interesting streaky effects, as you can see in Figure 7.6. I had the tripod collar of the lens attached to a monopod, and rotated the camera in four rapid twists during the 1/8th second exposure, producing four separate streaky images in one shot. You don't need to limit yourself to indoor photography, however. Even a single 8X ND filter will let you shoot at f/22 and 1/6th second in full daylight at ISO 100.

- **Produce light trails.** At night, car headlights and taillights and other moving sources of illumination can generate interesting light trails. Your camera doesn't even need to be mounted on a tripod; hand-holding the T5 for longer exposures adds movement and patterns to your trails. If you're shooting fireworks, a longer exposure may allow you to combine several bursts into one picture, as shown in the tripod shot in Figure 7.7.

Figure 7.6 These dancers produced a swirl of movement during the 1/8th second exposure.

Figure 7.7 A long exposure allows capturing several bursts of fireworks in one image.

- **Blur waterfalls, etc.** You'll find that waterfalls and other sources of moving liquid produce a special type of long-exposure blur, because the water merges into a fantasy-like veil that looks different at different exposure times, and with different waterfalls. Cascades with turbulent flow produce a rougher look at a given longer exposure than falls that flow smoothly. Although blurred waterfalls have become almost a cliché, there are still plenty of variations for a creative photographer to explore, as you can see in Figure 7.8.

- **Show total darkness in new ways.** Even on the darkest nights, there is enough starlight or glow from distant illumination sources to see by, and, if you use a long exposure, there is enough light to take a picture, too. (See Figure 7.9.)

Figure 7.8 A 1/4-second exposure blurred the falling water.

Figure 7.9 A 20-second exposure revealed this view of San Juan, Puerto Rico.

Delayed Exposures

Sometimes it's desirable to have a delay of some sort before a picture is actually taken. Perhaps you'd like to get in the picture yourself, and would appreciate it if the camera waited 10 seconds after you press the shutter release to actually take the picture. Maybe you want to give a tripod-mounted camera time to settle down and damp any residual vibration after the release is pressed to improve sharpness for an exposure with a relatively slow shutter speed. It's possible you want to explore the world of time-lapse photography. The next sections present your delayed exposure options.

Self-Timer

The EOS T5 has a built-in self-timer with 10-second and 2-second delays. Activate the timer by pressing the left cross key and selecting from the drive modes that appear on the LCD monitor. Press the shutter release button halfway to lock in focus on your subjects (if you're taking a self-portrait, focus on an object at a similar distance and use focus lock). When you're ready to take the photo, continue pressing the shutter release the rest of the way. The lamp on the front of the camera will blink slowly for eight seconds (when using the 10-second timer) and the beeper will chirp (if you haven't disabled it in the Shooting menu, as described in Chapter 8). During the final two seconds, the beeper sounds more rapidly and the lamp remains on until the picture is taken. The self-timer remains active until you turn it off—even if you power down the T5, so remember to turn it off when finished.

Time-Lapse/Interval Photography

Who hasn't marveled at a time-lapse photograph of a flower opening, a series of shots of the moon marching across the sky, or one of those extreme time-lapse picture sets showing something that takes a very, very long time, such as a building under construction.

You probably won't be shooting such construction shots, unless you have a spare T5 you don't need for a few months (or are willing to go through the rigmarole of figuring out how to set up your camera in precisely the same position using the same lens settings to shoot a series of pictures at intervals). However, other kinds of time-lapse photography are entirely within reach.

Although the EOS T5 can't take time-lapse/interval photographs all by itself, if you're willing to tether the camera to a computer (a laptop will do) using the USB cable, you can take time-lapse photos using EOS Utility software furnished with your camera (see Figure 7.10).

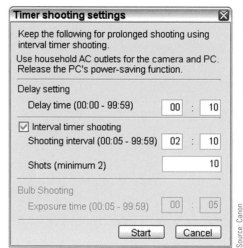

Figure 7.10
The EOS Utility can control time-lapse photography with a tethered camera.

Here are some tips for effective time-lapse photography:

- **Use AC power.** If you're shooting a long sequence, consider connecting your camera to an AC adapter, as leaving the T5 on for long periods of time will rapidly deplete the battery.

- **Make sure you have enough storage space.** Unless your memory card has enough capacity to hold all the images you'll be taking, you might want to change to a higher compression rate or reduced resolution to maximize the image count.

- **Make a movie.** While time-lapse stills are interesting, you can increase your fun factor by compiling all your shots into a motion picture using your favorite desktop movie-making software.

- **Protect your camera.** If your camera will be set up for an extended period of time (longer than an hour or two), make sure it's protected from weather, earthquakes, animals, young children, innocent bystanders, and theft.

- **Vary intervals.** Experiment with different time intervals. You don't want to take pictures too often or less often than necessary to capture the changes you hope to image.

Wi-Fi and Geotagging

These days, Wi-Fi and GPS capabilities work together with your EOS T5 in interesting new ways. Wireless capabilities allow you to upload photos directly from your T5 to your computer at home or in your studio, or, through a hotspot at your hotel or coffee shop back to your home computer or to a photo sharing service like Facebook or Flickr. In the past, Eye-Fi (www.eye.fi) sold a special Wi-Fi-enabled memory card that you could slip in the SD slot of your camera to perform the magic. GPS capabilities—built right into some of those Wi-Fi cards—allow you to mark your photographs

with location information, so you don't have to guess where a picture was taken. Although Eye-Fi continues to provide limited support for those who purchased GPS-compatible cards, they have discontinued offering the service to new buyers. So, T5 owners must turn to third-party add-on devices, or Canon's own GPS Receiver GP-E2 for GPS services.

Still, both capabilities are very cool. Wi-Fi uploads can provide instant backup of important shots and sharing. Geotagging is most important as a way to associate the geographical location where the photographer was when a picture was taken, with the actual photograph itself. It can be done with the location-mapping capabilities of those add-on devices that Canon and third parties make available for your T5.

Geotagging can also be done by attaching geographic information to the photo after it's already been taken. This is often done with online sharing services, such as Flickr, which allow you to associate your uploaded photographs with a map, city, street address, or postal code. When properly geotagged and uploaded to sites like Flickr, users can browse through your photos using a map, finding pictures you've taken in a given area, or even searching through photos taken at the same location by other users.

Although Canon has had $700 Wi-Fi gadgets, normal people like you and me need an affordable solution for Wi-Fi, like that offered by Eye-Fi. The Eye-Fi card is an SDHC memory card with a wireless transmitter built in. You insert it in your camera just as with any ordinary card, and then specify which networks to use. You can add as many as 32 different networks. The next time your camera is on within range of a specified network, your photos and videos can be uploaded to your computer and/or to your favorite sharing site. During setup, you can customize where you want your images uploaded. The Eye-Fi card will only send them to the computer and to the sharing site you choose. Upload to any of 25 popular sharing websites, including Flickr, Facebook, Costco, Adorama, Smugmug, YouTube, Shutterfly, or Walmart. Online Sharing is included as a lifetime, unlimited service with all X2 cards.

Your EOS T5 has an Eye-Fi Settings entry at the bottom of the Set-up 1 menu that appears when you have an Eye-Fi card inserted with one entry:

- **Eye-Fi trans.** This setting has two options: Enable and Disable. Because the Eye-Fi card draws its power from the T5, you might want to disable the capability when you don't want it, in order to save some juice. I tend to leave it on all the time, and allow the card to upload information to the networks I've specified. When enabled, the card can also draw location information from the hotspots it accesses, associating geographical information with each shot, too.

- **Connection info.** This displays current information about your Eye-Fi card's link to your network or hotspot, and other data, such as the firmware version. It appears only when the Eye-Fi card has been enabled. (See Figure 7.11.)

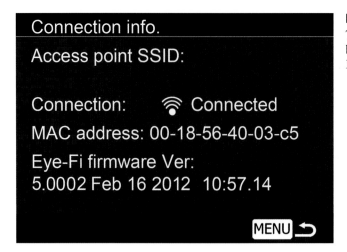

Figure 7.11
The EOS T5 has built-in support for Eye-Fi cards.

When uploading to online sites, you can specify not just where your images are sent, but how they are organized, by specifying preset album names, tags, descriptions, and even privacy preferences on certain sharing sites. (You should be cautious about sharing your location when using social media sites.) You don't need to have the password or a subscription for the Wi-Fi networks the card accesses; it can grab the location information directly without the need to "log in." You don't need to set up or control the Eye-Fi card from your camera.

If you frequently travel outside the range of your home (or business) Wi-Fi network, an optional service called Hotspot Access is available, allowing you to connect to any AT&T Wi-Fi hotspot in the USA. In addition, you can use your own Wi-Fi accounts from commercial network providers, your city, even organizations you belong to such as your university.

The card has another interesting feature called Endless Memory. When pictures have been safely uploaded to an external site, the card can be set to automatically erase the oldest images to free up space for new pictures. You choose the threshold where the card starts zapping your old pictures to make room.

Eye-Fi currently offers several models, in 8GB to 32GB sizes, and apps for your iPhone/iPad and Android smartphones, too. The most sophisticated options can add geographic location labels to your photo (so you'll know where you took it), and frees you from your own computer network by allowing uploads from more than 10,000 Wi-Fi hotspots around the USA. Very cool, and the ultimate in picture backup. Eye-Fi has recently added the ability to upload from your camera to your smartphone, too.

Focus Stacking

If you are doing macro (close-up) photography of flowers, or other small objects at short distances, the depth-of-field often will be extremely narrow. In some cases, it will be so narrow that it will be impossible to keep the entire subject in focus in one photograph. Although having part of the image out of focus can be a pleasing effect for a portrait of a person, it is likely to be a hindrance when you are trying to make an accurate photographic record of a flower, or small piece of precision equipment. One solution to this problem is focus stacking, a procedure that can be considered like HDR translated for the world of focus—taking multiple shots with different settings, and, using software as explained below, combining the best parts from each image in order to make a whole that is better than the sum of the parts. Focus stacking requires a non-moving object, so some subjects, such as flowers, are best photographed in a breezeless environment, such as indoors.

For example, see Figures 7.12 through 7.14, in which I took photographs of three colorful jacks using a macro lens. As you can see from these images, the depth-of-field was extremely narrow, and only a small part of the subject was in focus for each shot.

Now look at Figure 7.15, in which the entire subject is in reasonably sharp focus. This image is a composite, made up of the three preceding shots, as well as 10 others, each one focused on the same scene, but at very gradually increasing distances from the camera's lens. All 13 images were then combined in Adobe Photoshop using the focus stacking procedure.

Figure 7.12 **Figure 7.13** **Figure 7.14**

These three shots were all focused on different distances within the same scene. No single shot could bring the entire subject into sharp focus.

Figure 7.15 Three partially out-of-focus shots have been merged, along with ten others, through a focus stacking procedure in Adobe Photoshop, to produce a single image with the entire subject in focus.

Here are the steps you can take to combine shots for the purpose of achieving sharp focus in this sort of situation:

1. Set the camera firmly on a solid tripod. A tripod or other equally firm support is absolutely essential for this procedure.

2. Connect a wired remote control or use an infrared remote control if possible. If not, consider using the self-timer to avoid any movement of the camera when images are captured.

3. Set the camera to manual focus mode.

4. Set the exposure, ISO, and white balance manually, using test shots if necessary to determine the best values. This step will help prevent visible variations from arising among the multiple shots that you'll be taking.

5. Set the quality of the images to RAW & JPEG or FINE.

6. Focus manually on the very closest point of the subject to the lens. Trip the shutter, using the remote control or self-timer.

7. Focus on a point slightly farther away from the lens and trip the shutter again.

8. Continue taking photographs in this way until you have covered the entire subject with in-focus shots.

9. In Photoshop, select File > Scripts > Load Files into Stack. In the dialog box that then appears, navigate on your computer to find the files for the photographs you have taken, and highlight them all.

10. At the bottom of the next dialog box that appears, check the box that says, "Attempt to Automatically Align Source Images," then click OK. The images will load; it may take several minutes for the program to load the images and attempt to arrange them into layers that are aligned based on their content.

11. Once the program has finished processing the images, go to the Layers panel and select all of the layers. You can do this by clicking on the top layer and then Shift-clicking on the bottom one.

12. While the layers are all selected, in Photoshop go to Edit > Auto-Blend Layers. In the dialog box that appears, select the two options, Stack Images and Seamless Tones and Colors, then click OK. The program will process the images, possibly for a considerable length of time.

13. If the procedure worked well, the result will be a single image made up of numerous layers that have been processed to produce a sharply focused rendering of your subject. If it did not work well, you may have to take additional images the next time, focusing very carefully on small slices of the subject as you move progressively farther away from the lens.

Although this procedure can work very well in Photoshop, you also may want to try it with programs that were developed more specifically for focus stacking and related procedures, such as Helicon Focus (www.heliconsoft.com), PhotoAcute (www.photoacute.com), or CombineZM (www.hadleyweb.pwp.blueyonder.co.uk).

Part III

Advanced Tools

The next four chapters are devoted to helping you dig deeper into the capabilities of your Canon Rebel T5, so you can exploit all those cool features that your previous camera lacked. Chapters 8 and 9 list every setting and option found in the Shooting, Playback, Set-up, and Custom Functions menus. I'll not only tell you what each menu item does, I'll explain exactly when and why you should use every option. Then, in Chapter 10, I'll show you how to select the best lenses for the kinds of photography you want to do, with my recommendations for starter lenses as well as more advanced optics for specialized applications.

Chapter 11 is devoted to the magic of light—your fundamental tool in creating any photograph. There are entire books devoted to working with electronic flash, but I hope to get you started with plenty of coverage of the Rebel T5's capabilities. I'll show you how to master your camera's built-in flash—and avoid that "built-in flash" look, and offer an introduction to the use of external flash units, including the Canon Speedlite 600EX-RT. By the time you finish these essential chapters, you'll be well on the way to mastering your Canon Rebel T5.

8

Customizing with the Shooting and Playback Menus

The Canon Rebel T5 is undoubtedly one of the most customizable, tweakable, fine-tunable cameras Canon has offered entry-level users. If your camera doesn't behave in exactly the way you'd like, chances are you can make a small change in the Shooting, Playback, Set-up, and Custom Functions menus that will tailor the T5 to your needs. In fact, if you don't like the *menus*, you can create your own using the clever My Menu system.

This chapter and the next will help you sort out the settings you can make to customize how your Canon Rebel T5 uses its features, shoots photos, displays images, and processes the pictures after they've been taken. As I've mentioned before, this book isn't intended to replace the manual you received with your T5, nor have I any interest in rehashing its contents. You'll still find the original manual useful as a standby reference that lists every possible option in exhaustive (if mind-numbing) detail—without really telling you how to use those options to take better pictures. There is, however, some unavoidable duplication between the Canon manual and this chapter, because I'm going to explain the key menu choices and the options you may have in using them. You should find, though, that this chapter gives you the information you need in a much more helpful format, with plenty of detail on why you should make some settings that are particularly cryptic.

I'm not going to waste a lot of space on some of the more obvious menu choices. For example, you can probably figure out that the Beep option in the Shooting 1 menu deals with the solid-state beeper in your camera that sounds off during various activities (such as the self-timer countdown). You can certainly decipher the import of the two options available for the Beep entry (Enable and Disable). In this chapter, I'll devote no more than a sentence or two to the blatantly obvious settings and concentrate on the more confusing aspects of the T5's setup, such as automatic exposure bracketing. I'll cover the Shooting menus and Playback menus in this chapter, and turn to the Set-up, Custom Functions, and My Menu options in Chapter 9. Let's start off with an overview of the T5's menus themselves.

Anatomy of the Rebel T5's Menus

If you have jumped directly to the Canon Rebel T5 from an ancient model like the EOS 30D, you're in for a pleasant surprise from a menu perspective. Like all recent EOS cameras, this model abandons the time-consuming scrolling through one endless menu in favor of 10 individually tabbed menus, each with a single screen of options (so you won't need to scroll within a menu to see all the entries). The menus are much cleaner, too.

If you've used another EOS model, you'll find the T5's menu system familiar, but with a more attractive look that includes "shaded" menu tabs (see Figure 8.1). Some menu items have been moved around and/or renamed. With the current system, just press the MENU button, spin the Main Dial to highlight the menu tab you want to access, and then scroll up and down within a menu with the cross keys. What could be easier?

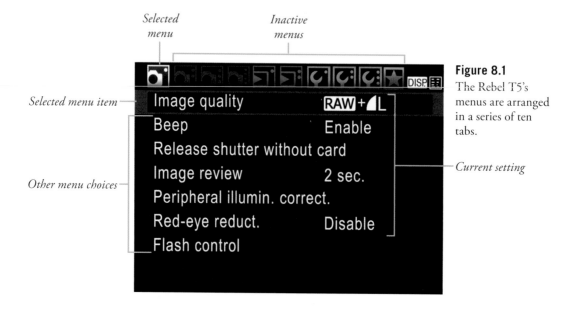

Figure 8.1
The Rebel T5's menus are arranged in a series of ten tabs.

MENU NAVIGATION

Remember: you can use the Main Dial to move from menu to menu, and the cross keys to highlight a particular menu entry. Press the SET button to select a menu item. That procedure is probably the best way to start out, because those controls are used to make so many settings with the Rebel T5 that they quickly become almost intuitive.

You can jump from tab to tab even if you've highlighted a particular menu setting on another tab—and the T5 will remember which menu entry you've highlighted when you return to that menu. The memorization works even if you leave the menu system or turn off your camera. The T5 always remembers the last menu entry you used with a particular tab. So, if you generally use the Format command each time you access the Set-up 1 menu, that's the entry that will be highlighted when you choose that tab. The camera remembers which tab was last used, too, so, potentially, formatting your memory card might take just a couple of presses (the MENU button, the SET button to select the highlighted Format command, then a press of the cross keys to choose OK, and another press of SET to start the format process).

Tapping the MENU button brings up a typical menu like the one shown in the figure. (If the camera goes to "sleep" while you're reviewing a menu, you may need to wake it up again by tapping the shutter release button.) When you're using any Mode Dial option other than Full Auto and Creative Auto, there are 10 menu tabs: Shooting 1, Shooting 2, Shooting 3, Shooting 4, Playback 1, Playback 2, Set-up 1, Set-up 2, Set-up 3, and My Menu.

In Full Auto and Creative Auto, the Shooting 3, Shooting 4, Set-up 3, and My Menu choices are not available, and the options within the menus are slightly different. When the Mode Dial is set to Movie mode, there are three Movie menus, one Shooting menu, two Playback menus, and two Set-up menus. In this chapter, I'm going to explain all the tabs and all the menu entries for still shooting, and not take the time to single out those that are not available when using Full Auto and Creative Auto modes. The automatic modes are intended for situations when you don't want full control over your T5's operation, anyway, and menu limitations go with the territory. The Movie menus were previously discussed in Chapter 6 and won't be repeated here.

The T5's tabs are color-coded: red for Shooting menus, blue for Playback menus, amber for Set-up menus, and green for the My Menu tab. The currently selected menu's icon is white within a white border, on a background corresponding to its color code. All the inactive menus are dimmed and the icons and their borders are color-coded.

Here are the things to watch for as you navigate the menus:

■ **Menu tabs.** In the top row of the menu screen, the menu that is currently active will be highlighted as described earlier. One, two, three, or four dots in the tab lets you know if you are in, say Shooting 1, Shooting 2, Shooting 3, or Shooting 4. Just remember that the four red camera icons stand for shooting options; the two blue right-pointing triangles represent playback

options; the three yellow wrench icons stand for set-up options; and the green star stands for personalized menus defined for the star of the show—you.

■ **Selected menu item.** The currently selected menu item will have a black background and will be surrounded by a box the same hue as its color code.

■ **Other menu choices.** The other menu items visible on the screen will have a dark gray background.

■ **Current setting.** The current settings for visible menu items are shown in the right-hand column, until one menu item is selected (by pressing the SET key). At that point all the settings vanish from the screen except for those dealing with the active menu choice.

When you've moved the menu highlighting to the menu item you want to work with, press the SET button to select it. The current settings for the other menu items in the list will be hidden, and a list of options for the selected menu item (or a submenu screen) will appear. Within the menu choices, you can scroll up or down with the cross keys. Press SET to select the choice you've made; and press the MENU button again to exit.

Shooting 1, 2, 3, & 4 Menu Options

The various direct setting buttons that serve as secondary functions for the cross keys are likely to be the most frequent settings changes you make, with changes during a particular session fairly common. You'll find that the Shooting menu options are those that you access second most frequently when you're using your Rebel T5. You might make such adjustments as you begin a shooting session, or when you move from one type of subject to another. Canon makes accessing these changes very easy.

This section explains the options of the four Shooting menus available in Creative Zone modes, and how to use them. The options you'll find in these red-coded menus include:

■ Image Quality

■ Beep

■ Release Shutter without Card

■ Review Time

■ Peripheral Illumination Correction

■ Red-eye Reduction

■ Flash Control

■ Exposure Compensation/AEB (Automatic Exposure Bracketing)

■ Auto Lighting Optimizer

■ Metering Mode

■ Custom White Balance

■ WB Shift/Bracketing

■ Color Space

■ Picture Style

■ Dust Delete Data

■ ISO Auto

■ Live View Shooting

■ AF Method

■ Grid Display

■ Aspect Ratio

■ Metering Timer

Image Quality

You can choose the image quality settings used by the T5 to store its files. Here are your choices:

- **Resolution.** The number of pixels captured determines the absolute resolution of the photos you shoot with your T5. Your choices range from 18 megapixels (Large or L), measuring 5,184 × 3,456; 8.0 megapixels (Medium or M), measuring 3,456 × 2,304 pixels; 4.5 megapixels (Small 1 or S1), measuring 2,592 × 1,728 pixels; 2.5 megapixels (Small 2 or S2), measuring 1,920 × 1,280 pixels; and 350,000 pixels (Small 3 or S3), measuring 1,080 × 480 pixels.

- **JPEG compression.** To reduce the size of your image files and allow more photos to be stored on a given memory card, the T5 uses JPEG compression to squeeze the images down to a smaller size. This compacting reduces the image quality a little, so you're offered your choice of Fine compression and Normal compression. The symbols help you remember that Fine compression (represented by a quarter-circle) provides the smoothest results, while Normal compression (signified by a stair-step icon) provides "jaggier" images.

- **JPEG, RAW, or both.** You can elect to store only JPEG versions of the images you shoot or you can save your photos as uncompressed, loss-free RAW files, which consume about four times as much space on your memory card. Or, you can store both at once as you shoot. Many photographers elect to save *both* a JPEG and a RAW file, so they'll have a JPEG version that might be usable as-is, as well as the original "digital negative" RAW file in case they want to do some processing of the image later. You'll end up with two different versions of the same file: one with a JPG extension, and one with the CR2 extension that signifies a Canon RAW file.

To choose the combination you want, access the menus, scroll to Image Quality, and press the SET button. A screen similar to the one shown in Figure 8.2 will appear with two rows of choices. The top row and first two entries on the second row are JPEG-only settings, two Large and Medium options (at Fine and Normal compression), and four Small choices, representing S1 Fine, S1 Normal, S2, and S3, at the resolutions listed above. A red box appears around the currently selected choice. You can also select RAW+JPEG Large Fine and RAW only. Both produce full-resolution versions of the image.

Why so many choices? There are some limited advantages to using the Medium and Small resolution settings, Normal JPEG compression setting, and the two lower resolution RAW formats. They all allow stretching the capacity of your memory card so you can shoehorn quite a few more pictures onto a single memory card. That can come in useful when on vacation and you're running out of storage, or when you're shooting non-critical work that doesn't require full resolution. The Small 2 and Small 3 settings can be useful for photos taken for real estate listings, web page display, photo ID cards, or similar non-critical applications.

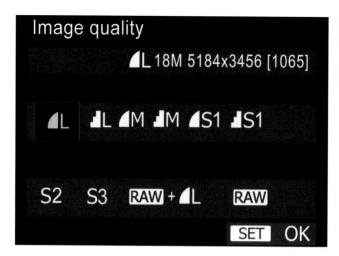

Figure 8.2
Choose your resolution, JPEG compression, and file format from this screen.

For most work, using lower resolution and extra compression is often false economy. You never know when you might actually need that extra bit of picture detail. Your best bet is to have enough memory cards to handle all the shooting you want to do until you have the chance to transfer your photos to your computer or a personal storage device.

However, reduced image quality can sometimes be beneficial if you're shooting sequences of photos rapidly, as the T5 is able to hold more of them in its internal memory buffer before transferring to the memory card. Still, for most sports and other applications, you'd probably rather have better, sharper pictures than longer periods of continuous shooting.

JPEG vs. RAW

You'll sometimes be told that RAW files are the "unprocessed" image information your camera produces, before it's been modified. That's nonsense. RAW files are no more unprocessed than your camera film is after it's been through the chemicals to produce a negative or transparency. A lot can happen in the developer that can affect the quality of a film image—positively and negatively—and, similarly, your digital image undergoes a significant amount of processing before it is saved as a RAW file. Canon even applies a name (DIGIC 4) to the digital image processing (DIP) chip used to perform this magic.

A RAW file is more similar to a film camera's processed negative. It contains all the information, captured in 14-bit channels per color (and stored in a 16-bit space), with no compression, no sharpening, and no application of any special filters or other settings you might have specified when you took the picture. Those settings are *stored* with the RAW file so they can be applied when the image is converted to a form compatible with your favorite image editor. However, using RAW conversion software such as Adobe Camera Raw or Canon's Digital Photo Professional, you can override those settings and apply settings of your own. You can select essentially the same changes there that you might have specified in your camera's picture-taking options.

RAW exists because sometimes we want to have access to all the information captured by the camera, before the camera's internal logic has processed it and converted the image to a standard file format. RAW doesn't save as much space as JPEG. What it does do is preserve all the information captured by your camera after it's been converted from analog to digital form. Of course, the T5's RAW format preserves the *settings* information.

So, why don't we always use RAW? Although some photographers do save only in RAW format, it's more common to use either RAW plus one of the JPEG options, or just shoot JPEG and avoid RAW altogether. That's because having only RAW files to work with can significantly slow down your workflow. While RAW is overwhelmingly helpful when an image needs to be fine-tuned, in other situations working with a RAW file, when all you really need is a good-quality, untweaked JPEG image, consumes time that you may not want to waste. For example, RAW images take longer to store on the memory card, and require more post-processing effort, whether you elect to go with the default settings in force when the picture was taken, or just make minor adjustments.

As a result, those who depend on speedy access to images or who shoot large numbers of photos at once may prefer JPEG over RAW. Wedding photographers, for example, might expose several thousand photos during a bridal affair and offer hundreds to clients as electronic proofs for possible inclusion in an album or transfer to a CD or DVD. These wedding shooters, who want JPEG images as their final product, take the time to make sure that their in-camera settings are correct, minimizing the need to post-process photos after the event. Given that their JPEGs are so good (in most cases thanks, in large part, to the pro photographer's extensive experience), there is little need to get bogged down shooting RAW.

Sports photographers also eschew RAW files. I visited a local Division III college one sunny September afternoon while I was writing this book and managed to cover a football game, trot down a hill to shoot a women's soccer match later that afternoon, and ended up in the adjacent field house shooting a volleyball invitational tournament an hour later. I managed to shoot 1,920 photos, most of them at a 3 fps clip, in about four hours. I certainly didn't have any plans to do post-processing on very many of those shots, and firing the T5 at its maximum frame rate isn't possible when using RAW or RAW+JPEG, so carefully exposed and precisely focused JPEG images were my file format of choice that day.

JPEG was invented as a more compact file format that can store most of the information in a digital image, but in a much smaller size. JPEG predates most digital SLRs, and was initially used to squeeze down files for transmission over slow dial-up connections. Even if you were using an early dSLR with 1.3 megapixel files for news photography, you didn't want to send them back to the office over a slow telephone line linkup.

But, as I noted, JPEG provides smaller files by compressing the information in a way that loses some image data. JPEG remains a viable alternative because it offers several different quality levels. At the highest quality Fine level, you might not be able to tell the difference between the original RAW file and the JPEG version.

In my case, I shoot virtually everything at RAW+JPEG Fine. Most of the time, I'm not concerned about filling up my memory cards, as I usually have a minimum of five fast 8GB memory cards with me. I also have some 32GB SD cards that are a little slower (so I don't use them for sports), but with even more capacity. If I think I may fill up all those cards, I have Apple's Camera Connection Kit for my iPad, and can transfer photos to that device. As I mentioned earlier, when shooting sports I'll shift to JPEG Fine (with no RAW file) to squeeze a little extra speed out of my T5's continuous shooting mode, and to reduce the need to wade through eight-photo bursts taken in RAW format. On the other hand, on my last trip to Europe, I took only RAW (instead of my customary RAW+JPEG) photos to fit more images onto my iPad, as I planned on doing at least some post-processing on many of the images for a travel book I was working on.

MANAGING LOTS OF FILES

The only long-term drawback to shooting everything in RAW+JPEG is that it's easy to fill up your computer's hard drive if you are a prolific photographer. Here's what I do. My most recent photos are stored on my working hard drive in a numbered folder, say T5-01, with subfolders named after the shooting session, such as 140501Trees, for pictures of trees taken on May 1, 2014. An automatic utility, TrueImage Home, copies new and modified photos to a different hard drive for temporary backup four times daily.

When the top-level folder accumulates about 30GB of images, I back it up to DVDs and then move the folder to a 2000GB (2 terabyte) drive dedicated solely for storage of folders that have already been backed up onto DVD. Then I start a new folder, such as T5-02, on the working hard drive and repeat the process. I always have at least one backup of every image taken, either on another hard drive or on a DVD.

Beep

The Rebel T5's internal beeper provides a helpful chirp to signify various functions, such as the countdown of your camera's self-timer. You can switch it off if you want to avoid the beep because it's annoying, impolite, or distracting (at a concert or museum), or undesired for any other reason. It's one of the few ways to make the T5 a bit quieter, other than live view's "silent shoot" mode. (I've actually had new dSLR owners ask me how to turn off the "shutter sound" the camera makes; such an option was available in the point-and-shoot camera they'd used previously.) Select Beep from the menu, press SET, and use the cross keys to choose Enable or Disable, as you prefer, as shown in Figure 8.3. Press SET again to activate your choice.

Figure 8.3
Silence your camera's beep when it might prove distracting.

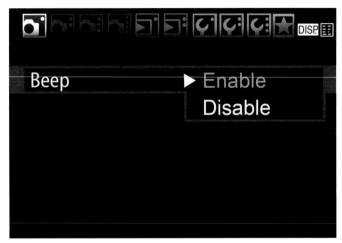

Release Shutter Without Card

This entry in the Set-up 1 menu (see Figure 8.4) gives you the ability to snap off "pictures" without a memory card installed—or to lock the camera shutter release if that is the case. It is sometimes called Play mode, because you can experiment with your camera's features or even hand your T5 to a friend to let him fool around, without any danger of pictures actually being taken. Back in our film days, we'd sometimes finish a roll, rewind the film back into its cassette surreptitiously, and then hand the camera to a child to take a few pictures—without actually wasting any film. It's hard to waste digital film, but Release Shutter without Card mode is still appreciated by some, especially camera vendors who want to be able to demo a camera at a store or trade show, but don't want to have to equip each and every demonstrator model with a memory card. Choose this menu item, press SET, select Enable or Disable, and press SET again to turn this capability on or off.

Figure 8.4
You can enable triggering the shutter even when no memory card is present.

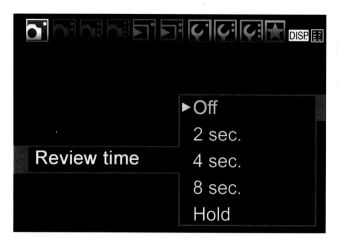

Figure 8.5
Adjust the time an image is displayed on the LCD for review after a picture is taken.

Review Time

You can adjust the amount of time an image is displayed for review on the LCD after each shot is taken. You can elect to disable this review entirely (Off), or choose display times of 2, 4, or 8 seconds. You can also select Hold, an indefinite display, which will keep your image on the screen until you use one of the other controls, such as the shutter button, Main Dial, or cross keys. Turning the review display off or choosing a brief duration can help preserve battery power. However, the T5 will always override the review display when the shutter button is partially or fully depressed, so you'll never miss a shot because a previous image was on the screen. Choose Review Time from the Shooting 1 menu, and select Off, 2 sec., 4 sec., 8 sec., or Hold, as shown in Figure 8.5. If you want to retain an image on the screen for a longer period, but don't want to use Hold as your default, press the Erase button under the LCD monitor. The image will display until you choose Cancel or Erase from the menu that pops up at the bottom of the screen.

Peripheral Illumination Correction

With certain lenses, under certain conditions, your images might suffer from a phenomenon called *vignetting*, which is a darkening of the four corners of the frame because of a slight amount of fall-off in illumination at those nether regions. This menu option allows you to activate a clever feature built in to the Rebel T5 that partially (or fully) compensates for this effect. Depending on the f/stop you use, the lens mounted on the camera, and the focal length setting, vignetting can be non-existent, slight, or may be so strong that it appears you've used a too-small hood on your camera. (Indeed, the wrong lens hood can produce a vignette effect of its own.) Vignetting can be affected by the use of a telephoto converter (more on those in Chapter 10, too).

Peripheral illumination drop-off, even if pronounced, may not be much of a problem. I actually *add* vignetting, sometimes, when shooting portraits and some other subjects. Slightly dark corners tend to focus attention on a subject in the middle of the frame. On the other hand, vignetting with subjects that are supposed to be evenly illuminated, such as landscapes, is seldom a benefit.

To minimize the effects of corner light fall-off, you can process RAW files using Digital Photo Professional, or, if you want your JPEG files fixed as you shoot them, by using this menu option. Figure 8.6 shows an image without peripheral illumination correction at top, and a corrected image at the bottom. I've exaggerated the vignetting a little to make it more evident on the printed page. Keep in mind that the amount of correction available with Digital Photo Pro can be a little more

Figure 8.6

Vignetting (top) is undesirable in a landscape photo. You can correct this defect in the camera or by using Digital Photo Pro software.

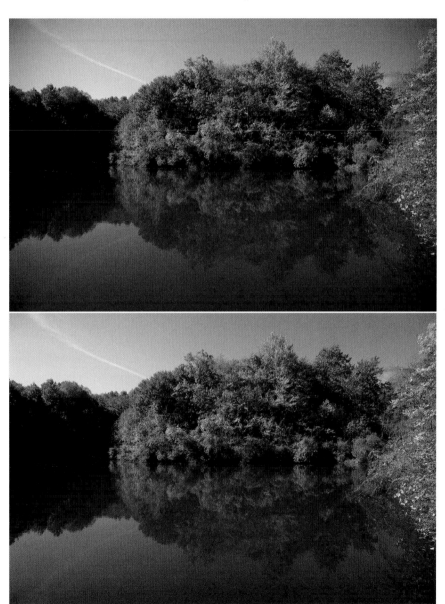

intense than that applied in the camera. In addition, the higher the ISO speed, the less correction is applied. If you see severe vignetting with a particular lens, focal length, or ISO setting, you might want to turn off this feature, shoot RAW, and apply correction using DPP instead.

When you select this menu option from the Shooting 1 menu, the screen shown in Figure 8.7 appears. The lens currently attached to the camera is shown, along with a notation whether correction data needed to brighten the corners is already registered in the camera. (Information about 20 of the most popular lenses is included in the T5's firmware.) If so, you can use the cross keys to choose Enable to activate the feature, or Disable to turn it off. Press the SET button to confirm your choice. Note that in-camera correction must be specified *before* you take the photo, so that the magical DIGIC 4 processing engine can lighten the corners of your photo before it is saved to the memory card.

If your lens is not registered in the camera, you can remedy that deficit using the EOS Utility. Just follow these steps:

1. **Link up your camera.** Connect your T5 to your computer using the USB cable supplied with the camera.

2. **Launch the EOS Utility.** Load the utility and click on Camera Settings/Remote Shooting from the splash screen that appears.

3. **Select the Shooting menu.** It's located on the menu bar located about midway in the control panel that appears on your computer display. The panel is shown at left in Figure 8.8. The Shooting menu icon is the white camera on a red background.

4. **Click on the Lens Aberration Correction choice.** The screen shown at right in Figure 8.8 will appear.

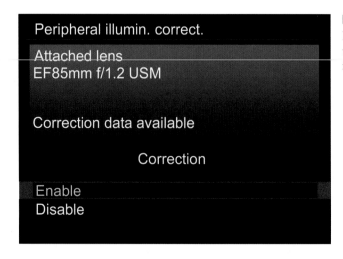

Figure 8.7
Peripheral illumination correction can fix dark corners.

Figure 8.8 Select the lenses to be corrected.

5. **Choose your lens.** Select the category containing the lens you want to register from the panels at the top of the new screen; then place a check mark next to all the lenses you'd like to register in the camera.

6. **Confirm your choice.** Click OK to send the data from your computer to the T5 and register your lenses.

7. **Activate correction.** When a newly registered lens is mounted on the camera, you will be able to activate the anti-vignetting feature for that lens from the Set-up 1 menu.

Red-Eye Reduction

Your Rebel T5 has a partially effective Red-Eye Reduction flash mode. Unfortunately, your camera is unable, on its own, to completely *eliminate* the red-eye effects that occur when an electronic flash (or, rarely, illumination from other sources) bounces off the retinas of the eye and into the camera lens. Animals seem to suffer from yellow or green glowing pupils, instead; the effect is equally undesirable. The effect is worst under low-light conditions (exactly when you might be using a flash) as the pupils expand to allow more light to reach the retinas. The most you can hope for is to *reduce* or minimize the red-eye effect.

The best way to truly eliminate red-eye is to raise the flash up off the camera so its illumination approaches the eye from an angle that won't reflect directly back to the retina and into the lens. The extra height of the built-in flash may not be sufficient, however. That alone is a good reason for using an external flash. If you're working with your T5's built-in flash, your only recourse may be to switch on the Red-Eye Reduction feature with the menu choice shown in Figure 8.9. It causes a lamp on the front of the camera to illuminate with a half-press of the shutter release button, which may cause your subjects' pupils to contract, decreasing the amount of the red-eye effect. (You may have to ask your subject to look at the lamp to gain maximum effect.) Figure 8.10 shows the effects of wider pupils (left) and those that have been contracted using the T5's Red-Eye Reduction feature.

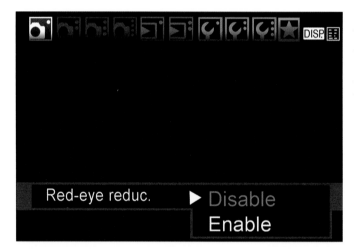

Figure 8.9
Turn on your camera's Red-Eye Reduction feature to help eliminate demon-red pupils.

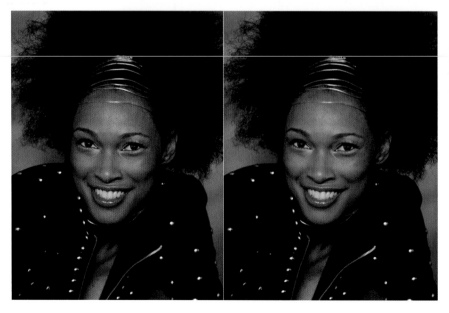

Figure 8.10
Red-eye (left) is tamed (right), thanks to the Rebel T5's red-eye reduction lamp.

Flash Control

This multi-level menu entry includes five settings for controlling the Canon Rebel T5's built-in, pop-up electronic flash unit, as well as accessory flash units you can attach to the camera (see Figure 8.11). I'll provide in-depth coverage of how you can use these options in Chapter 11, but will list the main options here for reference.

Flash Firing

Use this option to enable or disable the built-in electronic flash. You might want to totally disable the T5's flash (both built-in and accessory flash) when shooting in sensitive environments, such as concerts, in museums, or during religious ceremonies. When disabled, the flash cannot fire even if you accidentally elevate it, or have an accessory flash attached and turned on. If you turn off the flash here, it is disabled in any exposure mode.

Built-in Flash Function Setting

There are a total of four choices for this menu screen. All of these are explained in Chapter 11.

- **Flash mode.** This entry is fixed at E-TTL II. Other EOS cameras use this entry to allow you to choose Manual exposure.

- **Shutter sync.** You can choose 1st curtain sync, which fires the pre-flash used to calculate the exposure before the shutter opens, followed by the main flash as soon as the shutter is completely open. This is the default mode, and you'll generally perceive the pre-flash and main flash as a single burst. Alternatively, you can select 2nd curtain sync, which fires the pre-flash as soon as the shutter opens, and then triggers the main flash in a second burst at the end of

Figure 8.11
The Flash Control menu entry has five setting submenus.

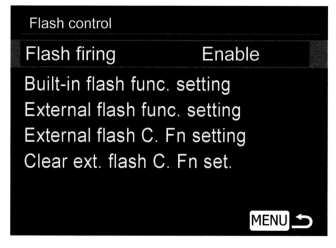

the exposure, just before the shutter starts to close. (If the shutter speed is slow enough, you may clearly see both the pre-flash and main flash as separate bursts of light.) This action allows photographing a blurred trail of light of moving objects with sharp flash exposures at the beginning and the end of the exposure. This type of flash exposure is slightly different from what some other cameras produce using 2nd curtain sync. I'll explain how it works in Chapter 11.

If you have an external compatible Speedlite attached, you can also choose Hi-speed sync, which allows you to use shutter speeds faster than 1/200th second, using the External Flash Function Setting menu, described next and explained in Chapter 11.

- **Flash exposure compensation.** If you'd like to adjust flash exposure using a menu, you can do that here. Select this option with the SET button, then dial in the amount of flash EV compensation you want using the cross keys. The EV that was in place before you started to make your adjustment is shown as a blue indicator, so you can return to that value quickly. Press SET again to confirm your change, then press the MENU button twice to exit.

- **E-TTL II meter.** Choose Evaluative metering (in which the camera analyzes the scene type and intelligently calculates the best overall exposure) or Average metering (which simply provides an exposure based on the average reflectance of the entire scene).

External Flash Function Setting

You can access this menu only when you have a compatible electronic flash attached and switched on. The first six settings available are shown in Figure 8.12. If you press the DISP. button while adjusting flash settings, both the changes made to the settings of an attached external flash and to the built-in flash will be cleared.

- **Flash mode.** This entry allows you to set the flash mode for the external flash, from E-TTL II, Manual flash, MULTI flash, TTL, AutoExtFlash, and Man.Ext flash. The first three are identical to the built-in flash modes just described. The second three are optional metering modes available with certain flash units, such as the 580 EX II, and are provided for those with a special need for one of those less sophisticated flash metering systems. While I don't recommend any of the latter three, you can find more information about them in your flash's manual.

- **Shutter sync.** As with the T5's built-in flash, you can choose 1st curtain sync, which fires the flash as soon as the shutter is completely open (this is the default mode). Alternatively, you can select 2nd curtain sync, which fires the flash as soon as the shutter opens, and then triggers a second flash at the end of the exposure, just before the shutter starts to close.

- **FEB.** Flash Exposure Bracketing (FEB) operates similarly to ordinary exposure bracketing, providing a series of different exposures to improve your chances of getting the exact right exposure, or to provide alternative renditions for creative purposes.

Figure 8.12
External flash units can be controlled from the Canon Rebel T5 using this menu.

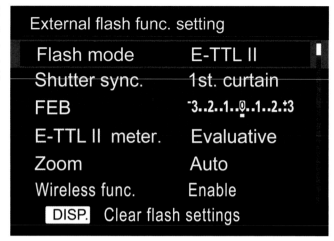

- **Flash exposure compensation.** You can adjust flash exposure using a menu here. Select this option with the SET button, then dial in the amount of flash EV compensation you want using the cross keys. The EV that was in place before you started to make your adjustment is shown as a blue indicator, so you can return to that value quickly. Press SET again to confirm your change, then press the MENU button twice to exit.

- **Zoom.** Some flash units can vary their coverage to better match the field of view of your lens at a particular focal length. You can allow the external flash to zoom automatically, based on information provided, or manually, using a zoom button on the flash itself. This setting is disabled when using a flash like the Canon 270EX II, which does not have zooming capability.

- **Wireless flash.** When an external flash is attached, you can scroll down this menu to discover additional wireless flash entries, which I'll explain in detail in Chapter 11.

External Flash Custom Function Setting

Many external Speedlites from Canon include their own list of Custom Functions, which can be used to specify things like flash metering mode and flash bracketing sequences, as well as more sophisticated features, such as modeling light/flash (if available), use of external power sources (if attached), and functions of any slave unit attached to the external flash. This menu entry allows you to set an external flash unit's Custom Functions from your T5's menu.

Clear External Flash Custom Function Setting

This entry allows you to zero-out any changes you've made to your external flash's Custom Functions, and return them to their factory default settings.

Exposure Compensation/Automatic Exposure Bracketing

The first entry on the Shooting 2 menu is Expo. Comp./AEB, or exposure compensation and automatic exposure bracketing. (See Figure 8.13.) As you learned in Chapter 4, exposure compensation (added/subtracted by rotating the cross keys while this menu screen is visible) increases or decreases exposure from the metered value.

Exposure bracketing using the T5's AEB feature is a way to shoot several consecutive exposures using different settings, to improve the odds that one will be exactly right. Automatic exposure bracketing is also an excellent way of creating the base exposures you'll need when you want to combine several shots to create a high dynamic range (HDR) image. (You'll find a discussion of HDR photography—one of the latest rages—in Chapter 4, too.)

To activate automatic exposure bracketing, select this menu choice, then rotate the Main Dial to spread or contract the three dots beneath the scale until you've defined the range you want the bracket to cover, shown as full-stop jumps in Figure 8.14. Then, use the cross keys to move the brackets right or left, biasing the bracketing toward underexposure (rotate left) or overexposure (rotate right).

When AEB is activated, the three bracketed shots will be exposed in this sequence: metered exposure, decreased exposure, increased exposure. You'll find more information about exposure bracketing in Chapter 4.

Auto Lighting Optimizer

The Auto Lighting Optimizer provides a partial fix for images that are too dark or flat. Such photos typically have low contrast, and the Auto Lighting Optimizer improves them—as you shoot—by increasing both the brightness and contrast as required. The feature can be activated in Program, Aperture-priority, and Shutter-priority modes (but not Manual mode). You can select from four settings: Standard (the default value, which is always selected when using Scene Intelligent Auto and Creative Auto modes, and used for Figure 8.15), plus Low, Strong, and Disable.

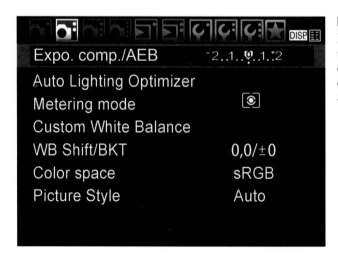

Figure 8.13

Exposure compensation/exposure bracketing is the first entry in the Shooting 2 menu.

Figure 8.14
Set the range of the three bracketed exposures.

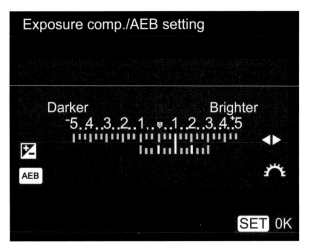

Figure 8.15
Auto Lighting Optimizer can brighten dark, low-contrast images (top), giving them a little extra snap and brightness (bottom).

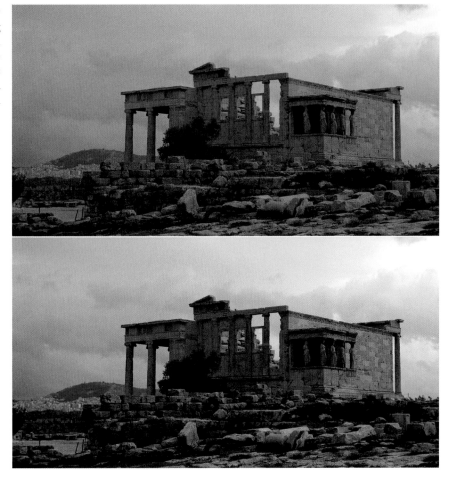

Metering Mode

Use this entry to select from among the available metering modes described in Chapter 2: Evaluative, Partial, and Center-weighted averaging.

Custom White Balance

If automatic white balance or one of the seven preset settings available (Auto, Daylight, Shade, Cloudy, Tungsten, White Fluorescent, or Flash) aren't suitable, you can set a custom white balance using this menu option. The custom setting you establish will then be applied whenever you select Custom using the White Balance menu that pops up when you press the WB button (the down cross key). (See Figure 8.16.)

To set the white balance to an appropriate color temperature under the current ambient lighting conditions, focus manually (with the lens set on MF) on a plain white or gray object, such as a card or wall, making sure the object fills the spot metering circle in the center of the viewfinder. Then, take a photo. Next press the MENU button and select Custom WB from the Shooting 2 menu. Use the cross keys until the reference image you just took appears and press the SET button to store the white balance of the image as your Custom setting.

A WHITE BALANCE LIBRARY

Shoot a selection of blank-card images under a variety of lighting conditions on a spare memory card. If you want to "recycle" one of the color temperatures you've stored, insert the card and set the Custom white balance to that of one of the images in your white balance library, as described above.

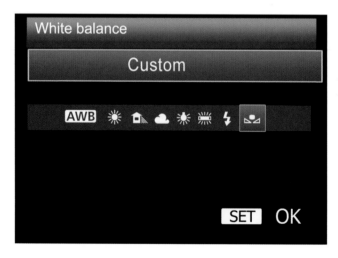

Figure 8.16
Preset white balance settings can be chosen from this menu, which appears when you press the WB button.

White Balance Shift and Bracketing

White balance shift allows you to dial in a white balance color bias along the blue-yellow/amber dimensions, and/or magenta/green scale. In other words, you can set your color balance so that it is a little bluer or yellower (only), a little more magenta or green (only), or a combination of the two bias dimensions. You can also bracket exposures, taking several consecutive pictures each with a slightly different color balance biased in the directions you specify.

The process is a little easier to visualize if you look at Figure 8.17. The center intersection of lines BA and GM (remember high school geometry!) is the point of zero bias. Move the point at that intersection using the cross keys to locate it at any point on the graph using the blue-yellow/amber and green-magenta coordinates. The amount of shift will be displayed in the SHIFT box to the right of the graph.

White balance bracketing is like white balance shifting, only the bracketed changes occur along the bias axis you specify. The three squares in Figure 8.17 show that the white balance bracketing will occur in two-stop steps along the blue-yellow/amber axis. The amount of the bracketing is shown in the lower box to the right of the graph.

This form of bracketing is similar to exposure bracketing, but with the added dimension of hue. Bias bracketing can be performed in any JPEG-only mode. You can't use any RAW format or RAW+JPEG format because the RAW files already contain the information needed to fine-tune the white balance and white balance bias.

When you select WB SHIFT/BKT, the adjustment screen appears. First, you press the cross keys to set the range of the shift in either the green/magenta dimension (move to the left to change the vertical separation of the three dots representing the separate exposures) or in the blue-yellow/amber dimension by pressing the right cross key. Use all four cross keys to move the bracket set around within the color space, and outside the green-magenta or blue-yellow/amber axes.

Figure 8.17
Use the cross keys to specify color balance bracketing using green-magenta bias or to specify blue-yellow/amber bias.

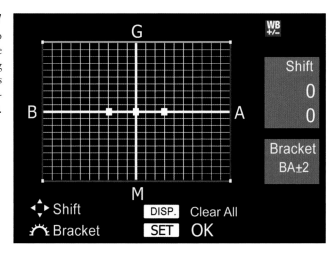

In most cases, it's fairly easy to determine if you want your image to be more green, more magenta, more blue, or more yellow, although judging your current shots on the LCD screen can be tricky unless you view the screen in a darkened location so it will be bright and easy to see. Bracketing is covered in Chapter 4.

Color Space

When you are using one of the Creative Zone modes, you can select one of two different color spaces (also called *color gamuts*) using this menu entry, shown previously among the other menu choices in Figure 8.13. One color space is named *Adobe RGB* (because it was developed by Adobe Systems in 1998), while the other is called *sRGB* (supposedly because it is the *standard* RGB color space). These two color gamuts define a specific set of colors that can be applied to the images your T5 captures.

The Color Space menu choice applies directly to JPEG images shot using P, Tv, Av, and M exposure modes. When you're using Full Auto or Creative Auto modes, the T5 uses the sRGB color space for all the JPEG images you take. RAW images are a special case. They have the information for *both* sRGB and Adobe RGB, but when you load such photos into your image editor, it will default to sRGB (with Full Auto or Creative Auto shots) or the color space specified here unless you change that setting while importing the photos. (See the "Best of Both Worlds" sidebar that follows for more information.)

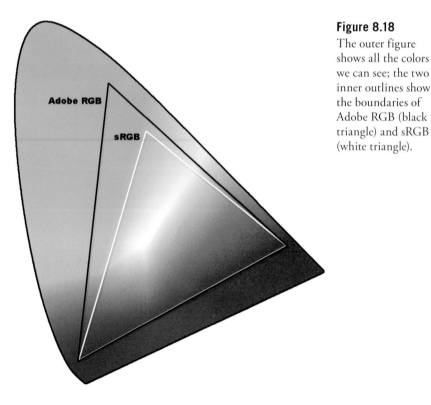

Figure 8.18
The outer figure shows all the colors we can see; the two inner outlines show the boundaries of Adobe RGB (black triangle) and sRGB (white triangle).

Adobe RGB

sRGB

You may be surprised to learn that the Rebel T5 doesn't automatically capture *all* the colors we see. Unfortunately, that's impossible because of the limitations of the sensor and the filters used to capture the fundamental red, green, and blue colors, as well as that of the elements used to display those colors on your camera and computer monitors. Nor is it possible to *print* every color our eyes detect, because the inks or pigments used don't absorb and reflect colors perfectly. In short, your sensor doesn't capture all the colors that we can see, your monitor can't display all the colors that the sensor captures, and your printer outputs yet another version.

On the other hand, the T5 does capture quite a few more colors than we need. The original 14-bit RAW image contains a possible 4.4 *trillion* different hues, which are condensed down to a mere 16.8 million possible colors when converted to a 24-bit (eight bits per channel) image. While 16.8 million colors may seem like a lot, it's a small subset of the 4.4 trillion captured, and an even smaller subset of all the possible colors we can see. The set of colors, or gamut, that can be reproduced or captured by a given device (scanner, digital camera, monitor, printer, or some other piece of equipment) is represented as a color space that exists within the larger full range of colors.

That full range is represented by the odd-shaped splotch of color shown in Figure 8.18, as defined by scientists at an international organization called the International Commission on Illumination (usually known as the CIE for its French name *Commission internationale de l'éclairage*) back in 1931. The colors possible with Adobe RGB are represented by the larger, black triangle in the figure, while the sRGB gamut is represented by the smaller white triangle.

Regardless of which triangle—or color space—is used by the T5, you end up with some combination of 16.8 million different colors that can be used in your photograph. (No one image will contain all 16.8 million! If each and every pixel in a 12-megapixel photo were a different color—which is extremely unlikely—you'd need only 12 million different colors.) But, as you can see from the figure, the colors available will be *different.*

Adobe RGB is what is often called an *expanded* color space, because it can reproduce a range of colors that is spread over a wider range of the visual spectrum. Adobe RGB is useful for commercial and professional printing. You don't need this range of colors if your images will be displayed primarily on your computer screen or output by your personal printer.

The other color space, sRGB, is recommended for images that will be output locally on the user's own printer, as this color space matches that of the typical inkjet printer fairly closely. While both Adobe RGB and sRGB can reproduce the exact same 16.8 million absolute colors, Adobe RGB spreads those colors over a larger portion of the visible spectrum, as you can see in the figure. Think of a box of crayons (the jumbo 16.8 million crayon variety). Some of the basic crayons from the original sRGB set have been removed and replaced with new hues not contained in the original box. Your "new" box contains colors that can't be reproduced by your computer monitor, but which work just fine with a commercial printing press.

BEST OF BOTH WORLDS

As I mentioned, if you're using a Basic Zone mode, the T5 selects the sRGB color space automatically. In addition, you may choose to set the sRGB color space with this menu entry to apply that gamut to all your other photos as well. But, in either case, you can still easily obtain Adobe RGB versions of your photos if you need them. Just shoot using RAW+JPEG. You'll end up with sRGB JPEGs suitable for output on your own printer, but you can still extract an Adobe RGB version from the RAW file at any time. It's like capturing two different color spaces at once—sRGB and Adobe RGB—and getting the best of both worlds.

Of course, choosing the right color space doesn't solve the problems that result from having each device in the image chain manipulating or producing a slightly different set of colors. To that end, you'll need to investigate the wonderful world of *color management*, which uses hardware and software tools to match or *calibrate* all your devices, as closely as possible, so that what you see more closely resembles what you capture, what you see on your computer display, and what ends up on a printed hardcopy. Entire books have been devoted to color management, and most of what you need to know doesn't directly involve your Canon Rebel T5, so I won't detail the nuts and bolts here.

To manage your color, you'll need, at the bare minimum, some sort of calibration system for your computer display, so that your monitor can be adjusted to show a standardized set of colors that is repeatable over time. (What you see on the screen can vary as the monitor ages, or even when the room light changes.) I use a Datacolor Spyder 4 color correction system for my computer, which has dual 26-inch widescreen LCD displays and a single 24-inch monitor. The Spyder checks room light levels every five minutes, and reminds me to recalibrate every week or two using the small sensor device shown in Figure 8.19, which attaches temporarily to the front of the screen with tiny suction cups and interprets test patches that the software displays during calibration. The rest of the time, the sensor sits in its stand, measuring the room illumination, and adjusting my monitors for higher or lower ambient light levels. If you're willing to make a serious investment in equipment to help you produce the most accurate color and make prints, you can get a more advanced system (up to $500) like the various Spyder products from Datacolor (www.datacolor.com), or Colormunki from X-Rite (www.colormunki.com).

Figure 8.19 Datacolor Spyder 4 monitor color correction system is an inexpensive device for calibrating your display.

Picture Style

The Picture Style feature is one of the most important tools for customizing the way your Canon Rebel T5 renders its photos. It carries the "ambience" idea of tweaking images as they are shot to a new level. Picture Styles are a type of fine-tuning you can apply to your photos to change certain characteristics of each image taken using a particular Picture Style setting. The parameters you can specify for full-color images include the amount of sharpness, degree of contrast, the richness of the color, and the hue of skin tones. For black-and-white images, you can tweak the sharpness and contrast, but the two color adjustments (meaningless in a monochrome image) are replaced by controls for filter effects (which I'll explain shortly), and sepia, blue, purple, or green tone overlays.

The Canon Rebel T5 has six preset color Picture Styles, for Auto, Standard, Portrait, Landscape, Neutral, and Faithful pictures, and three user-definable settings called User Def. 1, User Def. 2, and User Def. 3, which you can define to apply to any sort of shooting situation you want, such as sports, architecture, or baby pictures. There is also a seventh, Monochrome, Picture Style that allows you to adjust filter effects or add color toning to your black-and-white images. See Figure 8.20 for the main Picture Style menu.

Tip

As with the Color Space menu entry, the full range of Picture Styles can be applied directly *only* to JPEG images shot using P, Tv, Av, and M exposure modes. When using Full Auto, the Canon Rebel T5 selects the Standard Picture Style. In Creative Auto, you can't access the full Picture Styles. You can choose from Standard, Portrait, Landscape, or Monochrome modes (only) using the Quick Control screen (press the Q button to access it). Any RAW format file can be adjusted to any Picture Style you want when the photo is imported into your image editor.

Figure 8.20
Nine different Picture Styles are available from this scrolling menu; these six plus three User Def. styles not shown.

Picture Style				
A Auto	3,	0,	0,	0
S Standard	3,	0,	0,	0
P Portrait	2,	0,	0,	0
L Landscape	4,	0,	0,	0
N Neutral	0,	0,	0,	0
F Faithful	0,	0,	0,	0

DISP Detail set. SET OK

Picture Styles are extremely flexible. Canon has set the parameters for the six predefined color Picture Styles and the single monochrome Picture Style to suit the needs of most photographers. But you can adjust any of those "canned" Picture Styles to settings you prefer. Better yet, you can use those three User Definition files to create brand-new styles that are all your own. If you want rich, bright colors to emulate Velvia film or the work of legendary photographer Pete Turner, you can build your own color-soaked style. If you want soft, muted colors and less sharpness to create a romantic look, you can do that, too. Perhaps you'd like a setting with extra contrast for shooting outdoors on hazy or cloudy days.

The parameters applied when using Picture Styles follow. Figure 8.21 shows exaggerated examples of the first four (color photo) attributes, as applied by Picture Styles (your real-world tweaks may not be quite this drastic, but are more difficult to represent on the printed page):

- **Sharpness.** This parameter determines the apparent contrast between the outlines or edges in an image, which we perceive as image sharpness. You can adjust the sharpness of the image between values of 0 (no sharpening added) to 7 (dramatic additional sharpness). When adjusting sharpness, remember that more is not always a good thing. A little softness is necessary (and is introduced by a blurring "anti-alias" filter in front of the sensor) to reduce or eliminate the moiré effects that can result when details in your image form a pattern that is too close to the pattern, or frequency, of the sensor itself. The default levels of sharpening (which are, for most Picture Styles, not 0) were chosen by Canon to allow most moiré interference to be safely blurred to invisibility, at the cost of a little sharpness. As you boost sharpness (either using a Picture Style or in your image editor), moiré can become a problem, plus, you may end up with those noxious "halos" that appear around the edges of images that have been oversharpened. Use this adjustment with care.

- **Contrast.** Use this control, with values from −4 (low contrast) to +4 (higher contrast), to change the number of middle tones between the deepest blacks and brightest whites. Low contrast settings produce a flatter-looking photo, while high contrast adjustments may improve the tonal rendition while possibly losing detail in the shadows or highlights.

- **Saturation.** This parameter, adjustable from −4 (low saturation) to +4 (high saturation) controls the richness of the color, making, say, a red tone appear to be deeper and fuller when you increase saturation, and tend more toward lighter, pinkish hues when you decrease saturation of the reds. Boosting the saturation too much can mean that detail may be lost in one or more of the color channels, producing what is called "clipping." You can detect this phenomenon when using the RGB histograms, as described in Chapter 4.

- **Color tone.** This adjustment has the most effect on skin tones, making them either redder (0 to −4) or yellower (0 to +4).

- **Filter effect (Monochrome only).** Filter effects do not add any color to a black-and-white image. Instead, they change the rendition of gray tones as if the picture were taken through a color filter. I'll explain this distinction more completely in the sidebar "Filters vs. Toning" later in this section.

- **Toning effect (Monochrome only).** Using toning effects preserves the monochrome tonal values in your image, but adds a color overlay that gives the photo a sepia, blue, purple, or green cast.

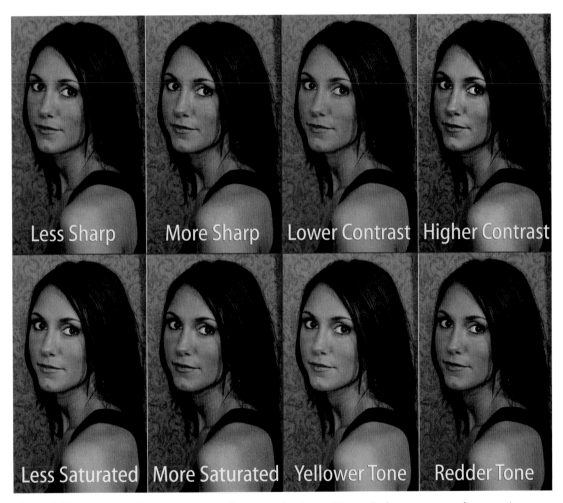

Figure 8.21 These sets of photos represent the main color image Picture Styles parameters: sharpness (upper-left pair); contrast (upper-right pair); saturation (lower-left pair); and color tone (lower-right pair).

The predefined Picture Styles are as follows:

- **Auto.** The camera adjusts the color tones automatically, producing vivid hues.

- **Standard.** This Picture Style applies a set of parameters, including boosted sharpness, that are useful for most picture taking, and which are applied automatically when using Basic Zone modes other than Portrait or Landscape.

- **Portrait.** This style boosts saturation for richer colors when shooting portraits, which is particularly beneficial for women and children, while reducing sharpness slightly to provide more flattering skin texture. The Basic Mode Portrait setting uses this Picture Style. You might prefer the Faithful style for portraits of men when you want a more rugged or masculine look, or when you want to emphasize character lines in the faces of older subjects of either gender.

- **Landscape.** This style increases the saturation of blues and greens, and increases both color saturation and sharpness for more vivid landscape images. The Basic Zone Landscape mode uses this setting.

- **Neutral.** This Picture Style is a less-saturated and lower-contrast version of the Standard style. Use it when you want a more muted look to your images, or when the photos you are taking seem too bright and contrasty (say, at the beach on a sunny day).

- **Faithful.** The goal of this style is to render the colors of your image as accurately as possible, roughly in the same relationships as seen by the eye.

- **Monochrome.** Use this Picture Style to create black-and-white photos in the camera. If you're shooting JPEG only, the colors are gone forever. But if you're shooting JPEG+RAW, sRAW1, or sRAW2, you can convert the RAW files to color as you import them into your image editor, even if you've shot using the Monochrome Picture Style. Your T5 displays the images in black-and-white on the screen during playback, but the colors are there in the RAW file for later retrieval.

Tip

You can use the Monochrome Picture Style even if you are using one of the RAW formats alone, without a JPEG version. The Rebel T5 displays your images on the screen in black-and-white, and marks the RAW image as monochrome so it will default to that style when you import it into your image editor. However, the color information is still present in the RAW file and can be retrieved, at your option, when importing the image.

Selecting Picture Styles

Canon makes selecting a Picture Style very easy, and, to prevent you from accidentally changing an existing style when you don't mean to, divides *selection* and *modification* functions into two separate tasks. There are actually two different ways to choose from among your existing Picture Styles.

One way is to choose Picture Styles from the Shooting 2 menu and press SET to produce the main Picture Style menu screen. Use the cross keys to rotate among the choices. (Auto, Standard, Portrait, Landscape, Neutral, Faithful, Monochrome, and User Def. 1, User Def. 2, and User Def. 3 are shown in Figure 8.22; the rest appear when you scroll using the cross keys.) The current settings for each Picture Style are shown on the right half of the screen. Press SET to activate your choice. Then press the MENU button to exit the menu system. You can see that even with this method, switching among Picture Styles is fast and easy enough to allow you to shift gears as often as you like during a shooting session.

But your T5 offers an even simpler way to activate a Picture Style. Press the Q button and navigate to the Picture Styles section, and press SET. Then use the cross keys to scroll through the list of available styles on the screen that appears, shown in Figure 8.23. When you use this method, the current settings for a particular style are shown *only* when you've highlighted that style. Press SET to activate the style of your choice.

Figure 8.22
You can select a style from the Picture Style menu in the Shooting 2 menu.

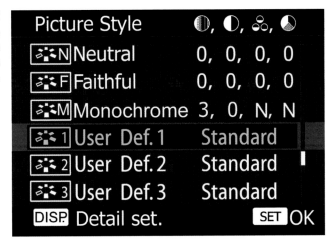

Figure 8.23
Choose Picture Style from the Quick Control menu to choose a style from this fast-access screen.

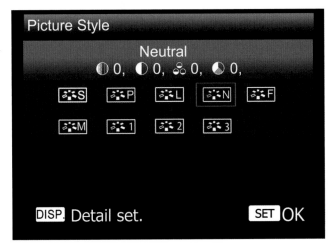

Defining Picture Styles

Canon makes interpreting current Picture Style settings and applying changes very easy. As you saw in Figures 8.22 and 8.23, the current settings of the visible Picture Style options are shown as numeric values on the menu screen. Some camera vendors use word descriptions, like Sharp, Extra Sharp, or Vivid, More Vivid that are difficult to relate to. The T5's settings, on the other hand, are values on uniform scales, with seven steps (from 1 to 7) for sharpness, and plus/minus four steps clustered around a zero (no change) value for contrast and saturation (so you can change from low contrast/low saturation, −4, to high contrast/high saturation, +4), as well as color tone (−4/reddish to +4/yellowish). The individual icons at the top of Figure 8.22 represent (left to right) Sharpness, Contrast, Saturation, and Color Tone.

You can change one of the existing Picture Styles or define your own whenever the Shooting 2 menu version of the Picture Styles menu, or the pop-up selection screen shown in Figure 8.23, is visible. Just press the DISP. button when either screen is on the LCD. Follow these steps:

1. **Choose a style to modify.** Use the cross keys to scroll to the style you'd like to adjust.

2. **Activate adjustment mode.** Press the DISP. button to choose Detail Set. If you're coming from the Shooting 2 menu, the screen that appears next will look like the one shown in Figure 8.24 for the five color styles or three User Def. styles.

3. **Choose a parameter to change.** Use the cross keys to scroll among the four parameters, plus Default Set. at the bottom of the screen, which restores the values to the preset numbers.

4. **Activate changes.** Press SET to change the values of one of the four parameters. If you're redefining one of the default presets, the menu screen will look like Figure 8.24, which represents the Landscape Picture Style.

5. **Adjust values.** Use the cross keys to move the triangle to the value you want to use. Note that the previous value remains on the scale, represented by a gray triangle. This makes it easy to return to the original setting if you want.

6. **Confirm changes.** Press the SET button to lock in that value, then press the MENU button three times to back out of the menu system.

Any Picture Style that has been changed from its defaults will be shown in the Picture Style menu with blue highlighting the altered parameter. You don't have to worry about changing a Picture Style and then forgetting that you've modified it. A quick glance at the Picture Style menu will show you which styles and parameters have been changed.

Making changes in the Monochrome Picture Style is slightly different, as the Saturation and Color Tone parameters are replaced with Filter Effect and Toning Effect options. (See Figure 8.25.) (Keep in mind that once you've taken a photo using a Monochrome Picture Style, you can't convert the image back to full color.) You can choose from Yellow, Orange, Red, Green filters, or None, and specify Sepia, Blue, Purple, or Green toning, or None. You can still set the Sharpness and Contrast parameters that are available with the other Picture Styles. Figure 8.26 shows filter effects being applied to the Monochrome Picture Style.

Figure 8.24
Each parameter can be changed separately.

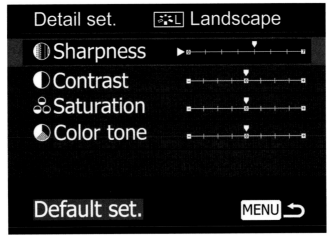

Figure 8.25
Apply changes to the Monochrome Picture Style.

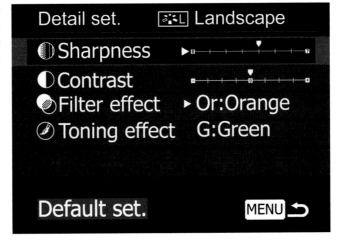

FILTERS VS. TONING

Although some of the color choices overlap, you'll get very different looks when choosing between Filter Effects and Toning Effects. Filter Effects add no color to the monochrome image. Instead, they reproduce the look of black-and-white film that has been shot through a color filter. That is, Yellow will make the sky darker and the clouds will stand out more, whereas Orange makes the sky even darker and sunsets more full of detail. The Red filter produces the darkest sky of all and darkens green objects, such as leaves. Human skin may appear lighter than normal. The Green filter has the opposite effect on leaves, making them appear lighter in tone. Figure 8.26 shows the same scene shot with no filter, then Yellow, Green, and Red filters. The Sepia, Blue, Purple, and Green Toning Effects, on the other hand, all add a color cast to your monochrome image. Use these when you want an old-time look or a special effect, without bothering to recolor your shots in an image editor. Figure 8.27 shows the various Toning Effects available.

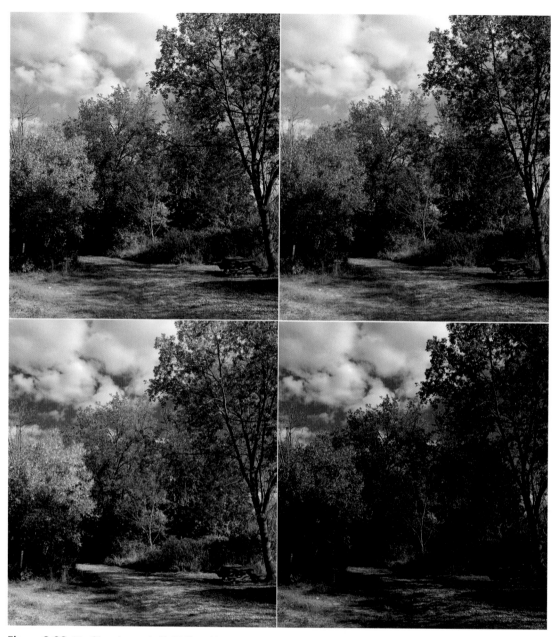

Figure 8.26 No filter (upper left); Yellow filter (upper right); Green filter (lower left); and Red filter (lower right).

Figure 8.27
Select from among four color filters in the Monochrome Picture Style, including Sepia (top left); Blue (top right); Purple (lower left); and Green (lower right).

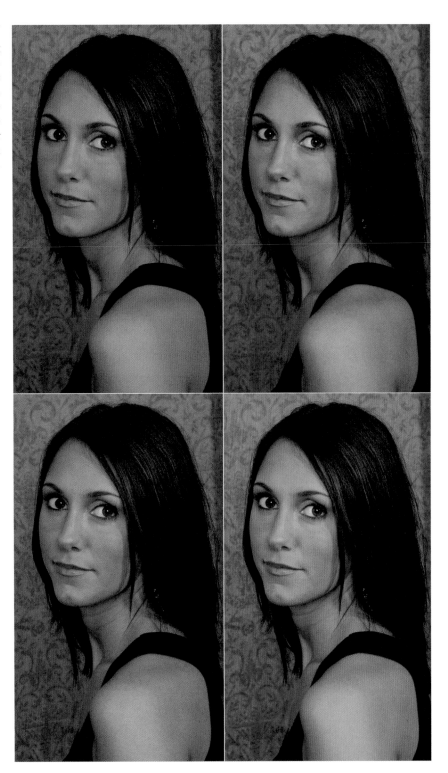

Adjusting Styles with the Picture Style Editor

If you'd rather edit Picture Styles in your computer, the Picture Style Editor, supplied for your camera in versions for both Windows and Macs, allows you to create your own custom Picture Styles, or edit existing styles, including the Standard, Landscape, Faithful, and other predefined settings already present in your Rebel T5. You can change sharpness, contrast, color saturation, and color tone—and a lot more—and then save the modifications as a PF2 file that can be uploaded to the camera, or used by Digital Photo Professional to modify a RAW image as it is imported.

To create and load your own Picture Style, just follow these steps:

1. **Load the editor.** Launch the Picture Style Editor (PSE, not to be confused with the *other* PSE, Photoshop Elements).

2. **Access a RAW file.** Load a RAW CR2 image you'd like to use as a reference into PSE. You can drag a file from a folder into the editor's main window, or use the Open command in the File menu.

3. **Choose an existing style to base your new style on.** Select any of the base styles except for Standard. Your new style will begin with all the attributes of the base style you choose, so start with one that already is fairly close to the look you want to achieve ("tweaking" is easier than building a style from the ground up).

4. **Split the screen.** You can compare the appearance of your new style with the base style you are working from. Near the lower-left edge of the display pane are three buttons you can click to split the old/new styles vertically, horizontally, or return to a single image.

5. **Dial in basic changes.** Click the Advanced button in the Tool palette to pop up the Advanced Picture Style Settings dialog box. These are the same parameters you can change in the camera. Click OK when you're finished.

6. **Make advanced changes.** The Tool palette has additional functions for adjusting hue, tonal range, and curves. Use of these tools is beyond the scope of a single chapter, let alone a notation in a list, but if you're familiar with the advanced tools in Photoshop, Photoshop Elements, Digital Photo Pro, or another image editor, you can experiment to your heart's content. Note that these modifications go way beyond what you can do with Picture Styles in the camera itself, so learning how to work with them is worth the effort.

7. **Save your Picture Style.** When you're finished, choose Save Picture Style File from the File menu to store your new style as a PF2 file on your hard disk. Add a caption and copyright information to your style in the boxes provided. If you click Disable Subsequent Editing, your style will be "locked" and protected from further changes, and the modifications you did make will be hidden from view (just in case you dream up your own personal, "secret" style). But you'll be unable to edit that style later on. If you think you might want to change your custom Picture Style, save a second copy without marking the Disable Subsequent Editing box.

Uploading a Picture Style to the Camera

Now it's time to upload your new style to your Canon Rebel T5 into one of your three User Def. slots in the Picture Style array. Just follow these steps:

1. **Link your camera for upload.** Connect your camera to your computer using the USB cable, turn the T5 on, launch the EOS Utility, and click the Camera Settings/Remote Shooting choice in the splash screen.

2. **Choose the Shooting menu.** It's marked with an icon of a white camera on a red background, from the menu bar located about midway in the control panel that appears on your computer display.

3. **Select Register User Defined Style.** Click on the box, outlined in red, to produce the Register Picture Style dialog box.

4. **Choose a User Def. tab.** Click on one of the three tabs, labeled User Def. 1, User Def. 2, or User Def. 3. Each tab will include the name of the current Picture Style active in that tab.

5. **Click the Open File button.**

6. **Choose the Picture Style file to load.** The Picture Styles you've saved (or downloaded from another source) will appear with a PF2 extension. Click on the one you want to use, and then click the Open button in the Open dialog box.

7. **Upload Picture Style to the camera.** The Register Picture Style File dialog box will return. Click OK and the Picture Style will be uploaded to the camera in the User Def. "slot" represented by the tab you've chosen. The name of the Picture Style will appear in the T5's menu in place of User Def. 1 (or User Def. 2/User Def. 3).

Changing a Picture Style's Settings from the EOS Utility

You can modify the settings of a Picture Style that's already loaded into your camera from the EOS Utility when your camera is linked to your computer. Just follow these steps:

1. **Link your camera to the computer.** Connect your camera to your computer using the USB cable, turn the T5 on, launch the EOS Utility, and click the Camera Settings/Remote Shooting choice in the splash screen.

2. **Choose the Shooting menu.** It's marked with an icon of a white camera on a red background, from the menu bar located about midway in the control panel that appears on your computer display.

3. **Access the Picture Style.** Click on the Picture Style choice. The currently active Picture Style in the camera will be shown, along with its detail settings.

4. **Choose a Picture Style to modify.** Click the Picture Style box to produce a listing of all the available Picture Styles.

5. **Click Detail Set**. At lower left Landscape is now highlighted. When you click on Detail Set, you can move the sliders to change the settings, as described earlier. You can also click the Default Set. button to return the settings to their original values.

6. **Confirm choice.** Click Return when you've finished making changes, and the Picture Style you've modified will be changed in the camera.

7. **Exit EOS Utility.** Disconnect your camera from your computer, and your modified style is ready to use.

Getting More Picture Styles

I've found that careful Googling can unearth other Picture Styles that helpful fellow EOS owners have made available, and even a few from the helpful Canon company itself. My own search turned up this link: http://web.canon.jp/imaging/picturestyle/file/index.html, where Canon offers a half dozen or more useful PF2 files you can download and install on your own. Remember that Picture Style files are compatible between various Canon EOS camera models (that is, you can use a style created for the Canon 70D with your T5), but you should be working with the latest software versions to work with the latest cameras and Picture Styles. If you installed your software from the CDs that came with your Rebel T5, you're safe. If you owned an earlier EOS and haven't re-installed the software since your camera upgrade, you might need to re-install the software. It's available for download from the Canon website.

Try the additional styles Canon offers. They include:

- **Studio Portrait.** Compared to the Portrait style built into the camera, this one, Canon says, expresses translucent skin in smooth tones, but with less contrast. (Similar to films in the pre-digital age that were intended for studio portraiture.)

- **Snapshot Portrait.** This is another "translucent skin" style, but with increased contrast with enhanced contrast indoors or out.

- **Nostalgia.** This style adds an amber tone to your images, while reducing the saturation of blue and green tones.

- **Clear.** This style adds contrast for what Canon says is additional "depth and clarity."

- **Twilight.** Adds a purple tone to the sky just before and after sunset or sunrise.

- **Emerald.** Emphasizes blues and greens.

- **Autumn Hues.** Increases the richness of browns and red tones seen in fall colors.

Dust Delete Data

This menu choice is the first of two that appear in the Shooting 3 menu. (See Figure 8.28.) It lets you "take a picture" of any dust or other particles that may be adhering to your sensor. The T5 will then append information about the location of this dust to your photos, so that the Digital Photo Professional software can use this reference information to identify dust in your images and remove it automatically. You should capture a Dust Delete Data photo from time to time as your final line of defense against sensor dust.

To use this feature, select Dust Delete Data to produce the screen shown in Figure 8.29. Select OK and press the SET button. The camera will first perform a self-cleaning operation by applying ultrasonic vibration to the low-pass filter that resides on top of the sensor. Then, a screen will appear asking you to press the shutter button. Point the T5 at a solid-white card with the lens set on manual focus and rotate the focus ring to infinity. When you press the shutter release, the camera takes a photo of the card using Aperture-priority and f/22 (which provides enough depth-of-field [actually, in this case, *depth-of-focus*] to image the dust sharply). The "picture" is not saved to your memory card but, rather, is stored in a special memory area in the camera. Finally, a "Data obtained" screen appears.

The Dust Delete Data information is retained in the camera until you update it by taking a new "picture." The T5 adds the information to each image file automatically.

Figure 8.28
Dust Delete Data is the first choice in the Shooting 3 menu.

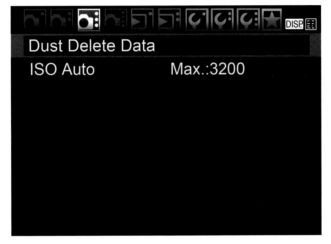

Figure 8.29
Capture updated dust data for your sensor to allow Digital Photo Professional to remove it automatically.

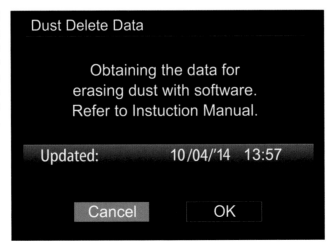

ISO Auto

When you select Auto for your ISO sensitivity setting, the T5 will choose an ISO appropriate for the amount of illumination available; that is, a higher ISO in dimmer conditions, and a lower ISO for brighter scenes. The actual ISO in use will be displayed on the top-panel LCD when you press the shutter button halfway, so you aren't necessarily in the dark (so to speak) about the ISO setting being applied. The actual range used depends on the shooting mode you're working with, and the maximum you set using this menu entry. This menu entry allows you to place a limitation on the ranges selected in certain shooting modes, as outlined in Table 8.1 and discussed next.

- **P, Tv, Av, M modes.** You can select a maximum ISO that will be selected when using any of these modes. Choose from ISO 400, 800, 1600, 3200, or 6400. Use this capability to minimize the amount of noise that might result by blocking the T5's ability to automatically select an ISO sensitivity higher than the limit you choose.

- **P and Basic Zone modes (except Night Portrait) with bounce flash.** If you select ISO 400 or ISO 800 as your maximum, then the T5 will adhere to that limitation when choosing an ISO speed with bounce flash and an external Speedlite. If you set the max to ISO 1600 or higher, then the T5 will apply the ISO 400–1600 range when using bounce flash in these modes.

Table 8.1 Automatic ISO Ranges

Shooting Mode	ISO Range
Basic Zone modes other than Portrait mode	ISO 100–3200 (Auto)
Portrait mode	ISO 100 (Fixed)
Bulb	ISO 800 (Fixed)
All modes, direct flash	ISO 800
Program mode/Basic Zone modes except Night Portrait, with bounce flash and external Speedlite	ISO 400–1600 (Auto)
Program, Tv, Av, M modes	ISO 100–6400 (Auto)
Movie shooting	ISO 100–6400

Live View Shooting

This menu entry is the first in the Shooting 4 menu (see Figure 8.30). All of the settings on this tab pertain to the T5's live view functions, which I explained in detail in Chapter 6. I'll provide only a recap here:

■ **Live View shoot.** Enable/disable live view shooting here. As I mentioned, disabling live view does not affect movie shooting, which is activated by rotating the Mode Dial to the Movie position.

■ **Autofocus mode (Quick mode, Live mode, Live "face detection" mode).** This option lets you choose between phase detection, contrast detection, and contrast detection with face recognition.

■ **Grid display (Off, Grid 1, Grid 2).** Overlays Grid 1, a "rule of thirds" grid, on the screen to help you compose your image and align vertical and horizontal lines; or Grid 2, which consists of four rows of six boxes, which allow finer control over placement of images in your frame.

■ **Aspect Ratio.** Choose from 3:2, 4:3, 16:9, or 1:1 proportions.

■ **Metering timer (4 sec. to 30 min.).** This option allows you to specify how long the EOS T5's metering system will remain active before switching off. Tap the shutter release to start the timer again after it switches off. This choice is not available when using a Basic Zone mode.

Figure 8.30
Most of the settings on the Shooting 4 menu involve live view functions.

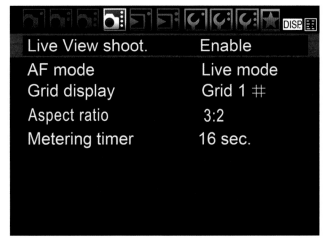

Playback 1 & 2 Menu Options

The two blue-coded Playback menus are where you select options related to the display, review, and printing of the photos you've taken. The choices you'll find include:

- Protect Images
- Rotate Image
- Erase Images
- Print Order
- Photobook Set-up
- Creative Filters

- Resizing
- Histogram Display
- Image Jump with Main Dial
- Slide Show
- Rating
- Ctrl over HDMI

Protect Images

This is the first entry in the Playback 1 menu (see Figure 8.31). If you want to keep an image from being accidentally erased (either with the Erase button or by using the Erase Images menu entry), you can mark that image for protection. To protect one or more images, press the MENU button while viewing an image and choose Protect Images. Then, select from the following options:

- Select Images
- All Images in Folder
- Unprotect All Images in Folder

- All Images on Card
- Unprotect All Images on Card

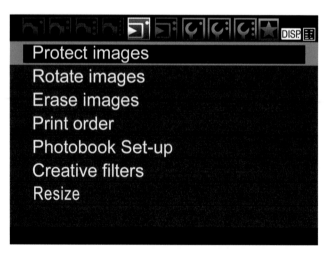

Figure 8.31
The Playback 1 menu.

Figure 8.32
Protected images can be locked against accidental erasure (but not preserved from formatting).

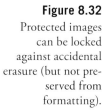

If you choose the first option, you can view and select individual images by pressing the SET button when they are displayed on the screen. A key icon will appear at the upper edge of the information display while still in the protection screen, and when reviewing that image later (see Figure 8.32). To remove protection, repeat the process. You can scroll among the other images on your memory card and protect/unprotect them in the same way. Image protection will not save your images from removal when the card is reformatted.

Rotate Image

While you can set the Rebel T5 to automatically rotate images taken in a vertical orientation using the Auto Rotate option in the Set-up 1 menu (as described in Chapter 9), you can manually rotate an image during playback using this menu selection. Select Rotate from the Playback 1 menu, use the cross keys to page through the available images on your memory card until the one you want to rotate appears, then press SET. The image will appear on the screen rotated 90 degrees, as shown in Figure 8.33. Press SET again, and the image will be rotated 270 degrees.

Figure 8.33
A vertically oriented image that isn't rotated appears larger on the LCD, but rotation allows viewing the photo without turning the camera.

Erase Images

Choose this menu entry and you'll be given three choices: Select and Erase Images, All Images in Folder, and All Images on Card. You can use the first two to selectively remove images; although the third option does delete all the pictures on a card, using the Format command is usually faster and more thorough.

- **Select and Erase Images.** View the images on your card by pressing the left/right cross keys to scroll through them. To mark an image for deletion or to remove a check mark, press the up/down cross keys. When you're finished selecting, press the Trash button (to the left of the viewfinder window) and you'll be asked to confirm. Choose Cancel or OK and press SET to finish.

- **All Images in Folder.** You'll be shown a list of the available folders on your memory card. Press SET, and a prompt will appear asking you to confirm, and reminding you that Protected images will not be removed.

- **All Images on Card.** A prompt will ask you to confirm this step. The All Images on Card choice removes all the pictures on the card, except for those you've marked with the Protect command, and does not reformat the memory card.

Print Order

The Rebel T5 supports the DPOF (Digital Print Order Format) that is now almost universally used by digital cameras to specify which images on your memory card should be printed, and the number of prints desired of each image. This information is recorded on the memory card, and can be interpreted by a compatible printer when the camera is linked to the printer using the USB cable, or when the memory card is inserted into a card reader slot on the printer itself. Photo labs are also equipped to read this data and make prints when you supply your memory card to them.

Direct Printing from the Camera

You can print photos stored on your camera's memory card directly to a PictBridge-compatible printer using the cable supplied with the T5. Just follow these steps to get started:

1. **Set up your printer.** Follow the instructions for your PictBridge-compatible printer to load it with paper, and prepare it for printing.

2. **Connect the camera to the printer.** With the T5 and printer both powered down, open the port cover on the left side of the camera (closest to the back of the camera when it's held in shooting position), and plug the Interface Cable IFC-200U into the A/V Out/Digital port. Connect the other end to the USB input port of your printer.

3. **Turn printer and camera on.** Flip the switch on the T5, and power up your printer using its power switch.

4. **Press the Playback button on the camera.** Navigate to the image on your memory card that you want to print using the cross keys.

5. **Select options.** The image, overlaid with the current status for options like those shown in Figure 8.34, will appear when the camera and printer are connected with a cable. (The options will vary, depending on what printer you have.) I'll describe the options next.

Figure 8.34
You can print directly from the EOS T5.

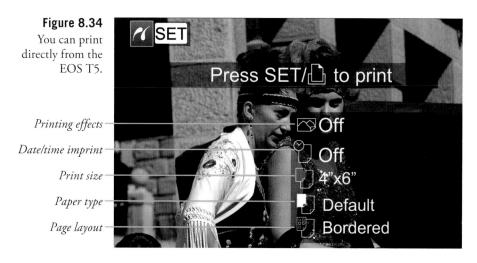

Printing effects
Date/time imprint
Print size
Paper type
Page layout

The EOS T5 offers a surprising number of options when direct printing from your camera. You can choose effects, print date and time on your hardcopies, select the number of copies to be output, trim the image, and select paper settings—from your camera! While you can print using the current values as shown in the status screen, to adjust the settings, follow the steps briefly summarized here, with the camera connected to the printer:

■ **Access the print options screen.** Press SET when the screen shown in Figure 8.35 is shown on your LCD.

■ **Use the cross keys.** Highlight the options shown at right in Figure 8.35 in any order, and press SET to adjust that option. Within each option, use the SET button to confirm your entry, or the MENU button to back out of the option's screen.

■ **Printing effects.** Use the cross keys to choose Off (no effects), On (the printer's automatic corrections will be applied), Default (values stored in your printer, and which will vary depending on your printer), Vivid (higher saturation in blues and greens), or NR (noise reduction is applied). Three B/W choices are also available, for B/W (true blacks), B/W Cool tone (bluish blacks), and B/W Warm tone (yellowish blacks). Natural and Natural M choices are also available to provide true colors. If the INFO. icon appears, you can press it to make some adjustments to the printing effect, including image brightening, levels, and red-eye correction.

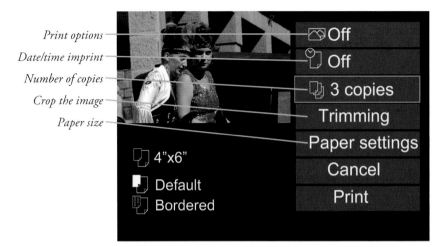

Print options
Date/time imprint
Number of copies
Crop the image
Paper size

Figure 8.35
Choose the number
of copies, crop the
image, and apply
other settings and
preferences.

- **Date/File number imprint.** You can set this On, Off, Default, Date, File No., or Both.

- **Copies.** Select 1 to 99 copies of the selected image.

- **Trimming.** Use this to crop your image. Your image appears on a trimming screen. Press the Magnify and Reduce buttons to magnify or reduce the size of the cropping frame. Use the cross keys to move the cropping frame around within the image. Rotate the cross keys to rotate the image. Press the INFO. button to toggle the cropping frame between horizontal and vertical orientations. When you've defined the crop for the image, press the SET button to apply your trimming to the image.

- **Paper settings.** Choose the paper size, type, and layout. Use the cross keys to select your paper size, with choices from credit card size through 8.5 × 11 inches. Press SET to confirm, and the screen changes to a Paper Type selection. After choosing Paper Type, press SET once more and choose a layout, from Borderless, Bordered, 2-up, 4-up, 9-up, 16-up, and 20-up (multiple copies of the image on a single sheet). When using Letter size (8.5 × 11-inch) paper, you can also elect to print 20-up and 35-up thumbnails of images you've chosen using the DPOF options described later in this chapter. The 20-up version will also include shooting information, such as camera and lens used, shooting mode, shutter speed, aperture, and other data. Another press of the SET button confirms Paper Type and returns to the settings screen.

- **Cancel.** Returns to the status screen.

- **Print.** Starts the printing process with the selected options. The camera warns you not to disconnect the cable during printing. To print another photo using the same settings, just select it, highlight Print and press the SET button.

Direct Print Order Format (DPOF) Printing

If you don't want to print directly from the camera, you can set some of the same options from the Playback 1 menu's Print Order entry, and designate single or multiple images on your memory card for printing. Once marked for DPOF printing, you can print the selected images, or take your memory card to a digital lab or kiosk, which is equipped to read the print order and make the copies you've specified. (You can't "order" prints of RAW images or movies.)

To create a DPOF print order, just follow these steps:

1. **Access Print Order screen.** In the Playback 1 menu, navigate to Print Order. Press SET.

2. **Access Set up.** The Print Order screen will appear. (See Figure 8.36.) Use the cross keys to highlight Set Up. Press SET.

3. **Select Print type.** Choose Print Type (Standard, Index/Thumbnails print, or Both), and specify whether Date or File Number imprinting should be turned on or off. (You can turn one or the other on, but not both Date and File Number imprinting.) Press MENU to return to the Print Order screen.

4. **Choose selection method.** Highlight Sel. Image (choose individual images), By Folder (to select/deselect all images in a folder), or All Image (to mark/unmark all the images on your memory card). Press SET.

5. **Select individual images.** With Sel. Image, use the cross keys to view the images, and press SET to mark or unmark an image for printing. If you'd rather view thumbnails of images, press the Magnify button. Press the Reduce button to return to single-image view.

Figure 8.36
Print orders can be assembled from the Playback 1 menu.

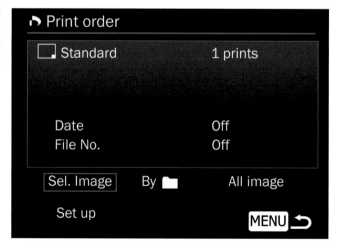

6. **Choose number of prints.** Once an image is selected, rotate the cross keys to specify 1 to 99 prints for that image. (For index prints, you can only specify whether the selected image is included in the index print, not the number of copies.) Press SET to confirm. You can then use the cross keys to select additional images. Press MENU when finished selecting to return to the Print Order screen.

7. **Output your hardcopies.** If the camera is linked to a PictBridge-compatible printer, an additional option appears on the Print Order screen, Print. You can select that; optionally, adjust paper settings as described in the previous section, and start the printing process. Alternately, you can exit the Print Order screen by tapping the shutter release button, removing the memory card, and inserting it in the memory card slot of a compatible printer, retailer kiosk, or digital minilab.

Photobook Set-up

You can select up to 998 images on your memory card, and then use the EOS Utility to copy them all to a specific folder on your computer. This is a handy way to transfer only specific images to a particular folder, and is especially useful when you're collecting photos to assemble in a photobook. Your choices include:

- **Select Images.** You can mark individual images from any folder on your memory card.
- **All Images in Folder.** Mark all the images in a particular folder for transfer.
- **Clear All in Folder.** Unmark all the images in a folder.
- **All Images on Card.** Mark all the images on the memory card for transfer to the specific folder.
- **Clear All on Card.** Unmark all the images on the card.

Once you marked the images you want to transfer to the specified folder, use the EOS Utility to copy them.

Creative Filters

One new feature of the T5 is the ability to apply Creative Filters to images as you take the picture, and preview their effect before shooting during live view. However, the original method of applying interesting effects to images you've already taken remains available. You can process an image using one of these filters, and save a copy alongside the original. When you select this menu entry, you'll be taken to a screen that allows you to choose an image to modify. You can scroll through the available images with the touch screen or cross keys or press the Reduce button to view thumbnails and select from those. Only images that can be edited are shown. Then, select SET, and choose the filter you want to apply from a list at the bottom of the screen using the left/right cross keys. Choose SET

to activate the filter, then use the touch screen or left/right cross keys again to adjust the amount of the effect (or select the area to be adjusted using the miniature effect). Choose SET once more to save your new image.

The seven effects include the following. Four of them (Grainy B/W, Soft Focus, Fish-Eye, and Toy Camera Effect) are shown in Figure 8.37.

- **Grainy B/W.** Creates a grainy monochrome image. You can adjust contrast among Low, Normal, and Strong settings.
- **Soft Focus.** Blur your image using Low, Normal, and Strong options.
- **Fish-eye Effect.** Creates a distorted, curved image.
- **Art Bold Effect.** Produces a three-dimensional oil painting effect. You can adjust contrast and saturation.
- **Water Painting Effect.** Gives you soft colors like a watercolor painting, and allows you to adjust color density.
- **Toy Camera Effect.** Darkens the corners of an image, much as a toy camera does, and adds a warm or cool tone (or none), as you wish.
- **Miniature Effect.** This is a clever effect, and it's hampered by a misleading name and the fact that its properties are hard to visualize (which is not a great attribute for a visual effect). This tool doesn't create a "miniature" picture, as you might expect. What it does is mimic tilt/shift lens effects that angle the lens off the axis of the sensor plane to drastically change the plane of focus, producing the sort of look you get when viewing some photographs of a diorama, or miniature scene. Confused yet? All you need to do is specify the area of the image that you want to remain sharp.

Figure 8.37 Top to bottom: Grainy B/W, Soft Focus, Fish-Eye, and Toy Camera Effect.

Resizing

If you've already taken an image and would like to create a smaller version (say, to send by e-mail), you can create one from this menu entry. Just follow these steps:

1. **Choose Resize.** Select this menu entry from the Playback 1 menu. (See Figure 8.31.)
2. **View images to resize.** You can scroll through the available images with the touch screen or press the Reduce button to view thumbnails and select from those. Only images that can be resized are shown. They include JPEG Large, Medium, Small 1, and Small 2 images. Small 3 and RAW images of any type cannot be resized.
3. **Select an image.** Choose SET to select an image to resize. A pop-up menu will appear on the screen offering the choice of reduced size images, using aspect ratios of 3:2, 4:3, 16:9, or 1:1. For the standard 3:2 proportions, the sizes include M (Medium: 8MP, 3,456 × 2,304 pixels); S1 (Small 1: 4.5MP, 2,592 × 1,728 pixels); S2 (Small 2: 2.5MP, 1,920 × 1,280 pixels); or S3 (Small 3, .3MP, 720 × 480 pixels).
4. **Resize and save.** Choose SET to save as a new file, and confirm your choice by selecting OK from the screen that pops up, or cancel to exit without saving a new version. The old version of the image is untouched.

Histogram Display

The T5 can show either a Brightness histogram or set of three separate Red, Green, and Blue histograms in the full information display during picture review, or, it can show you both types of histogram in the partial information display. This entry, the first on the Playback 2 menu, gives you those options. (See Figure 8.38.)

Brightness histograms give you information about the overall tonal values present in the image. The RGB histograms can show more advanced users valuable data about specific channels that might be "clipped" (details are lost in the shadows or highlights). This menu choice determines only how

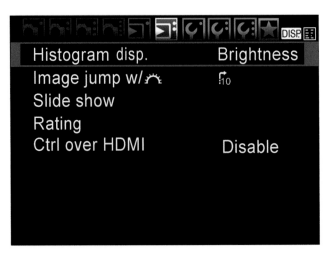

Figure 8.38
The Playback 2 menu.

they are displayed during picture review. The amount of information displayed cycles through the following list as you repeatedly press the DISP. button in Playback mode:

- **Single image display.** Only the image itself is shown, with basic shooting information displayed in a band across the top of the image, as you can see at upper left in Figure 8.39.

- **Single image display+Image-recording quality.** Identical to Single image display, except that the image size, RAW format (if selected), and JPEG compression (if selected) are overlaid on the image in the lower-left corner of the frame.

- **Histogram display.** Both RGB and brightness histograms are shown, along with partial shooting information. This menu choice has no effect on which histograms are shown in this display, which you can see at upper right in Figure 8.39.

- **Shooting information display.** Full shooting data is shown, along with either a brightness histogram (bottom left in Figure 8.39) or RGB histogram (bottom right in Figure 8.39). The type of histogram on view in this screen is determined by the setting you make in this menu choice. Select Histogram from the Playback 2 menu and choose Brightness or RGB. You can read more about *using* histograms in Chapter 4.

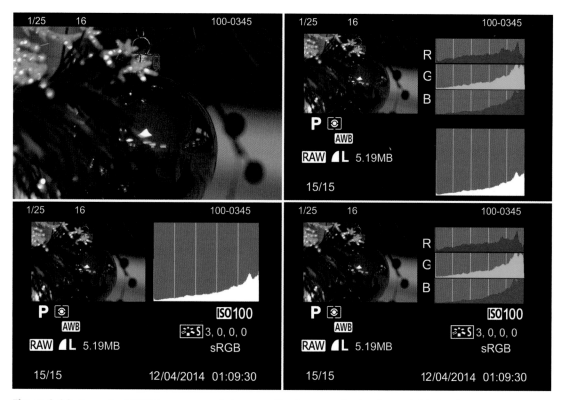

Figure 8.39 Press the DISP. button to cycle between Single image display (upper left); Single image display+Image-recording quality (not shown); Histogram display (upper right); Shooting information display with brightness histogram (bottom left); or RGB histogram (bottom right).

Image Jump with Main Dial

As first described in Chapter 3, you can leap ahead or back during picture review by rotating the Main Dial, using a variety of increments that you can select using this menu entry. The Jump method is shown briefly on the screen as you leap ahead to the next image displayed, as shown in Figure 8.40. Your options are as follows:

- **1 image.** Rotating the Main Dial one click jumps forward or back 1 image.
- **10 images.** Rotating the Main Dial one click jumps forward or back 10 images.
- **100 images.** Rotating the Main Dial one click jumps forward or back 100 images.
- **Date.** Rotating the Main Dial one click jumps forward or back to the first image taken on the next or previous calendar date.
- **Folder.** Rotating the Main Dial one click jumps forward or back to the first image in the next folder available on your memory card (if one exists).
- **Movies.** Rotating the Main Dial one click jumps forward or back, displaying movies you captured only.
- **Stills.** Rotating the Main Dial one click jumps forward or back, displaying still images only.
- **Rating.** Rotating the Main Dial one click jumps forward or back, displaying images by the ratings you've applied (as described next). Rotate the Main Dial to choose the rating parameter.

Figure 8.40
The Jump method is shown on the LCD briefly when you leap forward or back using the Main Dial.

Slide Show

Slide Show is a convenient way to review images one after another, without the need to manually switch between them. To activate, just choose Slide Show from the Playback 2 menu. During playback, you can press the SET button to pause the "slide show" (in case you want to examine an image more closely), or the DISP. button to change the amount of information displayed on the screen with each image. For example, you might want to review a set of images and their histograms to judge the exposure of the group of pictures. To set up your slide show, follow these steps:

1. **Begin set up.** Choose Slide Show from the Playback 2 menu, pressing SET to display the screen shown in Figure 8.41

2. **Choose image selection method.** Navigate to All Images, and press SET. Then rotate the cross keys to choose from All Images, Folder, or Date. Press SET to activate that selection mode. If you selected All Images, skip to Step 4.

3. **Choose images.** If you've selected Folder or Date, press the DISP. button to produce a screen that allows you to select from the available folders, or the available image creation dates on your memory card. When you've chosen a folder or date, press SET to confirm your choice.

4. **Choose Play Time and Repeat Options.** Highlight Set-up and press SET to produce a screen with playing time (1, 2, 3, or 5 seconds per image), and repeating options (On or Off). When you've specified either value, press the MENU button to confirm your choice, and then MENU once more to go back to the main Slide Show screen.

5. **Start the show.** Highlight Start and press SET to begin your show. (If you'd rather cancel the show you've just set up, press MENU instead.)

6. **Use show options during display.** Press SET to pause/restart; DISP. to cycle among the four information displays described in the section before this one; MENU to stop the show.

Figure 8.41
Set up your slide show using this screen.

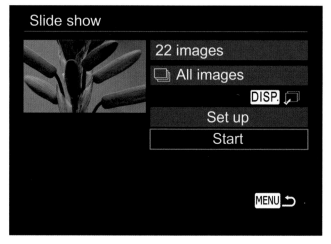

Rating

If you want to apply a quality rating to images or movies you've shot (or use the rating system to represent some other criteria), you can use this entry to give particular images one, two, three, four, or five stars, or turn the rating system off. The Image Jump function can display only images with a given rating. Suppose you were photographing a track meet with multiple events. You could apply a one-star rating to jumping events, two-stars to relays, three-stars to throwing events, four-stars to hurdles, and five-stars to dashes. Then, using the Image Jump feature, you could review only images of one particular type.

With a little imagination you can apply the rating system to all sorts of categories. At a wedding, you could classify pictures of the bride, the groom, guests, attendants, and parents of the couple. If you were shooting school portraits, one rating could apply to First Grade, another to Second Grade, and so on. Given a little thought, this feature has many more applications than you might think. To use it, just follow these steps:

1. Choose the Rating menu item.

2. Use the cross keys to select an image or movie. Press the Reduce button to display three images at once. Press the Magnify button to return to a single image.

3. When an image or movie is visible, press the up/down buttons to apply a one- to five-star rating. The display shows how many images have been assigned each rating so far.

4. When finished rating, press the MENU button to exit.

Ctrl over HDMI

When your camera is connected to a TV that is compatible with the HDMI CEC standard, you can use the remote control to activate playback functions. You'll need a compatible TV, remote control, and an HDMI cable to connect your camera to the television. Then, choose Enable in this menu entry, and then follow the directions that came with your television and remote for selecting still photo and movie playback features. If your TV does not allow use of the remote, return to the menu selection and chose Disable to give the camera control of playback.

Customizing with the Set-up Menu and My Menu

In the last chapter, I introduced you to the layout and general functions of the Canon EOS T5's menu system, with specifics on how to customize your camera with the Shooting 1, Shooting 2, Shooting 3, Shooting 4, Playback 1, and Playback 2 menus. In this chapter, you'll learn how to work with the three (count 'em) Set-up menus, and how to assemble your own roster of favorite menu listings with the My Menu feature.

If you're jumping directly to this chapter and need some guidance in how to navigate the T5's menu system, review the first few pages of Chapter 8. Otherwise, you're welcome to dive right in.

Set-up 1, 2, and 3 Menu Options

There are three amber-coded set-up menus where you make adjustments on how your camera *behaves* during your shooting session, as differentiated from the Shooting menu, which adjusts how the pictures are actually taken. Your choices include:

- Auto Power Off
- Auto Rotate
- Format Card
- File Numbering
- Select Folder
- Screen Color
- Eye-Fi Settings

- LCD Brightness
- LCD Off/On Button
- Date/Time/Zone
- Language
- Clean Manually
- Feature Guide
- GPS Device Settings

- Certification Logo Display
- Custom Functions
- Copyright Information
- Clear Settings
- Firmware Ver.

Auto Power Off

This setting, the first in Set-up 1 menu (see Figure 9.1), allows you to determine how long the EOS T5 remains active before shutting itself off. As you can see in Figure 9.2, you can select 30 seconds, 1, 2, 4, 8, or 15 minutes, or Off, which leaves the camera turned on indefinitely. However, even if the camera has shut itself off, if the power switch remains in the On position, you can bring the camera back to life by pressing the shutter button.

Auto Rotate

You can turn this feature On or Off. When activated, the EOS T5 rotates pictures taken in vertical orientation on the LCD screen so you don't have to turn the camera to view them comfortably. However, this orientation also means that the longest dimension of the image is shown using the shortest dimension of the LCD, so the picture is reduced in size. (You have three options, shown in Figure 9.3.) The image can be autorotated when viewing in the camera *and* on your computer screen using your image editing/viewing software. The image can be marked to autorotate *only* when reviewing your image in your image editor or viewing software. This option allows you to have rotation applied when using your computer, while retaining the ability to maximize the image on your LCD in the camera. The third choice is Off. The image will not be rotated when displayed in the camera or with your computer. Note that if you switch Auto Rotate off, any pictures shot while the feature is disabled will not be automatically rotated when you turn Auto Rotate back on; information embedded in the image file when the photo *is taken* is used to determine whether autorotation is applied.

Format Card

Use this item to erase everything on your memory card and set up a fresh file system ready for use. When you select Format, you'll see a display like Figure 9.4, showing the capacity of the card, how much of that space is currently in use, and two choices at the bottom of the screen to Cancel or OK (proceed with the format). Press the Trash button if you'd like to do a low-level format. That's a more basic format that removes all sectors from the card and creates new ones, which can help speed up a card that seems to be slow (because the camera must skip over "bad" sectors left behind from previous uses). An orange bar appears on the screen to show the progress of the formatting step.

File Numbering

The EOS T5 will automatically apply a file number to each picture you take, using consecutive numbering for all your photos over a long period of time, spanning many different memory cards, starting over from scratch when you insert a new card, or when you manually reset the numbers.

Figure 9.1
The Set-up 1 menu has seven options.

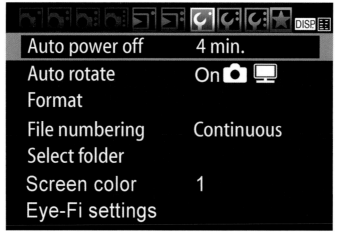

Figure 9.2
Select an automatic shut-off period to save battery power.

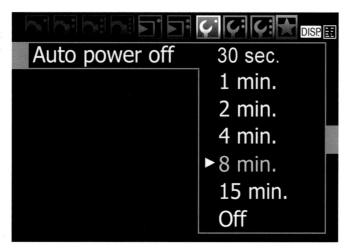

Figure 9.3
Choose auto rotation both in the camera and on your computer display (top); only on your computer display (middle); or no automatic rotation (bottom).

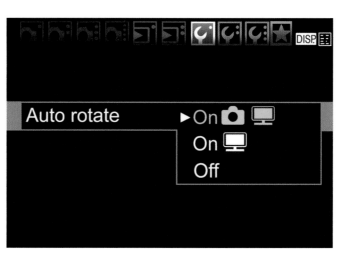

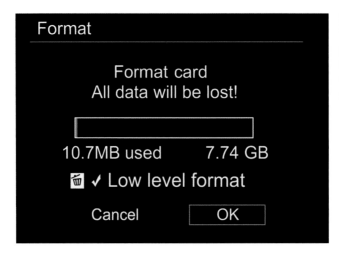

Figure 9.4

You must confirm the format step before the camera will erase a memory card.

Numbers are applied from 0001 to 9999, at which time the camera creates a new folder on the card (100, 101, 102, and so forth), so you can have 0001 to 9999 in folder 100, then numbering will start over in folder 101.

The camera keeps track of the last number used in its internal memory. That can lead to a few quirks you should be aware of. For example, if you insert a memory card that had been used with a different camera, the T5 may start numbering with the next number after the highest number used by the previous camera. (I once had a brand-new T5 start numbering files in the 8,000 range.) I'll explain how this can happen next.

On the surface, the numbering system seems simple enough: In the menu, you can choose Continuous, Automatic Reset, or Manual Reset. Here is how each works:

- **Continuous.** If you're using a blank/reformatted memory card, the T5 will apply a number that is one greater than the number stored in the camera's internal memory. If the card is not blank and contains images, then the next number will be one greater than the highest number on the card *or* in internal memory. (In other words, if you want to use continuous file numbering consistently, you must always use a card that is blank or freshly formatted.) Here are some examples:

 - You've taken 4,235 shots with the camera, and you insert a blank/reformatted memory card. The next number assigned will be 4,236, based on the value stored in internal memory.

 - You've taken 4,235 shots with the camera, and you insert a memory card with a picture numbered 2,728. The next picture will be numbered 4,236.

 - You've taken 4,235 shots with the camera, and you insert a memory card with a picture numbered 8,281. The next picture will be numbered 8,282, and that value will be stored in the camera's menu as the "high" shot number (and will be applied when you next insert a blank card).

- **Automatic Reset.** If you're using a blank/reformatted memory card, the next photo taken will be numbered 0001. If you use a card that is not blank, the next number will be one greater than the highest number found on the memory card. Each time you insert a memory card, the next number will either be 0001 or one higher than the highest already on the card.

- **Manual Reset.** The T5 creates a new folder numbered one higher than the last folder created, and restarts the file numbers at 0001. Then, the camera uses the numbering scheme that was previously set, either Continuous or Automatic Reset, each time you subsequently insert a blank or non-blank memory card.

Select Folder

Choose this menu option to create a folder where the images you capture will be stored on your memory card, or to switch between existing folders. Just follow these steps:

1. **Choose Select Folder.** Access the option from the Set-up 1 menu.

2. **View list of available folders.** The Select Folder screen pops up with a list of the available folders on your memory card, with names like 100EOST5, 101EOST5, etc.

3. **Choose a different folder.** To store subsequent images in a different existing folder, rotate the cross keys to highlight the label for the folder you want to use. When a folder that already has photos is selected, two thumbnails representing images in that folder are displayed at the right side of the screen.

4. **Confirm the folder.** Press SET to confirm your choice of an existing folder.

5. **Create new folder.** If you'd rather create a new folder, highlight Create Folder in the Select Folder screen and press SET. The name of the folder that will be created is displayed, along with a choice to Cancel or OK, creating the folder. Press SET to confirm your choice.

6. **Exit.** Press MENU to return to the Set-up 1 menu.

Screen Color

Here you can select one of four different shooting information screen color schemes, which are helpfully displayed in the set-up screen so you can decide which looks best.

Eye-Fi Settings

This menu item appears when you have an Eye-Fi card inserted in the camera. You can enable and disable Eye-Fi wireless functions, and view connection information. I explained the T5's Eye-Fi options in detail in Chapter 7.

LCD Brightness

Choose this menu option, the first on the second Set-up menu tab (see Figure 9.5), and a thumbnail image with a grayscale strip appears on the LCD, as shown in Figure 9.6. You can manually set brightness. Use the cross keys to adjust the brightness to a comfortable viewing level. Use the gray bars as a guide; you want to be able to see both the lightest and darkest steps at top and bottom, and not lose any of the steps in the middle. Brighter settings use more battery power, but can allow you to view an image on the LCD outdoors in bright sunlight. When you have the brightness you want, press the SET button to lock it in and return to the menu.

LCD Off/On Button

Choose which buttons can be used to turn the LCD on or off. Your choices are the shutter button alone, the shutter button plus the DISP. button, or Remains On (the LCD does not shut off).

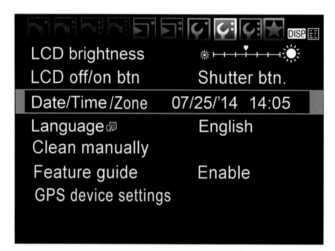

Figure 9.5
The Set-up 2 menu includes seven options.

Figure 9.6
Adjust LCD brightness for easier viewing under varying ambient lighting conditions.

Date/Time/Zone

Use this option to set the date, time, and time zone, which will be embedded in the image file along with exposure information and other data. As first outlined in Chapter 1, you can set the date and time by following these steps:

1. Access this menu entry from the Set-up 2 menu.

2. Use the cross keys to move the highlighting down to the Date/Time entry.

3. Press the SET button in the center of the cross keys to access the Date/Time setting screen, shown in Figure 9.7.

4. Use the cross keys to select the value you want to change. When the gold box highlights the month, day, year, hour, minute, second, or year format you want to adjust, press the SET button to activate that value. A pair of up/down pointing triangles appears above the value.

5. Use the cross keys to adjust the value up or down. Press the SET button to confirm the value you've entered.

6. Repeat steps 4 and 5 for each of the other values you want to change. The date format can be switched from the default mm/dd/yy to yy/mm/dd or dd/mm/yy.

7. When finished, rotate the cross keys to select either OK (if you're satisfied with your changes) or Cancel (if you'd like to return to the Set-up 2 menu without making any changes). Press SET to confirm your choice.

8. When finished setting the date and time, press the MENU button to exit, or just tap the shutter release.

Figure 9.7
Adjust the time and date.

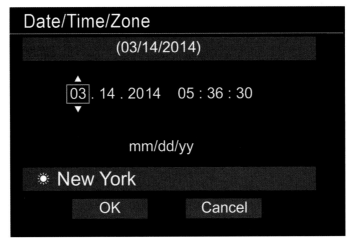

Language

Choose from 25 languages for menu display, rotating the cross keys until the language you want to select is highlighted. Press the SET button to activate. Your choices include English, German, French, Dutch, Danish, Portuguese, Finnish, Italian, Ukrainian, Norwegian, Swedish, Spanish, Greek, Russian, Polish, Czech, Magyar, Romanian, Turkish, Arabic, Thai, Simplified Chinese, Traditional Chinese, Korean, and Japanese.

If you accidentally set a language you don't read and find yourself with incomprehensible menus, don't panic. Just choose the fourth option from the top of the Set-up 2 menu, and select the idioma, sprache, langue, or kieli of your choice. English is the first selection in the list.

Clean Manually

The T5 lacks the automatic sensor cleaning of the other current EOS cameras, but you can clean it yourself manually. I'll provide instructions for doing that in Chapter 12. This entry allows you to flip the mirror up and open the shutter for the manual cleaning step. Turn the camera off to return to normal operation. If the battery level is too low to safely carry out the cleaning operation, the T5 will let you know and refuse to proceed, unless you use the optional AC Adapter Kit ACK-E10.

Feature Guide

The Feature Guide is an easy pop-up description of a function or option that appears when you change the shooting mode or use the Quick Control screen to select a function, switch to live view, movie making, or playback. The instructional screen quickly vanishes in a few seconds. You can use this setting to enable or disable the Feature Guide. I tend to find that it hangs around on my screen for much too long, and blocks other information, so I disabled it as soon as I became familiar with the T5.

GPS Device Settings

This entry allows you to adjust the settings of the optional Canon GP-E2 GPS device (a roughly $400 add-on). Or, you can disable GPS functions entirely. This menu option is available only when the device is mounted on your camera. A Set-up entry appears that allows you to access four different parameters:

- **Auto time setting.** The T5 can use time data embedded in the GPS signal to set the camera's internal clock accurately. You can choose Auto Update to set the time automatically whenever the camera is powered up and GPS data is available; Disable this function; or Set Now to update immediately.

- **Position update timing.** Use this to specify the interval the GPS device uses to update position information. Choose from every 1, 5, 10, 15, 30 seconds, or every 1, 2, or 5 minutes. Select a shorter interval when you are moving and/or accuracy is critical, or a longer interval to save power, when GPS reception is not optimal, or you are shooting from one position for a longer period.

- **GPS information display.** This entry simply displays a screen of current GPS information, including latitude, longitude, elevation, UTC time (essentially Greenwich Mean Time), and Satellite reception strength/status.
- **GPS logger.** Allows you to enable or disable tracking of GPS position data, transfer log data to your memory card for later manipulation by an appropriate software program, or to delete the camera's current GPS log.

Certification Logo Display

This cryptic entry, the first choice in the Set-up 3 menu (see Figure 9.8), is used by Canon to display the logos of some of the certification organizations that have approved the T5's specifications. You'll find others on the bottom of the camera itself. As a camera user, you don't really care about certifications, but Canon added this entry as a way of updating any new credentials through a firmware update, thus avoiding the need to change the labels/engravings on the camera body itself. So now you know.

Custom Functions

Custom Functions let you customize the behavior of your camera in a variety of different ways, ranging from whether or not the flash fires automatically to the function carried out when the SET button is pressed. If you don't like the default way the camera carries out a particular task, you just may be able to do something about it. You can find the Custom Functions in their own screen with 11 choices, divided into four groups of settings: Exposure (I, C.Fn 01, 02, and 03); Image (II, C.Fn 04, 05, and 06); Autofocus/Drive (III, C.Fn 07); and Operation/Others (IV, C.Fn 08, 09, 10, and 11). The Roman numeral divisions within a single screen with a single line of choices seem odd until you realize that some other more upscale Canon EOS models (such as the EOS 70D), separate each of these groups into separate screens (with larger numbers of options).

Figure 9.8
The Set-up 3 menu has five options.

Certification Logo Display
Custom Functions (C.Fn)
Copyright information
Clear settings
Firmware Ver. 1.0.0

Each of the Custom Functions is set in exactly the same way, so I'm not going to bog you down with a bunch of illustrations showing how to make this setting or that. One quick run-through using Figure 9.9 should be enough. Here are the key parts of the Custom Functions screen:

- **Custom Function category.** At the top of the settings screen is a label that tells you which category that screen represents.

- **Name of currently selected custom function.** Use the left/right cross keys to select the function you want to adjust. The name of the function currently selected appears at the top of the screen, and its number is marked with an overscore in the row of numbers at the bottom of the screen. You don't need to memorize the function numbers.

- **Function currently selected.** The function number appears in two places. In the upper-right corner you'll find a box with the current function clearly designated. In the lower half of the screen are two lines of numbers. The top row has numbers from 1 to 11, representing the Custom Function. The second row shows the number of the current setting. If the setting is other than the default value (a zero), it will be colored blue, so you can quickly see which Custom Functions have been modified. The currently selected function will have a gold line above it.

- **Available settings.** Within the alternating medium gray/dark gray blocks appear numbered setting options. The current setting is highlighted in blue. You can use the up/down cross keys to scroll to the option you want and then press the SET button to select it; then press the MENU button twice to back out of the Custom Functions menus.

- **Current setting.** Underneath each Custom Function is a number from 0 to 5 that represents the current setting for that function, with 0 representing the default value.

Custom Function category *Name of currently selected custom function* *Fn currently selected*

Figure 9.9
Each C.Fn screen has from two to six settings, represented by the numbers at the bottom of the screen. The currently selected function has a gold line above it.

Available settings

C.Fn currently selected

Current setting

Current setting of the custom function above

In the listings that follow, I'm going to depart from the sometimes-cryptic labels Canon assigns to each Custom Function in the menu, and instead categorize them by what they actually do. I'm also going to provide you with a great deal more information on each option and what it means to your photography.

C.Fn I-01: Size of Exposure Adjustments

Exposure level increments. This setting tells the Rebel T5 the size of the "jumps" it should use when making exposure adjustments—either one-third or one-half stop. The increment you specify here applies to f/stops, shutter speeds, EV changes, and autoexposure bracketing.

- **0: 1/3 stop.** Choose this setting when you want the finest increments between shutter speeds and/or f/stops. For example, the T5 will use shutter speeds such as 1/60th, 1/80th, 1/100th, and 1/125th second, and f/stops such as f/5.6, f/6.3, f/7.1, and f/8, giving you (and the autoexposure system) maximum control.

- **1: 1/2 stop.** Use this setting when you want larger and more noticeable changes between increments. The T5 will apply shutter speeds such as 1/60th, 1/125th, 1/250th, and 1/500th second, and f/stops including f/5.6, f/6.7, f/8, f/9.5, and f/11. These coarser adjustments are useful when you want more dramatic changes between different exposures.

C.Fn I-02: Whether H (ISO 12,800) Is Available

ISO Expansion. The T5 includes an expanded ISO setting labeled H, which is the equivalent of ISO 12,800. You may not want to use such a lofty rating, because it produces a significant amount of grainy visual noise in your image. This setting allows you to enable or disable the H setting.

- **0: Off.** The H setting is not available.

- **1: On.** The H setting and its ISO 12,800 equivalent can be selected.

C.Fn I-03: Flash Synchronization Speed When Using Aperture-Priority

Flash sync. speed in Av mode. You'll find this setting useful when using flash. When you're set to Aperture-priority mode (Av), you select a fixed f/stop and the Rebel T5 chooses an appropriate shutter speed. That works fine when you're shooting by available light. However, when you're using flash, the flash itself provides virtually all of the illumination that makes the main exposure, and the shutter speed determines how much, if any, of the ambient light contributes to a second, non-flash exposure. Indeed, if the camera or subject is moving, you can end up with two distinct exposures in the same frame: the sharply defined flash exposure, and a second, blurry "ghost" picture created by the ambient light.

If you *don't* want that second exposure, you should use the highest shutter speed that will synchronize with your flash (that's 1/200th second with the Rebel T5). If you do want the ambient light to contribute to the exposure (say, to allow the background to register in night shots, or to use the

ghost image as a special effect), use a slower shutter speed. For brighter backgrounds, you'll need to put the camera on a tripod or other support to avoid the blurry ghosts.

- **0: Auto.** The T5 will vary the shutter speed in Av mode, allowing ambient light to partially illuminate the scene in combination with the flash exposure. Use a tripod, because shutter speeds slower than 1/60th second may be selected.

- **1: 1/200–1/60 sec. (auto).** The camera will use a shutter speed from 1/200th second (to virtually eliminate ambient light) to 1/60th second (to allow ambient light to illuminate the picture). This compromise allows a slow enough shutter speed to permit ambient light to contribute to the exposure, but blocks use of shutter speeds slower than 1/60th second, to minimize the blurriness of the secondary, ambient light exposure.

- **2: 1/200th sec. (fixed).** The camera always uses 1/200th second as its shutter speed in Av mode, reducing the effect of ambient light and, probably, rendering the background dark.

C.Fn II-04: Reducing Noise Effects at Shutter Speeds of One Second or Longer

Long exposure noise reduction. Visual noise is that graininess that shows up as multicolored specks in images, and this setting helps you manage it. In some ways, noise is like the excessive grain found in some high-speed photographic films. However, while photographic grain is sometimes used as a special effect, it's rarely desirable in a digital photograph.

The visual noise-producing process is something like listening to a CD in your car, and then rolling down all the windows. You're adding sonic noise to the audio signal, and while increasing the CD player's volume may help a bit, you're still contending with an unfavorable signal-to-noise ratio that probably mutes tones (especially higher treble notes) that you really want to hear.

The same thing happens when the analog signal is amplified: You're increasing the image information in the signal, but boosting the background fuzziness at the same time. Tune in a very faint or distant AM radio station on your car stereo. Then turn up the volume. After a certain point, turning up the volume further no longer helps you hear better. There's a similar point of diminishing returns for digital sensor ISO increases and signal amplification as well.

These processes create several different kinds of noise. Noise can be produced from high ISO settings. As the captured information is amplified to produce higher ISO sensitivities, some random noise in the signal is amplified along with the photon information. Increasing the ISO setting of your camera raises the threshold of sensitivity so that fewer and fewer photons are needed to register as an exposed pixel. Yet, that also increases the chances of one of those phantom photons being counted among the real-life light particles, too.

Fortunately, the Rebel T5's sensor and its digital processing chip are optimized to produce the low noise levels, so ratings as high as ISO 800 can be used routinely (although there will be some noise, of course), and even ISO 3200 can generate good results.

A second way noise is created is through longer exposures. Extended exposure times allow more photons to reach the sensor, but increase the likelihood that some photosites will react randomly even though not struck by a particle of light. Moreover, as the sensor remains switched on for the longer exposure, it heats, and this heat can be mistakenly recorded as if it were a barrage of photons. This Custom Function can be used to tailor the amount of noise-canceling performed by the digital signal processor.

- **0: Off.** Disables long exposure noise reduction. Use this setting when you want the maximum amount of detail present in your photograph, even though higher noise levels will result. This setting also eliminates the extra time needed to take a picture caused by the noise reduction process. If you plan to use only lower ISO settings (thereby reducing the noise caused by ISO amplification), the noise levels produced by longer exposures may be acceptable. For example, you might be shooting a river spilling over rocks at ISO 100 with the camera mounted on a tripod, using a neutral-density filter and long exposure to cause the pounding water to blur slightly. To maximize detail in the non-moving portions of your photos, you can switch off long exposure noise reduction. Because the noise-reduction process used with settings 1 and 2 effectively doubles the time required to take a picture, this is a good setting to use when you want to avoid this delay when possible.

- **1: Auto.** The Rebel T5 examines your photo taken with an exposure of one second or longer, and if long exposure noise is detected, a second, blank exposure is made and compared to the first image. Noise found in the "dark frame" image is subtracted from your original picture, and only the noise-corrected image is saved to your memory card.

- **2: On.** When this setting is activated, the T5 applies dark frame subtraction to all exposures longer than one second. You might want to use this option when you're working with high ISO settings (which will already have noise boosted a bit) and want to make sure that any additional noise from long exposures is eliminated, too. Noise reduction will be applied to some exposures that would not have caused it to kick in using the Auto setting.

Tip

While the "dark frame" is being exposed, the LCD screen will be blank during live view, and the number of shots you can take in continuous shooting mode will be reduced. White balance bracketing is disabled during this process.

C.Fn II-05: Eliminating Noise Caused by Higher ISO Sensitivities

High ISO speed noise reduct'n. This setting applies noise reduction that is especially useful for pictures taken at high ISO sensitivity settings. The default is 0 (Standard noise reduction), but you can specify 1 (low) or 2 (strong) noise reduction, or disable noise reduction entirely. At lower ISO values, noise reduction improves the appearance of shadow areas without affecting highlights; at

higher ISO settings, noise reduction is applied to the entire photo. Note that when the 2: Strong option is selected, the maximum number of continuous shots that can be taken will decrease significantly, because of the additional processing time for the images.

- **0: Standard.** At lower ISO values, noise reduction is applied primarily to shadow areas; at higher ISO settings, noise reduction affects the entire image.
- **1: Low.** A smaller amount of noise reduction is used. This will increase the grainy appearance, but preserve more fine image detail.
- **2: Strong.** More aggressive noise reduction is used, at the cost of some image detail, adding a "mushy" appearance that may be noticeable and objectionable. Because of the image processing applied by this setting, your continuous shooting maximum burst will decrease significantly.
- **3: Disable.** No additional noise reduction will be applied.

C.Fn II-06: Improving Detail in Highlights

Highlight Tone Priority. This setting concentrates the available tones in an image from the middle grays up to the brightest highlights, in effect expanding the dynamic range of the image at the expense of shadow detail. You'd want to activate this option when shooting subjects in which there is lots of important detail in the highlights, and less detail in shadow areas. Highlight tones will be preserved, while shadows will be allowed to go dark more readily (and may exhibit an increase in noise levels). Bright beach or snow scenes, especially those with few shadows (think high noon, when the shadows are smaller) can benefit from using Highlight Tone Priority.

- **0: Disable.** The Rebel T5's normal dynamic range is applied.
- **1: Enable.** Highlight areas are given expanded tonal values, while the tones available for shadow areas are reduced. The ISO 100 sensitivity setting is disabled and only ISO 200 to ISO 12,800 are available. You can tell that this restriction is in effect by viewing the D+ icon shown in the viewfinder, on the ISO Selection screen, and in the shooting information display for a particular image.

C.Fn III-07: Activation of the Autofocus Assist Lamp

AF-assist beam firing. This setting determines when the AF assist lamp in the camera or an external flash is activated to emit a pulse of light prior to the main exposure that helps provide enough contrast for the Rebel T5 to focus on a subject.

- **0: Emits.** The AF assist light is emitted by the camera's built-in flash whenever light levels are too low for accurate focusing using the ambient light.
- **1: Does not emit.** The AF assist illumination is disabled. You might want to use this setting when shooting at concerts, weddings, or darkened locations where the light might prove distracting or discourteous.

- **2: Only external flash emits.** The built-in AF assist light is disabled, but if a Canon EX dedicated flash unit is attached to the camera, its AF assist feature (a flash pulse) will be used when needed. Because the flash unit's AF assist is more powerful, you'll find this option useful when you're using flash and are photographing objects in dim light that are more than a few feet away from the camera (and thus not likely to be illuminated usefully by the Rebel T5's built-in light source). Note that if AF assist beam firing is disabled within the flash unit's own Custom Functions, this setting will not override that.

- **3: IR AF assist beam only.** Canon dedicated Speedlites with an infrared assist beam can be set to use only the IR assist burst. That will keep other flash bursts from triggering the AF assist beam.

C.Fn IV-08: What Happens When You Partially Depress the Shutter Release/ Press the AE Lock Button

Shutter release/AE lock button (*). This setting controls the behavior of the shutter release and the AE lock button (*) when you are using Creative Zone exposure modes. With Basic Zone modes, the Rebel T5 always behaves as if it has been set to Option 0, described below. Options 1, 2, and 3 are designed to work with AI Servo mode, which locks focus as it is activated, but refocuses if the subject begins to move. The options allow you to control exactly when focus and exposure are locked when using AI Servo mode.

In the option list, the first action in the pair represents what happens when you press the shutter release; the second action says what happens when the AE lock button is pressed.

- **0: AF/AE lock.** With this option, pressing the shutter release halfway locks in focus; pressing the * button locks exposure. Use this when you want to control each of these actions separately.

- **1: AE lock/AF.** Pressing the shutter release halfway locks exposure; pressing the * button locks autofocus. This setting swaps the action of the two buttons compared to the default 0 option.

- **2: AF/AF lock, no AE lock.** Pressing the AE lock button interrupts the autofocus and locks focus in AI Servo mode. Exposure is not locked at all until the actual moment of exposure when you press the shutter release all the way. This mode is handy when moving objects may pass in front of the camera (say, a tight end crosses your field of view as you focus on the quarterback) and you want to be able to avoid change of focus. Note that you can't lock in exposure using this option.

- **3: AE/AF, no AE lock.** Pressing the shutter release halfway locks in autofocus, except in AI Servo mode, in which you can use the * button to start or stop autofocus. Exposure is always determined at the moment the picture is taken, and cannot be locked.

C.Fn IV-9: Using the SET Button as a Function Key

Assign SET button. You already know that the SET button is used to select a choice or option when navigating the menus. However, when you're taking photos, it has no function at all. You can easily remedy that with this setting. This setting allows you to assign one of five different actions to the SET key. Because the button is within easy reach of your right thumb, that makes it quite convenient for accessing a frequently used function. When this Custom Function is set to 5, the SET button has no additional function during shooting mode (except to activate live view when it is turned on), and options 0 through 4 assign an action to the button during shooting.

CAUTION

One thing to keep in mind when redefining the behavior of controls (including other controls that can be modified within the Custom Functions menus) is that any non-standard customization you do will definitely be confusing to others who use your camera, and may even confuse you if you've forgotten that you've changed a control from its default function.

- **0: Disabled.** This is the default during shooting; no action is taken. (If you have used the T1i, you know that this choice activated the Quick Control screen; the T5 now has a Q/Print button to perform the same function.)

- **1: Image quality.** Pressing the SET button produces the Shooting 1 menu's Quality menu screen on the color LCD. You can cycle among the various quality options with the up/down and left/right cross keys. Press SET again to lock in your choice.

- **2: Flash exposure comp.** The SET button summons the flash exposure compensation screen. Use the left/right cross keys to adjust flash exposure plus or minus two stops. If you're using an external flash unit, its internal flash exposure compensation settings override those set from the camera. Press SET to confirm your choice.

- **3: LCD monitor On/Off.** Assigns to the SET button the same functions as the DISP. button. Because the SET button can be accessed with the thumb, you may find it easier to use when turning the LCD monitor on or off.

- **4: Depth-of-field preview.** Pressing SET stops down the lens to the aperture that will be used to take the picture using the current exposure setting, allowing you to evaluate the range of sharpness/acceptable focus.

- **5: Depth-of-field preivew.** As the T5 lacks a traditional depth-of-field button, this option may be your best choice, unless you never need to preview depth-of-field. The camera will stop down the lens to the aperture that will be used to take the picture at the current meter reading.

C.Fn IV-10: Flash Button Function

Controls the behavior of the flash button on top of the camera. There are two options:

- **0: Raise built-in flash.** Press this button to flip up the built-in flash. You can also raise the flash using the Quick Control menu's Flash Up choice, so this default setting isn't a must. If you disable the flash-raising function, you can avoid accidentally raising the flash when you don't need it.

- **1: ISO speed.** Other Rebels have had an ISO button on top of the camera. If you change ISO often (especially if you change ISO more often than you manually flip up the built-in flash) you can transform the flash button into an ISO button with this setting.

C.Fn IV-11: LCD Display When Power On

Controls the behavior of the LCD when the Rebel T5 is switched on. There are two options:

- **0: Display on.** When the T5 is powered on, the shooting settings screen will be shown. You can turn this screen on and off by pressing the DISP. button. Use this option if you always want the settings screen to be displayed when the camera is turned on.

- **1: Previous display status.** When the Rebel T5 is turned on, the LCD monitor will display the shooting settings screen if it was turned on when the camera was last powered down. If the screen had been turned off (by pressing the DISP. button), it will not be displayed when the T5 is next powered up. Use this option if you frequently turn off the settings screen, and want the camera to "remember" whether the screen was on display when the T5 was last powered down.

Copyright Information

You can embed your name (as "author" or *auteur* of the image) and copyright information in the Exif (Exchangeable Image File format) data appended to each photo that you take. When you choose this menu entry (see Figure 9.10), you have four options:

- **Display copyright info.** Shows the current author and copyright data.

- **Enter author's name.** Produces a text entry screen like the one shown in Figure 9.11. See "Entering Text" for instructions on how to type in text for this screen and the Copyright Details screen.

- **Enter copyright details.** Produces the same text entry screen, allowing you to enter copyright details. Oddly enough, no copyright symbol is available (although the @ sign is provided so you can type in your e-mail address!). Just use the parentheses and a lowercase c: (c), or, more properly, (copr.).

- **Delete copyright information.** Removes the current copyright information (both author and copyright data). Once you delete the data, or if you haven't entered it yet, this option and the Display Copyright Info. option are grayed out and unavailable.

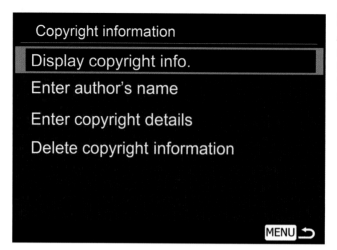

Figure 9.10
Access text entry screens for entering the name of the photographer and copyright details here.

Entering Text

Entering text into the Author's Name or Copyright Details screens is done in the same way, using a screen like the one shown in Figure 9.11. Just use these instructions:

- **Choose areas.** Either the text area (at top left) or available characters area (bottom half of the screen) will be highlighted with a blue outline. Switch between them by pressing the Q button on the right side of the back of the camera.

- **Scroll among text.** When the text area is highlighted, you can scroll among the text using the cross keys. Up to 63 alphanumeric characters can be entered/displayed.

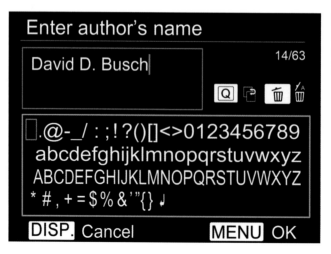

Figure 9.11
Select the alphanumeric characters for your text entry.

- **Enter characters.** When the available characters list is highlighted, use the cross keys to move among the alphanumeric characters shown. Press the SET button to enter that character at the cursor position in the text area above. You can delete the current character by pressing the Delete/Trash button.
- **Finish/Cancel.** When finished entering text, press the MENU button to confirm your choice, or press the DISP. button to cancel and return to the Copyright Information screen.

Clear Settings

This menu choice resets all the settings to their default values. Regardless of how you've set up your EOS T5, it will be adjusted for One-Shot AF mode, Automatic AF point selection, Evaluative metering, JPEG Fine Large image quality, Automatic ISO, sRGB color mode, Automatic white balance, and Standard Picture Style. Any changes you've made to exposure compensation, flash exposure compensation, and white balance will be canceled, and any bracketing for exposure or white balance nullified. Custom white balances and Dust Delete Data will be erased.

However, Custom Functions will *not* be cleared. If you want to cancel those, as well, you'll need to use the Camera User Setting option (described previously) and the Custom Functions clearing option, which I'll describe shortly. Table 9.1 shows the settings defaults after using this menu option.

Firmware Version

You can see the current firmware release in use in the menu listing. If you want to update to a new firmware version, insert a memory card containing the binary file, and press the SET button to begin the process. You can read more about firmware updates in Chapter 12.

Table 9.1 Camera Setting Defaults

Shooting Settings	Default Value
AF mode	One-Shot AF
AF point selection	Auto selection
Metering mode	Evaluative
ISO speed	Auto
Drive mode	Single shooting
Exposure compensation/AEB	Canceled
Flash exposure compensation	0
Custom Functions	Unchanged

Table 9.1 Camera Setting Defaults (continued)

Image-Recording Settings	Default Value
Quality	JPEG Large/Fine
Picture Style	Standard
Auto Lighting Optimizer	Standard
Peripheral illumination correction	Enable/Correction data retained
Color space	sRGB
White balance	Auto
Custom white balance	Canceled
White balance correction	Canceled
WB-BKT	Canceled
File numbering	Continuous
Dust Delete Data	Erased

Camera Settings	Default Value
Auto power off	30 seconds
Beep	Enable
Release shutter without card	Enable
Image Review	2 seconds
Histogram	Brightness
Image jump with Main Dial	10 images
Auto rotate	On/Camera/Computer
LCD brightness	Centered
LCD off/on button	Shutter button
Date/Time	Unchanged
Language	Unchanged
Feature Guide	Enable
Copyright information	Unchanged
Control over HDMI	Disable
Eye-Fi transmission	Disable
My Menu settings	Unchanged

Table 9.1 Camera Setting Defaults (continued)

Live View Settings	Default Value
Live view shooting	Enable
AF mode	Live mode
Grid display	Off
Metering timer	16 seconds

Movie Settings	Default Value
AF mode	Live mode
AF w/shutter button during movie shooting	Disable
Shutter/AE Lock Button	AF/AE lock
Movie shooting highlight tone priority	Disable
Movie-recording size	Unchanged
Sound recording	On
Metering timer	16 seconds
Grid display	Off
Auto Lighting Optimizer	Standard
Custom white balance	Canceled
Exposure compensation	Canceled
Picture Style	Standard

My Menu

The Canon EOS T5 has a great feature that allows you to define your own menu, with just the items listed that you want. Remember that the T5 always returns to the last menu and menu entry accessed when you press the MENU button. So you can set up My Menu to include just the items you want, and jump to those items instantly by pressing the MENU button. Or, you can set your camera so that My Menu appears when the MENU button has been pressed, regardless of what other menu entry you accessed last.

To create your own My Menu, you have to *register* the menu items you want to include. Just follow these steps:

1. Press the MENU button and use the Main Dial or cross keys to select the My Menu tab. When you first begin, the personalized menu will be empty except for the My Menu Settings entry. Press the SET button to select it. You'll then see a screen like the one shown in Figure 9.12.

2. Rotate the cross keys to select Register; then press the SET button.

3. Use the cross keys to scroll down through the continuous list of menu entries to find one you would like to add. Press SET.

4. Confirm your choice by selecting OK in the next screen and pressing SET again.

5. Continue to select up to six menu entries for My Menu.

6. When you're finished, press the MENU button twice to return to the My Menu screen to see your customized menu, which might look like Figure 9.13.

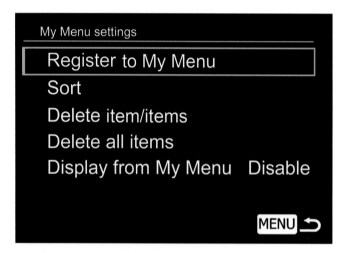

Figure 9.12
In the My Menu Settings screen you can add menu items, delete them, and specify whether My Menu always pops up when the MENU button is pressed.

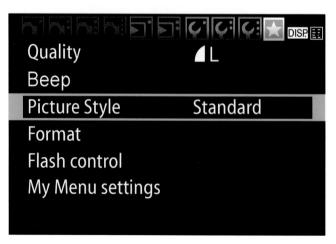

Figure 9.13
You can add one to six menu entries to My Menu.

In addition to registering menu items, you can perform other functions at the My Menu Settings screen:

- **Changing the order.** Choose Sort to reorder the items in My Menu. Select the menu item and press the SET button. Rotate the cross keys to move the item up and down within the menu list. When you've placed it where you'd like it, press the MENU button to lock in your selection and return to the previous screen.

- **Delete/Delete all items.** Use these to remove an individual menu item or all menu items you've registered in My Menu.

- **Display from My Menu.** As I mentioned earlier, the T5 (almost) always shows the last menu item accessed. That's convenient if you used My Menu last, but if you happen to use another menu, then pressing the MENU button will return to that item instead. If you enable the Display from My Menu option, pressing the MENU button will *always* display My Menu first. You are free to switch to another menu tab if you like, but the next time you press the MENU button, My Menu will come up again. Use this option if you work with My Menu a great deal and make settings with other menu items less frequently.

10

Working with Lenses

In 2014, Canon announced that it had produced its 100 millionth EF-series lens. Considering that it took 11 years for Canon to sell its first 10 million copies of its EF lens line, but only nine months to peddle its most recent 10 million lenses, it's easy to see that the digital photography revolution can take credit for the most recent explosion.

With nearly six dozen lenses in its current lineup, Canon is catering to the wide-ranging needs of a broad user base, from novice photo enthusiasts to advanced amateur and professional photographers. It's this mind-bending assortment of high-quality lenses available to enhance the capabilities of cameras like the Canon EOS T5 that make the product line so appealing. Thousands of current and older lenses introduced by Canon and third-party vendors since 1987 can be used to give you a wider view, bring distant subjects closer, let you focus closer, shoot under lower-light conditions, or provide a more detailed, sharper image for critical work. Other than the sensor itself, the lens you choose for your dSLR is the most important component in determining image quality and perspective of your images.

The most exciting development in recent years has been the introduction of Canon's initial STM (Stepper Motor) lenses, which, when coupled with a new diaphragm mechanism, provides especially fast and quiet autofocus that's perfect for video capture (where camera noises can be recorded while shooting).

This chapter explains how to select the best lenses for the kinds of photography you want to do.

But Don't Forget the Crop Factor

From time to time you've heard the term *crop factor*, and you've probably also heard the term *lens multiplier factor*. Both are misleading and inaccurate terms used to describe the same phenomenon: the fact that cameras like the T5 (and most other affordable digital SLRs) provide a field of view that's smaller and narrower than that produced by certain other (usually much more expensive) cameras, when fitted with exactly the same lens.

Figure 10.1 quite clearly shows the phenomenon at work. The outer rectangle, marked 1X, shows the field of view you might expect with a 28mm lens mounted on a Canon EOS 5D Mark III camera, a so-called "full-frame" model. The rectangle marked 1.3X shows the effective field of view from the same vantage point with the exact same lens mounted on the discontinued Canon EOS 1D Mark III camera, while the area marked 1.6X shows the field of view you'd get with that 28mm lens installed on a T5. It's easy to see from the illustration that the 1X rendition provides a wider, more expansive view, while the other two are, in comparison, *cropped*.

The cropping effect is produced because the sensors of the latter two cameras are smaller than the sensors of the 5D Mark III. The "full-frame" camera has a sensor that's the size of the standard 35mm film frame, 24mm × 36mm. Your T5's sensor does *not* measure 24mm × 36mm; instead, it specs out at 22.3mm × 14.9mm, or about 62.5 percent of the area of a full-frame sensor, as shown by the yellow boxes in the figure. You can calculate the relative field of view by dividing the focal length of the lens by .625. Thus, a 100mm lens mounted on a T5 has the same field of view as a

Figure 10.1
Canon offers digital SLRs with full-frame (1X) crops, as well as 1.3X and 1.6X crops.

160mm lens on the 5D Mark III. We humans tend to perform multiplication operations in our heads more easily than division, so such field of view comparisons are usually calculated using the reciprocal of .625—1.6—so we can multiply instead (100 / .625=160; 100 × 1.6=160).

This translation is generally useful only if you're accustomed to using full-frame cameras (usually of the film variety) and want to know how a familiar lens will perform on a digital camera. I strongly prefer *crop factor* over *lens multiplier*, because nothing is being multiplied; a 100mm lens doesn't "become" a 160mm lens—the depth-of-field and lens aperture remain the same. (I'll explain more about these later in this chapter.) Only the field of view is cropped. But *crop factor* isn't much better, as it implies that the 24mm × 36mm frame is "full" and anything else is "less." I get e-mails all the time from photographers who point out that they own full-frame cameras with 36mm × 48mm sensors (like the Mamiya 645ZD or Hasselblad H3D-39 medium-format digitals). By their reckoning, the "half-size" sensors found in cameras like the 1Ds Mark III and 5D Mark III are "cropped."

If you're accustomed to using full-frame film cameras, you might find it helpful to use the crop factor "multiplier" to translate a lens's real focal length into the full-frame equivalent, even though, as I said, nothing is actually being multiplied. Throughout most of this book, I've been using actual focal lengths and not equivalents, except when referring to specific wide-angle or telephoto focal length ranges and their fields of view.

Your First Lens

Back in ancient times (the pre-zoom, pre-autofocus era before the mid-1980s), choosing the first lens for your camera was a no-brainer: you had few or no options. Canon cameras (which used a different lens mount in those days) were sold with a 50mm f/1.4, a 50mm f/1.8, or, if you had deeper pockets, a super-fast 50mm f/1.2 lens. It was also possible to buy a camera as a body alone, which didn't save much money back when a film SLR like the Canon A-1 sold for $435—*with lens*. (Thanks to the era of relatively cheap optics, I still own a total of *eight* 50mm f/1.4 lenses; I picked one up each time I purchased a new or used body.)

Today, your choices are more complicated, and Canon lenses, which now include zoom, autofocus, and, more often than not, built-in image stabilization (IS) features, tend to cost a lot more compared to the price of a camera. (Adjusted for inflation, that $435 A-1 costs $879 in today's dollars.)

The Canon EOS T5 is frequently purchased with a lens, even now, and, on introduction, was available *only* as a lens/body kit. Otherwise, I would have purchased mine as a body-only rather than in a kit, because I already own a nice collection of Canon lenses, including the recent Canon EF-S 18-55mm f/3.5-5.6 IS STM autofocus lens that was not available as a kit lens for the T5. When/if Canon offers other T5 kits, you might be able to opt instead for the EF-S 18-135mm f/3.5-5.6 IS STM lens, which adds about $350 to the price of the body. Those looking for a longer zoom range might opt to pay an additional $700 for the older Canon EF-S 18-200mm f/3.5-5.6 IS lens, which provides a very useful 11X zoom range. Some buyers don't need quite that zoom range, and save a

few dollars by purchasing the Canon EF 28-135mm f/3.5-5.6 IS USM lens ($480). The latter lens has one advantage. *EF* lenses like the 28-135mm zoom can also be used with any *full-frame* camera you add/migrate to at a later date. You'll learn the difference later in this chapter.

So, depending on which category you fall into, you'll need to make a decision about what kit lens to buy, or decide what other kind of lenses you need to fill out your existing complement of Canon optics. This section will cover "first lens" concerns, while later in the chapter we'll look at "add-on lens" considerations.

When deciding on a first lens, there are several factors you'll want to consider:

- **Cost.** You might have stretched your budget a bit to purchase your T5, so you might want to keep the cost of your first lenses fairly low. Fortunately, as I've noted, there are excellent lenses available that will add from $100 to $600 to the price of your camera if purchased at the same time.

- **Zoom range.** If you have only one lens, you'll want a fairly long zoom range to provide as much flexibility as possible. Fortunately, the two most popular basic lenses for the T5 have 3X to 5X zoom ranges, extending from moderate wide-angle/normal out to medium telephoto. These are fine for everyday shooting, portraits, and some types of sports.

- **Adequate maximum aperture.** You'll want an f/stop of at least f/3.5 to f/4 for shooting under fairly low-light conditions. The thing to watch for is the maximum aperture when the lens is zoomed to its telephoto end. You may end up with no better than an f/5.6 maximum aperture. That's not great, but you can often live with it.

- **Image quality.** Your starter lens should have good image quality, befitting a camera with 18MP of resolution, because that's one of the primary factors that will be used to judge your photos. Even at a low price, the several different lenses sold with the T5 as a kit include extra-low dispersion glass and aspherical elements that minimize distortion and chromatic aberration; they are sharp enough for most applications. If you read the user evaluations in the online photography forums, you know that owners of the kit lenses have been very pleased with their image quality.

- **Size matters.** A good walking-around lens is compact in size and light in weight.

- **Fast/close focusing.** Your first lens should have a speedy autofocus system (which is where the ultrasonic motor/USM and new STM system found in nearly all moderately priced lenses is an advantage). Close focusing (to 12 inches or closer) will let you use your basic lens for some types of macro photography.

You can find comparisons of the lenses discussed in the next section, as well as third-party lenses from Sigma, Tokina, Tamron, and other vendors, in online groups and websites. I'll provide my recommendations, but obtaining more information from these additional sources is always helpful when making a lens purchase, because, while camera bodies come and go, lenses may be a lifetime addition to your kit.

Buy Now, Expand Later

The T5 is commonly available with several good, basic lenses that can serve you well as a "walk-around" lens (one you keep on the camera most of the time, especially when you're out and about without your camera bag). The number of options available to you is actually quite amazing, even if your budget is limited to about $100–$500 for your first lens. One other vendor, for example, offers only 18-70mm and 18-55mm kit lenses in that price range, plus a 24-85mm zoom. Two popular starter lenses Canon offers are shown in Figures 10.2 and 10.3. Canon's best-bet first lenses are in the list that follows, which includes some lenses that have been discontinued or otherwise require some hunting on sites like www.keh.com to find:

■ **Canon EF-S 18-55mm f/3.5-5.6 IS STM autofocus lens.** This lens replaces the old "II" version that comes with the T5, and is a bit larger than the older optic. It boasts the new STM stepper motor technology that Canon video fans have found to be so useful. It has image stabilization that can counter camera shake by providing the vibration-stopping capabilities of a shutter speed four stops faster than the one you've dialed in. That is, with image stabilization activated, you can shoot at 1/30th second and eliminate camera shake as if you were using a shutter speed of 1/250th second. (At least, that's what Canon claims; I usually have slightly less impressive results.) Of course, IS doesn't freeze subject motion—that basketball player driving for a layup will still be blurry at 1/30th second, even though the effects of camera shake will be effectively nullified. But this lens is an all-around good choice if your budget is tight.

Figure 10.2 The Canon EF-S 18-55mm f/3.5-5.6 IS autofocus lens ships as a basic kit lens for entry-level Canon cameras.

Figure 10.3 The new EF-S 18-135mm f/3.5-5.6 IS STM lens is affordable and features near-silent autofocus that's perfect for video shooting.

■ **Canon EF-S 18-135mm f/3.5-5.6 IS STM autofocus lens.** This one, priced at about $550 when not purchased in a kit, is an upgrade from a similar earlier lens without the stepper motor technology. It's also light, compact (you can see it mounted on the T5 in Figure 10.3), and covers a useful range from true wide-angle to intermediate telephoto. As with Canon's other affordable zoom lenses, image stabilization partially compensates for the slow f/5.6 maximum aperture at the telephoto end, by allowing you to use longer shutter speeds to capture an image under poor lighting conditions. I'll explain the advantages of the STM autofocus later in this chapter.

■ **Canon EF-S 18-200mm f/3.5-5.6 IS autofocus lens.** This one, priced at about $700, has been popular as a basic lens for the T5, because it's light, compact, and covers a full range from true wide-angle to long telephoto. Image stabilization keeps your pictures sharp at the long end of the zoom range, allowing the longer shutter speeds that the f/5.6 maximum aperture demands at 200mm. Automatic panning detection turns the IS feature off when panning in both horizontal and vertical directions. An improved "Super Spectra Coating" minimizes flare and ghosting, while optimizing color rendition.

■ **Canon EF-S 17-85mm f/4-5.6 IS USM autofocus lens.** This older lens (introduced in 2004 with the EOS 20D) is a very popular "basic" lens still sold for the T5. The allure here with this $800 lens is the longer telephoto range, coupled with the built-in image stabilization, which allows you to shoot rock-solid photos at shutter speeds that are at least two or three notches slower than you'd need normally (say, 1/8th second instead of 1/30th or 1/60th second), as long as your subject isn't moving. It also has a quiet, fast, reliable ultrasonic motor (more on that later, too). This is another lens designed for the 1.6X crop factor; all but one of the remaining lenses in this list can also be used on full-frame cameras. (I'll tell you why later in this chapter.) This lens is shown in Figure 10.4.

■ **Canon EF 55-200mm f/4.5-5.6 II USM autofocus lightweight compact telephoto zoom lens.** If you bought the 18-55mm kit lens, this one picks up where that one leaves off, going from short telephoto to medium long (88mm-320mm full-frame equivalent). It features a desirable ultrasonic motor. Best of all, it's very affordable at around $300. If you can afford only two lenses, the 18-55mm and this one make a good basic set.

Figure 10.4 The Canon EF-S 17-85mm f/4-5.6 IS USM autofocus lens is another popular lens.

- **EF-S 55-250mm f/4-5.6 IS telephoto zoom lens.** This is an image-stabilized EF-S lens (which means it can't be used with Canon's 1.3X and 1.0X crop-factor pro cameras), providing the longest focal range in the EF-S range to date, and that 4-stop Image Stabilizer. It's about $300, but it's worth the cost for the stabilization.

- **Canon EF 24-85mm f/3.5-4.5 USM autofocus wide-angle telephoto zoom lens.** If you can get by with normal focal length to medium telephoto range, Canon offers four affordable lenses, plus one more expensive killer lens that's worth the extra expenditure. All of them can be used on full-frame or cropped-frame digital Canons, which is why they include "wide angle" in their product names. They're really wide-angle lenses only when mounted on a full-frame camera. This one, priced in the $300 range if you can find one for sale, offers a useful range of focal lengths, extending from the equivalent of 38mm to 136mm.

- **Canon EF 28-105mm f/3.5-4.5 II USM autofocus wide-angle telephoto zoom lens.** If you want to save about $100 and gain a little reach compared to the 24-85mm zoom, this 45mm-168mm (equivalent lens) might be what you are looking for.

- **Canon EF 28-200mm f/3.5-5.6 USM autofocus wide-angle telephoto zoom lens.** If you want one lens to do everything except wide-angle photography, this 7X zoom lens costs less than $400 in excellent condition used and takes you from the equivalent of 45mm out to a long 320mm.

- **Canon EF 24-70mm f/2.8L II USM autofocus zoom wide-angle-telephoto lens.** I couldn't leave this premium lens out of the mix, even though it costs well over $2,000. As part of Canon's L-series (Luxury) lens line, it offers the best sharpness over its focal range than any of the other lenses in this list. Best of all, it's fast (for a zoom), with an f/.2.8 maximum aperture that *doesn't change* as you zoom out. Unlike the other lenses, which may offer only an f/5.6 maximum f/stop at their longest zoom setting, this is a *constant aperture* lens, which retains its maximum f/stop. The added sharpness, constant aperture, and ultra-smooth USM motor are what you're paying for with this lens. Another version with an f/4 maximum aperture with image stabilization can be purchased for less than $1,500.

What Lenses Can You Use?

The previous section helped you sort out what lens you need to buy with your T5 (assuming you already didn't own any Canon lenses). Now, you're probably wondering what lenses can be added to your growing collection (trust me, it will grow). You need to know which lenses are suitable and, most importantly, which lenses are fully compatible with your T5.

With the Canon T5, the compatibility issue is a simple one: It accepts any lens with the EF or EF-S designation, with full availability of all autofocus, autoaperture, autoexposure, and image-stabilization features (if present). It's comforting to know that any EF (for full-frame or cropped sensors) or EF-S (for cropped sensor cameras only) lens will work as designed with your camera. As I noted at the beginning of the chapter, that's more than 70 million lenses!

But wait, there's more. You can also attach Nikon F mount, Leica R, Olympus OM, and M42 ("Pentax screw mount") lenses with a simple adapter, if you don't mind losing automatic focus and aperture control. If you use one of these lenses, you'll need to focus manually (even if the lens operates in Autofocus mode on the camera it was designed for), and adjust the f/stop to the aperture you want to use to take the picture. That means that lenses that don't have an aperture ring (such as Nikon G-series lenses) must be used only at their maximum aperture if you use them with a simple adapter. However, Novoflex makes expensive adapter rings (the Nikon-Lens-on-Canon-Camera version is called EOS/NIK NT) with an integral aperture control that allows adjusting the aperture of lenses that do not have an old-style aperture ring. Expect to pay as much as $300 for an adapter of this type. Should you decide to pick up a new Canon EOS-M mirrorless camera, you'll be able to get double-duty with your EF and EF-S lenses, too, with an adapter that will allow you to use the same lenses on your T5 and companion EOS-M cameras.

Because of the limitations imposed on using "foreign" lenses on your T5, you probably won't want to make extensive use of them, but an adapter can help you when you really, really need to use a particular focal length but don't have a suitable Canon-compatible lens. For example, I occasionally use an older 400mm lens that was originally designed for the Nikon line on my T5. The lens needs to be mounted on a tripod for steadiness, anyway, so its slower operation isn't a major pain. Another good match is the 105mm Micro-Nikkor I sometimes use with my Canon T5. Macro photos, too, are most often taken with the camera mounted on a tripod, and manual focus makes a lot of sense for fine-tuning focus and depth-of-field. Because of the contemplative nature of close-up photography, it's not much of an inconvenience to stop down to the taking aperture just before exposure.

WHY SO MANY LENS MOUNTS?

Four different lens mounts in 40-plus years (five, if you count the EF-M mount for the new EOS-M cameras) might seem like a lot of different mounting systems, especially when compared to the Nikon F mount of 1959, which retained quite a bit of compatibility with that company's film and digital camera bodies during that same span. However, in digital photography terms, the EF mount itself is positively ancient, having remained reasonably stable for more than 25 years. Lenses designed for the EF system work reliably with every EOS film and digital camera ever produced.

However, at the time, yet another lens mount switch, especially a change from the traditional breech system to a more conventional bayonet-type mount, was indeed a daring move by Canon. One of the reasons for staying with a particular lens type is to "lock" current users into a specific camera system. By introducing the EF mount, Canon in effect cut loose every photographer in its existing user base. If they chose to upgrade, they were free to choose another vendor's products and lenses. Only satisfaction with the previous Canon product line and the promise of the new system would keep them in the fold.

The restrictions on use of lenses within Canon's own product line (as well as lenses produced for earlier Canon SLRs by third-party vendors) are fairly clear-cut. The T5 cannot be used with any of Canon's earlier lens mounting schemes for its film cameras, including the immediate predecessor to the EF mount, the FD mount (introduced with the Canon F1 in 1964 and used until the Canon T60 in 1990), FL (1964-1971), or the original Canon R mount (1959–1964). That's really all you need to know. While you'll find FD-to-EF adapters for about $40, you'll lose so many functions that it's rarely worth the bother.

In retrospect, the switch to the EF mount seems like a very good idea, as the initial EOS film cameras can now be seen as the beginning of Canon's rise to eventually become the leader in film and (later) digital SLR cameras. By completely revamping its lens mounting system, the company was able to take advantage of the latest advances in technology without compromise.

For example, when the original EF bayonet mount was introduced in 1987, the system incorporated new autofocus technology (EF actually stands for "electro focus") in a more rugged and less complicated form. A tiny motor was built into the lens itself, eliminating the need for mechanical linkages with the camera. Instead, electrical contacts are used to send power and the required focusing information to the motor. That's a much more robust and resilient system that made it easier for Canon to design faster and more accurate autofocus mechanisms just by redesigning the lenses.

EF vs. EF-S

Today, in addition to its EF lenses, Canon offers lenses that use the EF-S (the S stands for "short back focus") mount, with the chief difference being (as you might expect) lens components that extend farther back into the camera body of some of Canon's latest digital cameras (specifically those with smaller than full-frame sensors), such as the T5. As I'll explain next, this refinement allows designing more compact, less-expensive lenses especially for those cameras, but not for models that include current cameras like the EOS 5D Mark III, 1D X, or 1D Mark III (even though the latter camera does have a sensor that is slightly smaller than full frame).

Canon's EF-S lens mount variation was born in 2003, when the company virtually invented the consumer-oriented digital SLR category by introducing the original EOS 300D/Digital Rebel, a dSLR that cost less than $1,000 *with lens* at a time when all other interchangeable lens digital cameras (including the T5's "grandparent," the original EOS 10D) were priced closer to $2,000 with a basic lens. Like the EOS 10D, the EOS T5 features a smaller than full-frame sensor with a 1.6X crop factor (Canon calls this format APS-C). But the EOS Digital accepted lenses that took advantage of the shorter mirror found in APS-C cameras, with elements of shorter focal length lenses (wide angles) that extended *into* the camera, space that was off limits in other models because the mirror passed through that territory as it flipped up to expose the shutter and sensor. (Canon even calls its flip-up reflector a "half mirror.")

In short (so to speak), the EF-S mount made it easier to design less-expensive wide-angle lenses that could be used *only* with 1.6X-crop cameras, and featured a simpler design and reduced coverage

area suitable for those non-full-frame models. The new mount made it possible to produce lenses like the ultra-wide EF-S 10-22mm f/3.5-4.5 USM lens, which has the equivalent field of view as a 16mm-35mm zoom on a full-frame camera. (See Figure 10.5.)

Suitable cameras for EF-S lenses include all recent non-full-frame models. The EF-S lenses cannot be used on the APS-C-sensor EOS 10D, the 1D Mark II N/Mark III (which have a 28.7mm × 19.1mm APS-H sensor with a 1.3X crop factor), or any of the full-frame digital or film EOS models, such as the EOS 1D X, EOS 1Ds Mark III, or EOS 5D Mark III. It's easy to tell an EF lens from an EF-S lens: The latter incorporate EF-S into their name! Plus, EF lenses have a raised red dot on the barrel that is used to align the lens with a matching dot on the camera when attaching the lens. EF-S lenses and compatible bodies use a white square instead. Some EF-S lenses also have a rubber ring at the attachment end that provides a bit of weather/dust sealing and protects the back components of the lens if a user attempts to mount it on a camera that is not EF-S compatible.

Figure 10.5 The EF-S 10-22mm ultra-wide lens was made possible by the shorter back focus difference offered by the original Digital and subsequent Canon 1.6X "cropped sensor" models.

Ingredients of Canon's Alphanumeric Soup

The actual product names of individual Canon lenses are fairly easy to decipher; they'll include either the EF or EF-S designation, the focal length or focal length range of the lens, its maximum aperture, and some other information. Additional data may be engraved or painted on the barrel or ring surrounding the front element of the lens, as shown in Figure 10.6. Here's a decoding of what the individual designations mean:

- **EF/EF-S.** If the lens is marked EF, it can safely be used on any Canon EOS camera, film or digital. If it is an EF-S lens, it should be used only on an EF-S compatible camera.

- **Focal length.** Given in millimeters or a millimeter range, such as 60mm in the case of a popular Canon macro lens, or 17-55mm, used to describe a medium-wide to short-telephoto zoom.

- **Maximum aperture.** The largest f/stop available with a particular lens is given in a string of numbers that might seem confusing at first glance. For example, you might see 1:1.8 for a fixed-focal length (prime) lens, and 1:4.5-5.6 for a zoom. The initial 1: signifies that the f/stop given is actually a ratio or fraction (in regular notation, f/ replaces the 1:), which is why a 1:2 (or f/2) aperture is larger than an 1:4 (or f/4) aperture—just as 1/2 is larger than 1/4. With most zoom lenses, the maximum aperture changes as the lens is zoomed to the telephoto position, so a range is given instead: 1:4.5-5.6. (Some zooms, called *constant aperture* lenses, keep the same maximum aperture throughout their range.)

Figure 10.6
Most of the key specifications of the lens are marked on the ring around the front element.

■ **Autofocus type.** Most newer Canon lenses that aren't of the bargain-basement type use Canon's *ultrasonic motor* autofocus system (more on that later) and are given the USM designation. Several of the company's newest optics use the Stepper Motor (STM) technology. If USM or STM does not appear on the lens or its model name, the lens uses the less sophisticated AFD (arc-form drive) autofocus system or the micromotor (MM) drive mechanism.

■ **Series.** Canon adds a Roman numeral to many of its products to represent an updated model with the same focal length or focal length range, so some lenses will have a II or III added to their name.

■ **Pro quality.** Canon's more expensive lenses with more rugged construction and higher optical quality, intended for professional use, include the letter L (for "luxury") in their product name. You can further differentiate these lenses visually by a red ring around the lens barrel and the off-white color of the metal barrel itself in virtually all telephoto L-series lenses. (Some L-series lenses have shiny or textured black plastic exterior barrels.) Internally, every L lens includes at least one lens element that is built of ultra-low dispersion glass, is constructed of expensive fluorite crystal, or uses an expensive ground (not molded) aspheric (non-spherical) lens component.

■ **Filter size.** You'll find the front lens filter thread diameter in millimeters included on the lens, preceded by a Ø symbol, as in Ø67 or Ø72.

■ **Special-purpose lenses.** Some Canon lenses are designed for specific types of work, and they include appropriate designations in their names. For example, close-focusing lenses such as the Canon EF-S 60mm f/2.8 Macro USM lens incorporate the word *Macro* into their name. Lenses with perspective control features preface the lens name with T-S (for tilt-shift). Lenses with built-in image-stabilization features, such as the nifty EF 28-300mm f/3.5-5.6L IS USM telephoto zoom include *IS* in their product names.

SORTING THE MOTOR DRIVES

Incorporating the autofocus motor inside the lens was an innovative move by Canon, and this allowed the company to produce better and more sophisticated lenses as technology became available to upgrade the focusing system. As a result, you'll find four different types of motors in Canon-designed lenses, each with cost and practical considerations. Most newer lenses use only the latest USM motor, and incorporate that designation in their names.

■ **AFD (Arc-form drive)** and **Micromotor (MM)** drives are built around tiny versions of electromagnetic motors, which generally use gear trains to produce the motion needed to adjust the focus of the lens. Both are slow, noisy, and not particularly effective with larger lenses. Manual focus adjustments are possible only when the motor drive is disengaged.

■ **Micromotor ultrasonic motor (USM)** drives use high-frequency vibration to produce the motion used to drive the gear train, resulting in a quieter operating system at a cost that's not much more than that of electromagnetic motor drives. With the exception of a couple lenses that have a slipping clutch mechanism, manual focus with this kind of system is possible only when the motor drive is switched off and the lens is set in manual mode. This is the kind of USM system you'll find in lower-cost lenses.

■ **Ring ultrasonic motor (USM)** drives, available in two different types (*electronic focus ring USM* and *ring USM*), also use high-frequency movement, but generate motion using a pair of vibrating metal rings to adjust focus. Both variations allow a feature called Full Time Manual (FTM) focus, which lets you make manual adjustments to the lens's focus even when the autofocus mechanism is engaged. With electronic focus ring USM, manual focus is possible only when the lens is mounted on the camera and the camera is turned on; the focus ring of lenses with ring USM can be turned at any time.

■ **Stepper motor (STM) drives.** In autofocus mode, the precision motor of STM lenses, along with a new aperture mechanism, allows lenses equipped with this technology to focus quickly, accurately, silently, and with smooth continuous increments. If you think about video capture, you can see how these advantages pay off. Silent operation is a plus, especially when noise from autofocusing can easily be transferred to the camera's built-in microphones through the air or transmitted through the body itself. In addition, because autofocus is often done *during* capture, it's important that the focus increments are continuous. USM motors are not as smooth, but are better at jumping quickly to the exact focus point. You can adjust focus manually, using a focus-by-wire process. As you rotate the focus ring, that action doesn't move the lens elements; instead, your rotation of the ring sends a signal to the motor to change the focus. Figure 10.7 shows the new Canon EF-S 40mm f/2.8 STM lens.

Figure 10.7
Canon's 40mm f/2.8 lens, with an STM motor, is designed for video capture.

Your Second (and Third...) Lens

There are really only two advantages to owning just a single lens. One of them is creative. Keeping one set of optics mounted on your T5 all the time forces you to be especially imaginative in your approach to your subjects. I once visited Europe with only a single camera body and a 35mm f/2 lens. The experience was actually quite exciting, because I had to use a variety of techniques to allow that one lens to serve for landscapes, available-light photos, action, close-ups, portraits, and other kinds of images. Canon makes an excellent 35mm f/2 lens (which focuses down to 9.6 inches) that's perfect for that kind of experiment; although, today, my personal choice would be the sublime (and expensive) Canon Wide-Angle EF 35mm f/1.4L USM autofocus lens. I also own the Canon EF 50mm f/1.8 II lens, which I favor as a very compact and light walkaround/short telephoto/portrait lens, especially indoors. It makes a great close-up/macro lens, too, and, at around $125, is my choice as a very good second lens.

Of course, it's more likely that your "single" lens is actually a zoom, which is, in truth, many lenses in one, taking you from, say, 17mm to 85mm (or some other range) with a rapid twist of the zoom ring. You'll still find some creative challenges when you stick to a single zoom lens's focal lengths.

The second advantage of the unilens camera is only a marginal technical benefit since the introduction of the T5. If you don't exchange lenses, the chances of dust and dirt getting inside your T5 and settling on the sensor is reduced (but *not* eliminated entirely). Although I've known some photographers who minimized the number of lens changes they made for this very reason, reducing the number of lenses you work with is not a productive or rewarding approach for most of us.

It's more likely that you'll succumb to the malady known as *Lens Lust*, which is defined as an incurable disease marked by a significant yen for newer, better, longer, faster, sharper, anything-er optics for your camera. (And, it must be noted, this disease can *cost* you significant yen—or dollars, or whatever currency you use.) In its worst manifestations, sufferers find themselves with lenses that have overlapping zoom ranges or capabilities, because one or the other offers a slight margin in performance or suitability for specific tasks. When you find yourself already lusting after a new lens before you've really had a chance to put your latest purchase to the test, you'll know the disease has reached the terminal phase.

What Lenses Can Do for You

A saner approach to expanding your lens collection is to consider what each of your options can do for you and then choosing the type of lens that will really boost your creative opportunities. Here's a general guide to the sort of capabilities you can gain by adding a lens to your repertoire:

- **Wider perspective.** Your 18-55mm f/3.5-5.6 or 17-85mm f/4-5.6 or 18-200mm lens has served you well for moderate wide-angle shots. Now you find your back is up against a wall and you *can't* take a step backward to take in more subject matter. Perhaps you're standing on the rim of the Grand Canyon, and you want to take in as much of the breathtaking view as you can. You might find yourself just behind the baseline at a high school basketball game and want an interesting shot with a little perspective distortion tossed in the mix. There's a lens out there that will provide you with what you need, such as the EF-S 10-22mm f/3.5-4.5 USM zoom. If you want to stay in the sub-$800 price category, you'll need something like the Sigma Super Wide-Angle 10-20mm f/4-5.6 EX DC HSM autofocus lens. The two lenses provide the equivalent of a 16mm to 32/35mm wide-angle view. For a distorted view, there is the Canon Fisheye EF 15mm f/2.8 autofocus, with a similar lens available from Sigma, which offers an extra-wide circular fisheye, and the Sigma Fisheye 8mm f/3.5 EX DG Circular Fisheye. Your extra-wide choices may not be abundant, but they are there. Figure 10.8 shows the perspective you get from an ultra-wide-angle, non-fisheye lens.

- **Bring objects closer.** A long lens brings distant subjects closer to you, offers better control over depth-of-field, and avoids the perspective distortion that wide-angle lenses provide. They compress the apparent distance between objects in your frame. In the telephoto realm, Canon is second to none, with a dozen or more offerings in the sub-$650 range, including the Canon EF 100-300mm f/4.5-5.6 USM autofocus and Canon EF 70-300mm f/4-5.6 IS USM autofocus telephoto zoom lenses, and a broad array of zooms and fixed-focal length optics if you're willing to spend up to $1,000 or a bit more. Don't forget that the T5's crop factor narrows the field of view of all these lenses, so your 70-300mm lens looks more like a 112mm-480mm zoom through the viewfinder. Figures 10.9 and 10.10 were taken from the same position as Figure 10.8, but with an 85mm and 500mm lens, respectively.

- **Bring your camera closer.** Macro lenses allow you to focus to within an inch or two of your subject. Canon's best close-up lenses are all fixed focal length optics in the 50mm to 180mm range (including the well-regarded Canon EF-S 60mm f/2.8 compact and Canon EF 100mm f/2.8 USM macro autofocus lenses). But you'll find macro zooms available from Sigma and others. They don't tend to focus quite as close, but they provide a bit of flexibility when you want to vary your subject distance (say, to avoid spooking a skittish creature).

- **Look sharp.** Many lenses, particularly Canon's luxury "L" line, are prized for their sharpness and overall image quality. While your run-of-the-mill lens is likely to be plenty sharp for most applications, the very best optics are even better over their entire field of view (which means no fuzzy corners), are sharper at a wider range of focal lengths (in the case of zooms), and have better correction for various types of distortion.

Figure 10.8
An ultra-wide-angle lens provided this view of a castle in Prague, Czech Republic.

Figure 10.9
This photo, taken from roughly the same distance, shows the view using a short telephoto lens.

Figure 10.10
A longer telephoto lens captured this closer view of the castle from approximately the same shooting position.

- **More speed.** Your Canon EF 100-300mm f/4.5-5.6 telephoto zoom lens might have the perfect focal length and sharpness for sports photography, but the maximum aperture won't cut it for night baseball or football games, or, even, any sports shooting in daylight if the weather is cloudy or you need to use some unusually fast shutter speed, such as 1/4,000th second. You might be happier with the Canon EF 100mm f/2 medium telephoto for close-range stuff, or even the pricier Canon EF 135mm f/2L. If money is no object, you can spring for Canon's 400mm f/2.8 and 600mm f/4 L-series lenses (both with image stabilization and priced in the four- and five-figure stratosphere). Or, maybe you just need the speed and can benefit from an f/1.8 or f/1.4 lens in the 20mm-85mm range. They're all available in Canon mounts (there's even an 85mm f/1.2 and 50mm f/1.2 for the real speed demons). With any of these lenses you can continue photographing under the dimmest of lighting conditions without the need for a tripod or flash.

- **Special features.** Accessory lenses give you special features, such as tilt/shift capabilities to correct for perspective distortion in architectural shots. Canon offers four of these TS-E lenses in 17mm, 24mm, 45mm, and 90mm focal lengths, at more than $1,300 to $2,000 (and up) each. You'll also find macro lenses, including the MP-E 65mm f/2.8 1-5x macro photo lens, a manual focus lens which shoots *only* in the 1X to 5X life-size range. If you want diffused images, check out the EF 135mm f/2.8 with two soft-focus settings. The fisheye lenses mentioned earlier and all IS (image-stabilized) lenses also count as special-feature optics. The recent Canon EF 8-15mm f/4L Fisheye USM ultra-wide zoom lens is highly unusual in offering a *zoomable* fisheye range. Tokina's 10-17mm fisheye zoom is its chief competitor; I've owned one and it is not in the same league in terms of sharpness and speed (or price).

Zoom or Prime?

Zoom lenses have changed the way serious photographers take pictures. One of the reasons that I own 12 SLR film bodies is that in ancient times it was common to mount a different fixed focal length prime lens on various cameras and take pictures with two or three cameras around your neck (or tucked in a camera case) so you'd be ready to take a long shot or an intimate close-up or wide-angle view on a moment's notice, without the need to switch lenses. It made sense (at the time) to have a half dozen or so bodies (two to use, one in the shop, one in transit, and a couple backups). Zoom lenses of the time had a limited zoom range, were heavy, and not very sharp (especially when you tried to wield one of those monsters hand-held).

That's all changed today. Lenses like the razor-sharp Canon EF 28-300mm f/3.5-5.6L IS USM can boast 10X or longer zoom ranges, in a package that's about 7 inches long, and while not petite at 3.7 pounds, it is quite usable hand-held (especially with IS switched on). Although such a lens might seem expensive at $2,600-plus, it's actually much less costly than the six or so lenses it replaces.

When selecting between zoom and prime lenses, there are several considerations to ponder. Here's a checklist of the most important factors. I already mentioned image quality and maximum aperture earlier, but those aspects take on additional meaning when comparing zooms and primes.

■ **Logistics.** As prime lenses offer just a single focal length, you'll need more of them to encompass the full range offered by a single zoom. More lenses mean additional slots in your camera bag, and extra weight to carry. Just within Canon's line alone you can select from about a dozen general-purpose prime lenses in 28mm, 35mm, 50mm, 85mm, 100mm, 135mm, 200mm, and 300mm focal lengths, all of which are overlapped by the 28-300mm zoom I mentioned earlier. Even so, you might be willing to carry an extra prime lens or two in order to gain the speed or image quality that lens offers.

■ **Image quality.** Prime lenses usually produce better image quality at their focal length than even the most sophisticated zoom lenses at the same magnification. Zoom lenses, with their shifting elements and f/stops that can vary from zoom position to zoom position, are in general more complex to design than fixed focal length lenses. That's not to say that the very best prime lenses can't be complicated as well. However, the exotic designs, aspheric elements, low-dispersion glass, and Canon's technology (a three-layer diffraction grating to better control how light is captured by a lens) can be applied to improving the quality of the lens, rather than wasting a lot of it on compensating for problems caused by the zoom process itself.

■ **Maximum aperture.** Because of the same design constraints, zoom lenses usually have smaller maximum apertures than prime lenses, and the most affordable zooms have a lens opening that grows effectively smaller as you zoom in. The difference in lens speed verges on the ridiculous at some focal lengths. For example, the 18mm-55mm basic zoom gives you a 55mm f/5.6 lens when zoomed all the way out, while prime lenses in that focal length commonly have f/1.8 or faster maximum apertures. Indeed, the fastest f/2, f/1.8, f/1.4, and f/1.2 lenses are all primes, and if you require speed, a fixed focal length lens is what you should rely on. Figure 10.11 shows an image taken with a Canon 85mm f/1.8 Series EF USM telephoto lens.

■ **Speed.** Using prime lenses takes time and slows you down. It takes a few seconds to remove your current lens and mount a new one, and the more often you need to do that, the more time is wasted. If you choose not to swap lenses, when using a fixed focal length lens you'll still have to move closer or farther away from your subject to get the field of view you want. A zoom lens allows you to change magnifications and focal lengths with the twist of a ring and generally saves a great deal of time.

■ **Special features.** Prime lenses often have special features not found in zoom lenses. For example, the new EF 40mm f/2.8 STM lens boasts that smooth, silent autofocus motor described earlier in this chapter. It functions as a wide-angle lens on a full-frame camera like the 5D Mark III, and as a short telephoto, portrait lens on cameras like the T5. You'll also find close-focusing capabilities and perspective control features on prime lenses.

Figure 10.11 An 85mm f/1.8 lens was perfect for this hand-held photo of a musician.

TIP

Early copies of the EF 40mm f/2.8 STM lens (including the one I purchased), had suffered from a defect that caused autofocusing to cease functioning when pressure was applied to the lens barrel. In my case, gripping the barrel while removing the UV filter I use as a lens cap was enough. Until Canon issued a product advisory, I was really puzzled by this phenomenon. When I removed the lens and tried it on my 5D Mark III to see if the problem was in the lens or the camera body, it went away (temporarily). Before a firmware fix was issued in August 2012, Canon advised the workaround of removing and reattaching the lens, or removing and reinserting the battery. If you own this lens, make sure your T5 firmware updates are all current.

Categories of Lenses

Lenses can be categorized by their intended purpose—general photography, macro photography, and so forth—or by their focal length. The range of available focal lengths is usually divided into three main groups: wide-angle, normal, and telephoto. Prime lenses fall neatly into one of these classifications. Zooms can overlap designations, with a significant number falling into the catch-all, wide-to-telephoto zoom range. This section provides more information about focal length ranges, and how they are used.

Any lens with an equivalent focal length of 10mm to 20mm is said to be an *ultra-wide-angle lens*; from about 20mm to 40mm (equivalent) is said to be a *wide-angle lens*. *Normal lenses* have a focal length roughly equivalent to the diagonal of the film or sensor, in millimeters, and so fall into the range of about 45mm to 60mm (on a full-frame camera). *Telephoto lenses* usually fall into the 75mm and longer focal lengths, while those from about 300mm to 400mm and longer often are referred to as *super-telephotos*.

Using Wide-Angle and Wide-Zoom Lenses

To use wide-angle prime lenses and wide zooms, you need to understand how they affect your photography. Here's a quick summary of the things you need to know:

- **More depth-of-field.** Practically speaking, wide-angle lenses offer more depth-of-field at a particular subject distance and aperture. (But see the sidebar below for an important note.) You'll find that helpful when you want to maximize sharpness of a large zone, but not very useful when you'd rather isolate your subject using selective focus (telephoto lenses are better for that).

- **Stepping back.** Wide-angle lenses have the effect of making it seem that you are standing farther from your subject than you really are. They're helpful when you don't want to back up, or can't because there are impediments in your way.

■ **Wider field of view.** While making your subject seem farther away, as implied above, a wide-angle lens also provides a larger field of view, including more of the subject in your photos. Table 10.1 shows the diagonal field of view offered by an assortment of lenses, taking into account the crop factor introduced by the T5's smaller-than-full-frame sensor.

■ **More foreground.** As background objects retreat, more of the foreground is brought into view by a wide-angle lens. That gives you extra emphasis on the area that's closest to the camera. Photograph your home with a normal lens/normal zoom setting, and the front yard probably looks fairly conventional in your photo (that's why they're called "normal" lenses). Switch to a wider lens and you'll discover that your lawn now makes up much more of the photo. So, wide-angle lenses are great when you want to emphasize that lake in the foreground, but problematic when your intended subject is located farther in the distance.

■ **Super-sized subjects.** The tendency of a wide-angle lens to emphasize objects in the foreground, while de-emphasizing objects in the background can lead to a kind of size distortion that may be more objectionable for some types of subjects than others. Shoot a bed of flowers up close with a wide angle, and you might like the distorted effect of the larger blossoms nearer the lens. Take a photo of a family member with the same lens from the same distance, and you're likely to get some complaints about that gigantic nose in the foreground.

■ **Perspective distortion.** When you tilt the camera so the plane of the sensor is no longer perpendicular to the vertical plane of your subject, some parts of the subject are now closer to the sensor than they were before, while other parts are farther away. So, buildings, flagpoles, or NBA players appear to be falling backward, as you can see in Figure 10.12. While this kind of apparent distortion (it's not caused by a defect in the lens) can happen with any lens, it's most apparent when a wide angle is used.

Figure 10.12
Tilting the camera back produces this "falling back" look in architectural photos.

■ **Steady cam.** You'll find that you can hand-hold a wide-angle lens at slower shutter speeds, without need for image stabilization, than you can with a telephoto lens. The reduced magnification of the wide-lens or wide-zoom setting doesn't emphasize camera shake like a telephoto lens does.

■ **Interesting angles.** Many of the factors already listed combine to produce more interesting angles when shooting with wide-angle lenses. Raising or lowering a telephoto lens a few feet probably will have little effect on the appearance of the distant subjects you're shooting. The same change in elevation can produce a dramatic effect for the much-closer subjects typically captured with a wide-angle lens or wide-zoom setting.

The crop factor strikes again! You can see from Table 10.1 that wide-angle lenses provide a broader field of view, and that, because of the T5's 1.6 crop factor, lenses must have a shorter focal length to provide the same field of view. If you like working with a 28mm lens with your full-frame camera, you'll need an 18mm lens for your T5 to get the same field of view. (Some focal lengths have been rounded slightly for simplification.)

Table 10.1 Field of View at Various Focal Lengths

Diagonal Field of View	Focal Length at 1X Crop	Focal Length Needed to Produce Same Field of View at 1.6X Crop
107 degrees	16mm	10mm
94 degrees	20mm	12mm
84 degrees	24mm	15mm
75 degrees	28mm	18mm
63 degrees	35mm	22mm
47 degrees	50mm	31mm
28 degrees	85mm	53mm
18 degrees	135mm	85mm
12 degrees	200mm	125mm
8.2 degrees	300mm	188mm

DOF IN DEPTH

The depth-of-field (DOF) advantage of wide-angle lenses is diminished when you enlarge your picture; believe it or not, a wide-angle image enlarged and cropped to provide the same subject size as a telephoto shot would have the *same* depth-of-field. Try it: take a wide-angle photo of a friend from a fair distance, and then zoom in to duplicate the picture in a telephoto image. Then, enlarge the wide shot so your friend is the same size in both. The wide photo will have the same DOF (and will have much less detail, too).

Avoiding Potential Wide-Angle Problems

Wide-angle lenses have a few quirks that you'll want to keep in mind when shooting so you can avoid falling into some common traps. Here's a checklist of tips for avoiding common problems:

- **Symptom: converging lines.** Unless you want to use wildly diverging lines as a creative effect, it's a good idea to keep horizontal and vertical lines in landscapes, architecture, and other subjects carefully aligned with the sides, top, and bottom of the frame. That will help you avoid undesired perspective distortion. Sometimes it helps to shoot from a slightly elevated position so you don't have to tilt the camera up or down.

- **Symptom: color fringes around objects.** Lenses are often plagued with fringes of color around backlit objects, produced by *chromatic aberration*, which comes in two forms: *longitudinal/axial*, in which all the colors of light don't focus in the same plane; and *lateral/transverse*, in which the colors are shifted to one side. Axial chromatic aberration can be reduced by stopping down the lens, but transverse chromatic aberration cannot. Both can be reduced by using lenses with low-diffraction index glass (or UD elements, in Canon nomenclature) and by incorporating elements that cancel the chromatic aberration of other glass in the lens. For example, a strong positive lens made of low-dispersion crown glass (made of a soda-lime-silica composite) may be mated with a weaker negative lens made of high-dispersion flint glass, which contains lead.

- **Symptom: lines that bow outward.** Some wide-angle lenses cause straight lines to bow outward, with the strongest effect at the edges. In fisheye (or *curvilinear*) lenses, this defect is a feature, as you can see in Figure 10.13. When distortion is not desired, you'll need to use a lens that has corrected barrel distortion. Manufacturers like Canon do their best to minimize or eliminate it (producing a *rectilinear* lens), often using *aspherical* lens elements (which are not cross-sections of a sphere). You can also minimize less severe barrel distortion simply by framing your photo with some extra space all around, so the edges where the defect is most obvious can be cropped out of the picture.

- **Symptom: dark corners and shadows in flash photos.** The Canon EOS T5's built-in electronic flash is designed to provide even coverage for lenses as wide as 17mm. If you use a wider lens, you can expect darkening, or *vignetting*, in the corners of the frame. At wider focal lengths,

the lens hood of some lenses (my 17mm-85mm lens is a prime offender) can cast a semi-circular shadow in the lower portion of the frame when using the built-in flash. Sometimes removing the lens hood or zooming in a bit can eliminate the shadow. Mounting an external flash unit, such as the mighty Canon 580EX II or 600EX-RT, can solve both problems, as it has zoomable coverage up to 114 degrees with the included adapter, sufficient for a 15mm rectilinear lens. Its higher vantage point eliminates the problem of lens hood shadow, too.

■ **Symptom: light and dark areas when using polarizing filter.** If you know that polarizers work best when the camera is pointed 90 degrees away from the sun and have the least effect when the camera is oriented 180 degrees from the sun, you know only half the story. With lenses having a focal length of 10mm to 18mm (the equivalent of 16mm-28mm), the angle of view (107 to 75 degrees diagonally, or 97 to 44 degrees horizontally) is extensive enough to cause problems. Think about it: when a 10mm lens is pointed at the proper 90-degree angle from the sun, objects at the edges of the frame will be oriented at 135 to 41 degrees, with only the center at exactly 90 degrees. Either edge will have much less of a polarized effect. The solution is to avoid using a polarizing filter with lenses having an actual focal length of less than 18mm (or 28mm equivalent).

Figure 10.13 Many wide-angle lenses cause lines to bow outward toward the edges of the image; with a fisheye lens, this tendency is especially useful for creating special effects, as in this shot.

Using Telephoto and Tele-Zoom Lenses

Telephoto lenses also can have a dramatic effect on your photography, and Canon is especially strong in the long-lens arena, with lots of choices in many focal lengths and zoom ranges. You should be able to find an affordable telephoto or tele-zoom to enhance your photography in several different ways. Here are the most important things you need to know. In the next section, I'll concentrate on telephoto considerations that can be problematic—and how to avoid those problems.

- **Selective focus.** Long lenses have reduced depth-of-field within the frame, allowing you to use selective focus to isolate your subject. You can open the lens up wide to create shallow depth-of-field (see Figure 10.14), or close it down a bit to allow more to be in focus. The flip side of the coin is that when you *want* to make a range of objects sharp, you'll need to use a smaller f/stop to get the depth-of-field you need. Like fire, the depth-of-field of a telephoto lens can be friend or foe.

Figure 10.14 A wide f/stop helped isolate the lemur from its background.

- **Getting closer.** Telephoto lenses bring you closer to wildlife, sports action, and candid subjects. No one wants to get a reputation as a surreptitious or "sneaky" photographer (except for paparazzi), but when applied to candids in an open and honest way, a long lens can help you capture memorable moments while retaining enough distance to stay out of the way of events as they transpire.

- **Reduced foreground/increased compression.** Telephoto lenses have the opposite effect of wide angles: they reduce the importance of things in the foreground by squeezing everything together. This compression even makes distant objects appear to be closer to subjects in the foreground and middle ranges. You can use this effect as a creative tool.

- **Accentuates camera shakiness.** Telephoto focal lengths hit you with a double-whammy in terms of camera/photographer shake. The lenses themselves are bulkier, more difficult to hold steady, and may even produce a barely perceptible see-saw rocking effect when you support them with one hand halfway down the lens barrel. Telephotos also magnify any camera shake. It's no wonder that image stabilization is popular in longer lenses.

- **Interesting angles require creativity.** Telephoto lenses require more imagination in selecting interesting angles, because the "angle" you do get on your subjects is so narrow. Moving from side to side or a bit higher or lower can make a dramatic difference in a wide-angle shot, but raising or lowering a telephoto lens a few feet probably will have little effect on the appearance of the distant subjects you're shooting.

Avoiding Telephoto Lens Problems

Many of the "problems" that telephoto lenses pose are really just challenges and not that difficult to overcome. Here is a list of the seven most common picture maladies and suggested solutions:

- **Symptom: flat faces in portraits.** Head-and-shoulders portraits of humans tend to be more flattering when a focal length of 50mm to 85mm is used. Longer focal lengths compress the distance between features like noses and ears, making the face look wider and flat. A wide angle might make noses look huge and ears tiny when you fill the frame with a face. So stick with 50mm to 85mm focal lengths, going longer only when you're forced to shoot from a greater distance, and wider only when shooting three-quarters/full-length portraits, or group shots.

- **Symptom: blur due to camera shake.** Use a higher shutter speed (boosting ISO if necessary), consider an image-stabilized lens, or mount your camera on a tripod, monopod, or brace it with some other support. Of those three solutions, only the first will reduce blur caused by *subject* motion; an IS lens or tripod won't help you freeze a race car in mid-lap.

- **Symptom: color fringes.** Chromatic aberration is the most pernicious optical problem found in telephoto lenses. There are others, including spherical aberration, astigmatism, coma, curvature of field, and similarly scary-sounding phenomena. The best solution for any of these is to use a better lens that offers the proper degree of correction, or stop down the lens to minimize the problem. But that's not always possible. Your second-best choice may be to correct the

fringing in your favorite RAW conversion tool or image editor. Photoshop's Lens Correction filter offers sliders that minimize both red/cyan and blue/yellow fringing.

- **Symptom: lines that curve inward.** Pincushion distortion is found in many telephoto lenses. You might find after a bit of testing that it is worse at certain focal lengths with your particular zoom lens. Like chromatic aberration, it can be partially corrected using tools like Photoshop's Lens Correction filter and Photoshop Elements' Correct Camera Distortion filter.

- **Symptom: low contrast from haze or fog.** When you're photographing distant objects, a long lens shoots through a lot more atmosphere, which generally is muddied up with extra haze and fog. That dirt or moisture in the atmosphere can reduce contrast and mute colors. Some feel that a skylight or UV filter can help, but this practice is mostly a holdover from the film days. Digital sensors are not sensitive enough to UV light for a UV filter to have much effect. So you should be prepared to boost contrast and color saturation in your Picture Styles menu or image editor if necessary.

- **Symptom: low contrast from flare.** Lenses are furnished with lens hoods for a good reason: to reduce flare from bright light sources at the periphery of the picture area, or completely outside it. Because telephoto lenses often create images that are lower in contrast in the first place, you'll want to be especially careful to use a lens hood to prevent further effects on your image (or shade the front of the lens with your hand).

- **Symptom: dark flash photos.** Edge-to-edge flash coverage isn't a problem with telephoto lenses as it is with wide angles. The shooting distance is. A long lens might make a subject that's 50 feet away look as if it's right next to you, but your camera's flash isn't fooled. You'll need extra power for distant flash shots, and probably more power than your T5's built-in flash provides. The shoe-mount Canon 580EX II or 600EX-RT Speedlites, for example, can automatically zoom its coverage down to that of a medium telephoto lens, providing a theoretical full-power shooting aperture of about f/8 at 50 feet and ISO 400. (Try *that* with the built-in flash!)

Telephotos and Bokeh

Bokeh describes the aesthetic qualities of the out-of-focus parts of an image and whether out-of-focus points of light—circles of confusion—are rendered as distracting fuzzy discs or smoothly fade into the background. *Boke* is a Japanese word for "blur," and the h was added to keep English speakers from rendering it monosyllabically to rhyme with *broke*. Although bokeh is visible in blurry portions of any image, it's of particular concern with telephoto lenses, which, thanks to the magic of reduced depth-of-field, produce more obviously out-of-focus areas.

Bokeh can vary from lens to lens, or even within a given lens depending on the f/stop in use. Bokeh becomes objectionable when the circles of confusion are evenly illuminated, making them stand out as distinct discs, or, worse, when these circles are darker in the center, producing an ugly "doughnut" effect. A lens defect called spherical aberration may produce out-of-focus discs that are

brighter on the edges and darker in the center, because the lens doesn't focus light passing through the edges of the lens exactly as it does light going through the center. (Mirror or *catadioptric* lenses also produce this effect.)

Other kinds of spherical aberration generate circles of confusion that are brightest in the center and fade out at the edges, producing a smooth blending effect, as you can see at right in Figure 10.15. Ironically, when no spherical aberration is present at all, the discs are a uniform shade, which, while better than the doughnut effect, is not as pleasing as the bright center/dark edge rendition. The shape of the disc also comes into play, with round smooth circles considered the best, and nonagonal or some other polygon (determined by the shape of the lens diaphragm) considered less desirable.

If you plan to use selective focus a lot, you should investigate the bokeh characteristics of a particular lens before you buy. Canon user groups and forums will usually be full of comments and questions about bokeh, so the research is fairly easy.

Figure 10.15 Bokeh is less pleasing when the discs are prominent (left), and less obtrusive when they blend into the background (right).

Add-ons and Special Features

Once you've purchased your telephoto lens, you'll want to think about some appropriate accessories for it. There are some handy add-ons available that can be valuable. Here are a couple of them to think about.

Lens Hoods

Lens hoods are an important accessory for all lenses, but they're especially valuable with telephotos. As I mentioned earlier, lens hoods do a good job of preserving image contrast by keeping bright light sources outside the field of view from striking the lens and, potentially, bouncing around inside that long tube to generate flare that, when coupled with atmospheric haze, can rob your

image of detail and snap. In addition, lens hoods serve as valuable protection for that large, vulnerable, front lens element. It's easy to forget that you've got that long tube sticking out in front of your camera and accidentally whack the front of your lens into something. It's cheaper to replace a lens hood than it is to have a lens repaired, so you might find that a good hood is valuable protection for your prized optics.

When choosing a lens hood, it's important to have the right hood for the lens, usually the one offered for that lens by Canon or the third-party manufacturer. You want a hood that blocks precisely the right amount of light: neither too much light nor too little. A hood with a front diameter that is too small can show up in your pictures as vignetting. A hood that has a front diameter that's too large isn't stopping all the light it should. Generic lens hoods may not do the job.

When your telephoto is a zoom lens, it's even more important to get the right hood, because you need one that does what it is supposed to at both the wide-angle and telephoto ends of the zoom range. Lens hoods may be cylindrical, rectangular (shaped like the image frame), or petal shaped (that is, cylindrical, but with cut-out areas at the corners which correspond to the actual image area). Lens hoods should be mounted in the correct orientation (a bayonet mount for the hood on the front of the lens usually takes care of this).

Telephoto Extenders

Telephoto extenders (often called teleconverters outside the Canon world), multiply the actual focal length of your lens, giving you a longer telephoto for much less than the price of a lens with that actual focal length. These extenders fit between the lens and your camera and contain optical elements that magnify the image produced by the lens. Available in 1.4X and 2.0X configurations from Canon, an extender transforms, say, a 200mm lens into a 280mm or 400mm optic, respectively. Given the T5's crop factor, your 200mm lens now has the same field of view as a 448mm or 640mm lens on a full-frame camera. At around $500 each, they're quite a bargain, aren't they?

Actually, there are some downsides. While extenders retain the closest focusing distance of your original lens, autofocus is maintained only if the lens's original maximum aperture is f/4 or larger (for the 1.4X extender) or f/2.8 or larger (for the 2X extender). The components reduce the effective aperture of any lens they are used with, by one f/stop with the 1.4X extender, and 2 f/stops with the 2X extender. So, your EF 200mm f/2.8L II USM becomes a 280mm f/4 or 400mm f/5.6 lens. Although Canon extenders are precision optical devices, they do cost you a little sharpness, but that improves when you reduce the aperture by a stop or two. Each of the extenders is compatible only with a particular set of lenses of 135mm focal length or greater, so you'll want to check Canon's compatibility chart to see if the component can be used with the lens you want to attach to it.

If your lenses are compatible and you're shooting under bright lighting conditions, the Canon Extender EF 1.4x III, and Canon Extender EF 2x III make handy accessories.

Macro Focusing

Some telephotos and telephoto zooms available for the T5 have particularly close focusing capabilities, making them *macro* lenses. Of course, the object is not necessarily to get close (get too close and you'll find it difficult to light your subject). What you're really looking for in a macro lens is to magnify the apparent size of the subject in the final image. Camera-to-subject distance is most important when you want to back up farther from your subject (say, to avoid spooking skittish insects or small animals). In that case, you'll want a macro lens with a longer focal length to allow that distance while retaining the desired magnification.

Canon makes 50mm, 60mm, 65mm, 100mm, and 180mm lenses with official macro designations. You'll also find macro lenses, macro zooms, and other close-focusing lenses available from Sigma, Tamron, and Tokina. If you want to focus closer with a macro lens, or any other lens, you can add an accessory called an *extension tube*, shown in Figure 10.16. These add-ons move the lens farther from the focal plane, allowing it to focus more closely. Canon also sells add-on close-up lenses, which look like filters, and allow lenses to focus more closely.

Figure 10.16
Extension tubes enable any lens to focus more closely to the subject.

Image Stabilization

Canon has a burgeoning line of more than a dozen lenses with built-in image stabilization (IS) capabilities. This feature uses lens elements that are shifted internally in response to the motion of the lens during hand-held photography, countering the shakiness the camera and photographer produce and which telephoto lenses magnify. However, IS is not limited to long lenses; the feature works like a champ at the 17mm zoom position of Canon's EF-S 17-85mm f/4-5.6 IS USM and EF-S 17-55mm f/2.8 IS USM lenses. Other Canon IS lenses provide stabilization with zooms that are as wide as 24-28mm.

IMAGE STABILIZATION: IN THE CAMERA OR IN THE LENS?

Sony's acquisition of Konica Minolta's dSLR assets and the introduction of an improved in-camera image-stabilization system has revived an old debate about whether IS belongs in the camera or in the lens. Perhaps it's my Canon bias showing, but I am quite happy not to have image stabilization available in the body itself. Here are some reasons:

- Should in-camera IS fail, you have to send the whole camera in for repair, and camera repairs are generally more expensive than lens repairs. I like being able to simply switch to another lens if I have an IS problem.

- IS in the camera doesn't steady your view in the viewfinder, whereas an IS lens shows you a steadied image as you shoot.

- You're stuck with the IS system built into your camera. If an improved system is incorporated into a lens and the improvements are important to you, just trade in your old lens for the new one.

- Optimized stabilization. Canon claims that it is able to produce the best possible image stabilization for each lens it introduces, something that would not be possible if a "one size fits all lenses" stabilization scheme had to be built into the camera.

Image stabilization provides you with camera steadiness that's the equivalent of at least two or three shutter speed increments. (Canon claims four, which I feel may be optimistic.) This extra margin can be invaluable when you're shooting under dim lighting conditions or hand-holding a long lens for, say, wildlife photography. Perhaps that shot of a foraging deer calls for a shutter speed of 1/1,000th second at f/5.6 with your EF 100-400mm f/4.5-5.6L IS USM lens. Relax. You can shoot at 1/250th second at f/11 and get virtually the same results, as long as the deer doesn't decide to bound off.

Or, maybe you're shooting a high school play without a tripod or monopod, and you'd really, really like to use 1/15th second at f/4. Assuming the actors aren't flitting around the stage at high speed, your 17-85mm IS lens can grab the shot for you at its wide-angle position. However, keep these facts in mind:

- **IS doesn't stop action.** Unfortunately, no IS lens is a panacea to replace the action-stopping capabilities of a higher shutter speed. Image stabilization applies only to camera shake. You still need a fast shutter speed to freeze action. IS works great in low light, when you're using long lenses, and for macro photography. It's not always the best choice for action photography (unless you're willing to let subject motion become part of your image, as in Figure 10.17). In other situations, you may need enough light to allow a sufficiently high shutter speed. But in that case, IS can make your shot even sharper.

- **IS slows you down.** The process of adjusting the lens elements takes time, just as autofocus does, so you might find that IS adds to the lag between when you press the shutter and when the picture is actually taken. That's another reason why image stabilization might not be a good choice for sports.

Figure 10.17
Image stabilization made it possible to shoot this concert photo with a 200mm lens at 1/60th second. Note that the drummer's hands are still a blur, but her beautiful costume is vividly sharp.

- **Use when appropriate.** Some IS lenses produce worse results if you use them while you're panning, although newer Canon IS lenses have a mode that works fine when the camera is deliberately moved from side to side (or up and down) during exposure. Older lenses can confuse the motion with camera shake and overcompensate. You might want to switch off IS when panning or when your camera is mounted on a tripod.

- **Do you need IS at all?** Remember that an inexpensive monopod might be able to provide the same additional steadiness as an IS lens, at a much lower cost. If you're out in the field shooting wild animals or flowers and think a tripod isn't practical, try a monopod first.

Using the Lensbaby

I'm going to depart from my Canon-only regimen to include the wonderful Lensbaby line of optics, because Canon doesn't offer anything similar, nor as delightfully affordable. The Lensbaby comes in several varieties (including Edge 80, a shift-tilt model for about $300, and the Composer Pro shown in Figure 10.18), and uses distortion-heavy glass elements mounted on a system that allows you to bend, twist, and distort the lens's alignment to produce transmogrified images unlike anything else you've ever seen. Like the legendary cheap-o Diana and Holga cameras, the pictures are prized expressly because of their plastic image quality. Jack and Meg White (formerly of the White

Stripes) have, in fact, sold personalized Diana and Holga cameras on their website for wacky *lomography* (named after the Lomo, another low-quality/high-concept camera). The various Lensbaby models are for more serious photographers, if you can say that about anyone who yearns to take pictures that look like they were shot through a glob of corn syrup.

Lensbaby optics are capable of creating all sorts of special effects. You use a Lensbaby by shifting the front mount to move the lens's sweet spot to a particular point in the scene. This is basically a selective focus lens that gets very soft outside the sweet spot. There are several different types, which can be interchanged using the system's Optic Swap technology.

Figure 10.18 Lensbaby optics are specialized lens replacements with some special soft-focus features.

- **Macro.** A Lensbaby accessory makes it possible to use this tool for macro photography.

- **Wide-angle/telephoto conversion.** Add-on lenses convert the basic Lensbaby into a wide-angle or telephoto version.

- **Edge 80.** This is an 80mm f/2.8 lens with a flat field of focus—ideal for portraits. It has a 12-blade adjustable aperture, focuses as close as 17 inches, and functions as a tilt-shift lens. When canted, the Edge 80 delivers a slice of tack sharp focus through the image, bordered by a soft blur. When pointed straight ahead, Edge 80 can be used like a conventional lens. You can also use it in any of the traditional selective focus applications you'd use one of Canon's PC-E lenses for—but *not* for perspective correction. (It tilts, but does not shift from side to side.)

- **Creative aperture kit.** Various shaped cutouts can be used in place of the regular aperture inserts that control depth-of-field. These shapes can include things like hearts, stars, and other shapes.

- **Optic swap kit.** This three-lens accessory kit provides different adapters that include a pinhole lens, plastic lens, and single glass lens.

Among the interchangeable components are the Sweet 35, Fisheye, Soft Focus, Double Glass, Single Glass, and Pinhole lenses. Models include the Composer Pro, Composer, Muse, Control Freak, and Scout, each with varying amounts of adjustments. (The Scout does not bend at all, making it ideal for use with the fisheye component.)

The other Lensbaby models, like the Composer Pro, have the same tilting lens configuration as previous editions, but are designed for easier and more precise distorting movements. Hold the camera with your finger gripping the knobs as you bend the camera to move the central "sweet spot" (sharp area) to any portion of your image. With two (count 'em) multicoated optical glass lens elements, you'll get a blurry image, but the amount of distortion is under your control. F/stops from f/2 to f/22 are available to increase/decrease depth-of-field and allow you to adjust exposure. The

50mm lens focuses down to 12 inches and is strictly manual focus/manual exposure in operation. At up to $300 or so, these lenses are not cheap accessories, but there is really no other easy way to achieve the kind of looks you can get with a Lensbaby.

Figures 10.19 and 10.20 are examples of the type of effect you can get, in photographs crafted by Cleveland photographer Nancy Balluck. She also produced the back cover photography of yours truly, and one of her specialties is Lensbaby effects.

Nancy regularly gives demonstrations and classes on the use of these optics, and you can follow her work at www.nancyballuckphotography.com.

Figure 10.19
Everything is uniquely blurry outside the Lensbaby's "sweet spot," but you can move that spot around within your frame at will.

Source: Nancy Balluck

Figure 10.20 They can be used for selective focus effects, and can simulate the dreamy look of some old-style cameras.

11

Working with Light

Successful photographers and artists have an intimate understanding of the importance of light in shaping an image. Rembrandt was a master of using light to create moods and reveal the character of his subjects. Artist Thomas Kinkade's official tagline is "Painter of Light." The late Dean Collins, co-founder of Finelight Studios, revolutionized how a whole generation of photographers learned and used lighting. Photo guru Ed Pierce has a popular seminar called "Captivated by the Light." It's impossible to underestimate how the use of light adds to—and how misuse can detract from—your photographs.

All forms of visual art use light to shape the finished product. Sculptors don't have control over the light used to illuminate their finished work, so they must create shapes using planes and curved surfaces so that the form envisioned by the artist comes to life from a variety of viewing and lighting angles. Painters, in contrast, have absolute control over both shape and light in their work, as well as the viewing angle, so they can use both the contours of their two-dimensional subjects and the qualities of the "light" they use to illuminate those subjects to evoke the image they want to produce.

Photography is a third form of art. The photographer may have little or no control over the subject (other than posing human subjects) but can often adjust both viewing angle *and* the nature of the light source to create a particular compelling image. The direction and intensity of the light sources create the shapes and textures that we see. The distribution and proportions determine the contrast and tonal values: whether the image is stark or high key, or muted and low in contrast. The colors of the light (because even "white" light has a color balance that the sensor can detect), and how much of those colors the subject reflects or absorbs, paint the hues visible in the image.

As a Rebel T5 photographer, you must learn to be a painter and sculptor of light if you want to move from *taking* a picture to *making* a photograph. This chapter provides an introduction to using

the two main types of illumination: *continuous* lighting (such as daylight, incandescent, or fluorescent sources) and the brief, but brilliant snippets of light we call *electronic flash.*

Continuous Illumination versus Electronic Flash

Continuous lighting is exactly what you might think: uninterrupted illumination that is available all the time during a shooting session. Daylight, moonlight, and the artificial lighting encountered both indoors and outdoors count as continuous light sources (although all of them can be "interrupted" by passing clouds, solar eclipses, a blown fuse, or simply by switching off a lamp). Indoor continuous illumination includes both the lights that are there already (such as incandescent lamps or overhead fluorescent lights indoors) and fixtures you supply yourself, including photoflood lamps or reflectors used to bounce existing light onto your subject.

Electronic flash is notable because it can be much more intense than continuous lighting, lasts only a brief moment, and can be much more portable than supplementary incandescent sources. It's a light source you can carry with you and use anywhere. Indeed, your Rebel T5 has a flip-up electronic flash unit built in.

But you can also use an external flash, either mounted on the T5's accessory shoe or used off-camera and linked with a cable or triggered by a slave light (which sets off a flash when it senses the firing of another unit). Studio flash units are electronic flash, too, and aren't limited to "professional" shooters, as there are economical "monolight" (one-piece flash/power supply) units available in the $200 price range. You can buy a couple to store in a closet and use to set up a home studio, or use as supplementary lighting when traveling away from home.

There are advantages and disadvantages to each type of illumination. Here's a quick checklist of pros and cons:

- **Lighting preview—Pro: continuous lighting.** With continuous lighting, you always know exactly what kind of lighting effect you're going to get and, if multiple light sources are used, how they will interact with each other, as shown in Figure 11.1, where the main light was the sun, directly overhead, but a bit of fill was provided by a gold reflector held up a few feet off-camera to her left.

- **Lighting preview—Con: electronic flash.** With electronic flash, the general effect you're going to see may be a mystery until you've built some experience, and you may need to review a shot on the LCD monitor, make some adjustments, and then reshoot to get the look you want. (In this sense, a digital camera's review capabilities replace the Polaroid test shots pro photographers relied on in decades past.) An image like the one in Figure 11.1 would have been difficult to achieve with an off-camera battery-powered flash unit, because it would be tricky to preview exactly how the shadows would fall without a true continuous modeling light.

Figure 11.1 You always know how the lighting will look when using continuous illumination.

- **Exposure calculation—Pro: continuous lighting.** Your T5 has no problem calculating exposure for continuous lighting, because the illumination remains constant and can be measured through a sensor that interprets the light reaching the viewfinder. The amount of light available just before the exposure will, in almost all cases, be the same amount of light present when the shutter is released. The T5's Partial metering mode can be used to measure and compare the proportions of light in the highlights and shadows, so you can make an adjustment (such as using more or less fill light) if necessary. You can even use a hand-held light meter to measure the light yourself.

- **Exposure calculation—Con: electronic flash.** Electronic flash illumination doesn't exist until the flash fires and so can't be measured by the T5's exposure sensor when the mirror is flipped up during the exposure. Instead, the light must be measured metering the intensity of a pre-flash triggered an instant before the main flash, as it is reflected back to the camera and through the lens. An alternative is to use a sensor built into an external flash itself and measure reflected light that has not traveled through the lens. If you have a do-it-yourself bent, there are hand-held flash meters, too, including models that measure both flash and continuous light.

- **Evenness of illumination—Pro/con: continuous lighting.** Of continuous light sources, daylight, in particular, provides illumination that tends to fill an image completely, lighting up the foreground, background, and your subject almost equally. Shadows do come into play, of course, so you might need to use reflectors or fill-in light sources to even out the illumination further, but barring objects that block large sections of your image from daylight, the light is spread fairly evenly. Indoors, however, continuous lighting is commonly less evenly distributed. The average living room, for example, has hot spots and dark corners. But on the plus side, you can *see* this uneven illumination and compensate with additional lamps.

- **Evenness of illumination—Con: electronic flash.** Electronic flash units (like continuous light sources such as lamps that don't have the advantage of being located 93 million miles from the subject) suffer from the effects of their proximity. The *inverse square law*, first applied to both gravity and light by Sir Isaac Newton, dictates that as a light source's distance increases from the subject, the amount of light reaching the subject falls off proportionately to the square of the distance. In plain English, that means that a flash or lamp that's 12 feet away from a subject provides only one-quarter as much illumination as a source that's 6 feet away (rather than half as much). (See Figure 11.2.) This translates into relatively shallow "depth-of-light."

- **Action stopping—Con: continuous lighting.** Action stopping with continuous light sources is completely dependent on the shutter speed you've dialed in on the camera. And the speeds available are dependent on the amount of light available and your ISO sensitivity setting. Outdoors in daylight, there will probably be enough sunlight to let you shoot at 1/2,000th second and f/6.3 with a non-grainy sensitivity setting of ISO 400. That's a fairly useful combination of settings if you're not using a super-telephoto with a small maximum aperture. But inside, the reduced illumination quickly has you pushing your Rebel T5 to its limits. For

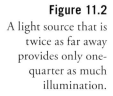
Figure 11.2
A light source that is twice as far away provides only one-quarter as much illumination.

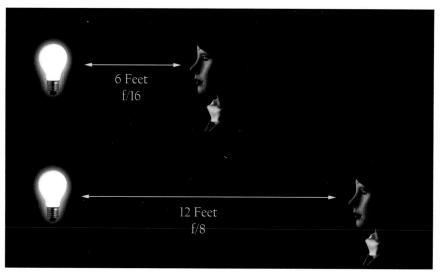

6 Feet
f/16

12 Feet
f/8

example, if you're shooting indoor sports, there probably won't be enough available light to allow you to use a 1/2,000th second shutter speed (although I routinely shoot indoor basketball with my T5 at ISO 1600 and 1/500th second at f/4). In many indoor sports situations, you may find yourself limited to 1/500th second or slower.

■ **Action stopping—Pro: electronic flash.** When it comes to the ability to freeze moving objects in their tracks, the advantage goes to electronic flash. The brief duration of electronic flash serves as a very high "shutter speed" when the flash is the main or only source of illumination for the photo. Your Rebel T5's shutter speed may be set for 1/200th second during a flash exposure, but if the flash illumination predominates, the *effective* exposure time will be the 1/1,000th to 1/50,000th second or less duration of the flash, as you can see in Figure 11.3, because the flash unit reduces the amount of light released by cutting short the duration of the flash. The only fly in the ointment is that, if the ambient light is strong enough, it may produce a secondary, "ghost" exposure, as I'll explain later in this chapter.

■ **Cost—Pro: continuous lighting.** Incandescent or fluorescent lamps are generally much less expensive than electronic flash units, which can easily cost several hundred dollars. I've used everything from desktop high-intensity lamps to reflector flood lights for continuous illumination at very little cost. There are lamps made especially for photographic purposes, too, priced up to $50 or so. Maintenance is economical, too: many incandescent or fluorescents use bulbs that cost only a few dollars.

■ **Cost—Con: electronic flash.** Electronic flash units aren't particularly cheap. The lowest-cost dedicated flash designed specifically for the Canon dSLRs is about $160. Such units are limited in features, however, and intended for those with entry-level cameras. Plan on spending some money to get the features that a sophisticated electronic flash offers.

Figure 11.3 Electronic flash can freeze almost any action.

■ **Flexibility—Con: continuous lighting.** Because incandescent and fluorescent lamps are not as bright as electronic flash, the slower shutter speeds required (see Action stopping, above) mean that you may have to use a tripod more often, especially when shooting portraits. The incandescent variety of continuous lighting gets hot, especially in the studio, and the side effects range from discomfort (for your human models) to disintegration (if you happen to be shooting perishable foods like ice cream). The heat also makes it more difficult to add filtration to incandescent sources.

■ **Flexibility—Pro: electronic flash.** Electronic flash's action-freezing power allows you to work without a tripod in the studio (and elsewhere), adding flexibility and speed when choosing angles and positions. Flash units can be easily filtered, and, because the filtration is placed over the light source rather than the lens, you don't need to use high-quality filter material. Roscoe or Lee lighting gels, which may be too flimsy to use in front of the lens, can be mounted or taped in front of your flash with ease.

Continuous Lighting Basics

While continuous lighting and its effects are generally much easier to visualize and use than electronic flash, there are some factors you need to take into account, particularly the color temperature of the light. (Color temperature concerns aren't exclusive to continuous light sources, of course, but the variations tend to be more extreme and less predictable than those of electronic flash.)

Color temperature, in practical terms, is how "bluish" or how "reddish" the light appears to be to the digital camera's sensor. Indoor illumination is quite warm, comparatively, and appears reddish to the sensor. Daylight, in contrast, seems much bluer to the sensor. Our eyes (our brains, actually) are quite adaptable to these variations, so white objects don't appear to have an orange tinge when viewed indoors, nor do they seem excessively blue outdoors in full daylight. Yet, these color temperature variations are real and the sensor is not fooled. To capture the most accurate colors, we need to take the color temperature into account in setting the color balance (or *white balance*) of the T5—either automatically using the camera's smarts or manually, using our own knowledge and experience.

Color temperature can be confusing, because of a seeming contradiction in how color temperatures are named: warmer (more reddish) color temperatures (measured in degrees Kelvin) are the *lower* numbers, while cooler (bluer) color temperatures are *higher* numbers. It might not make sense to say that 3,400K is warmer than 6,000K, but that's the way it is. If it helps, think of a glowing red ember contrasted with a white-hot welder's torch, rather than fire and ice.

The confusion comes from physics. Scientists calculate color temperature from the light emitted by a mythical object called a black body radiator, which absorbs all the radiant energy that strikes it, and reflects none at all. Such a black body not only *absorbs* light perfectly, but it *emits* it perfectly when heated (and since nothing in the universe is perfect, that makes it mythical).

At a particular physical temperature, this imaginary object always emits light of the same wave-length or color. That makes it possible to define color temperature in terms of actual temperature in degrees on the Kelvin scale that scientists use. Incandescent light, for example, typically has a color temperature of 3,200K to 3,400K. Daylight might range from 5,500K to 6,000K. Each type of illumination we use for photography has its own color temperature range—with some cautions. The next sections will summarize everything you need to know about the qualities of these light sources.

Daylight

Daylight is produced by the sun, and so is moonlight (which is just reflected sunlight). Daylight is present, of course, even when you can't see the sun. When sunlight is direct, it can be bright and harsh. If daylight is diffused by clouds, softened by bouncing off objects such as walls or your photo reflectors, or filtered by shade, it can be much dimmer and less contrasty.

Daylight's color temperature can vary quite widely. It is highest (most blue) at noon when the sun is directly overhead, because the light is traveling through a minimum amount of the filtering layer we call the atmosphere. The color temperature at high noon may be 6,000K. At other times of day, the sun is lower in the sky and the particles in the air provide a filtering effect that warms the illu-mination to about 5,500K for most of the day. Starting an hour before dusk and for an hour after sunrise, the warm appearance of the sunlight is even visible to our eyes when the color temperature may dip below 4,500K, as shown in Figure 11.4

Figure 11.4
At dawn and dusk, the color tempera-ture of daylight may dip below 4,500K, providing this red-dish rendition.

Because you'll be taking so many photos in daylight, you'll want to learn how to use or compensate for the brightness and contrast of sunlight, as well as how to deal with its color temperature. I'll provide some hints later in this chapter.

Incandescent/Tungsten Light

The term *incandescent* or *tungsten illumination* is usually applied to the direct descendents of Thomas Edison's original electric lamp. Such lights consist of a glass bulb that contains a vacuum, or is filled with a halogen gas, and contains a tungsten filament that is heated by an electrical current, producing photons and heat. Tungsten-halogen lamps are a variation on the basic lightbulb, using a more rugged (and longer-lasting) filament that can be heated to a higher temperature, housed in a thicker glass or quartz envelope, and filled with iodine or bromine ("halogen") gases. The higher temperature allows tungsten-halogen (or quartz-halogen/quartz-iodine, depending on their construction) lamps to burn "hotter" and whiter. Although popular for automobile headlamps today, they are also popular for photographic illumination. Although incandescent illumination isn't a perfect black body radiator, it's close enough that the color temperature of such lamps can be precisely calculated and used for photography without concerns about color variation (at least, until the very end of the lamp's life).

ARE INCANDESCENT LAMPS ON THE WAY OUT?

Relax. The effects of the Federal "ban" on conventional incandescent lamps are a lot less overwhelming than you might conclude from panicky news reports. The law affects only medium-base general service bulbs in 40-, 60-, 75-, and 100-watt sizes. Other lamp sizes, base types, and applications are safe, including your 25-watt and 150-watt bulbs, three-way bulbs, bug lights, UV and black light bulbs, plant lights, appliance lamps, shatter-resistant bulbs, and every bulb you might need for your chandeliers. And the law doesn't *ban* incandescent bulbs; after the 2012–2014 phase in, such bulbs must be at least 25 percent more energy efficient. So, the incandescent lamps you'll buy after that will have newer designs, such as found in halogen incandescent lamps.

We're not going to be dragged kicking and screaming to compact fluorescent lights (CFL), which may not work in all fixtures and for all applications, such as dimmers (even if you purchase special "dimmable" CFLs), electronic timer or "dusk-to-dawn" light controllers, illuminated wall switches, or motion sensors. Only certain cold cathode CFLs operate outside in cold weather; they emit IR signals that can confuse the remote control of your TV, air-conditioner, etc., and the typical CFL has a Color Rendering Index of 80, compared to the virtually perfect 100 rating of incandescent lights.

The biggest change will be that you'll be paying a bit more for your bulbs, and will be purchasing them by their *brightness* rating rather than wattage. If you want the same illumination as an old-style 100 watt bulb, you'll purchase one rated at 1,600 lumens instead, and won't care that it's a 72-watt halogen incandescent bulb, 23–26-watt CFL, or even an 8-watt LED bulb (except at the cash register, and again when your electric bill arrives).

Fluorescent Light/Other Light Sources

Fluorescent light has some advantages in terms of illumination, but some disadvantages from a photographic standpoint, especially when it comes to CFLs, as I outlined earlier. This type of lamp generates light through an electro-chemical reaction that emits most of its energy as visible light, rather than heat, which is why the bulbs don't get as hot. The type of light produced varies depending on the phosphor coatings and type of gas in the tube. So, the illumination fluorescent bulbs produce can vary widely in its characteristics.

That's not great news for photographers. Different types of lamps have different "color temperatures" that can't be precisely measured in degrees Kelvin, because the light isn't produced by heating. Worse, fluorescent lamps have a discontinuous spectrum of light that can have some colors missing entirely, producing that substandard Color Rendering Index I mentioned. A particular type of tube can lack certain shades of red or other colors (see Figure 11.5), which is why fluorescent lamps and other alternative technologies such as sodium-vapor illumination can produce ghastly looking human skin tones. Their spectra can lack the reddish tones we associate with healthy skin and emphasize the blues and greens popular in horror movies.

Figure 11.5
The fluorescent lighting in this gym added a distinct greenish cast to the image.

Adjusting White Balance

In most cases the Rebel T5 will do a good job of calculating white balance for you, so Auto can be used as your choice most of the time. Use the preset values or set a custom white balance that matches the current shooting conditions when you need to. The only really problematic light sources are likely to be fluorescents. Vendors, such as GE and Sylvania, may actually provide a figure known as the *color rendering index* (or CRI), which is a measure of how accurately a particular light source represents standard colors, using a scale of 0 (some sodium-vapor lamps) to 100 (daylight and most incandescent lamps). Daylight fluorescents and deluxe cool white fluorescents might have a CRI of about 79 to 95, which is perfectly acceptable for most photographic applications. Warm white fluorescents might have a CRI of 55. White deluxe mercury vapor lights are less suitable with a CRI of 45, while low-pressure sodium lamps can vary from CRI 0 to 18.

Remember that if you shoot RAW, you can specify the white balance of your image when you import it into Photoshop, Photoshop Elements, or another image editor using your preferred RAW converter. While color-balancing filters that fit on the front of the lens exist, they are primarily useful for film cameras, because film's color balance can't be tweaked as extensively or as easily as that of a sensor.

Electronic Flash Basics

Until you delve into the situation deeply enough, it might appear that serious photographers have a love/hate relationship with electronic flash. You'll often hear that flash photography is less natural looking, and that the built-in flash in most cameras should never be used as the primary source of illumination because it provides a harsh, garish look. Indeed, most "pro" cameras like the Canon EOS 1D Mark III and 1Ds Mark III don't have a built-in flash at all. Available ("continuous") lighting is praised, and built-in flash photography seems to be roundly denounced.

In truth, however, the bias is against *bad* flash photography. Indeed, flash has become the studio light source of choice for pro photographers, because it's more intense (and its intensity can be varied to order by the photographer), freezes action, frees you from using a tripod (unless you want to use one to lock down a composition), and has a snappy, consistent light quality that matches daylight. (While color balance changes as the flash duration shortens, some Canon flash units can communicate to the camera the exact white balance provided for that shot.) And even pros will cede that the built-in flash of the Rebel T5 has some important uses as an adjunct to existing light, particularly to illuminate dark shadows using a technique called *fill flash*.

But electronic flash isn't as inherently easy to use as continuous lighting. As I noted earlier, electronic flash units are more expensive, don't show you exactly what the lighting effect will be (unless you use a second source called a *modeling light* for a preview), and the exposure of electronic flash units is more difficult to calculate accurately.

How Electronic Flash Works

The bursts of light we call electronic flash are produced by a flash of photons generated by an electrical charge that is accumulated in a component called a *capacitor* and then directed through a glass tube containing xenon gas, which absorbs the energy and emits the brief flash. For the pop-up flash built into the Rebel T5, the full burst of light lasts about 1/1,000th of a second and provides enough illumination to shoot a subject 10 feet away at f/4 using the ISO 100 setting. In a more typical situation, you'd use ISO 200, f/5.6 to f/8 and photograph something 8 to 10 feet away. As you can see, the built-in flash is somewhat limited in range; you'll see why external flash units are often a good idea later in this chapter.

An electronic flash (whether built in or connected to the Rebel T5 through a cable plugged into a hot shoe adapter) is triggered at the instant of exposure, during a period when the sensor is fully exposed by the shutter. As I mentioned earlier in this book, the T5 has a vertically traveling shutter that consists of two curtains. The first curtain opens and moves to the opposite side of the frame, at which point the shutter is completely open. The flash can be triggered at this point (so-called *1st curtain sync* or *front curtain sync*), making the flash exposure. Then, after a delay that can vary from 30 seconds to 1/200th second (with the Rebel T5; other cameras may sync at a faster or slower speed), a second curtain begins moving across the sensor plane, covering up the sensor again. If the flash is triggered just before the second curtain starts to close, then *2nd curtain sync* (or *rear curtain sync*) is used. In both cases, though, a shutter speed of 1/200th second is the maximum that can be used to take a photo.

Figure 11.6 illustrates how this works. At upper left, you can see a fanciful illustration of a generic shutter (your Rebel T5's shutter does *not* look like this), with both curtains tightly closed. At upper

Figure 11.6

A focal plane shutter has two curtains, the first, or front curtain, and a second, rear curtain.

right, the first curtain begins to move downward, starting to expose a narrow slit that reveals the sensor behind the shutter. At lower left, the first curtain moves downward farther until, as you can see at lower right in the figure, the sensor is fully exposed.

Ghost Images

The difference between triggering the flash when the shutter just opens, or just when it begins to close might not seem like much. But whether you use 1st curtain sync (the default setting) or 2nd curtain sync (an optional setting) can make a significant difference to your photograph *if the ambient light in your scene also contributes to the image.* You can set either of these sync modes in the Shooting 1 menu, under Flash Control and the Built-in Flash Func. setting and External Flash Func. setting options.

At faster shutter speeds, particularly 1/200th second, there isn't much time for the ambient light to register, unless it is very bright. It's likely that the electronic flash will provide almost all the illumination, so 1st curtain sync or 2nd curtain sync isn't very important. However, at slower shutter speeds, or with very bright ambient light levels, there is a significant difference, particularly if your subject is moving, or the camera isn't steady.

In any of those situations, the ambient light will register as a second image accompanying the flash exposure, and if there is movement (camera or subject), that additional image will not be in the same place as the flash exposure. It will show as a ghost image and, if the movement is significant enough, as a blurred ghost image trailing in front of or behind your subject in the direction of the movement.

As I noted, when you're using 1st curtain sync, the flash's main burst goes off the instant the shutter opens fully (a pre-flash used to measure exposure in auto flash modes fires *before* the shutter opens). This produces an image of the subject on the sensor. Then, the shutter remains open for an additional period (30 seconds to 1/200th second, as I said). If your subject is moving, say, toward the right side of the frame, the ghost image produced by the ambient light will produce a blur on the right side of the original subject image, making it look as if your sharp (flash-produced) image is chasing the ghost. For those of us who grew up with lightning-fast superheroes who always left a ghost trail *behind them*, that looks unnatural (see Figure 11.7).

So, Canon uses 2nd curtain sync to remedy the situation. In that mode, the shutter opens, as before. The shutter remains open for its designated duration, and the ghost image forms. If your subject moves from the left side of the frame to the right side, the ghost will move from left to right, too. *Then*, about 1.5 milliseconds before the second shutter curtain closes, the flash is triggered, producing a nice, sharp flash image *ahead* of the ghost image. Voilà! We have monsieur *Speed Racer* outdriving his own trailing image.

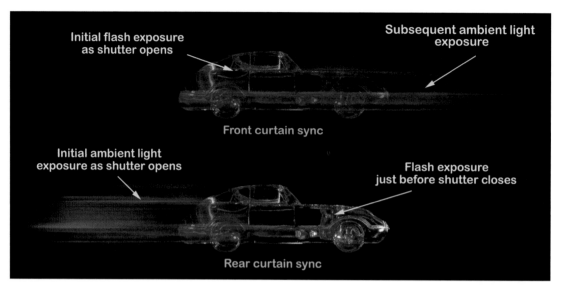

Figure 11.7 First (front) curtain sync produces an image that trails in front of the flash exposure (top), whereas 2nd (rear) curtain sync creates a more "natural looking" trail behind the flash image.

Avoiding Sync Speed Problems

Using a shutter speed faster than 1/200th second can cause problems. Triggering the electronic flash only when the shutter is completely open makes a lot of sense if you think about what's going on. To obtain shutter speeds faster than 1/200th second, the T5 exposes only part of the sensor at one time, by starting the second curtain on its journey before the first curtain has completely opened, as shown in Figure 11.8. That effectively provides a briefer exposure as a slit, narrower than the full height of the sensor, passes over the surface of the sensor. If the flash were to fire during the time when the first and second curtains partially obscured the sensor, only the slit that was actually open would be exposed.

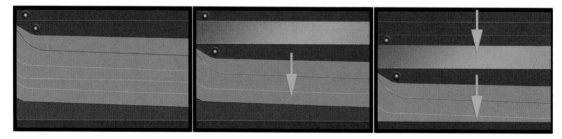

Figure 11.8 A closed shutter (left); partially open shutter as the first curtain begins to move downward (middle); only part of the sensor is exposed as the slit moves (right).

You'd end up with only a narrow band, representing the portion of the sensor that was exposed when the picture is taken. For shutter speeds *faster* than 1/200th second, the second curtain begins moving *before* the first curtain reaches the bottom of the frame. As a result, a moving slit, the distance between the first and second curtains, exposes one portion of the sensor at a time as it moves from the top to the bottom. Figure 11.8 shows three views of our typical (but imaginary) focal plane shutter. At left is pictured the closed shutter; in the middle version you can see the first curtain has moved down about 1/4 of the distance from the top; and in the right-hand version, the second curtain has started to "chase" the first curtain across the frame toward the bottom.

If the flash is triggered while this slit is moving, only the exposed portion of the sensor will receive any illumination. You end up with a photo like the one shown in Figure 11.9. Note that a band across the bottom of the image is black. That's a shadow of the second shutter curtain, which had started to move when the flash was triggered. Sharp-eyed readers will wonder why the black band is at the *bottom* of the frame rather than at the top, where the second curtain begins its journey. The answer is simple: your lens flips the image upside down and forms it on the sensor in a reversed position. You never notice that, because the camera is smart enough to show you the pixels that make up your photo in their proper orientation. But this image flip is why, if your sensor gets dirty and you detect a spot of dust in the upper half of a test photo, if cleaning manually, you need to look for the speck in the *bottom* half of the sensor.

I generally end up with sync speed problems only when shooting in the studio, using studio flash units rather than my T5's built-in flash or a Canon-dedicated Speedlite. That's because if you're using either type of "smart" flash, the camera knows that a strobe is attached, and remedies any

Figure 11.9

If a shutter speed faster than 1/200th second is used, you can end up photographing only a portion of the image.

unintentional goof in shutter speed settings. If you happen to set the T5's shutter to a faster speed in Tv or M mode, the camera will automatically adjust the shutter speed down to 1/200th second. In Av, P, or any of the automatic modes, where the T5 selects the shutter speed, it will never choose a shutter speed higher than 1/200th second when using flash. In P mode, shutter speed is automatically set between 1/60th to 1/200th second when using flash.

But when using a non-dedicated flash, such as a studio unit plugged into an adapter with a PC/X connector, the camera has no way of knowing that a flash is connected, so shutter speeds faster than 1/200th second can be set inadvertently. Note that the T5 can use a feature called *high-speed sync* that allows shutter speeds faster than 1/200th second with certain external dedicated Canon flash units. When using high-speed sync, the flash fires a continuous series of bursts at reduced power for the entire duration of the exposure, so that the illumination is able to expose the sensor as the slit moves. High-speed sync is set using the controls on the attached and powered-up compatible external flash.

Determining Exposure

Calculating the proper exposure for an electronic flash photograph is a bit more complicated than determining the settings by continuous light. The right exposure isn't simply a function of how far away your subject is (which the T5 can figure out based on the autofocus distance that's locked in just prior to taking the picture). Various objects reflect more or less light at the same distance so, obviously, the camera needs to measure the amount of light reflected back and through the lens. Yet, as the flash itself isn't available for measuring until it's triggered, the T5 has nothing to measure.

The solution is to fire the flash twice. The initial shot is a pre-flash that can be analyzed, then followed by a main flash that's given exactly the calculated intensity needed to provide a correct exposure. As a result, the primary flash may be longer for distant objects and shorter for closer subjects, depending on the required intensity for exposure. This through-the-lens evaluative flash exposure system is called E-TTL II, and it operates whenever the pop-up internal flash is used, or you have attached a Canon dedicated flash unit to the T5.

Guide Numbers

Guide numbers, usually abbreviated GN, are a way of specifying the power of an electronic flash in a way that can be used to determine the right f/stop to use at a particular shooting distance and ISO setting. In fact, before automatic flash units became prevalent, the GN was actually used to do just that. A GN is usually given as a pair of numbers for both feet and meters that represent the range at ISO 100. For example, the Rebel T5's built-in flash has a GN of 13/43 (meters/feet) at ISO 200. To calculate the right exposure at that ISO setting, you'd divide the guide number by the distance to arrive at the appropriate f/stop.

Using the T5's built-in flash as an example, at ISO 200 with its GN of 43, if you wanted to shoot a subject at a distance of 10 feet, you'd use f/4.3 (43 divided by 10; round to f/4 for simplicity's sake). At 8 feet, an f/stop of f/5.3 (round up to f/5.6) would be used. Some quick mental calculations with the GN will give you any particular electronic flash's range. You can easily see that the built-in flash would begin to peter out at about 15 feet, where you'd need an aperture of roughly f/2.8 at ISO 200. Of course, in the real world you'd probably bump the sensitivity up to a setting of ISO 400 so you could use a more practical f/5.6 at that distance.

Today, guide numbers are most useful for comparing the power of various flash units. You don't need to be a math genius to see that an electronic flash with a GN of, say, 190 would be *a lot* more powerful than your built-in flash (at ISO 100, you could use f/13 instead of f/2.8 at 15 feet).

Getting Started with the Built-in Flash

The Canon Rebel T5's built-in flash is a handy accessory because it is available as required, without the need to carry an external flash around with you constantly. The next sections explain how to use the flip-up flash in the various Basic Zone and Creative Zone modes.

Basic Zone Flash

When the T5 is set to one of the Basic Zone modes (except for Landscape, Sports, or Flash Off modes), the built-in flash will pop up when needed to provide extra illumination in low-light situations, or when your subject matter is backlit and could benefit from some fill flash. The flash doesn't pop up in Landscape mode because the flash doesn't have enough reach to have much effect for pictures of distant vistas in any case; nor does the flash pop up automatically in Sports mode, because you'll often want to use shutter speeds faster than 1/200th second and/or be shooting subjects that are out of flash range. Pop-up flash is disabled in Flash Off mode for obvious reasons.

If you happen to be shooting a landscape photo and do want to use flash (say, to add some illumination to a subject that's closer to the camera), or you want flash with your sports photos, or you *don't* want the flash popping up all the time when using one of the other Basic Zone modes, switch to an appropriate Creative Zone mode and use that instead.

Creative Zone Flash

When you're using a Creative Zone mode, you'll have to judge for yourself when flash might be useful, and flip it up yourself by pressing the Flash button on top right of the camera. (If you've redefined this button to serve as an ISO button instead, as explained in Chapter 9, you can still raise the flash using the Flash Up option in the Quick Control screen.) The behavior of the internal flash varies, depending on which Creative Zone mode you're using:

- **P.** In this mode, the T5 fully automates the exposure process, giving you subtle fill flash effects in daylight, and fully illuminating your subject under dimmer lighting conditions. The camera selects a shutter speed from 1/60th to 1/200th second and sets an appropriate aperture.

- **Av.** In Aperture-priority mode, you set the aperture as always, and the T5 chooses a shutter speed from 30 seconds to 1/200th second. Use this mode with care, because if the camera detects a dark background, it will use the flash to expose the main subject in the foreground, and then leave the shutter open long enough to allow the background to be exposed correctly, too. If you're not using an image-stabilized lens, you can end up with blurry ghost images even of non-moving subjects at exposures longer than 1/30th second, and if your camera is not mounted on a tripod, you'll see these blurs at exposures longer than about 1/8th second even if you are using IS.

 To disable use of a slow shutter speed with flash, access C.Fn I-3: Flash Sync. Speed in Av mode, and change from the default setting (0: Auto) to either 1: 1/200-1/60sec. auto or 2:1/200sec. (fixed), as described in Chapter 9. (If anything other than Auto is chosen, you won't be able to use high-speed sync, described later in this chapter, otherwise available only when using a compatible external flash.)

- **Tv.** When using flash in Tv mode, you set the shutter speed from 30 seconds to 1/200th second, and the T5 will choose the correct aperture for the correct flash exposure. If you accidentally set the shutter speed higher than 1/200th second, the camera will reduce it to 1/200th second when you're using the flash.

- **M/B.** In Manual or Bulb exposure modes, you select both shutter speed (30 seconds to 1/200th second) and aperture. The camera will adjust the shutter speed to 1/200th second if you try to use a faster speed with the internal flash. The E-TTL II system will provide the correct amount of exposure for your main subject at the aperture you've chosen (if the subject is within the flash's range, of course). In Bulb mode, the shutter will remain open for as long as the release button on top of the camera is held down, or the release of your remote control is activated.

Flash Range

The illumination of the Rebel T5's built-in flash varies with distance, focal length, and ISO sensitivity setting.

- **Distance.** The farther away your subject is from the camera, the greater the light fall-off, thanks to the inverse square law discussed earlier. Keep in mind that a subject that's twice as far away receives only one-quarter as much light, which is two f/stops' worth.

- **Focal length.** The built-in flash "covers" only a limited angle of view, which doesn't change. So, when you're using a lens that is wider than the default focal length, the frame may not be covered fully, and you'll experience dark areas, especially in the corners. As you zoom in using longer focal lengths, some of the illumination is outside the area of view and is "wasted." (This phenomenon is why some external flash units, such as the 600EX-RT, "zoom" to match the zoom setting of your lens to concentrate the available flash burst onto the actual subject area.)

- **ISO setting.** The higher the ISO sensitivity, the more photons captured by the sensor. So, doubling the sensitivity from ISO 100 to 200 produces the same effect as, say, opening up your lens from f/8 to f/5.6.

Red-Eye Reduction and Autofocus Assist

When Red-Eye Reduction is turned on in the Shooting 1 menu (as described in Chapter 8), and you are using flash with any shooting mode except for Flash Off, Landscape, Sports, or Movie, the red-eye reduction lamp on the front of the camera will illuminate for about 1.5 seconds when you press down the shutter release halfway, theoretically causing your subjects' irises to contract (if they are looking toward the camera), and thereby reducing the red-eye effect in your photograph. Red-eye effects are most frequent under low-light conditions, when the pupils of your subjects' eyes open to admit more light, thus providing a larger "target" for your flash's illumination to bounce back from the retinas to the sensor.

Another phenomenon you'll encounter under low light levels may be difficulty in focusing. Canon's answer to that problem is an autofocus assist beam emitted by the T5's built-in flash, or by any external dedicated flash unit that you may have attached to the camera (and switched on). In dim lighting conditions, the built-in flash will emit a burst of reduced-intensity flashes when you press the shutter release halfway, providing additional illumination for the autofocus system. Here are some things you need to know about the AF-assist beam:

- **Basic Zone activation.** When using a Basic Zone exposure mode other than Flash Off, Landscape, Sports, or Movie, if AF-assist is required, the T5's built-in flash will pop up automatically.

- **Creative Zone activation.** If you're working with a Creative Zone exposure mode, you must pop up the built-in flash manually using the Flash button to enable AF-assist.

- **Focus mode.** The AF-assist beam will fire only if you are using One-Shot AF (single autofocus) or AI Focus AF (automatic autofocus). The beam is disabled if the camera is set to AI Servo AF (continuous autofocus) mode.

- **Distance.** The beam provides autofocus assistance only for subjects closer than roughly 13 feet from the camera. The illumination is too dim at great distances to improve autofocus performance. If you need more of an assist, an external flash such as the 600EX-RT can provide a focusing aid for subjects as far as 32.8 feet away.

- **Live view.** The AF-assist flash is disabled when using live liew's Live mode and Live "face detection" focusing modes, for both the built-in flash and external flash. However, if a Canon Speedlite with an LED light is used (such as the 320EX), the beam will illuminate to provide autofocus assistance. The AF-assist beam functions normally when using Quick mode autofocus in live view.

- **Enabling/Disabling AF-assist.** You can specify how the AF-assist beam is fired using C.Fn III-7, as described below.

AF-Assist with Flash Disabled

You can still use the Autofocus Assist Beam function even when you don't want the flash to contribute to the exposure by disabling flash while enabling autofocus assist, using one of the Flash Control options in the Shooting 1 menu. Just follow these steps:

1. Press the MENU button and navigate to the Shooting 1 menu.
2. Use the cross keys to select the Flash Control entry.
3. Select Flash Firing, press SET, and choose Disable. That option disables both the built-in flash and any external dedicated flash you may have attached. However, the AF-assist beam will still fire as described earlier.
4. Press the MENU button twice to exit. (Or just tap the shutter release button.)

Enabling/Disabling AF-Assist

Use C.Fn III-07, described in Chapter 9, to choose whether the AF-assist beam is emitted by the built-in flash or the external Speedlite. You can disable the feature, activate it for both built-in and external Speedlite, specify only external flash assist, or use only the infrared AF-assist beam included with some Canon flash units, such as the 600EX-RT. That option eliminates the obtrusive visible flashes, but still allows autofocus assistance using IR signals.

Using FE Lock and Flash Exposure Compensation

If you want to lock flash exposure for a subject that is not centered in the frame, you can use the FE lock button (*) to lock in a specific flash exposure. Just depress and hold the shutter button halfway to lock in focus, then center the viewfinder on the subject you want to correctly expose and press the * button. The pre-flash fires and calculates exposure, displaying the FEL (flash exposure lock) message in the viewfinder. Then, recompose your photo and press the shutter down the rest of the way to take the photo.

You can also manually add or subtract exposure to the flash exposure calculated by the T5 when using a Creative Zone mode. Just press the Choose the Flash Control entry in the Shooting 1 menu, then the Built-in Flash function setting, and choose Flash Exp. Comp (see Figure 11.10). Then use the left/right cross keys to enter flash exposure compensation plus or minus two f/stops. The exposure index scale on the LCD and in the viewfinder will indicate the change you've made, and a flash exposure compensation icon will appear to warn you that an adjustment has been made. As with non-flash exposure compensation, the compensation you make remains in effect for the pictures that follow, and even when you've turned the camera off, remember to cancel the flash exposure compensation adjustment by reversing the steps used to set it when you're done using it.

You can also specify flash exposure compensation using the Quick Control screen (see Figure 11.11). A third way to access flash exposure compensation is to assign that feature to the SET button, using C.Fn IV-08, as described in Chapter 9. Thereafter, you can press the SET button when in shooting

mode, and rotate the Main Dial to adjust flash exposure compensation from the screen that pops up on the LCD. Flash exposure compensation can also be adjusted using the controls on your attached and active external flash unit. Those settings (any setting other than 0 dialed in with the external flash) will override any flash exposure compensation you've specified in the camera.

> **Tip**
>
> If you've enabled the Auto Lighting Optimizer in the Shooting 2 menu, as described in Chapter 8, it may cancel out any EV you've subtracted using flash exposure compensation. Disable the Auto Lighting Optimizer if you find your images are still too bright when using flash exposure compensation.

Figure 11.10
One way to set exposure compensation is to use the Shooting 2 menu's Expo. Comp/AEB entry.

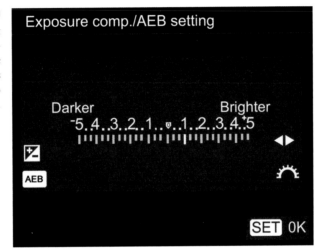

Figure 11.11
Access flash exposure compensation from the Quick Control screen.

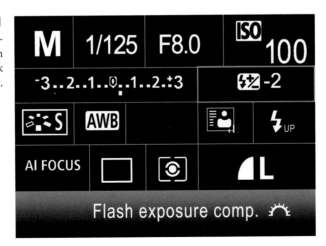

More on Flash Control Settings

I introduced the Shooting 1 menu's Flash Control settings in Chapter 8. This next section offers additional information for using the Flash Control menu. The menu includes five options (see Figure 11.12): Flash Firing, Built-in Flash Function Settings, External Flash Function Settings, External Flash C.Fn Settings, and Clear External Flash C.Fn Settings.

Flash Firing

This menu entry has two options: Enable and Disable. It can be used to activate or deactivate the built-in electronic flash and any attached external electronic flash unit. When disabled, the flash cannot fire even if you accidentally elevate it, or have an accessory flash attached and turned on. However, you should keep in mind that the AF-assist beam can still be used. If you want to disable that, too, you'll need to turn it off using C.Fn III-07. Disabling the flash here does so for all exposure modes, and so is a better choice than using the Basic Zone Flash Off setting of the Mode Dial.

Here are some applications where I always disable my flash and AF-assist beam, even though my T5 won't pop up the flash and fire without my intervention anyway. Some situations are too important to take chances. (Who knows, maybe I've accidentally set the Mode Dial to Creative Auto?)

- **Venues where flash is forbidden.** I've discovered that many No Photography signs actually mean "No Flash Photography," either because those who make the decisions feel that flash is distracting or they fear it may potentially damage works of art. Tourists may not understand the difference between flash and available-light photography, or may be unable to set their camera to turn off the flash. One of the first phrases I learn in any foreign language is "Is it permitted to take photos if I do not use flash?" A polite request, while brandishing an advanced camera like the T5 (which may indicate you know what you are doing), can often result in permission to shoot away.

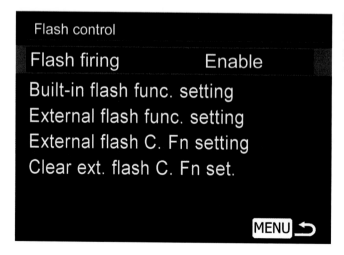

Figure 11.12
Five entries are available from the Flash Control menu.

- **Venues where flash is ineffective anyway.** We've all seen the concert goers who stand up in the last row to shoot flash pictures from 100 yards away. I tend to not tell friends that their pictures are not going to come out, because they usually come back to me with a dismal, grainy shot (actually exposed by the dim available light) that they find satisfactory, just to prove I was wrong.

- **Venues where flash is annoying.** If I'm taking pictures in a situation where flash is permitted, but mostly supplies little more than visual pollution, I'll disable or avoid using it. Concerts or religious ceremonies may *allow* flash photography, but who needs to add to the blinding bursts when you have a camera that will take perfectly good pictures at ISO 3200? Of course, I invariably see one or two people flashing away at events where flash is not allowed, but that doesn't mean I am eager to join in the festivities.

Built-in Flash Function Setting

There are three user-selectable choices for this menu, which normally appears as shown in Figure 11.13. Pressing the DISP. button to the right of the LCD while this menu screen is visible clears the current flash settings.

- **Flash Mode.** This entry is fixed at E-TTL II in the T5, and user changes are not allowed. Other Rebels allow changing flash mode to Manual using this menu entry.

- **Shutter sync.** Choose 1st curtain sync, which fires the pre-flash used to calculate the exposure before the shutter opens, followed by the main flash as soon as the shutter is completely open. This is the default mode, and you'll generally perceive the pre-flash and main flash as a single burst. Alternatively, you can select 2nd curtain sync, which fires the pre-flash as soon as the shutter opens, and then triggers the main flash in a second burst at the end of the exposure,

Figure 11.13
Three entries are available on the Built-in Flash Functions menu.

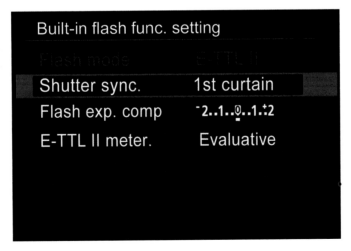

just before the shutter starts to close. (If the shutter speed is slow enough, you may clearly see both the pre-flash and main flash as separate bursts of light.) This action allows photographing a blurred trail of light of moving objects with sharp flash exposures at the beginning and the end of the exposure.

If you have an external compatible Speedlite attached, you can also choose High-speed sync, which allows you to use shutter speeds faster than 1/200th second, using the External Flash Function Setting menu, described next.

- **Flash exposure compensation.** You can use the Quick Control screen (press the Q button) and enter flash exposure compensation. If you'd rather adjust flash exposure using a menu, you can do that here. Select this option with the SET button, then dial in the amount of flash EV compensation you want using the cross keys. The EV that was in place before you started to make your adjustment is shown as a blue indicator, so you can return to that value quickly. Press SET again to confirm your change, then press the MENU button twice to exit.

- **E-TTL II metering.** This choice allows you to choose the type of exposure metering the T5 uses for electronic flash. You can select the default Evaluative metering, which selectively interprets the 63 metering zones in the viewfinder to intelligently classify the scene for exposure purposes. Alternatively, you can select Average, which melds the information from all the zones together as an average exposure. You might find this mode useful for evenly lit scenes, but, in most cases, exposure won't be exactly right and you may need some flash exposure compensation adjustment.

External Flash Function Setting

You can access this menu only when you have a compatible electronic flash attached and switched on. The settings available are shown in Figure 11.14. If you press the DISP. button while adjusting flash settings, both the changes made to the settings of an attached external flash and to the built-in flash will be cleared.

- **Flash mode.** This entry allows you to set the flash mode for the external flash, from E-TTL II, Manual flash, MULTI flash, TTL, AutoExFlash, and ManEx flash. The first two are identical to the modes described earlier. The third, MULTI flash, allows stroboscopic/repeating flash effects, and will be described next. The remaining three are optional metering modes available with certain flash units, such as the 580EX II or 600EX-RT, and are offered for those who might need one of those less sophisticated flash metering systems. TTL measures light bouncing back from your subject through the lens to calculate exposure but, unlike E-TTL II, does not use a pre-flash or intelligent evaluation of the measurements to adjust for different types of scenes. AutoExFlash and ManEx flash don't measure light through the lens at all, but, instead, meter the illumination falling on an external sensor (with an unvarying 20-degree angle of view) that's built into the flash. The former method performs automatic exposure calculation using this information, while the latter provides data you can use for manual flash exposure.

Figure 11.14
External flash units can be controlled from the Canon Rebel T5 using this menu.

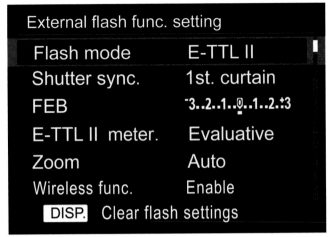

- **Shutter sync.** As with the T5's internal flash, you can choose 1st curtain sync, which fires the flash as soon as the shutter is completely open (this is the default mode). Alternatively, you can select 2nd curtain sync, which fires the flash as soon as the shutter opens, and then triggers a second flash at the end of the exposure, just before the shutter starts to close. If a compatible Canon flash, such as the Speedlite 600EX-RT is attached and turned on, you can also select high-speed sync (shown as HSS) and shoot using shutter speeds faster than 1/200th second. That can be especially handy if you want to use the external flash for fill light outdoors. For example, in Figure 11.15, I wanted to use an exposure at ISO 200 of 1/1,000th second and f/7.1 so the wider f/stop would give me less depth-of-field to isolate the model's face. With high-speed sync, I was able to use my 600-EX-RT flash as a fill light.

- **FEB.** Flash Exposure Bracketing (FEB) operates similarly to ordinary exposure bracketing, providing a series of different exposures to improve your chances of getting the exact right exposure, or to provide alternative renditions for creative purposes.

- **Flash exposure compensation.** You can adjust flash exposure for external flash using a menu here. Select this option with the SET button, then dial in the amount of flash EV compensation you want using the cross keys. The EV that was in place before you started to make your adjustment is shown as a blue indicator, so you can return to that value quickly. Press SET again to confirm your change, then press the MENU button twice to exit.

- **E-TTL II metering.** As described under Built-in Flash Function Settings, this choice allows you to choose the type of exposure metering the T5 uses for electronic flash with an external unit. You can select the default Evaluative metering, which selectively interprets the 63 metering zones in the viewfinder to intelligently classify the scene for exposure purposes. Alternatively, you can select Average, which melds the information from all the zones together as an average exposure. You might find this mode useful for evenly lit scenes, but, in most cases, exposure won't be exactly right and you may need some flash exposure compensation adjustment.

Figure 11.15 High-speed sync allows using an external flash as a fill light at faster shutter speeds.

- **Zoom.** Some flash units can vary their coverage to better match the field of view of your lens at a particular focal length. You can allow the external flash to zoom automatically, based on information provided, or manually, using a zoom button on the flash itself. This setting is disabled when using a flash like the Canon 270EX II, which does not have zooming capability. You can select Auto, in which case the camera will tell the flash unit the focal length of the lens, or choose individual focal lengths from 24mm to 105mm.

- **Wireless Functions.** At the bottom of this menu are seven functions related to wireless flash photography, and I'm going to save descriptions of those for later in this chapter.

Learning about MULTI Flash

The MULTI flash setting makes it possible to shoot cool stroboscopic effects, with the flash firing several times in quick succession. You can use the capability to produce multiple images of moving objects, to trace movement (say, your golf swing). When you've activated MULTI flash, additional parameters appear on the External Flash Function Setting menu. They include:

- **Flash output.** You can select from 1/4 power to 1/128th power. The flash output you choose determines how many flashes per second can be produced. The higher the power level, the fewer flashes the external unit can emit in a continuous burst.

- **Frequency.** This figure specifies the number of bursts per second. With an external flash, you can choose (theoretically) 1 to 199 bursts per second. The actual number of flashes produced will be determined by your flash count (which turns off the flash after the specified number of flashes), and flash output (higher output levels will deplete the available energy in your flash unit), and your shutter speed.

- **Flash count.** This setting determines the number of flashes in a given burst, and can be set from 1 to 50 flashes.

These factors work together to determine the maximum number of flashes you can string together in a single shot. The exact number will vary, depending on your settings. You can produce multiple images in one shot, like the image seen in Figure 11.16.

High-Speed Sync

High-speed sync is a special mode that allows you to synchronize an external flash at all shutter speeds, rather than just 1/200th second and slower. The entire frame is illuminated by a series of continuous bursts as the shutter opening moves across the sensor plane, so you do *not* end up with a horizontal black band, as shown earlier in Figure 11.9.

Figure 11.16 MULTI flash can be specified when an external flash is attached.

HSS is especially useful in three situations, all related to problems associated with high ambient light levels:

- **Eliminate "ghosts" with moving images.** When shooting with flash, the primary source of illumination may be the flash itself. However, if there is enough available light, a secondary image may be recorded by that light (as described under "Ghost Images" earlier in this chapter). If your main subject is not moving, the secondary image may be acceptable or even desirable. Indeed, the T5 has a provision for slow sync in its Basic Mode Night Portrait setting that allows using a slow shutter speed to record the ambient light and help illuminate dark backgrounds. But if your subject is moving, the secondary image creates a ghost image.

 High-speed sync gives you the ability to use a higher shutter speed. If ambient light produces a ghost image at 1/200th second, upping the shutter speed to 1/500th or 1/1,000th second may eliminate it.

 Of course, HSS *reduces* the amount of light the flash produces. If your subject is not close to the camera, the waning illumination of the flash may force you to use a larger f/stop to capture the flash exposure. So, while shifting from 1/200th second at f/8 to 1/500th second at f/8 *will* reduce ghost images, if you switch to 1/500th second at f/5.6 (because the flash is effectively less intense), you'll end up with the same ambient light exposure. Still, it's worth a try.

■ **Improved fill flash in daylight.** The T5 can use the built-in flash or an attached unit to fill in inky shadows—both automatically and using manually specified power ratios, as described earlier in this chapter. However, both methods force you to use a 1/200th second (or slower) shutter speed. That limitation can cause three complications.

First, in very bright surroundings, such as beach or snow scenes, it may be difficult to get the correct exposure at 1/200th second. You might have to use f/16 or a smaller f/stop to expose a given image, even at ISO 100. If you want to use a larger f/stop for selective focus, then you encounter the second problem—1/200th second won't allow apertures wider than f/8 or f/5.6 under many daylight conditions at ISO 100. (See the discussion of fill flash with Aperture-priority in the next bullet.)

Finally, if you're shooting action, you'll probably want a shutter speed faster than 1/200th second, if at all possible under the current lighting. That's because, in fill flash situations, the ambient light (often daylight) provides the primary source of illumination. For many sports and fast-moving subjects, 1/500th second, or faster, is desirable. HSS allows you to increase your shutter speed and still avail yourself of fill flash. This assumes that your subject is close enough to your camera that the fill flash has some effect; forget about using fill and HSS with subjects a dozen feet away or farther. The flash won't be powerful enough to have much effect on the shadows.

■ **When using fill flash with Aperture-priority.** The difficulties of using selective focus with fill flash, mentioned earlier, become particularly acute when you switch to Av exposure mode. Selecting f/5.6, f/4, or a wider aperture when using flash is guaranteed to create problems when photographing close-in subjects, particularly at ISO settings higher than ISO 100. If you own an external flash unit, HSS may be the solution you are looking for.

To use high-speed sync, using the discontinued, but still widely used Speedlite 580EX II as an example, just follow these steps:

1. **Attach the flash.** Mount/connect the external flash on the T5, using the hot shoe or a cable. (HSS cannot be used with a flash linked through an adapter that provides a PC/Xterminal.)

2. **Power up.** Turn the flash and camera on.

3. **Check C.Fn I-02.** To use HSS, this Custom Function must be set to 0: Auto. Otherwise, the T5 will not allow you to choose a shutter speed faster than 1/200th second.

4. **Select HSS in the camera.** Set the External Flash Function Setting *in the camera* to HSS as the T5's sync mode.

 ■ Choose Flash Control in the Shooting 1 menu.

 ■ Select External Flash Func. Setting.

 ■ Navigate to the Shutter Sync. Entry, press SET, and choose Hi-Speed. Press SET again to confirm.

5. **Choose HSS on the flash.** Activate HSS (FP flash) on your attached external flash. With the 580EX II, press the High-speed sync button on the back of the flash unit (it's the second from the right under the LCD). (See Figure 11.17.)

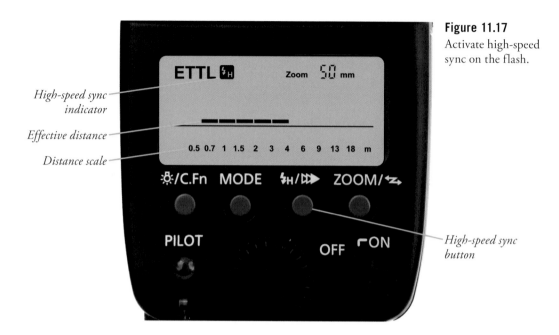

Figure 11.17
Activate high-speed sync on the flash.

High-speed sync indicator

Effective distance

Distance scale

High-speed sync button

6. **Confirm HSS is active.** The HSS icon will be displayed on the flash unit's LCD (at the upper-left side with the 580EX II), and at bottom left in the T5's viewfinder. If you choose a shutter speed of 1/200th second or slower, the indicator will not appear in the viewfinder, as HSS will not be used at slower speeds.

7. **View minimum/maximum shooting distance.** Choose a distance based on the maximum shown in the line at the bottom of the flash's LCD display (from 0.5 to 18 meters).

8. **Shoot.** Take the picture. To turn off HSS press the button on the flash again. Remember that you can't use MULTI flash or Wireless mode (using your external flash as a Master) when working with high-speed sync.

External Flash Custom Function Setting

Some external Speedlites from Canon include their own list of Custom Functions, which can be used to specify things like flash metering mode and flash bracketing sequences, as well as more sophisticated features, such as modeling light/flash (if available), use of external power sources (if attached), and functions of any slave unit attached to the external flash. This menu entry allows you to set an external flash unit's Custom Functions from your T5's menu. The settings available in the T5 for the Speedlite 580EX II are shown later in the section that describes that flash.

Clear External Flash Custom Function Setting

This entry allows you to zero-out any changes you've made to your external flash's Custom Functions, and return them to their factory default settings.

Using Wireless Flash

Using wireless flash is an ambitious endeavor for those using an entry-level camera like the EOS T5. However, Canon has taken the time to invest wireless capabilities in the T5, and even though the topic deserves several entire chapters (or a book) of its own (see *David Busch's Guide to Canon Flash Photography*), I hope to get you started.

I need to emphasize that the information in the next few sections is provided as an introduction only for the intermediate photographers who want to try out wireless flash. After all, in order to work with wireless Speedlites, you'll need to have spent more than the cost of the T5 itself on at least two external flash units—one to use as a master, and one as a slave/remote wireless flash. If you're ready, then read on.

Any individual electronic flash, including external Speedlites and the flash built into most EOS models *other* than the T5, can have one of two functions. It can serve as a *master* flash that's capable of triggering other compatible Canon units that are on the same channel. Or, a Speedlite can be triggered wirelessly as a *slave unit* that's activated by a *master*, with full control over exposure through the camera's eTTL flash system. The second function is easy: all current Canon shoe-mount flash, including the 600EX-RT, 580EX II, 430EX II, 320EX, and 270EX II can be *triggered* wirelessly as a slave unit. In addition, some Speedlites but *not* the T5's built-in flash have the ability to serve as a master flash. That means that when using the T5 and external flashes wirelessly, you must use an external flash connected to the T5 as the master flash. The T5 itself cannot trigger other Speedlites wirelessly. The extra expense of paying at least a few hundred dollars extra for a unit to use as a master flash is one reason why this entry-level camera isn't used more for wireless flash photography.

I'm not going to discuss older, discontinued flash units in this chapter; if you own one, particularly a non-Canon unit, it may or may not function as a slave. For example, the early Speedlite 380EX lacked the wireless capabilities added with later models, such as the 420EX, 430EX, and 430EX II.

Here's a quick run-down of current flash capabilities:

■ **Built-in flash.** As I noted, the flash built into the Canon EOS T5 and its predecessors the T3 or the EOS Rebel SL1, cannot serve as a master. Other Canon cameras unveiled after the EOS 7D (which introduced wireless in-camera triggering to the Canon line), the T3i, T4i, T5i, 60D, and 70D can use their built-in units as a master flash. Canon cameras with a built-in flash, introduced *prior* to the 7D, as well as the SL1, T3, and T5, can activate external flash units wirelessly *only* when physically connected to an external flash that has master capabilities, the Canon ST-E2/ST-E3-RT transmitter, or third-party transmitters. T5's built-in flash (of course) cannot itself function as a slave unit. (It has no facility for receiving signals from a master flash.)

■ **Canon Speedlite 600EX-RT.** This top-of-the-line flash can function as a master flash when physically attached to any Canon EOS model, using either optical or radio transmission, and can be triggered wirelessly by another master flash (a 7D/60D/T3i/T4i/T5i camera, another 600EX-RT or 580EX II, or the ST-E2/ST-E3-RT transmitters).

- **Canon Speedlite 580EX II.** This flash can function as a master flash when physically attached to any Canon EOS model, and can be triggered wirelessly by an optical (not radio) transmission from another master flash (a 7D/60D/T3i/T4i/T5i camera, another 580EX II, a 600EX-RT, the ST-E2 transmitter, or ST-E3-RT transmitter in optical mode).

- **Canon Speedlite 430EX II.** This flash cannot function as a master, but can be triggered wirelessly by a master flash (a 7D/60D/T3i/T4i/T5i/T5 camera, a Speedlite 600EX-RT/580EX II, or the ST-E-2 and ST-E3-RT transmitters in optical mode).

- **Canon Speedlite 320EX.** This flash can be triggered wirelessly by a master flash (a 7D/60D/T3i/T4i/T5i camera, a 600EX-RT/580EX II, or the ST-E-2 and ST-E3-RT transmitters in optical mode).

- **Canon Speedlite 270EX II.** This flash can be triggered wirelessly by a master flash (a 7D/60D/70D/T3i/T4i/T5i camera, a 600EX-RT/580EX II, or the ST-E-2 and ST-E3-RT transmitters in optical mode).

You can use any combination of compatible flash units in your wireless setup. You can use an attached 600EX-RT, 580EX II, or ST-E2/ST-E3-RT as a master, with any number of 600EX-RT, 580EX II, 430EX II, 320EX, or 270EX II units (or older compatible Speedlites not discussed in this chapter) as wireless slaves. I'll get you started assigning these flash to groups and channels later on.

There are three key concepts you must understand before jumping into wireless flash photography: channels, groups, and flash ratios. Here is an explanation of each:

- **Channel controls.** Canon's wireless flash system offers users the ability to determine on which of four possible channels the flash units can communicate. (The pilots, ham radio operators, or scanner listeners among you can think of the channels as individual communications frequencies.) When using optical transmission, the channels are numbered 1, 2, 3, and 4, and each flash must be assigned to one of them. Moreover, in general, each of the flash units you are working with should be assigned to the *same* channel, because the slave Speedlites will respond *only* to a master flash that is on the same channel.

 When using the 600EX-RT in radio control mode, there are 15 different channels, plus an Auto setting that allows the flash to select a channel. In addition, you can assign a four-digit Wireless Radio ID that further differentiates the communications channel your flashes use.

 The channel ability is important when you're working around other photographers who are also using the same system. Photojournalists, including sports photographers, encounter this situation frequently. At any event populated by a sea of "white" lenses you'll often find photographers who are using Canon flash units triggered by Canon's own optical or (now) radio control. Third-party triggers from PocketWizard or RadioPopper are also popular, but Canon's technology remains a mainstay for many shooters.

 Each photographer sets flash units to a different channel so as to not accidentally trigger other users' strobes. (At big events with more than four photographers using Canon flash and optical

transmission, you may need to negotiate.) I use this capability at workshops I conduct where we have two different setups. Photographers working with one setup use a different channel than those using the other setup, and can work independently even though we're at opposite ends of the same large room.

There is less chance of a channel conflict when working with radio control and all 600EX-RT flash units. With 15 channels to select from, and almost 10,000 wireless radio IDs to choose from, any overlap is unlikely. (It's smart not to use a radio ID like 0000, 1111, 2222, etc., to avoid increasing the chances of conflicts. I use the last four digits of my mother-in-law's Social Security Number.) Remember that you must use either all optical or all radio transmission for all your flash units; you can't mix and match.

■ **Groups.** Canon's wireless flash system lets you designate multiple flash units in separate groups. There can be as many as three groups, labeled A, B, and C.

With the 600EX-RT and ST-E3-RT, up to five groups (A, B, C, D, and E) can be used with as many as 15 different flash units. All the flashes in all the groups use the exact same *channel* and all respond to the same master controller, but you can set the output levels of each group separately. So, Speedlites in Group A might serve as the main light, while Speedlites in Group B might be adjusted to produce less illumination and serve as a fill light. It's convenient to be able to adjust the output of all the units within a given group simultaneously. This lets you create different styles of lighting for portraits and other shots.

■ **Flash ratios.** This ability to control the output of one flash (or set of flashes) compared to another flash or set allows you to produce lighting *ratios*. You can control the power of multiple off-camera Speedlites to adjust each unit's relative contribution to the image, for more dramatic portraits and other effects.

While explaining how to use each of these settings is beyond the scope of this book, you'll find the adjustments in the External Flash Func. Setting menu within the Flash Control entry. The options include:

■ **Wireless Func.** You can enable or disable wireless triggering here.

■ **Master flash.** Enable or disable master flash capabilities.

■ **Channel.** Select from Channel 1 through 4.

■ **Firing Group.** Choose to use all groups, A, B, and C; just A:B, or A:B and C.

■ **Flash Exposure Compensation.** Add or subtract exposure from the TTL metered exposure for all flashes fired.

■ **A:B Fire Ratio.** When either of the A:B choices are selected, you can adjust the output ratio between them from 8:1 (A Group 8X as powerful as B Group) to 1:1 (both equal) to 1:8 (B Group 8X as powerful as A Group).

■ **Group C Exposure Compensation.** When A:B C is selected, you can add or subtract exposure *only* for the flashes in the C Group.

■ **DISP.** Pressing the DISP. button clears all external flash wireless settings.

Getting Started

The first step in using an external flash or controller as the master is to set up one unit (either a flash or controller) as the external *master*. You can mount a Speedlite 580EX, 580EX II, or 600EX-RT to your camera, which can serve as the master unit, transmitting E-TTL II optical signals to one or more off-camera Speedlite *slave* units. The master unit can have its flash output set to "off" so that it controls the remote units without contributing any flash output of its own to the exposure. This is useful for images where you don't want noticeable flash illumination coming in from the camera position. The next sections explain your options for setting up a master unit for fully automatic, E-TTL II exposure.

Here are the steps to follow to set up and use a compatible Speedlite as a camera-mounted master unit for automatic exposure.

600EX-RT

1. Press the Wireless button (it's the button in the top row at the far left) repeatedly until the LCD panel indicates you are in optical wireless master mode.
2. Press Mode to cycle through the ETTL, M, and Multi modes.
3. Use the menu system described earlier to control and make changes to ratio, output, and other options on the master and slave units.

580EX II

1. Press and hold the Zoom button to bring up the wireless options. Use the Select dial to cycle through the Off, Master on, and Slave on options. Select and confirm Master on.
2. Press Mode to cycle through the ETTL, M, and Multi modes.
3. Press the Zoom button repeatedly to cycle through the following options: Flash zoom, Ratio, CH., flash emitter On/Off. Use the Select dial and Select/SET button to make any changes to these options.
4. Use the Select/SET button to select and confirm the output power settings when using Manual and Multi modes, or to use FEC or FEB when in ETTL mode.

580EX

1. Slide the Off/Master/Slave wireless switch near the base of the unit to Master.
2. Press Mode to cycle through the ETTL, M, and Multi modes.
3. Press the Zoom button repeatedly to cycle through the following options: Flash zoom, Ratio, CH., flash emitter On/Off. Use the Select dial and Select/SET button to make any changes to these options.
4. Use the Select/SET button to select and confirm the output power settings when using Manual and Multi modes, or to use FEC or FEB when in ETTL mode.

Using the ST-E2 Transmitter as Master

Canon's Speedlite Transmitter (ST-E2) is mounted on the camera's hot shoe and provides a way to control one or more Speedlites and/or units assigned to Groups A and B. The ST-E2 does not provide any flash output of its own and will not trigger units assigned to Group C. It has the following features and controls:

- **Transmitter.** Located on the top front of the unit, the transmitter emits E-TTL II pulses through an infrared filter.

- **AF-assist beam emitter.** Just below the transmitter, the AF-assist beam emitter works similarly to the Speedlite 430EX II and higher models.

- **Battery compartment.** The ST-E2 uses a 6.0V 2CR5 lithium battery. The battery compartment is accessed from the top of the unit.

- **Lock slider and mounting foot.** The lock slider is located on the right side of the unit when facing the front. Sliding it to the left lowers the lock pin in the mounting foot (located on the bottom of the unit) to secure it to the camera's hot shoe.

- **Back panel.** The rear of the unit features several indicators and controls:

 - **Ratio indicator.** A series of red LED lights indicating the current A:B ratio setting.

 - **Flash ratio control lamp.** A red LED that lights up when flash ratio is in use.

 - **Flash ratio setting button.** Next to the flash ratio control lamp. Press this button to activate flash ratio control.

 - **Flash ratio adjustment buttons.** Two buttons with raised arrows (same color as buttons) pointing left and right. Use these to change the A:B ratio setting.

 - **Channel indicator.** The channel number in use (1–4) glows red.

 - **Channel selector button.** Next to the channel indicator. Press this button to select the communication channel.

 - **High-speed sync (FP flash) indicator.** A red LED that glows when high-speed sync is in use.

 - **High-speed sync button.** Press this button to activate/deactivate high-speed sync.

 - **ETTL indicator.** A red LED that glows when E-TTL II is in use.

 - **Off/On/Hold switch.** Slide this switch to turn the unit off, on, or on with adjustments disabled (Hold). The ST-E2 will power off after approximately 90 seconds of idle time. It will turn back on when the shutter button or test transmission button is pressed.

 - **Pilot lamp/Test transmission button.** This lamp works similarly to the Speedlite pilot lamp/test buttons. The lamp glows red when ready to transmit. Press the lamp button to send a test transmission to the slave units.

 - **Flash confirmation lamp.** This lamp glows green for about three seconds when the ST-E2 detects a good flash exposure.

Here are the steps to follow to set up and use the ST-E2 transmitter as a camera-mounted master unit:

1. Mount the ST-E2 unit on your T5.

2. Make sure both the ST-E2 unit and your camera are powered on.

3. Make sure the slave units are set to E-TTL II, assigned to the appropriate group(s), and that all units are operating on the same channel.

4. If you'd like to set a flash ratio between Groups A and B, press the flash ratio setting button and flash ratio adjustment buttons to select the desired ratio. Press the high-speed sync button to use high-speed sync (often helpful with outdoor shooting).

Using the Speedlite 600EX-RT as Radio Master

The Speedlite 600EX-RT can serve as the master unit when mounted to your camera, transmitting radio signals to one or more off-camera Speedlite 600EX-RT slave units. The master unit can have its flash output set to "off" so that it controls the remote units without contributing any flash output of its own to the exposure. This is useful for images where you don't want noticeable flash illumination coming in from the camera position.

Here are the steps to follow to set up and use a Speedlite 600EX-RT as a camera-mounted master unit for radio wireless E-TTL II operation:

1. Mount the Speedlite 600EX-RT to your T5.

2. Make sure the 600EX-RT master units, slave units, and the camera are powered on.

3. Set the camera-mounted 600EX-RT to radio wireless Master mode. Press the Wireless button until the LCD panel indicates you are on radio wireless master mode.

4. Set the slave 600EX-RT units to radio wireless Slave mode. For each unit, press the Wireless button until the LCD panel indicates you are on radio wireless slave mode.

5. Confirm that all units are set to E-TTL II, assigned to the appropriate group(s), and that all units are operating on the same channel and ID number. The LINK lamps on all units should glow green.

Using the ST-E3-RT as Radio Master

The ST-E3-RT transmitter can be mounted to the camera's hot shoe and used as a master controller to one or more slave Speedlite 600EX-RT units. The ST-E3-RT and the 600EX-RT share essentially the same radio control capabilities except that the ST-E3-RT does not produce flash, provide AF-assist, or otherwise emit light, and is therefore incapable of optical wireless transmission.

The layout of the ST-E3-RT's control panel is virtually identical to the 600EX-RT. So is the menu system and operation, except that, as stated earlier, it will only operate as a radio wireless transmitter.

Here are the steps to follow to set up and use the ST-E3-RT transmitter as a camera-mounted master unit for radio wireless E-TTL II operation:

1. Mount the ST-E3-RT unit on your T5.

2. Make sure both the ST-E3-RT unit and your camera are powered on.

3. Set the slave 600EX-RT units to radio wireless Slave mode. For each unit, press the Wireless button until the LCD panel indicates you are on radio wireless slave mode.

4. Confirm that all units are set to E-TTL II, assigned to the appropriate group(s), and that all units are operating on the same channel and ID number. The Link lamps on all units should glow green.

You need to follow these steps with your external flash units first:

1. **Set the wireless off-camera Speedlite to slave mode.** Any of the flash units listed earlier can be used as a slave flash. The first step is to set the off-camera flash to slave mode. The procedure differs for each individual flash model. Check your manual for exact instructions.

2. **Assign a channel.** All units must use the same channel. The default channel is 1. If you need to change to a different communications channel, do so using the instructions for your particular flash unit.

3. **Assign slave to a group.** If you want to use a flash ratio to adjust the output of some slave units separately, you'll want to assign the slave flash to a group, either Group A (the default) or Group B. All units within a particular group fire at the same proportionate level. If you've set Group B to fire at half power, *all* the Speedlites that have been assigned to Group B will fire at half power.

 And remember that all flash units on a particular channel are controlled by the same master flash, regardless of the group they belong to. Set the group according to the instructions for your particular flash.

4. **Position the off-camera flash units, with the Speedlite's wireless sensor facing the camera/ master flash.** Indoors, you can position the external flash up to 33 feet from the master unit; outdoors, keep the distance to 23 feet or less. Your ability to use a flash wirelessly can depend on whether the Speedlite's sensor can receive communication from the master flash. Factors can include the direction the slave flash is pointed, and whether light can bounce off walls or other surfaces to reach the sensor.

If you want to use more than one slave unit, follow these instructions. All additional units using the same communications channel will fire at once, regardless of the Group assignment.

Setting Up a Slave Flash

The whole point of working wirelessly is to have a master flash/controller trigger and adjust one or more slave flash units. So, once you've defined your master flash, the next step is to switch your remaining Speedlites into slave mode. That's done differently with each particular Canon Speedlite.

- **Speedlite 600EX-RT.** Press the Wireless button repeatedly until the LCD panel indicates that the unit is in optical wireless slave mode or radio wireless slave mode. In this mode, the 600EX-RT is assigned a flash mode by the master transmitter, either a flash or ST-E2 or ST-E3-RT.

- **Speedlite 580EX II.** Press and hold the Zoom button until the wireless setting options appear. Use the Select dial and Select/SET button to select and confirm that wireless is on and in slave mode.

- **Speedlite 430EX II.** Press and hold the Zoom button until the wireless setting options appear. Use the Select dial and Select/SET button to select and confirm that wireless is on and in slave mode.

- **Speedlite 320EX.** This flash has an On/Off/Slave switch at the lower left of the back panel. In Slave mode, you can use the flash's C.Fn 10 to tell the unit to power down after either 10 or 60 minutes of idle time. That can help preserve the 320EX's batteries. The unit's C.Fn 11 can be set to allow the master transmitter to "wake" a sleeping 320EX after your choice of within 1 hour or within 8 hours. Note that the C.Fn settings of the 320EX and 270EX II (described next) can be set only while the Speedlites are connected to the camera with the hot shoe and powered on.

- **Speedlite 270EX II.** This flash has an Off/Slave/On switch. If left on and idle, the 270EX II will power itself off after approximately 90 seconds. C.Fn 01 can be used to disable auto power off. As with the 320EX, in Slave mode, you can use the flash's C.Fn 10 to tell the unit to power down after either 10 or 60 minutes of idle time. The unit's C.Fn 11 can be set to allow the master transmitter to "wake" a sleeping unit after your choice of within 1 hour or within 8 hours.

Wireless Flash Shooting

Just follow these steps:

1. **Enable internal flash.** Press the MENU button and navigate to the Shooting 2 menu. Choose the Flash Control entry, and press the SET button. This brings up the Flash Control menu (which is at the bottom of the menu). Press the SET button to enter the Flash Control menu. Next, select the Flash Firing setting and set the camera to Enable. This activates the built-in flash, which makes wireless flash control with the T5 possible.

2. **Confirm/Enable E-TTL II exposure.** While you can use wireless flash techniques and manual flash exposure, you're better off learning to use wireless features with the EOS T5 set to automatic exposure. So, from the Flash Control menu, choose E-TTL II metering and select Evaluative exposure.

3. **Enable wireless functions.** Next, choose Built-in Flash Settings and select Wireless Func. Press SET to confirm and return to the Built-in Flash Settings menu.

4. **Access wireless configuration.** In the Built-in Flash Setting menu, scroll down to Wireless Func. and press SET.

5. **Select wireless configuration.** Choose the External Flash:Built-in Flash icon at the top of the list of choices. Press SET to confirm. The colon between the two flash icons indicates that in this mode you can set a flash *ratio* between the units.

6. **Choose a channel.** Scroll down to Channel, press SET, and select the channel you want to use (generally that will be Channel 1).

7. **Set flash ratio.** Scroll down to the Ratio Setting entry (it's directly under the Flash Exp. Comp entry) and set a flash ratio between 1:1 (equal output) and 8:1 (external flash 8X the output of the internal flash, or, three stops). Ratios where the internal flash is *more* powerful than the external flash (i.e., 1:2, 1:4, etc.) are not possible.

8. **Take photos.** You're all set! You can now take photos wirelessly.

9. **Exit wireless mode.** When you're finished using wireless flash, deactivate wireless mode.

Once you've completed the steps above, your T5 is set up to begin using wireless flash using your attached external flash and external off-camera flash. Additional options are available for the brave. I'll show you each of these one at a time.

Using External Electronic Flash

Canon offers a broad range of accessory electronic flash units for the T5. They can be mounted to the flash accessory shoe, or used off-camera with a dedicated cord that plugs into the flash shoe to maintain full communications with the camera for all special features. (Non-dedicated flash units, such as studio flash, can be connected using a PC terminal adapter mounted in the accessory shoe.) They range from the Speedlite 600EX-RT and Speedlite 580EX II, which can correctly expose subjects up to 24 feet away at f/11 and ISO 200, to the 270EX, which is good out to 19 feet at f/11 and ISO 200. (You'll get greater ranges at even higher ISO settings, of course.) There are also two electronic flash units specifically for specialized close-up flash photography.

I power my Speedlites with Sanyo Eneloop AA nickel metal hydrid batteries. These are a special type of rechargeable battery with a feature that's ideal for electronic flash use. The Eneloop cells, unlike conventional batteries, don't self-discharge over relative short periods of time. Once charged, they can hold onto their juice for a year or more. That means you can stuff some of these into your Speedlite, along with a few spares in your camera bag, and not worry about whether the batteries have retained their power between uses. There's nothing worse than firing up your strobe after not using it for a month, and discovering that the batteries are dead.

Speedlite 600EX-RT

This flagship of the Canon accessory flash line (and most expensive at about $550) is the most powerful unit the company offers, with a GN of 197, and a manual/automatic zoom flash head that covers the full frame of lenses from 24mm wide angle to 200mm telephoto. (There's a flip-down, wide-angle diffuser that spreads the flash to cover a 14mm lens's field of view, too.) All angle specifications given by Canon refer to full-frame sensors, but this flash unit automatically converts its field of view coverage to accommodate the crop factor of the T5 and the other 1.6X crop Canon dSLRs. The 600EX-RT shares its basic features with the 580EX II, described next, so I won't repeat them here, because the typical T5 owner is more likely to own one of the less expensive Speedlites.

The killer feature of this unit is the new wireless two-way radio communication between the camera and this flash (or ST-E3-RT wireless controller and the flash) at distances of up to 98 feet. You can link up to 15 different flash units with radio control, using *five* groups (A, B, C, D, and E), and no line-of-sight connection is needed. (You can hide the flash under a desk or in a potted plant.) With the latest Canon cameras having a revised "intelligent" hot shoe (which includes the T5), a second 600EX-RT can be used to trigger a *camera* that also has a 600EX-RT mounted, from a remote location. That means you can set up multiple cameras equipped with multiple flash units to all fire simultaneously! For example, if you were shooting a wedding, you could photograph the bridal couple from two different angles, with the second camera set up on a tripod, say, behind the altar. A pro shooter might find the T5 to be an excellent, affordable second (or third) camera to use in such situations.

The 600EX-RT maintains backward compatibility with optical transmission used by earlier cameras. However, it's a bit pricey for the average EOS T5 owner, who is unlikely to be able to take advantage of all its features. If you're looking for a high-end flash unit and don't need radio control, I still recommend the Speedlite 580EX II (described next), which remains widely available both new or used.

Remember that with the 600EX-RT, you can't use radio control and some other features unless you own at least *two* of these Speedlites, or one 600EX-RT plus the ST-E3-RT, which costs half as much. Radio control is possible only between a camera that has a 600EX-RT or ST-E3-RT in the hot shoe, and an additional 600EX-RT flash or ST-E3-RT.

Some 18 Custom Functions of the 600EX-RT can be set using the T5's External Flash C.Fn Setting menu. Additional Personal Functions can be specified on the flash itself. The T5-friendly functions include:

C.Fn-00 Distance indicator display (Meters/Feet)

C.Fn-01 Auto power off (Enabled/Disabled)

C.Fn-02 Modeling flash (Enabled-DOF preview button/Enabled-test firing button/Enabled-both buttons/Disabled)

C.Fn-03 FEB Flash exposure bracketing auto cancel (Enabled/Disabled)

C.Fn-04 FEB Flash exposure bracketing Sequence (Metered > Decreased > Increased Exposure/Decreased > Metered > Increased Exposure)

C.Fn-05 Flash metering mode (E-TTL II-E-TTL/TTL/External metering: Auto/External metering: Manual)

C.Fn-06 Quickflash with continuous shot (Disabled/Enabled)

C.Fn-07 Test firing with autoflash (1/32/Full power)

C.Fn-08 AF-assist beam firing (Enabled/Disabled)

C.Fn-09 Auto zoom adjusted for image/sensor size (Enabled/Disabled)

C.Fn-10 Slave auto power off timer (60 minutes/10 minutes)

C.Fn-11 Cancellation of slave unit auto power off by master unit (Within 8 Hours/Within 1 Hour)

C.Fn-12 Flash recycling on external power (Use internal and external power/Use only external power)

C.Fn-13 Flash exposure metering setting button (Speedlite button and dial/Speedlite dial only)

C.Fn-20 Beep (Enable/Disable)

C.Fn-21 Light Distribution (Standard, Guide Number Priority, Even Coverage)

C.Fn-22 LCD panel illumination (On for 12 seconds, Disable, Always On)

C.Fn-23 Slave Flash Battery Check (AF-assist beam/Flash Lamp, Flash Lamp only)

The Personal Functions available include the following. Note that you can set the LCD panel color to differentiate at a glance whether a given flash is functioning in Master or Slave mode.

P.Fn-01 LCD panel display contrast (Five levels of contrast)

P.Fn-02 LCD panel illumination color: Normal (Green, Orange)

P.Fn-03 LCD panel illumination color: Master (Green, Orange)

P.Fn-04 LCD panel illumination color: Slave (Green, Orange)

P.Fn-05 Color filter auto detection (Auto, Disable)

P.Fn-06 Wireless button toggle sequence (Normal>Radio>Optical, Normal< >Radio, Normal< >Optical)

P.Fn-07 Flash firing during linked shooting (Disabled, Enabled)

Speedlite 580EX II

This deposed flagship of the Canon accessory flash line (and still available new or used from some sources) is the second-most powerful unit the company offered, with a GN of 190, and a manual/automatic zoom flash head that covers the full frame of lenses from 24mm wide angle to 105mm telephoto, as well as 14mm optics with a flip-down diffuser.

Like the 600EX-RT, this unit offers full-swivel, 180 degrees in either direction, and has its own built-in AF-assist beam and an exposure system that's compatible with the nine focus points of the T5. Powered by economical AA-size batteries, the unit recycles in 0.1 to 6 seconds, and can squeeze 100 to 700 flashes from a set of alkaline batteries.

The 580EX II automatically communicates white balance information to your camera, allowing it to adjust WB to match the flash output. You can even simulate a modeling light effect: When you press the depth-of-field preview button on the T5, the 580EX II emits a one-second burst of light that allows you to judge the flash effect. If you're using multiple flash units with Canon's wireless E-TTL system, this model can serve as a master flash that controls the slave units you've set up (more about this later) or function as a slave itself.

It's easy to access all the features of this unit, because it has a large backlit LCD panel on the back that provides information about all flash settings. There are 14 Custom Functions that can be controlled from the flash, numbered from 00 to 13. These functions are (the first setting is the default value):

C.Fn-00 Distance indicator display (Meters/Feet)

C.Fn-01 Auto power off (Enabled/Disabled)

C.Fn-02 Modeling flash (Enabled-DOF preview button/Enabled-test firing button/Enabled-both buttons/Disabled)

C.Fn-03 FEB Flash exposure bracketing auto cancel (Enabled/Disabled)

C.Fn-04 FEB Flash exposure bracketing sequence (Metered > Decreased > Increased Exposure/Decreased > Metered > Increased Exposure)

C.Fn-05 Flash metering mode (E-TTL II-E-TTL/TTL/External metering: Auto/External metering: Manual)

C.Fn-06 Quickflash with continuous shot (Disabled/Enabled)

C.Fn-07 Test firing with autoflash (1/32/Full power)

C.Fn-08 AF-assist beam firing (Enabled/Disabled)

C.Fn-09 Auto zoom adjusted for image/sensor size (Enabled/Disabled)

C.Fn-10 Slave auto power off timer (60 minutes/10 minutes)

C.Fn-11 Cancellation of slave unit auto power off by master unit (Within 8 Hours/Within 1 Hour)

C.Fn-12 Flash recycling on external power (Use internal and external power/Use only external power)

C.Fn-13 Flash exposure metering setting button (Speedlite button and dial/Speedlite dial only)

Speedlite 430EX II

This less pricey electronic flash (available for less than $300) has automatic and manual zoom coverage from 24mm to 105mm, and the same wide-angle pullout panel found on the 580EX II that covers the area of a 14mm lens on a full-frame camera, and automatic conversion to the cropped frame area of the T5 and other 1.6X crop Canon dSLRs. The 430EX II also communicates white balance information with the camera, and has its own AF-assist beam. Compatible with Canon's wireless E-TTL system, it makes a good slave unit, but cannot serve as a master flash. It, too, uses AA batteries, and offers recycle times of 0.1 to 3.7 seconds for 200 to 1,400 flashes, depending on subject distance.

The Canon Speedlite 430EX II offers a sophisticated set of features, including an LCD panel that allows you to navigate the unit's menu and view its status. These features, along with powerful output and automatic zoom means this unit has more in common with Canon's high-end Speedlites than it does with the 320EX or the 270EX II. The Speedlite 430EX II is compatible with E-TTL II and earlier flash technologies. It can serve as a slave unit in an optical wireless configuration. The Speedlite 430EX II has a Guide Number of 43/141 (meters/feet) at ISO 100, at 105mm focal length.

This is another aging unit, dating from mid-2008, and possibly due for replacement. It's a bit more powerful than the just-introduced Speedlite 320EX (described next), which is roughly in the same price range. So, I'm guessing that there will be a slightly more powerful 400-series Speedlite unveiled in the near future with a roughly $325 price point.

Speedlite 320EX

One of two flash units (with the Speedlite 270EX II, described next) introduced early in 2011, this $249 flash has a GN of 105. Lightweight and more pocket-sized than the 430EX II or 580EX II, this bounceable (both horizontally and vertically) flash has some interesting features, including a built-in LED video light that can be used for shooting movies with the T5, or as a modeling light or even AF-assist beam when shooting with live view. Canon says that this efficient LED light can provide up to four hours of illumination with a set of AA batteries. It can be used as a wireless slave unit, and has a new flash release function that allows the shutter to be triggered remotely with a two-second delay. See Figure 11.18.

Figure 11.18 The Canon Speedlite 320EX is the second-most powerful shoe-mount flash Canon offers.

Speedlite 270EX II

The Canon Speedlite 270EX II is designed to work with compatible EOS cameras utilizing E-TTL II and E-TTL automatic flash technologies. This flash unit is entirely controlled from the camera, making it as simple to use as a built-in flash. Its options can be selected and set via the camera's menu system. The 270EX II can also be used as an off-camera slave unit when controlled by a master Speedlite, transmitter unit, or a camera with an integrated Speedlite transmitter. One interesting feature of this unit is that it is also a remote control transmitter, allowing you to wirelessly release the shutter on cameras compatible with certain remote controller units. The Speedlite 270EX II has a Guide Number of 27/89 (meters/feet) at ISO 100, with the flash head pulled forward.

This $170 ultra-compact unit is Canon's entry-level Speedlite, and suitable for T5 owners who want a simple strobe for occasional use, without sacrificing the ability to operate it as a wireless slave unit. With its modest guide number, it provides a little extra pop for fill flash applications. It has vertical bounce capabilities of up to 90 degrees, and can be switched between Tele modes to Normal (28mm full-frame coverage) at a reduced guide number of 72.

The 270EX II functions as a wireless slave unit triggered by any Canon EOS unit or flash (such as the 580EX II) with a Master function. It also has the new flash release function with a two-second delay that lets you reposition the flash. There's a built-in AF-assist beam, and this 5.5-ounce, 2.6 × 2.6 × 3–inch unit is powered by just two AA-size batteries.

Ring/Macro Lites

Canon offers two macro lites, the Macro Ring Lite MR-14EX and Macro Twin Lite flash MT-24EX. As you might guess from their names, they are especially suitable for close-up, or macro photography, because they provide a relatively shadowless illumination. It's always tricky photographing small subjects up close, because there often isn't room enough between the camera lens and the subject to position lights effectively. Such flash units, especially those with their own modeling lamps to help you visualize the illumination you're going to get, mount around the lens at the camera position, and help solve many close-up lighting problems.

In recent years, the ring lite, in particular, has gone far beyond the macro realm and is now probably even more popular as a light source for fashion and glamour photography. The right ring lite, properly used, can provide killer illumination for glamour shots, while eliminating the need to move and reset lights for those shots that lend themselves to ring lite illumination. As you, the photographer, move around your subject, the ring lite moves with you.

One of the key drawbacks to these lites (whether used for macro or glamour photography) is that they are somewhat bulky and clumsy to use (they must be fastened around the camera lens itself, or the photographer must position the ring lite, and then shoot "through" the opening or ring). That means that you might not be moving round your subject as much as you thought and will, instead, mount the ring lite and camera on a tripod, studio stand, or other support.

Another drawback is the cost. The MR-14EX and MR-24EX are priced in the $550 and $800 range, respectively. You have to be planning a *lot* of macro or fashion work to pay for one of those. Specialists take note. I tend to favor a third-party substitute, the Alien Bees ABR800 Ringflash, shown in Figure 11.19. It's priced at about $400, and, besides, it integrates very well with my other Alien Bees studio flash units.

Figure 11.19
This Alien Bees ringflash is a more economical alternative to Canon's own units.

More Advanced Lighting Techniques

As you advance in your Canon Rebel T5 photography, you'll want to learn more sophisticated lighting techniques, using more than just straight-on flash, or using just a single flash unit. Check out *David Busch's Quick Snap Guide to Lighting* if you want to delve further. I'm going to provide a quick introduction to some of the techniques you should be considering.

Diffusing and Softening the Light

Direct light can be harsh and glaring, especially if you're using the flash built into your camera, or an auxiliary flash mounted in the hot shoe and pointed directly at your subject. The first thing you should do is stop using direct light (unless you're looking for a stark, contrasty appearance as a creative effect). Here are a number of simple things you can do with both continuous and flash illumination:

- **Use window light.** Light coming in a window can be soft and flattering, and a good choice for human subjects. Move your subject close enough to the window that its light provides the primary source of illumination. You might want to turn off other lights in the room, particularly to avoid mixing daylight and incandescent light (see Figure 11.20).

- **Use fill light.** Your T5's built-in flash makes a perfect fill-in light for the shadows, brightening inky depths with a kicker of illumination.

- **Bounce the light.** External electronic flash units mounted on the T5 usually have a swivel that allows them to be pointed up at a ceiling for a bounce light effect. You can also bounce the light off a wall. You'll want the surface to be white or have a neutral gray color to avoid a color cast.

- **Use reflectors.** Another way to bounce the light is to use reflectors or photo umbrellas that you can position yourself to provide a greater degree of control over the quantity and direction of the bounced light. Good reflectors can be pieces of foamboard, Mylar, or a reflective disk held in place by a clamp and stand. Although some expensive photo umbrellas and reflectors are available, spending a lot isn't necessary. A simple piece of white foamboard does the job beautifully. Umbrellas have the advantage of being compact and foldable, while providing a soft, even kind of light. They're relatively cheap, too, with a good 40-inch umbrella designed specifically for photographic applications available for as little as $20.

- **Use diffusers.** Sto-Fen and some other vendors offer clip-on diffusers like the one shown in Figures 11.21 and 11.22, that fit over your electronic flash head and provide a soft, flattering light. These add-ons are more portable than umbrellas and other reflectors, yet provide a nice diffuse lighting effect.

Figure 11.20 Window light makes the perfect diffuse illumination for informal soft-focus portraits like this one.

Figure 11.21 The Sto-Fen OmniBounce is a clip-on diffuser that softens the light of an external flash unit.

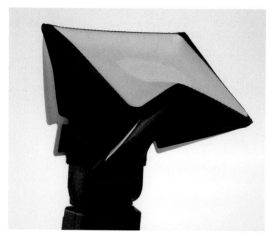

Figure 11.22 Soft boxes use Velcro strips to attach them to third-party flash units (like the one shown) or any Canon external flash.

Using Multiple Light Sources

Once you gain control over the qualities and effects you get with a single light source, you'll want to graduate to using multiple light sources. Using several lights allows you to shape and mold the illumination of your subjects to provide a variety of effects, from backlighting to side lighting to more formal portrait lighting. You can start simply with several incandescent light sources, bounced off umbrellas or reflectors that you construct. Or you can use more flexible multiple electronic flash setups.

Effective lighting is the one element that differentiates great photography from candid or snapshot shooting. Lighting can make a mundane subject look a little more glamorous. Make subjects appear to be soft when you want a soft look, or bright and sparkly when you want a vivid look, or strong and dramatic if that's what you desire. As you might guess, having control over your lighting means that you probably can't use the lights that are already in the room. You'll need separate, discrete lighting fixtures that can be moved, aimed, brightened, and dimmed on command.

Selecting your lighting gear will depend on the type of photography you do, and the budget you have to support it. It's entirely possible for a beginning T5 photographer to create a basic, inexpensive lighting system capable of delivering high-quality results for a few hundred dollars, just as you can spend megabucks ($1,000 and up) for a sophisticated lighting system.

Basic Flash Setups

If you want to use multiple electronic flash units, the Canon Speedlites described earlier will serve admirably. The two higher-end models can be used with Canon's wireless E-TTL feature, which allows you to place up to three separate groups of flash units (several flashes can be included in each group) and trigger them using a master flash (such as the 580EX II) and the camera. Just set up one master unit (there's a switch on the unit's foot that sets it for master mode) and arrange the compatible slave units around your subject. You can set the relative power of each unit separately, thereby controlling how much of the scene's illumination comes from the main flash, and how much from the auxiliary flash units, which can be used as fill flash, background lights, or, if you're careful, to illuminate the hair of portrait subjects.

Studio Flash

If you're serious about using multiple flash units, a studio flash setup might be more practical. The traditional studio flash is a multi-part unit, consisting of a flash head that mounts on your light stand, and is tethered to an AC (or sometimes battery) power supply. A single power supply can feed two or more flash heads at a time, with separate control over the output of each head.

When they are operating off AC power, studio flash don't have to be frugal with the juice, and are often powerful enough to illuminate very large subjects or to supply lots and lots of light to smaller subjects. The output of such units is measured in watt seconds (ws), so you could purchase a 200ws, 400ws, or 800ws unit, and a power pack to match.

Their advantages include greater power output, much faster recycling, built-in modeling lamps, multiple power levels, and ruggedness that can stand up to transport, because many photographers pack up these kits and tote them around as location lighting rigs. Studio lighting kits can range in price from a few hundred dollars for a set of lights, stands, and reflectors, to thousands for a high-end lighting system complete with all the necessary accessories.

A more practical choice these days are *monolights* (see Figure 11.23), which are "all-in-one" studio lights that sell for about $200–$400. They have the flash tube, modeling light, and power supply built into a single unit that can be mounted on a light stand. Monolights are available in AC-only and battery-pack versions, although an external battery eliminates some of the advantages of having a flash with everything in one unit. They are very portable, because all you need is a case for the monolight itself, plus the stands and other accessories you want to carry along. Because these units are so popular with photographers who are not full-time professionals, the lower-cost monolights are often designed more for lighter duty than professional studio flash. That doesn't mean they aren't rugged; you'll just need to handle them with a little more care, and, perhaps, not expect them to be used eight hours a day for weeks on end. In most other respects, however, monolights are the equal of traditional studio flash units in terms of fast recycling, built-in modeling lamps, adjustable power, and so forth.

Figure 11.23
All-in-one "mono-lights" contain flash, power supply, and a modeling light in one compact package (umbrella not included).

Connecting Multiple Units to Your Canon Rebel T5

Non-dedicated electronic flash units can't use the automated E-TTL II features of your Rebel T5; you'll need to calculate exposure manually, through test shots evaluated on your camera's LCD or by using an electronic flash meter. Moreover, you don't have to connect them to the accessory shoe on top of the camera. Instead, you can use an adapter in the hot shoe to provide a PC/X connector (perhaps with a voltage regulator) to connect these flashes, and use a shutter speed of 1/60th second or slower.

You should be aware that older electronic flash units sometimes use a triggering voltage that is too much for your T5 to handle. You can actually damage the camera's electronics if the voltage is too high. You won't need to worry about this if you purchase brand-new units from Alien Bees, Adorama, or other vendors. But if you must connect an external flash with an unknown triggering voltage, I recommend using a Wein Safe Sync (see Figure 11.24), which isolates the flash's voltage from the camera triggering circuit, and provides a PC/X adapter for plugging in non-dedicated flash units.

Another safe way to connect external cameras is through a radio-control device, such as the popular Pocket Wizard products and Radio Poppers. They generally transmit a signal to a matching receiver that's connected to your flash unit. The receiver has both a PC connector of its own as well as a "monoplug" connector (it looks like a headphone plug) that links to a matching port on compatible flash units.

Finally, some flash units have an optical slave trigger built in, or can be fitted with one, so that they fire automatically when another flash, including your camera's built-in unit, fires. You'll need a unit that isn't "fooled" by the pre-flash before the main flash burst.

Other Lighting Accessories

Once you start working with light, you'll find there are plenty of useful accessories that can help you. Here are some of the most popular that you might want to consider.

Soft Boxes

Soft boxes are large square or rectangular devices that may resemble a square umbrella with a front cover, and produce a similar lighting effect. They can extend from a few feet square to massive boxes that stand five or six feet tall—virtually a wall of light. With a flash unit or two inside a soft box, you have a very large, semi-directional light source that's very diffuse and very flattering for portraiture and other people photography.

Soft boxes are also handy for photographing shiny objects. They not only provide a soft light, but if the box itself happens to reflect in the subject (say you're photographing a chromium toaster), the box will provide an interesting highlight that's indistinct and not distracting.

You can buy soft boxes (like the one shown in Figure 11.25) or make your own. Some lengths of friction-fit plastic pipe and a lot of muslin cut and sewed just so may be all that you need.

Figure 11.24 A voltage isolator can prevent frying your T5's flash circuits if you use an older electronic flash, and provides a PC/X connector, which the Rebel T5 lacks.

Figure 11.25 Soft boxes provide an even, diffuse light source.

Light Stands

Both electronic flash and incandescent lamps can benefit from light stands. These are lightweight, tripod-like devices (but without a swiveling or tilting head) that can be set on the floor, tabletops, or other elevated surfaces and positioned as needed. Light stands should be strong enough to support an external lighting unit, up to and including a relatively heavy flash with soft box or umbrella reflectors. You want the supports to be capable of raising the lights high enough to be effective. Look for light stands capable of extending six to seven feet high. The nine-foot units usually have larger, steadier bases, and extend high enough that you can use them as background supports. You'll be using these stands for a lifetime, so invest in good ones.

Backgrounds

Backgrounds can be backdrops of cloth, sheets of muslin you've painted yourself using a sponge dipped in paint, rolls of seamless paper, or any other suitable surface your mind can dream up. Backgrounds provide a complementary and non-distracting area behind subjects (especially portraits) and can be lit separately to provide contrast and separation that outlines the subject, or which helps set a mood.

I like to use plain-colored backgrounds for portraits, and white seamless backgrounds for product photography. You can usually construct these yourself from cheap materials and tape them up on the wall behind your subject, or mount them on a pole stretched between a pair of light stands.

Snoots and Barn Doors

These fit over the flash unit and direct the light at your subject. Snoots are excellent for converting a flash unit into a hair light, while barn doors give you enough control over the illumination by opening and closing their flaps that you can use another flash as a background light, with the capability of feathering the light exactly where you want it on the background. A barn door unit is shown in Figure 11.26.

Figure 11.26
Barn doors allow you to modulate the light from a flash or lamp, and they are especially useful for hair lights and background lights.

12

Canon EOS T5/1200D:
Troubleshooting and
Prevention

One of the nice things about modern electronic cameras like the Canon EOS T5 is that they have fewer mechanical moving parts to fail, so they are less likely to "wear out." No film transport mechanism, no wind lever or motor drive, no complicated mechanical linkages from camera to lens to physically stop down the lens aperture. Instead, tiny, reliable motors are built into each lens (and you lose the use of only that lens should something fail), and one of the few major moving parts in the camera itself is a lightweight mirror (its small size one of the advantages of the T5's 1.6X crop factor) that flips up and down with each shot.

Of course, the camera also has a moving shutter that can fail, but the shutter is built rugged enough that you can expect it to last 100,000 shutter cycles or more. Unless you're shooting sports in continuous mode day in and day out, the shutter on your T5 is likely to last as long as you expect to use the camera.

The only other things on the camera that move are switches, dials, buttons, the flip-up electronic flash, and the door that slides open to allow you to remove and insert the memory card. Unless you're extraordinarily clumsy or unlucky or give your built-in flash a good whack while it is in use, there's not a lot that can go wrong mechanically with your EOS T5.

On the other hand, one of the chief drawbacks of modern electronic cameras is that they are modern *electronic* cameras. (See Figure 12.1.) Your T5 is fully dependent on two different batteries.

Figure 12.1
Your T5 and its lenses are packed full of sophisticated electronic components, including sensors for focus, exposure, and image capture; plus LEDs, tiny motors, and circuit boards.

Without them, the camera can't be used. There are numerous other electrical and electronic connections in the camera (many connected to those mechanical switches and dials), and components like the color LCD that can potentially fail or suffer damage. The camera also relies on its "operating system," or *firmware*, which can be plagued by bugs that cause unexpected behavior. Luckily, electronic components are generally more reliable and trouble-free, especially when compared to their mechanical counterparts from the pre-electronic film camera days. (Film cameras of the last 10 to 20 years have had almost as many electronic features as digital cameras, but, believe it or not, there where whole generations of film cameras that had *no* electronics or batteries.)

Digital cameras have problems unique to their breed, too; the most troublesome being the need to clean the sensor of dust and grime periodically. This chapter will show you how to diagnose problems, fix some common ills, and, importantly, learn how to avoid many of them in the future.

Updating Your Firmware

As I said, the firmware in your EOS T5 is the camera's operating system, which handles everything from menu display (including fonts, colors, and the actual entries themselves), what languages are available, and even support for specific devices and features. Upgrading the firmware to a new version makes it possible to add new features while fixing some of the bugs that sneak in.

Official Firmware

Official firmware for your T5 is given a version number that you can view by turning the power on, pressing the MENU button, and scrolling to Firmware Ver. x.x.x in the Set-up 3 menu. As I write this, the current version is still 1.0.0. The first number in the string represents the major release number, while the second and third represent less significant upgrades and minor tweaks,

respectively. Theoretically, a camera should have a firmware version number of 1.0.0 when it is introduced, as my T5 did, but vendors have been known to do some minor fixes during testing and unveil a camera with a 1.0.4 firmware designation. If a given model is available long enough, it can evolve into significant upgrades, such as 2.0.3.

Firmware upgrades are used most frequently to fix bugs in the software, and much less frequently to add or enhance features. For example, previous firmware upgrades for Canon cameras have mended things like incorrect color temperature reporting when using specific Canon Speedlites, or problems communicating with memory cards under certain conditions. The exact changes made to the firmware are generally spelled out in the firmware release announcement. You can examine the remedies provided and decide if a given firmware patch is important to you. If not, you can usually safely wait a while before going through the bother of upgrading your firmware—at least long enough for the early adopters to report whether the bug fixes have introduced new bugs of their own. Each new firmware release incorporates the changes from previous releases, so if you skip a minor upgrade you should have no problems.

Upgrading Your Firmware

If you're computer savvy, you might wonder how your EOS T5 is able to overwrite its own operating system—that is, how can the existing firmware be used to load the new version on top of itself? It's a little like lifting yourself by reaching down and pulling up on your bootstraps. Not ironically, that's almost exactly what happens: At your command (when you start the upgrade process), the T5 shifts into a special mode in which it is no longer operating from its firmware but, rather, from a small piece of software called a *bootstrap loader*, a separate, protected software program that functions only at startup or when upgrading firmware. The loader's function is to look for firmware to launch or, when directed, to copy new firmware from a memory card or your computer to the internal memory space where the old firmware is located. Once the new firmware has replaced the old, you can turn your camera off and then on again, and the updated operating system will be loaded.

WARNING

Use a fully charged battery or Canon's optional ACK-E8 AC adapter kit to ensure that you'll have enough power to operate the camera for the entire upgrade. Moreover, you should not turn off the camera while your old firmware is being overwritten. Don't open the memory card door or do anything else that might disrupt operation of the T5 while the firmware is being installed.

Because the loader software is small in size and limited in function, there are some restrictions on what it can do. For example, the loader software isn't set up to go hunting through your memory card for the firmware file. It looks only in the top or root directory of your card, so that's where you must copy the firmware you download. Once you've determined that a new firmware update is available for your camera and that you want to install it, just follow these steps. (If you chicken out, any Canon service center can install the firmware upgrade for you.)

1. Download the firmware from Canon (you'll find it in the Downloads section of the Support portion of Canon's website) and place it on your computer's hard drive. The firmware is contained in a self-extracting file for either Windows or Mac OS. It will have a name such as T5000101.fir.

2. In your camera, format a memory card. Choose Format from the Set-up menu, and initialize the card (make sure you don't have images you want to keep before you do this!).

3. You can copy the upgrade software to the card either using a memory card reader or by connecting the camera to your computer with a USB cable and using the EOS Utility application furnished with your camera (and described in the next section). The Firmware Version entry in the Set-up 3 menu will remind you that a memory card containing the firmware is required before you can proceed.

4. Insert the memory card in the camera and then turn the camera on. With the T5 set to any mode other than Creative Auto or Full Auto, press MENU and scroll to Firmware Ver. x.x.x in the Set-up 3 menu and press the SET button.

5. You'll see the current firmware version, and an option to update, as shown in Figure 12.2. (This is a "fictional" update.) Choose OK and press the SET button to begin loading the update program.

6. A confirmation screen will appear (see Figure 12.3). Select OK and press SET to continue. As the Firmware Update Program loads, you'll see the screen shown in Figure 12.4.

Figure 12.2

Firmware update

Current version is 1.0.0
Update.

Cancel OK

7. Next, you'll get the opportunity to confirm that the version you're upgrading to is the one you want, as you can see in Figure 12.5. You can press the MENU button to cancel. (Yes, I know there are a lot of confirmation screens; Canon wants to make sure you don't upgrade your firmware by accident, or, possibly, intentionally.)

8. Finally, the very last confirmation screen (see Figure 12.6). Select OK, and press SET, and, I promise, the actual firmware update will really begin.

9. While the firmware updates, you'll be warned not to turn off the power switch or touch any of the T5's buttons. (See Figure 12.7.)

10. When the update complete screen appears (Figure 12.8), you can turn off the EOS T5, remove the AC adapter, if used, and replace or recharge the battery. Then turn the camera on to boot up your camera with the new firmware update.

11. Be sure to reformat the card before returning it to regular use to remove the firmware software.

Figure 12.3

Figure 12.4

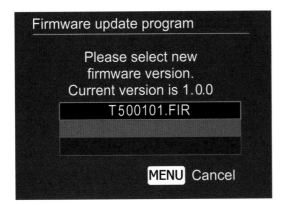

Figure 12.5

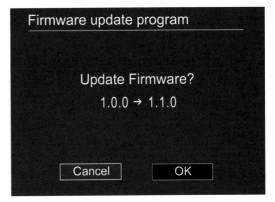

Figure 12.6

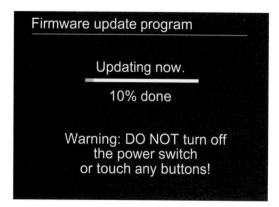

Figure 12.7 **Figure 12.8**

Using Direct Camera USB Link to Copy the Software

The procedure is slightly different (and a little more automated) if you choose to transfer the firmware software to the camera through a USB linkup. Follow these instructions to get started:

1. Connect the camera (with a freshly charged battery or attached to AC Adapter) to the computer using the USB cable and turn it on.

2. Load the EOS Utility.

3. Click the Camera/Settings/Remote Shooting button.

4. Select the Firmware Update option. When the Update Firmware window appears at the bottom of the EOS Utility, choose OK.

5. Click Yes in the confirmation screen.

6. Follow the instructions in the dialog boxes that pop up next by pressing the SET button on the camera.

Protecting Your LCD

The color LCD on the back of your EOS T5 almost seems like a target for banging, scratching, and other abuse. Fortunately, it's quite rugged, and a few errant knocks are unlikely to shatter the protective cover over the LCD, and scratches won't easily mar its surface. However, if you want to be on the safe side, there are a number of protective products you can purchase to keep your LCD safe—and, in some cases, make it a little easier to view.

Here's a quick overview of your options:

■ **Plastic overlays.** The simplest solution (although not always the cheapest) is to apply a plastic overlay sheet or "skin" cut to fit your LCD. These adhere either by static electricity or through a light adhesive coating that's even less clingy than stick-it notes. You can cut down overlays made for PDAs (although these can be pricey at up to $19.95 for a set of several sheets), or purchase overlays sold specifically for digital cameras. Vendors such as Hoodman (www.hoodmanusa.com) offer overlays of this type. These products will do a good job of shielding your T5's LCD screen from scratches and minor impacts, but will not offer much protection from a good whack. These are your best choice if you plan to reverse the LCD so it faces the camera; thicker shields may not allow the LCD panel to close completely in the reversed position.

■ **Acrylic/glass shields.** These scratch-resistant panels, laser cut to fit your camera perfectly, are my choice as the best protection solution, and what I use on my own T5. At about $6 each, they also happen to be the least expensive option as well. I get mine, shown in Figure 12.9, from a company called GGS. They attach using strips of sticky adhesive that hold the panel flush and tight, but which allow the acrylic to be pried off and the adhesive removed easily if you want to remove or replace the shield. They don't attenuate your view of the LCD and are non-reflective enough for use under a variety of lighting conditions.

Figure 12.9

A tough acrylic or glass shield can protect your LCD from scratches.

- **Flip-up hoods.** These protectors slip on using the flanges around your T5's eyepiece, and provide a cover that completely shields the LCD, but unfolds to provide a three-sided hood that allows viewing the LCD while minimizing the extraneous light falling on it and reducing contrast. They're sold for about $40 by Hoodman (www.hoodmanusa.com) and Delkin (www.delkin.com). If you want to completely protect your LCD from hard knocks and need to view the screen outdoors in bright sunlight, there is nothing better. However, I have a couple problems with these devices. First, with the cover closed, you can't peek down after taking a shot to see what your image looks like during picture review. You must open the cap each time you want to look at the LCD. Moreover, with the hood unfolded, it's difficult to look through the viewfinder: Don't count on being able to use the viewfinder *and* the LCD at the same time with one of these hoods in place.

- **Magnifiers.** If you look hard enough, you should be able to find an LCD magnifier that fits over the monitor panel and provides a 2X magnification. These often strap on clumsily, and serve better as a way to get an enlarged view of the LCD than as protection. Hoodman and other suppliers offer these specialized devices.

Troubleshooting Memory Cards

Sometimes good memory cards go bad. Sometimes good photographers can treat their memory cards badly. It's possible that a memory card that works fine in one camera won't be recognized when inserted into another. In the worst case, you can have a card full of important photos and find that the card seems to be corrupted and you can't access any of them. Don't panic! If these scenarios sound horrific to you, there are lots of things you can do to prevent them from happening, and a variety of remedies available if they do occur. You'll want to take some time—before disaster strikes—to consider your options.

All Your Eggs in One Basket?

The debate about whether it's better to use one large memory card or several smaller ones has been going on since even before there were memory cards. I can remember when computer users wondered whether it was smarter to install a pair of 200MB (not *gigabyte*) hard drives in their computer, or if they should go for one of those new-fangled 500MB models. By the same token, a few years ago the user groups were full of proponents who insisted that you ought to use 128MB memory cards rather than the huge 512MB versions. Today, most of the arguments involve 8GB cards versus 16GB or 32GB cards, and I expect that as prices for 64GB memory cards continue to drop, they'll find their way into the debate as well. Size is especially important when you're using a camera like the T5 that captures 18-megapixel images.

Why all the fuss? Are 16GB memory cards more likely to fail than 8GB cards? Are you risking all your photos if you trust your images to a larger card? Isn't it better to use several smaller cards, so

that if one fails you lose only half as many photos? Or, isn't it wiser to put all your photos onto one larger card, because the more cards you use, the better your odds of misplacing or damaging one and losing at least some pictures?

In the end, the "eggs in one basket" argument boils down to statistics, and how you happen to use your T5. The rationales can go both ways. If you have multiple smaller cards, you do increase your chances of something happening to one of them, so, arguably, you might be boosting the odds of losing some pictures. If all your images are important, the fact that you've lost 100 rather than 200 pictures isn't very comforting.

Also consider that the eggs/basket scenario assumes that the cards that are lost or damaged are always full. It's actually likely that your 16GB card might suffer a mishap when it's less than half-full (indeed, it's more likely that a large card won't be completely filled before it's offloaded to a computer), so you really might not lose any more shots with a single 16GB card than with multiple 8GB cards.

If you shoot photojournalist-type pictures, you probably change memory cards when they're less than completely full in order to avoid the need to do so at a crucial moment. (When I shoot sports, my cards rarely reach 80 to 90 percent of capacity before I change them.) Using multiple smaller cards means you have to change them that more often, which can be a real pain when you're taking a lot of photos. As an example, if you use tiny 2GB memory cards with an EOS T5 and shoot RAW+JPEG FINE, you may get only 68 pictures on the card. That's not even twice the capacity of a 36-exposure roll of film (remember those?). In my book, I prefer keeping all my eggs in one basket, and then making very sure that nothing happens to that basket.

There are only two really good reasons to justify limiting yourself to smaller memory cards when larger ones can be purchased at the same cost per-gigabyte. One of them is when every single picture is precious to you and the loss of any of them would be a disaster. If you're a wedding photographer, for example, and unlikely to be able to restage the nuptials if a memory card goes bad, you'll probably want to shoot no more pictures than you can afford to lose on a single card, and have an assistant ready to copy each card removed from the camera onto a backup hard drive or DVD onsite.

To be even safer, you'd want to alternate cameras or have a second photographer at least partially duplicating your coverage so your shots are distributed over several memory cards simultaneously. (Strictly speaking, the safest route of all is to use an Eye-Fi wireless card and beam the images to a computer as you shoot them.)

If none of these options are available to you, consider *interleaving* your shots. Say you don't shoot weddings, but you do go on vacation from time to time. Take 50 or so pictures on one card, or whatever number of images might fill about 25 percent of its capacity. Then, replace it with a different card and shoot about 25 percent of that card's available space. Repeat these steps with diligence (you'd have to be determined to go through this inconvenience), and, if you use four or more

memory cards, you'll find your pictures from each location scattered among the different memory cards. If you lose or damage one, you'll still have *some* pictures from all the various stops on your trip on the other cards. That's more work than I like to do (I usually tote around a portable hard disk and copy the files to the drive as I go), but it's an option.

What Can Go Wrong?

There are lots of things that can go wrong with your memory card, but the ones that aren't caused by human stupidity are statistically very rare. Yes, a memory card's internal bit bin or controller can suddenly fail due to a manufacturing error or some inexplicable event caused by old age. However, if your memory card works for the first week or two that you own it, it should work forever. There's really not a lot that can wear out.

The typical memory card is rated for a Mean Time Between Failures of 1,000,000 hours of use. That's constant use 24/7 for more than 100 years! According to the manufacturers, they are good for 10,000 insertions in your camera, and should be able to retain their data (and that's without an external power source) for something on the order of 11 years. Of course, with the millions of memory cards in use, there are bound to be a few lemons here or there.

Given the reliability of solid-state memory, compared to magnetic memory, though, it's more likely that your memory problems will stem from something that you do. Memory cards are small and easy to misplace if you're not careful. For that reason, it's a good idea to keep them in their original cases or a "card safe" offered by Gepe (www.gepecardsafe.com), Pelican (www.pelican.com), and others. Always placing your memory card in a case can provide protection from the second-most common mishap that befalls memory cards: the common household laundry. If you slip a memory card in a pocket, rather than a case or your camera bag, often enough, sooner or later it's going to end up in the washing machine and probably the clothes dryer, too. There are plenty of reports of relieved digital camera owners who've laundered their memory cards and found they still worked fine, but it's not uncommon for such mistreatment to do some damage.

Memory cards can also be stomped on, accidentally bent, dropped into the ocean, chewed by pets, and otherwise rendered unusable in myriad ways. It's also possible to force a card into your T5's memory card slot incorrectly if you're diligent enough, doing a little damage to the card itself or the slot. Or, if the card is formatted in your computer with a memory card reader, your T5 may fail to recognize it. Occasionally, I've found that a memory card used in one camera would fail if used in a different camera (until I reformatted it in Windows, and then again in the camera). Every once in awhile, a card goes completely bad and—seemingly—can't be salvaged.

Another way to lose images is to do commonplace things with your memory card at an inopportune time. If you remove the card from the T5 while the camera is writing images to the card, you'll lose any photos in the buffer and may damage the file structure of the card, making it difficult or impossible to retrieve the other pictures you've taken. The same thing can happen if you remove the

memory card from your computer's card reader while the computer is writing to the card (say, to erase files you've already moved to your computer). You can avoid this by *not* using your computer to erase files on a memory card but, instead, always reformatting the card in your T5 before you use it again.

What Can You Do?

Pay attention: If you're having problems, the *first* thing you should do is *stop* using that memory card. Don't take any more pictures. Don't do anything with the card until you've figured out what's wrong. Your second line of defense (your first line is to be sufficiently careful with your cards that you avoid problems in the first place) is to *do no harm* that hasn't already been done. Read the rest of this section and then, if necessary, decide on a course of action (such as using a data recovery service or software described later) before you risk damaging the data on your card further.

Now that you've calmed down, the first thing to check is whether you've actually inserted a card in the camera. If you've set the camera in the Shooting menu so that Shoot w/o Card has been turned on, it's entirely possible (although not particularly plausible) that you've been snapping away with no memory card to store the pictures to, which can lead to massive disappointment later on. Of course, the No Memory Card message appears on the LCD when the camera is powered up, and it is superimposed on the review image after every shot, but maybe you're inattentive, aren't using picture review, or have purchased one of those LCD fold-up hoods mentioned earlier in this chapter. You can avoid all this by turning the Shoot w/o Card feature off and leaving it off.

Things get more exciting when the card itself is put in jeopardy. If you lose a card, there's not a lot you can do other than take a picture of a similar card and print up some Have You Seen This Lost Flash Memory? flyers to post on utility poles all around town.

If all you care about is reusing the card, and have resigned yourself to losing the pictures, try reformatting the card in your camera. You may find that reformatting removes the corrupted data and restores your card to health. Sometimes I've had success reformatting a card in my computer using a memory card reader (this is normally a no-no because your operating system doesn't understand the needs of your T5), and *then* reformatting again in the camera.

If your memory card is not behaving properly, and you *do* want to recover your images, things get a little more complicated. If your pictures are very valuable, either to you or to others (for example, a wedding), you can always turn to professional data recovery firms. Be prepared to pay hundreds of dollars to get your pictures back, but these pros often do an amazing job. You wouldn't want them working on your memory card on behalf of the police if you'd tried to erase some incriminating pictures. There are many firms of this type, and I've never used them myself, so I can't offer a recommendation. Use a Google search to turn up a ton of them. I use a software program called RescuePro, which came free with one of my SanDisk memory cards.

THE ULTIMATE IRONY

I recently purchased an 8GB Kingston memory card that was furnished with some nifty OnTrack data recovery software. The first thing I did was format the card to make sure it was okay. Then I hunted around for the free software, only to discover it was preloaded onto the memory card. I was supposed to copy the software to my computer before using the memory card for the first time.

Fortunately, I had the OnTrack software that would reverse my dumb move, so I could retrieve the software. No, wait. I *didn't* have the software I needed to recover the software I erased. I'd reformatted it to oblivion. Chalk this one up as either the ultimate irony or Stupid Photographer Trick #523.

A more reasonable approach is to try special data recovery software you can install on your computer and use to attempt to resurrect your "lost" images yourself. They may not actually be gone completely. Perhaps your memory card's "table of contents" is jumbled, or only a few pictures are damaged in such a way that your camera and computer can't read some or any of the pictures on the card. Some of the available software was written specifically to reconstruct lost pictures, while other utilities are more general-purpose applications that can be used with any media, including floppy disks and hard disk drives. They have names like OnTrack, Photo Rescue 2, Digital Image Recovery, MediaRecover, Image Recall, and the aptly named Recover My Photos. You'll find a comprehensive list and links, as well as some picture-recovery tips at www.ultimateslr.com/memory-card-recovery.php.

DIMINISHING RETURNS

Usually, once you've recovered any images on a memory card, reformatted it, and returned it to service, it will function reliably for the rest of its useful life. However, if you find a particular card going bad more than once, you'll almost certainly want to stop using it forever. See if you can get it replaced by the manufacturer, if you can, but, in the case of memory card failures, the third time is never the charm.

Cleaning Your Sensor

There's no avoiding dust. No matter how careful you are, some of it is going to settle on your camera and on the mounts of your lenses, eventually making its way inside your camera to settle in the mirror chamber. As you take photos, the mirror flipping up and down causes the dust to become airborne and eventually make its way past the shutter curtain to come to rest on the anti-aliasing filter atop your sensor. There, dust and particles can show up in every single picture you take at a small enough aperture to bring the foreign matter into sharp focus. No matter how careful you are

and how cleanly you work, eventually you will get some of this dust on your camera's sensor. Some say that CMOS sensors, like the one found in the EOS T5, "attract" less dust than CCD sensors found in cameras from other vendors. But even the cleanest-working photographers using Canon cameras are far from immune.

Unfortunately, the EOS T5 lacks one of the most common features found in all Canon cameras other than a stray entry-level model or two like this one: automatic sensor cleaning. Fortunately, if some dust does collect on your sensor, you can often map it out of your images (making it invisible) using software techniques with the Dust Delete Data feature in the Shooting 3 menu. Operation of this feature is described in Chapter 8. Of course, you may still be required to manually clean your sensor from time to time. This section explains the phenomenon and provides some tips on minimizing dust and eliminating it when it begins to affect your shots. I also cover this subject in my book, *Digital SLR Pro Secrets*, with complete instructions for constructing your own sensor cleaning tools. However, I'll provide a condensed version here of some of the information in that book, because sensor dust and sensor cleaning are two of the most contentious subjects Canon EOS T5 owners have to deal with.

Dust the FAQs, Ma'am

Here are some of the most frequently asked questions about sensor dust issues:

Q. I see tiny specks in my viewfinder. Do I have dust on my sensor?

A. If you see sharp, well-defined specks, they are clinging to the underside of your focus screen and not on your sensor. They have absolutely no effect on your photographs, and are merely annoying or distracting.

Q. I can see dust on my mirror. How can I remove it?

A. Like focus screen dust, any artifacts that have settled on your mirror won't affect your photos. You can often remove dust on the mirror or focus screen with a bulb air blower, which will loosen it and whisk it away. Stubborn dust on the focus screen can sometimes be gently flicked away with a soft brush designed for cleaning lenses. I don't recommend brushing the mirror or touching it in any way. The mirror is a special front-surface-silvered optical device (unlike conventional mirrors, which are silvered on the back side of a piece of glass or plastic) and can be easily scratched. If you can't blow mirror dust off, it's best to just forget about it. You can't see it in the viewfinder, anyway.

Q. I see a bright spot in the same place in all of my photos. Is that sensor dust?

A. You've probably got either a "hot" pixel or one that is permanently "stuck" due to a defect in the sensor. A hot pixel is one that shows up as a bright spot only during long exposures as the sensor warms. A pixel stuck in the "on" position always appears in the image. Both show up as bright red, green, or blue pixels, usually surrounded by a small cluster of other improperly illuminated pixels, caused by the camera's interpolating the hot or stuck pixel

into its surroundings, as shown in Figure 12.10. A stuck pixel can also be permanently dark. Either kind is likely to show up when they contrast with plain, evenly colored areas of your image.

Finding one or two hot or stuck pixels in your sensor is unfortunately fairly common. They can be "removed" by telling the T5 to ignore them through a simple process called *pixel mapping*. If the bad pixels become bothersome, Canon can remap your sensor's pixels with a quick trip to a service center.

Bad pixels can also show up on your camera's color LCD panel, but, unless they are abundant, the wisest course is to just ignore them.

Figure 12.10 A stuck pixel is surrounded by improperly interpolated pixels created by the T5's demosaicing algorithm.

Q. I see an irregular out-of-focus blob in the same place in my photos. Is that sensor dust?

A. Yes. Sensor contaminants can take the form of tiny spots, larger blobs, or even curvy lines if they are caused by minuscule fibers that have settled on the sensor. They'll appear out of focus because they aren't actually on the sensor surface but, rather, a fraction of a millimeter above it on the filter that covers the sensor. The smaller the f/stop used, the more in-focus the dust becomes. At large apertures, it may not be visible at all.

Q. I never see any dust on my sensor. What's all the fuss about?

A. Those who never have dust problems with their EOS T5 fall into one of three categories: those who seldom change their lenses and have clean working habits that minimize the amount of dust that invades their cameras in the first place; those who simply don't notice the dust (often because they don't shoot many macro photos or other pictures using the small f/stops that makes dust evident in their images); and those who are very, very lucky.

Identifying and Dealing with Dust

Sensor dust is less of a problem than it might be because it shows up only under certain circumstances. Indeed, you might have dust on your sensor right now and not be aware if it. The dust doesn't actually settle on the sensor itself, but, rather, on a protective filter a very tiny distance above the sensor, subjecting it to the phenomenon of *depth-of-focus*. Depth-of-focus is the distance the focal plane can be moved and still render an object in sharp focus. At f/2.8 to f/5.6 or even smaller, sensor dust, particularly if small, is likely to be outside the range of depth-of-focus and blur into an unnoticeable dot.

However, if you're shooting at f/16 to f/22 or smaller, those dust motes suddenly pop into focus. Forget about trying to spot them by peering directly at your sensor with the shutter open and the lens removed. The period at the end of this sentence, about .33mm in diameter, could block a group of pixels measuring 40 × 40 pixels (160 pixels in all!). Dust spots that are even smaller than that can easily show up in your images if you're shooting large, empty areas that are light colored. Dust motes are most likely to show up in the sky, as in Figure 12.11, or in white backgrounds of your seamless product shots and are less likely to be a problem in images that contain lots of dark areas and detail.

Figure 12.11 Only the dust spots in the sky are apparent in this shot.

To see if you have dust on your sensor, take a few test shots of a plain, blank surface (such as a piece of paper or a cloudless sky) at small f/stops, such as f/22, and a few wide open. Open Photoshop, copy several shots into a single document in separate layers, then flip back and forth between layers to see if any spots you see are present in all layers. You may have to boost contrast and sharpness to make the dust easier to spot.

Avoiding Dust

Of course, the easiest way to protect your sensor from dust is to prevent it from settling on the sensor in the first place. Some Canon lenses come with rubberized seals around the lens mounts that help keep dust from infiltrating, but you'll find that dust will still find a way to get inside. Here are my tips for eliminating the problem before it begins:

- **Clean environment.** Avoid working in dusty areas if you can do so. Hah! Serious photographers will take this one with a grain of salt, because it usually makes sense to go where the pictures are. Only a few of us are so paranoid about sensor dust (considering that it is so easily removed) that we'll avoid moderately grimy locations just to protect something that is, when you get down to it, just a tool. If you find a great picture opportunity at a raging fire, during a sandstorm, or while surrounded by dust clouds, you might hesitate to take the picture, but, with a little caution (don't remove your lens in these situations, and clean the camera afterward!) you can still shoot. However, it still makes sense to store your camera in a clean environment. One place cameras and lenses pick up a lot of dust is inside a camera bag. Clean your bag from time to time, and you can avoid problems.

- **Clean lenses.** There are a few paranoid types that avoid swapping lenses in order to minimize the chance of dust getting inside their cameras. It makes more sense just to use a blower or brush to dust off the rear lens mount of the replacement lens first, so you won't be introducing dust into your camera simply by attaching a new, dusty lens. Do this before you remove the lens from your camera, and then avoid stirring up dust before making the exchange.

- **Work fast.** Minimize the time your camera is lens-less and exposed to dust. That means having your replacement lens ready and dusted off, and a place to set down the old lens as soon as it is removed, so you can quickly attach the new lens.

- **Let gravity help you.** Face the camera downward when the lens is detached so any dust in the mirror box will tend to fall away from the sensor. Turn your back to any breezes, indoor forced air vents, fans, or other sources of dust to minimize infiltration.

- **Protect the lens you just removed.** Once you've attached the new lens, quickly put the end cap on the one you just removed to reduce the dust that might fall on it.

- **Clean out the vestibule.** From time to time, remove the lens while in a relatively dust-free environment and use a blower bulb like the one shown in Figure 12.12 (*not* compressed air or a vacuum hose) to clean out the mirror box area. A blower bulb is generally safer than a can of compressed air, or a strong positive/negative airflow, which can tend to drive dust further into nooks and crannies.

- **Be prepared.** If you're embarking on an important shooting session, it's a good idea to clean your sensor *now*, rather than come home with hundreds or thousands of images with dust spots caused by flecks that were sitting on your sensor before you even started. Before I left on my recent trip to Spain, I put both cameras I was taking through a rigid cleaning regimen, figuring they could remain dust-free for a measly 10 days. I even left my bulky blower bulb at home. It was a big mistake, but my intentions were good.

Figure 12.12
Use a robust air bulb for cleaning your sensor.

- **Clone out existing spots in your image editor.** Photoshop and other editors have a clone tool or healing brush you can use to copy pixels from surrounding areas over the dust spot or dead pixel. This process can be tedious, especially if you have lots of dust spots and/or lots of images to be corrected. The advantage is that this sort of manual fix-it probably will do the least damage to the rest of your photo. Only the cloned pixels will be affected.

- **Use filtration in your image editor.** A semi-smart filter like Photoshop's Dust & Scratches filter can remove dust and other artifacts by selectively blurring areas that the plug-in decides represent dust spots. This method can work well if you have many dust spots, because you won't need to patch them manually. However, any automated method like this has the possibility of blurring areas of your image that you didn't intend to soften.

Sensor Cleaning

Those new to the concept of sensor dust actually hesitate before deciding to clean their camera themselves. Isn't it a better idea to pack up your T5 and send it to a Canon service center so their crack technical staff can do the job for you? Or, at the very least, shouldn't you let the friendly folks at your local camera store do it?

Of course, if you choose to let someone else clean your sensor, they will be using methods that are more or less identical to the techniques you would use yourself. None of these techniques are difficult, and the only difference between their cleaning and your cleaning is that they might have done it dozens or hundreds of times. If you're careful, you can do just as good a job.

Of course, vendors like Canon won't tell you this, but it's not because they don't trust you. It's not that difficult for a real goofball to mess up his camera by hurrying or taking a shortcut. Perhaps the person uses the "Bulb" method of holding the shutter open and a finger slips, allowing the shutter curtain to close on top of a sensor cleaning brush. Or, someone tries to clean the sensor using masking tape, and ends up with goo all over its surface. If Canon recommended *any* method that's mildly risky, someone would do it wrong, and then the company would face lawsuits from those who'd contend they did it exactly in the way the vendor suggested, so the ruined camera is not their fault. If you visit Canon's website or peruse the manual, you'll find this type of recommendation: "If the image sensor needs cleaning, we recommend having it cleaned at a Canon service center, as it is a very delicate component."

You can see that vendors like Canon tend to be conservative in their recommendations, and, in doing so, make it seem as if sensor cleaning is more daunting and dangerous than it really is. Some vendors recommend only dust-off cleaning, through the use of reasonably gentle blasts of air, while condemning more serious scrubbing with swabs and cleaning fluids. However, these cleaning kits for the exact types of cleaning they recommended against are for sale in Japan only, where, apparently, your average photographer is more dexterous than those of us in the rest of the world. These kits are similar to those used by official repair staff to clean your sensor if you decide to send your camera in for a dust-up.

As I noted, sensors can be affected by dust particles that are much smaller than you might be able to spot visually on the surface of your lens. The filters that cover sensors tend to be fairly hard compared to optical glass. Cleaning the 22.3mm × 14.9mm sensor in your Canon T5 within the tight confines of the mirror box can call for a steady hand and careful touch. If your sensor's filter becomes scratched through inept cleaning, you can't simply remove it yourself and replace it with a new one.

There are three basic kinds of cleaning processes that can be used to remove dusty and sticky stuff that settles on your dSLR's sensor. All of these must be performed with the shutter locked open. I'll describe these methods and provide instructions for locking the shutter later in this section.

- **Air cleaning.** This process involves squirting blasts of air inside your camera with the shutter locked open. This works well for dust that's not clinging stubbornly to your sensor.
- **Brushing.** A soft, very fine brush is passed across the surface of the sensor's filter, dislodging mildly persistent dust particles and sweeping them off the imager.
- **Liquid cleaning.** A soft swab dipped in a cleaning solution such as ethanol is used to wipe the sensor filter, removing more obstinate particles.

Placing the Shutter in the Locked and Fully Upright Position for Landing

Make sure you're using a fully charged battery or the optional AC Adapter Kit ACK-E10.

1. Remove the lens from the camera and then turn the camera on.
2. Set the EOS T5 to any one of the non-fully automatic modes.
3. You'll find the Clean Manually menu choice in the Set-up 2 menu. Press the SET button.
4. Select OK and press SET again. The mirror will flip up and the shutter will open (see Figure 12.13).
5. Use one of the methods described below to remove dust and grime from your sensor. Be careful not to accidentally switch the power off or open the memory card or battery compartment doors as you work. If that happens, the shutter may be damaged if it closes onto your cleaning tool.
6. When you're finished, turn the power off, replace your lens, and switch your camera back on.

Air Cleaning

Your first attempts at cleaning your sensor should always involve gentle blasts of air. Many times, you'll be able to dislodge dust spots, which will fall off the sensor and, with luck, out of the mirror box. Attempt one of the other methods only when you've already tried air cleaning and it didn't remove all the dust.

Figure 12.13
With the shutter open and the mirror locked up, you can commence cleaning the exposed sensor.

Here are some tips for doing air cleaning:

- **Use a clean, powerful air bulb.** Your best bet is bulb cleaners designed for the job, like the Giottos Rocket. Smaller bulbs, like those air bulbs with a brush attached sometimes sold for lens cleaning or weak nasal aspirators, may not provide sufficient air or a strong enough blast to do much good.

- **Hold the EOS T5 upside down.** Then look up into the mirror box as you squirt your air blasts, increasing the odds that gravity will help pull the expelled dust downward, away from the sensor. You may have to use some imagination in positioning yourself. (See Figure 12.14.)

- **Never use air canisters.** The propellant inside these cans can permanently coat your sensor if you tilt the can while spraying. It's not worth taking a chance.

- **Avoid air compressors.** Super-strong blasts of air are likely to force dust under the sensor filter.

Figure 12.14 Hold the camera upside down when cleaning to allow dust to fall out.

Brush Cleaning

If your dust is a little more stubborn and can't be dislodged by air alone, you may want to try a brush, charged with static electricity, that can pick off dust spots by electrical attraction. One good, but expensive, option is the Sensor Brush sold at www.visibledust.com. A cheaper version can be purchased at www.copperhillimages.com. You need a 16mm version, like the one shown in Figure 12.15, that can be stroked across the short dimension of your T5's sensor.

Ordinary artist's brushes are much too coarse and stiff and have fibers that are tangled or can come loose and settle on your sensor. A good sensor brush's fibers are resilient and described as "thinner than a human hair." Moreover, the brush has a wooden handle that reduces the risk of static sparks.

Brush cleaning is done with a dry brush by gently swiping the surface of the sensor filter with the tip. The dust particles are attracted to the brush particles and cling to them. You should clean the brush with compressed air before and after each use, and store it in an appropriate air-tight container between applications to keep it clean and dust-free. Although these special brushes are expensive, one should last you a long time.

Figure 12.15
A proper brush, preferably with a grounding strap to eliminate static electricity, is required for dusting off your sensor.

Liquid Cleaning

Unfortunately, you'll often encounter really stubborn dust spots that can't be removed with a blast of air or flick of a brush. These spots may be combined with some grease or a liquid that causes them to stick to the sensor filter's surface. In such cases, liquid cleaning with a swab may be necessary. During my first clumsy attempts to clean my own sensor, I accidentally got my blower bulb tip too close to the sensor, and some sort of deposit from the tip of the bulb ended up on the sensor. I panicked until I discovered that liquid cleaning did a good job of removing whatever it was that took up residence on my sensor.

You can make your own swabs out of pieces of plastic (some use fast-food restaurant knives, with the tip cut at an angle to the proper size) covered with a soft cloth or Pec-Pad, as shown in Figures 12.16 and 12.17. However, if you've got the bucks to spend, you can't go wrong with good-quality commercial sensor cleaning swabs, such as those sold by Photographic Solutions, Inc. (www.photosol.com/swabproduct.htm).

Figure 12.16 You can make your own sensor swab from a plastic knife that's been truncated.

Figure 12.17 Carefully wrap a Pec-Pad around the swab.

You want a sturdy swab that won't bend or break so you can apply gentle pressure to the swab as you wipe the sensor surface. Use the swab with methanol (as pure as you can get it, particularly medical grade; other ingredients can leave a residue), or the Eclipse solution also sold by Photographic Solutions. Eclipse is actually quite a bit purer than even medical-grade methanol. A couple drops of solution should be enough, unless you have a spot that's extremely difficult to remove. In that case, you may need to use extra solution on the swab to help "soak" the dirt off.

Once you overcome your nervousness at touching your T5's sensor, the process is easy. You'll wipe continuously with the swab in one direction, then flip it over and wipe in the other direction. You need to completely wipe the entire surface; otherwise, you may end up depositing the dust you collect at the far end of your stroke. Wipe; don't rub.

If you want a close-up look at your sensor to make sure the dust has been removed, you can pay $50 to $100 for a special sensor "microscope" with an illuminator. (See Figure 12.18.) Or, you can do like I do and work with a plain old Carson MiniBrite PO-55 illuminated 3X magnifier, as seen in Figure 12.19. It has a built-in LED and, held a few inches from the lens mount with the lens removed from your T5, provides a sharp, close-up view of the sensor, with enough contrast to reveal any dust that remains. You can read more about this great device at http://dslrguides.com/carson/.

Figure 12.18
This SensorKlear magnifier provides a view of your sensor as you work.

Figure 12.19
An illuminated magnifier like this Carson MiniBrite PO-25 can be used as a 'scope to view your sensor.

Index

R

R mount lenses, Canon, 241
RadioPopper
 channel control triggers, 298
 radio-control devices, 316
rangefinder system and phase detection, 96
rating images. *See* image rating
RAW formats. *See also* RAW+JPEG format
 Color Space menu and, 178
 continuous shooting with, 136–137
 JPEG formats compared, 162–164
 Merge to HDR and, 79
 Monochrome Picture Style with, 184
 Picture Styles in, 181
 Shooting menu options, 161– 164
 WB (white balance), working with, 277
RAW utilities. *See* Adobe Camera Raw
RAW+JPEG format
 benefits of shooting in, 164
 continuous shooting with, 136
 managing files, 164
 Shooting menu options, 161– 164
rear-curtain sync. *See* second-curtain sync
rear lens cap, removing, 13
rear view of camera, 40–46
reciprocity failure, 138
Recover My Photos, 330
rectilinear lenses, 254
red-eye reduction
 with built-in flash, 285
 Camera Functions display for, 52
 Shooting menu options, 169–170
 viewfinder information display for, 53–54
red-eye reduction lamp, 37
Red filters, 186–188
Reduce button, 42, 44
reflected light, 60
reflectors for softening light, 312
registering
 camera, 9
 lenses, 168–169
 My Menu items, 230

registration card, 9
Release Shutter Without Card options, Shooting menu, 165
remaining shots. *See* shots remaining
Rembrandt, 267
remote control. *See also* wireless flash
 terminal, 40
RescuePro, SanDisk, 329
resizing. *See* sizing/resizing
resolution
 for movies, 116–117
 Shooting menu options, 161
revealing images with short exposures, 139
reviewing images, 30–32
 information overlays for, 50–51
 jumping through images, 30
 movies, reviewing, 121–123
 thumbnails, navigating through, 31–32
 time for reviewing images, Shooting menu options for, 166
 zooming in/out on, 31
RGB histograms, 84
 example of, 85
 LCD display, 50–51
 Playback menu options, 204–205
right angle viewer, 10
ring lights, 311
Ritchie, Guy, 128
Roscoe lighting gels, 273
rotating images
 Auto Rotate options, Set-up menu, 210–211
 Camera Functions display for, 52
 Playback menu options for, 197
rule of thirds grids, 111

S

SanDisk's RescuePro, 329
Sanyo Eneloop AA batteries, 305
saturation Picture Style parameter, 182–183
saving
 movies, 123
 Picture Styles, 190
 video snapshots, 124